Art and the Reformation in Germany

Art
and the
Reformation
in
Germany

Carl C. Christensen
*University of Colorado
at Boulder*

*Ohio University Press
Wayne State University Press
1979*

Studies in the Reformation, Volume II
Edited by Robert C. Walton

Copyright © 1979 by
Ohio University Press, Athens, Ohio 45701
and Wayne State University Press, Detroit, Michigan 48202
No part of this book may be reproduced without formal permission.

Library of Congress Cataloging in Publication Data

Christensen, Carl C 1935–
 Art and the Reformation in Germany.

 (Studies in the Reformation; v. 2)
 Bibliography: p.
 Includes index.
 1. Art, German. 2. Art, Renaissance—Germany.
3. Reformation and art—Germany. 4. Christian art and
symbolism—Modern, 1500– —Germany. I. Title.
II. Series.
N7950.A1C47 704.948'2'0943 79-16006
ISBN 0-8214-0388-5

for Katherine

Contents

Illustrations

Preface

For a long time the need has been felt for a book analyzing the relationship between art and the Reformation in Germany. The lack of such a volume assumes particular significance in the English-speaking world, where little of a general nature has been published on the topic. The present work was undertaken in an attempt partially to meet that need. In writing it I have utilized the results of my own detailed investigations as well as the research of numerous other scholars. To the many authors from whom I have borrowed material and ideas I am deeply indebted. I hope that my obligations to them are sufficiently indicated in the footnotes to this volume.

Over the years I have incurred many other debts of gratitude as well, some of which I now wish to acknowledge. I first was encouraged to begin my investigation of this topic while a Ph.D. candidate at the Ohio State University working under the direction of Professor Harold J. Grimm, a man who enjoys a well-earned reputation as an extraordinarily learned and inspiring teacher of Reformation history. Dr. Grimm has continued to offer generously his support and advice in the ensuing years. Portions of the present book benefited from his careful attention. Other persons also have read my manuscript and made many very helpful suggestions for its improvement.

Support has been forthcoming from institutions as well as individuals. In the early stages of my career I was fortunate enough to receive the award of a Woodrow Wilson Dissertation Fellowship, as well as a Fulbright Grant that helped make possible my initial research in Germany. More recently, the University of Colorado Graduate School's Council on Research and Creative Work has contributed much to the completion of my project by the provision of a Faculty Fellowship and two grants-in-aid permitting further travel

and scholarly investigation abroad. Numerous other members of the University of Colorado community also have rendered valuable assistance. I wish to single out for thanks here the able personnel of the Interlibrary Loan Department of Norlin Library and the efficient members of the Department of History office staff, who have typed most of my manuscript.

My wife, too, has contributed in various ways to the completion of the present volume. Most important, she has given me unfailing moral support and cheerfully endured the burden that this enterprise often has placed upon our family life.

Acknowledgments

Portions of the following book were originally published in the essays listed below. This material is reprinted here by permission.

"Iconoclasm and the Preservation of Ecclesiastical Art in Reformation Nuernberg," *Archiv für Reformationsgeschichte* 61 (1970): 205–21.

"Luther's Theology and the Uses of Religious Art," *The Lutheran Quarterly* 22 (1970): 147–65.

"The Significance of the Epitaph Monument in Early Lutheran Ecclesiastical Art (ca. 1540–1600): Some Social and Iconographical Considerations," in *The Social History of the Reformation,* ed. Lawrence P. Buck and Jonathan W. Zophy (Columbus: Ohio State University Press, 1972), pp. 297–314.

"The Reformation and the Decline of German Art," *Central European History* 6 (1973): 207–32.

Unless otherwise indicated, Scripture quotations are from the Revised Standard Version of the Bible, copyright 1946 and 1952 by the Division of Christian Education of the National Council of Churches.

1

The Origins of Reformation
Iconoclasm

Art and Piety in the Later Middle Ages

N THE REALM of higher culture certainly one of the most
notorious consequences of the Protestant Reformation was
the destruction of countless paintings and statues in the
wave of iconoclasm that swept parts of Europe in the sixteenth
century. In order to understand the reasons for this assault on eccle-
siastical imagery it will be helpful not only to examine, as we shall,
some of the theological and social considerations involved, but also
to gain some appreciation of the place that these artifacts occupied
in the religious piety of the time. For those reformers who led the
campaign to remove the images from the churches did so not
merely for abstract doctrinal reasons; they were motivated in many
instances by indignation over what they believed to be the concrete
abuses that all too often had become associated with the use of the
representational arts for cultic purposes.

To introduce the matter of late medieval piety is, admittedly, to
bring up a very large topic.[1] Recent scholars who have attempted to
characterize this phenomenon have alerted us to its richness and
diversity, its puzzling complexity, its antitheses and seeming con-
tradictions.[2] Fortunately, it is not necessary here to undertake the
difficult assignment of formulating a rounded and complete de-
scription; it will suffice merely to indicate a few of those features

that seem especially relevant to a consideration of the purpose and function of the religious art of the period.

Modern historians generally agree that, judging from outward appearances at least, the eve of the Reformation was an intensely religious period in German history. Some of the forms taken by that religiosity may subsequently have been criticized—indeed, in many instances they were criticized at the time—but concerning the pervasiveness of Christian attitudes and values there can be little doubt. To be sure, the frequent gap between professed belief and personal behavior constituted one of the inner contradictions of the age.[3] Nonetheless, it was a period in which society and thought were permeated with sacred associations, and all areas of life continued to be correlated to the teachings of the church.[4] Heresy actually was on the decline from earlier decades, and the fundamental dogmas of the church remained virtually without opposition.[5]

Measured in terms of such indices as the formation of new religious brotherhoods and confraternities,[6] the celebration of liturgical festivals and processions,[7] the resurgence of church construction,[8] and the widespread use of devotional literature,[9] an intensification of religious piety can be detected at the very end of the Middle Ages.[10] To take another example, the endowment of altars and anniversary masses for the dead had become more and more popular among the middle and upper classes, so much so that in the judgment of Roman Catholic historians such as Joseph Lortz the practice was getting out of hand by the time of the Reformation.[11] Some statistics provided by modern authors illustrate the point. Lortz informs us that "in Breslau at the end of the fifteenth century two churches could count a total of 236 chaplains alone, priests whose sole job was to say daily Mass."[12] Historian Gordon Rupp relates that in pre-Reformation Wittenberg, "the Castle Church had sixty-four clergy to attend to the divine offices and perform some 9,000 commemorative Masses annually."[13] Professor Eric Gritsch reports that in Zwickau, where there were eight churches in all, "St. Mary's Church alone employed twenty-seven priests serving daily at twenty-three altars."[14]

It is little wonder that some modern historians speak of religious observances in the later Middle Ages multiplying in an almost mechanical way and point to the apparently quantitative approach to

piety, the seemingly "aimless reiteration of the ceremonial" that prevailed.[15] In any case, the magnificent efflorescence of the fine arts that occurred in late medieval Germany surely was closely linked to the spectacular increase in the number and variety of ritualized devotional practices observed to have taken place at that time.[16] For this ever-expanding cycle of cultic acts required—in addition to the production of new altars, communion vessels, and clerical vestments—the preparation of countless altar paintings and carvings, tabernacles, candelabra, and numerous other types of liturgical utensils and furnishings. The Christian church, as a consequence, had never displayed such visual splendor.[17]

At this point it might be well to pause and examine the motives of the faithful, particularly the increasingly numerous lay donors, who responded to this need by contributing to the churches all these products of the painter's, sculptor's, or goldsmith's art. For, as we shall see, in the minds of certain Protestant reformers this was an important consideration in evaluating the propriety of ecclesiastical imagery. First, it might be said that benefactors providing gifts of paintings and sculpture that displayed a sacred iconography undoubtedly assumed that the gifts would assist in the teaching and evangelizing work of the church as well as proving useful in private devotions. Strong and traditional grounds existed for those assumptions, even if they were later challenged by some Protestant critics, and of all the reasons for contributing ecclesiastical art works these rationales perhaps proved the least vulnerable to attack. Ever since the pontificate of Gregory the Great (d. 604) the classic defense of religious imagery in the Christian West had been that it served as the "Bible of the illiterate,"[18] and the educational use of visual art remained very important in the late medieval church.[19] In addition to this didactic function, there was a widespread belief in the Middle Ages that religious images served as a valuable stimulus to intensified devotion. Due to their capacity for rendering persons and events vivid to the imagination, such images were considered to possess a unique effectiveness in arousing the emotions and moving the will.[20] This assumption is reflected in a statement by the fifteenth-century Augustinian Eremite Gottschalk Hollen, who claimed that many people are more efficaciously incited to piety through viewing an image than through hearing a sermon.[21]

Another concern of many devout donors of ecclesiastical art works surely was to adorn and embellish the church building in such a manner that it should become a truly worthy setting for divine worship. This consideration had taken on added dimensions with the spread and popularization of cultic observances associated with the dogma of transubstantiation. The eucharistic presence of Christ in the consecrated and reserved Host or communion wafer meant that the cathedral or chapel literally became the house of God. As such it was thought deserving of being beautified and dignified by the best creative efforts of the Christian artist.[22]

It is clear, however, that the incentive underlying endowment of art monuments in the churches was not always entirely disinterested. The evidence suggests that at times a type of spiritual profit motive came into play. Modern scholars, both Catholic and non-Catholic, concede the point made most strongly by Luther, i.e., that the notion of performing good works or meritorious service in the eyes of God stimulated many such donations.[23] This is especially understandable in view of the extraordinary anxiety concerning personal salvation that modern commentators find to have existed during this age of religious unrest.[24] To give an altar painting or statue to the church was a "good work" and a rather distinctive one at that.[25] It also seems likely that the attempt to atone for guilt—for example, that felt by wealthy merchants whose profit-oriented business activities sometimes brought them into conflict with the law of the church—accounts for many ecclesiastical benefactions.[26] All in all, we may conclude that a great deal of religious art arose from the somewhat self-centered fear of individuals with respect to the eternal destiny of their own souls.[27]

Donors, in fact, sometimes were explicitly informed that money contributed to ecclesiastical monuments would produce spiritual benefits to them. As an example may be cited the instance of the financing of the shrine created by Peter Vischer for Nuernberg's patron, St. Sebald, in the church bearing his name. When in 1519 adequate funding to pay for this large monument had not yet been raised, Anton Tucher, head of the municipal government and also lay superintendent of St. Sebald Church, called upon the wealthiest citizens of the community to appear at the city hall. During a series of meetings there, he requested contributions from them, saying

among other things that the benefactors without doubt would receive rich rewards, material and spiritual, from both God and the saint himself.[28] Instances also occurred when donors of altar paintings were granted the privilege of having an anniversary Mass sung in their honor.[29]

A full consideration of the factors that prompted individuals to place art works in churches, however, would have to take into account additional, mundane motives that had nothing to do with religion at all. In the fourteenth century the great German mystic, Johannes Tauler, had already protested that many persons were making such contributions only to satisfy their own vanity and egoism.[30] The temptation to do so was greatly strengthened by the practice, widespread among the urban patriciate as well as the nobility, of placing family coats of arms on everything from altar panels to Mass vestments.[31] Indeed, it reached the point that altars often were named, in common usage at least, after their donors rather than the saints to which they were dedicated.[32] There can be little doubt, in other words, that ecclesiastical art works often functioned as status symbols for those individuals or families who had commissioned and installed them.[33] Similarly, guilds or confraternities and their members basked in the reflected glory from the magnificent chapels dedicated to their patron saint.[34] It is important to note, however, that the various spiritual and worldly considerations enumerated here normally were not so clearly distinguished in the mind of the late medieval Christian. A salient feature of the piety of the period was its tendency to blend or confuse the two realms of sacred and secular in a fashion sometimes baffling to the modern mentality.[35] In a culture so universally, if at times naively, religious as this one, the danger always existed that the holy and the profane might intertwine in such a way as to violate the integrity of the former.

A closely related danger arose from the externalism that characterized so much of the church life of this age.[36] The prominence that this problem assumed even for contemporaries can be inferred from the vigorous verbal attacks made upon it by late medieval reformers, such as Savonarola, as well as spiritual-minded humanists, such as Erasmus.[37] And an aspect of this externalism that directly affected the role of art in religious practice is found in the extraordinary

craving for the sensible—and above all the visible—that prevailed in much late medieval Christianity.[38] To borrow the words of a recent essay, there existed a widespread inclination toward a "sensuous perception of the sacred."[39] One significant expression of this tendency was the remarkably strong desire evinced by the populace to view and venerate the consecrated Host.[40] In addition to the theological basis provided by the Real Presence doctrine mentioned above, this phenomenon has been explained as being due, in part, to the general trend in the later Middle Ages whereby the laity no longer received the Eucharist in both kinds (i.e., bread and wine).[41] In any case, the great reverence accorded the Host is especially noteworthy in view of the seeming infrequency with which the average Christian actually partook of Holy Communion.[42]

The great cultural historian Johan Huizinga speaks of a tendency during this age for thought to seek expression in images or embodiment in visible forms.[43] This inclination perhaps was nowhere so apparent as in the realm of religion, and it provides an important historical contrast to subsequent Protestant Christianity with the latter's de-emphasis of sensuous—or at least visual—elements and strong stress instead on the spoken Word.[44] Numerous examples of the late medieval attitude can be found in the area of popular piety, and these reinforce what has been said about the visual emphasis reflected in the veneration of the Host. For example, a brief exposition of the Mass published in Augsburg in 1484 compared preparation for Holy Communion with the construction and furnishing of a church. Upon its completion, the author states, the temple of one's soul must be adorned with paintings—of Christ's crucifixion, the Virgin, and St. John the Evangelist.[45] Ludolph of Saxony, fourteenth-century author of the enduringly popular *Vita Christi,* in this work urged that the worshiper must have the face of Christ quite literally and visibly before his eyes in order to experience effective devotions.[46] Albrecht von Eybe, in an early sixteenth-century writing entitled *Der Sittenspiegel,* suggested that near the deathbed should be placed a crucifix and an image of Christ, the Virgin, or some other saint whose aid the expiring person has been accustomed to invoke, in order that he might call upon and be strengthened by them.[47]

Mention of the veneration of the Virgin and saints, of course,

brings us to one of the most prominent features of late medieval piety as described by almost all modern historians,[48] one that had immense significance for ecclesiastical art. Everywhere we turn in considering the religiosity of the waning Middle Ages we find evidence of the cult of the saints. It was endorsed by prominent theologians such as Gabriel Biel[49] and affirmed even by men influenced by the new humanistic learning.[50] It constituted a staple topic in late medieval preaching and prayer book literature.[51] It was reflected in the large numbers of inexpensive biographies of individual saints published at the time.[52] And it provided the nucleus of the subject matter or iconography of religious art.[53] The last point may be illustrated by the iconographical tabulation of the themes of almost 450 German religious paintings from the years 1495–1520 (Appendix). Of these, 137 portray the Virgin as a major figure. Another 125 depict lesser saints of the church. If the two categories are combined, the total accounts for nearly 60 percent of the entire sample.[54]

Johannes Herolt, Nuernberg Dominican and author of perhaps the most widely printed pre-Reformation collection of sermons dealing with the topic, spelled out three essential aspects of the cult of the saints: veneration, imitation, and invocation.[55] To treat the last of these first, the practice of the invocation of the saints in time of need underwent a very interesting development in the later Middle Ages, i.e., the completion of a process of specialization of function and division of labor.[56] The practice increasingly became to rely upon not merely one all-purpose guardian or patron, but to assign specific salvific, curative, or restorative powers to individual saints. Among them all, the Virgin quite naturally continued to hold her special and leading place.[57] In this regard, popular piety agreed with the formal theology of the period. Indeed, in her role as Mediatrix or even Co-Redemptrix, the theologians as well as the laity often exalted her to a status seemingly almost commensurate with that of Christ.[58] Among the lesser intercessors, local patron saints and other traditional celestial benefactors remained important. But what is striking is the addition of new saints, including some with rather dubious credentials, the increased prominence and importance given certain inherited guardians such as St. Anne, Mother of the Virgin, and, above all, the practice of calling upon

different patrons depending upon the specific need of the moment.[59] Thus, the pious Christian might turn to St. Stephen for aid in developing patience, to St. Sebastian for protection from the plague, to St. Valentine for healing from leprosy, to St. Barbara for protection from a sudden death, to St. Apollonia for avoiding a toothache, and so on.[60] Throughout the fifteenth century the veneration of a whole special group of saints known as the "Fourteen Holy Helpers" had grown in significance and popularity, especially in central and southern Germany.[61] The modern historian Willy Andreas probably attributes to the artists too much influence on the direction of popular piety when he suggests that it was they who helped to foster and spread the cults of newly popular saints by eagerly seizing upon them for purposes of representation.[62] But there can be no doubt that the painters and sculptors of the time did indeed profit from the increased number of commissions that resulted from this proliferation.

Turning from the invocation of the saints to their veneration, we should note at the outset that an effort was made by responsible theologians to teach the people that a suitable discrimination must be practiced in regard to the type of homage offered, respectively, to God, the saints, and the Virgin. For example, the book prepared by Johannes Nider for use by the parish clergy and entitled *Praeceptorium divinae legis,* which was widely circulated in the late fifteenth century in Germany, carefully distinguished between (1) that full worship which properly is offered only to God (*latria*); (2) the lesser veneration due the saints, their images, and relics (*dulia*); and (3) the intermediate type of veneration owed the Virgin (*hyperdulia*).[63] Whether ordinary lay Christians proved able to make an equally exact differentiation while actively engaged in their devotions no doubt is another matter. The heavy reliance upon visual imagery in the late medieval church probably did nothing to diminish the danger inherent in this situation, for, as Huizinga has observed, "when faith is too directly connected with a pictured representation of doctrine, it runs the risk of no longer making qualitative distinctions between the nature and the degree of sanctity of the different elements of religion. The image by itself does not teach the faithful that one should adore God and only venerate the saints."[64]

The popular perplexity concerning degrees of worship properly

due God and the saints was all too likely to be compounded by a similar confusion over the amount of reverence owing, respectively, to the saints and their images. Being aware of the danger of relapsing into pagan idolatry, the church also in this matter attempted to preserve a suitable degree of discrimination. Centuries earlier it had been definitively established that the honor shown to an image passes to its prototype; therefore, whoever adores an image actually adores the person represented in that image.[65] St. Thomas Aquinas, the most authoritative theologian of the High Middle Ages, put it this way: "An image, apart from its representational function, has no claim to veneration."[66] Or, at another point: "Religion does not offer worship to images considered as mere things in themselves, but as images drawing us to God incarnate. Motion to an image does not stop there at the image, but goes on to the thing it represents."[67] This teaching was repeated in the later Middle Ages. In a book on confession published in 1473 the statement appears that "we must honor them [i.e., the images] not for themselves, but as reminders of what they represent . . . otherwise it would be idolatry."[68] Again, however, one is left with the question of how lasting an impression such an admonition may have made upon the untutored laity. There is considerable evidence to suggest that among the common people images often simply were adored.[69] As Professor Richard Trexler recently has put it, in the supplicatory acts of many worshipers a practical identity existed between the prototype and the image.[70] Despite the reminders in the Middle Ages that people were to place their confidence in God and the saints and not in the pictures and statues in which they were portrayed,[71] it seems that often the images themselves came to be treated as if they were real bearers of spiritual forces.[72] Perhaps the veneration of the Host and the cult of relics so prominent at that time contributed to this confusion. In any case, according to Trexler, "the belief in power-laden natural objects . . . stretched from the Host, through the image, to the relic, from the body of the dead to that of the living saint."[73]

A consideration of the devotional practices associated with the images tends to confirm these observations. It is in the nature of things that some of our most explicit and detailed evidence concerning such usages should come from critics, both reforming Catholics and Reformation Protestants. In a letter written to Cardinal Sadoleto

in 1531, the great Erasmus mentioned among the superstitions that he had previously condemned such things as that images should be treated as if they were alive; that people should bow their heads, fall on the ground, or crawl on their knees before them; and that worshipers should kiss or fondle the carvings.[74] Huldreich Zwingli, the Zurich reformer, in a major treatise of 1525, provided his own catalog of the cultic acts directed toward images in popular devotion: men kneel, bow, and remove their hats before them; candles and incense are burned before them; men name them after the saints whom they represent; men kiss them; men adorn them with gold and jewels; men designate them with the appellation merciful or gracious; men seek consolation merely from touching them and even hope to acquire remission of sins thereby.[75] Luther, for his part, complained that late medieval prayer books instructed their readers that for their petitions to be efficacious they should utter specific supplications before the images of various individual saints.[76] But we need not rely exclusively upon the testimony of hostile witnesses. John Geiler of Keisersberg, perhaps the most popular preacher in all of Germany on the eve of the Reformation, informed his hearers that when any one of them passed by a picture or statue of the Virgin he should speak a petition that she might intercede with God on his behalf or at least bow before her image.[77] Evidence exists of still other popular usages connected with the representations of the saints. It was widely believed, for example, that if one merely looked upon a figure of St. Christopher in the morning, he would be protected from harm all that day.[78] Similarly, carrying about an image of St. Jerome was thought by some to result in one's being protected against temptation.[79] Trexler has summarized all this recently by stating that in that day it was more common to speak with and trust an image than to confess to a priest.[80]

Perhaps the more extreme forms of the image cult were most manifest in connection with the late medieval enthusiasm for religious pilgrimages. As the noted Roman Catholic historian Joseph Lortz has pointed out, in that religiously excited age the urge to go on pilgrimage reached almost epidemic proportions. Further, it was a phenomenon often accompanied by a craze for miracles and visions.[81] Among the most popular destinations in Germany was the shrine of Mary the Beautiful at Regensburg, which had an image of

the Virgin as its focal point.[82] A local artist named Michael Ostendorfer executed a woodcut portraying the devotion directed to this figure (fig. 1); Lortz comments on how this print "clearly shows, in addition to orderly processions and prayers, many signs of a mental and physical excitement that went far beyond mere fervour."[83] Sometimes pilgrimages arose in connection with images that were reputed to have extraordinary origins or qualities, such as a wooden statue of the Virgin that was miraculously discovered in a beech forest or thicket in the vicinity of the Premonstratensian monastery of Himmelspforte near Basel.[84] An Augsburg chronicler reports that in 1476 when stories of marvelous signs began to be circulated in connection with the Mary image at the local Franciscan church, there immediately followed a great concourse of people.[85] It was this sort of curiosity concerning miraculous images that the Heidelberg author of a late fifteenth-century confessional booklet criticized as too often replacing true devotion in motivating pilgrimages.[86]

To be sure, not all devotees of saints' images were guilty of such excesses. Nor did all late medieval religious paintings and statues depict saints. There also appeared a strong christocentric strain in the art of the time, as evidenced above all by the very numerous Passion scenes.[87]

But it nonetheless remains true that the potential dangers inherent in late medieval image piety were sufficient to arouse considerable resistance against the cultic use of the visual arts in the period before Luther. The iconoclasm of the Wycliffites or Lollards in England and the Hussites in Bohemia is well known to students of the fourteenth and fifteenth centuries.[88] The Reformation of the sixteenth century, however, brought new developments in the age-old controversy over the propriety and place of images in Christian churches. In this case, the theological ideas and policy precedents originated largely in Germany and Switzerland and derived from men associated with the origins of the Protestant tradition.

Karlstadt's Iconoclastic Theology

The pioneering figure among the iconoclastic theologians of the Reformation was Andreas Bodenstein von Karlstadt, professorial colleague of Martin Luther at the university in Wittenberg. On

January 27, 1522, he published a pamphlet in that city under the title *Von abtuhung der Bylder Vnd das keyn Betdler vnther den Christen seyn sollen* [On the abolishing of the images, and that there should be no beggars among Christians].[89] The treatise contains, in the original edition, thirty-eight pages of text, twenty-seven of which are devoted to the problem of religious images. Although within a period of but a few years Karlstadt's composition was destined to be surpassed in both scope and profundity by the writings of Zwingli on the same subject,[90] it nonetheless deserves the distinction of being viewed as the first significant discussion of iconoclasm of the Reformation.

What caused Karlstadt to bring out this provocative pamphlet when he did? How had he come to such a radical rejection of religious imagery as is proclaimed in this work? To be sure, the great humanist critic Erasmus, under whose all-pervasive influence Karlstadt also stood,[91] for years prior to the Reformation had been expressing a certain skepticism about the spiritual efficacy of religious images but nonetheless had stopped short of a complete condemnation of their use.[92] Luther, too, by this time had articulated some of his own reservations concerning the value of the visual arts in worship but had produced nothing comparable to his more radical colleague's call here for the total abolition of statuary and figurative paintings in the churches.[93] Could Karlstadt have been motivated in part by a desire to stake out a claim to some theological territory not already preempted by his younger but by now more famous Wittenberg associate? A recent biographer, Gordon Rupp, has described the man as ambitious and, at least in his earlier days, "over-anxious to claim originality."[94] Luther, by no means an impartial judge on matters concerning a person who finally became his bitter rival, once commented later that Karlstadt "always looks for that which is unusual and no one hitherto has known."[95]

Such considerations, however, surely are not sufficient to explain the publication of this tract. Another clue of a psychological nature is provided by Karlstadt himself toward the end of his discussion. In an autobiographical passage somewhat reminiscent of a personal confession, he admits that he has come to recognize how deeply the images are rooted in his own heart and how much he stands in fear of them:

My heart since childhood has been brought up in the veneration of images, and a harmful fear has entered me which I gladly would rid myself of, and cannot. . . . When one pulls someone by the hair, then one notices how firmly his hair is rooted. If I had not heard the spirit of God crying out against the idols, and not read His Word, I would have thought thus: "I do not love images." "I do not fear images." But now I know how I stand in this matter in relation to God and the images, and how firmly and deeply images are seated in my heart.[96]

Two points are to be noted here. First, Karlstadt openly acknowledges that he personally has been susceptible to the temptations of image abuse in a manner such as never seems to have been the case with Luther.[97] This being true, he undoubtedly also experienced a correspondingly greater need for liberating himself and others from this particular burden of conscience.[98]

Second, Karlstadt's reference here to reading God's Word obviously is of importance and indeed suggests one of the chief theological pillars of his iconoclastic teaching. By mid-1520, it seems, he had come to a firm commitment to the principle of the unique authority of the Bible; from this time on his slogan, as Luther's, was *sola scriptura*.[99] Yet to speak of Karlstadt's "biblicism," as some authors do,[100] is only to raise the question of wherein his method of interpretation of Scripture may have differed from that of other Bible-oriented early reformers. The critical issue, at least for our purposes, arose with respect to the divergent solutions given for the problem of how normative the Mosaic commandments were to be considered for Christians. Here Karlstadt was "legalistic" to a significantly greater degree than Luther.[101] To be sure, he acknowledged that the ceremonial aspect of the Old Testament law was no longer binding.[102] But he construed the implications of this principle more narrowly than did Luther and, unlike the latter, did not believe that the image prohibition should be understood as being invalidated thereby.[103] As we shall see, this led him to take very seriously the divine injunction not to make or serve graven images. He insisted that even if images were of some positive religious value—which he did not concede—their use would still be impermissible due to their prohibition by God.[104]

Some other features of Karlstadt's thought, although not necessarily reflected in the passage quoted above, also need to be dis-

cussed before undertaking an analysis of his specific doctrine on images. One such tendency, as Ronald Sider has shown recently, is a sharp criticism of the externalism that characterized much religious practice of his day.[105] This seeming preoccupation with "mere externals" may have derived, as James Preus suggests, from a peculiar sensitivity to the impact of outward forms and rites upon spiritual life.[106] In any case, as early as 1518 Karlstadt was engaging in an Erasmian attack on externalized piety, a critique that became a continuous theme of his writing by 1520.[107] For one thing, he apparently hoped that in condemning religious externalism he would be helping to reassert the primacy of the Word. But at a deeper level, he believed that since God is a spirit and should be worshiped spiritually, visible and external acts of worship are essentially useless.[108] In his attacks on externals, he constantly buttressed his arguments with reference to the Gospel text from John 6:63: "It is the spirit that gives life, the flesh is of no avail."[109]

The emphasis placed upon this particular scriptural passage would seem to reflect another feature of Karlstadt's theology, a tendency to think in terms of a basic dualism of flesh and spirit—derived, apparently, from mystical and Erasmian or humanist sources.[110] Roland Bainton observes that Karlstadt was "an incipient Puritan who felt that the physical, the sensory, is an impediment to the life of the spirit and should be discarded."[111]

In Karlstadt we also find, as a slightly later writing of his makes especially clear, a view radically different from that held by Luther of the proper approach to practical reform and the demands of brotherly love.[112] In relation to the problem of concrete implementation of the new teachings, both reformers were faced with the difficulty of dealing with those individuals who were as yet "weak in faith," i.e., still attached to the old customs. Luther believed it important to avoid as much as possible giving undue offense to such persons. He renounced compulsion and felt that the proper application of brotherly love here was to attempt slowly to wean such Christians from their errors through the preaching of God's Word. By means of such a patient approach, Luther desired to achieve a broad consensus and thus maintain the unity of the Reformation movement. Karlstadt, on the other hand, believed—as Hans Hillerbrand has shown—that "a biblical insight must be resolutely

translated into practice."[113] He argued that delay amounted to sinful disobedience. Furthermore, he ridiculed the notion that changes should be postponed until a majority agreed. "I ask," he said, "whether one should not stop coveting another's goods until the others follow? May one steal until the thieves stop stealing?"[114] As Ronald Sider recently has pointed out, rather than proposing that people compromise their beliefs while waiting for a consensus to emerge, Karlstadt advocated a decentralized approach. Individuals and local communities were advised to proceed on their own immediately.[115] As the radical reformer himself put it, "Every community, whether small or large, should see for itself that it acts correctly and well and waits for no one."[116]

Furthermore, Karlstadt believed that it was in the very nature of brotherly love to require immediate action, since he felt that Luther's gradualist approach did not further the best interests of the weak themselves. Since people still were being led astray by the images, the source of the superstition and idolatry must be abolished in order that the weak might be protected from the danger. And this was to be done even before evangelical preaching had brought people to a willingness to relinquish superstition gladly.[117] The problem, he thought, was similar to that of a child who obstinately insists on clinging to a dangerous knife:

We should take such horrible things from the weak, and snatch them from their hands, and not consider whether they cry, call out or curse because of it. The time will come when they who now curse and damn us will thank us. . . . Therefore I ask whether, if I should see that a little innocent child holds a sharp pointed knife in his hand and wants to keep it, I would show him brotherly love if I would allow him to keep the dreadful knife as he desires with the result that he would wound or kill himself, or when I would break his will and take the knife?[118]

With such views it is not surprising that Karlstadt should have decided to issue a public call for action.

Actually, Karlstadt's first written expression of his opposition to the cult of images seems to have taken the form of some remarks made in a tract composed in June, 1521, and entitled *Uon gelubden vnterrichtung* [Instruction concerning vows].[119] Karlstadt's continuing concern with the problem is reflected in other actions and state-

ments dating from mid-1521. On July 22 one of his Wittenberg university students defended a disputation thesis labeling images of Christ, the Virgin, and other saints as deserving of being overthrown in the churches.[120] Then, in a writing of July 29 devoted to the exegesis of a passage in the Gospel of Matthew, the radical reformer included a condemnation of the makers of religious images.[121]

But Karlstadt's first extended discussion of the image problem came with his *Von abtuhung der Bylder*. With respect to the timing of this particular pamphlet it must be noted that only three days before its composition the Wittenberg city council, under the influence of Karlstadt and other theologians, had issued a set of reforming decrees including one providing for the removal of both images and superfluous altars from the local parish church.[122] The publication of the radical reformer's tract was intended, among other things, to make clear to the people the justification for and significance of what had been decided and to prod the authorities into a prompt execution of their newly announced policy.[123]

Karlstadt begins his tract with a bold enunciation of the following three theses: (1) "That we have images in churches and houses of God is wrong and contrary to the first commandment: 'Thou shalt not have strange gods.' " (2) "That carved and painted idols are standing on the altars is even more pernicious and devilish." (3) "Therefore, it is good, necessary, praiseworthy, and godly that we abolish them, and give to the Scripture its proper right and judgment."[124] At the very outset, thus, with the appeal to the Old Testament Decalogue in the first thesis and the explicit reference to Scripture in the third thesis, we are made aware of the resolutely biblical approach that the author will follow. Indeed, Karlstadt explicitly cites some eighty scriptural passages in the portion of the pamphlet dealing with images.[125]

Scriptural in foundation Karlstadt's treatise may be; systematic in presentation it definitely is not. There is little evidence of any serious or sustained effort to base the structure of the composition upon the series of opening propositions. In fact, the reader soon forgets entirely that the work had ever begun with this set of ringing proclamations—forgets, that is, until the author rather abruptly informs him in the middle of a paragraph a few short pages from the end that he has covered the first two articles and will take up the third.[126] The

rambling style and repetitious quality of the piece would seem to justify a modern biographer's reference to Karlstadt's "turgid and long-winded pamphlets."[127] Because of these characteristics, the treatise is not an easy one to analyze for the sake of the modern reader. At the risk of doing some violence to the splendidly illogical structure of the radical reformer's own argument, his main points shall be presented here in a more or less systematic fashion.[128]

At least this much can be said: the leitmotif of the entire composition is struck appropriately enough in the very first thesis with the reference to the Mosaic prohibition of "strange gods" and images.[129] On a half dozen other occasions[130] Karlstadt refers to or quotes from the pertinent passage in the Old Testament book of Exodus containing the Ten Commandments:

You shall have no other gods before me. You shall not make yourself a graven image, or any likeness of anything that is in heaven above, or that is in the earth beneath, or that is in the water under the earth; you shall not bow down to them or serve them; for I the Lord your God am a jealous God, visiting the iniquity of the fathers upon the children to the third and the fourth generation of those who hate me. [Exod. 20:3–5][131]

God has forbidden all religious images, Karlstadt states, because He knows men are thoughtless and inclined to worship them.[132] He understands that a person can so easily manufacture an idol that he himself scarcely is aware of it.[133] "God's houses," however, "are houses in which God alone should be heard, appealed to, and worshiped."[134] The house of prayer is made into a murderer's pit when filled with fraudulent images that murder the spirits of their worshipers.[135]

It is true, Karlstadt concedes, that in one place in the Old Testament God actually instructed the ancient Hebrews to erect an image—that of the brazen serpent, as described in Num. 21—so that the rebellious people, bitten by the fiery serpents sent among them as punishment by God, might look upon the bronze serpent and live. But, as the radical reformer is quick to note, this serpent was not conceived of as portraying God. Second, this image was given by God and was not the invention of human minds. The distinction is made clear when the author states, "Our images do not have their

origin from God; indeed, they are forbidden by God."[136] Further-
more, Scripture praises King Hezekiah, who subsequently broke
the brazen serpent into pieces because the people were burning
incense before it (2 Kings 18:4).

The later prophets of the Old Testament, Karlstadt informs his
reader, also preached against the use of images.[137] He quotes Hab.
2:19: "Woe to him who says to a wooden thing, Awake; to a dumb
stone, Arise! Can this give revelation? Behold, it is overlaid with
gold and silver, and there is no breath at all in it." The "Awake"
and "Arise," he informs us, signify to render devotion to mere
wood or stone and to come to them for help instead of appealing to
God. But this is just what the "fools" do who urge those on their
deathbeds to place their hope in carved or painted crucifixes.[138]

Karlstadt, in his effort to show that the images are profitless,
makes striking use of one particular passage from the book of Isa-
iah. This biblical work, cited more often in the radical reformer's
treatise than any other,[139] is clearly a favorite of his; he indeed
refers here to its author as an "evangelical prophet."[140] Karlstadt
takes note of the scornful tone of Isaiah's description (44:16–17) of
how the idols are made: the idolater burns half of the wood in the
fire, roasts his meat over it and warms himself; the other half he
makes into a god, before which he falls down to worship, calling
upon it for deliverance. The idolaters who make such false gods,
however, have forgotten that their images can neither see nor un-
derstand; but the Lord, again speaking through the prophet (44:24),
proclaims that it is He alone who performs all things.[141]

In view of this heavy reliance upon the Old Testament,[142] one
objection that Karlstadt obviously would have to meet was the claim
that the Mosaic law had been abrogated or superseded by the com-
ing of the New Testament. Somewhat surprisingly, this topic is not
taken up until five paragraphs before the end of the image portion
of his pamphlet.[143] Nevertheless, even if somewhat belatedly, the
radical reformer vehemently denies this "heretical" contention and
adduces a whole battery of arguments in favor of his own posi-
tion.[144] Christ, he asserts, came not to destroy but to fulfill the law;
indeed, He Himself appealed to the teachings of Moses and the
prophets. Christ did not break the law; He did away with nothing
that was God-pleasing in the law; in fact, He neither added to it nor

subtracted from it. Pursuing a different line, Karlstadt inquires why, if we disregard the prohibition against images, do we not also ignore the command that we honor father and mother? Or those forbidding murder, adultery, or theft? Not only that, but the image prohibition appears at the beginning of the Ten Commandments, while the other matters come later in the Decalogue. Should not the former, therefore, be viewed as more important? "I say to you that God has forbidden images with no less diligence than killing, stealing, adultery, and the like."[145]

The continuity of the Old and New Testaments that Karlstadt is attempting to affirm here was already implied, in fact, much earlier in the treatise. He there cites the injunction of St. Paul (1 Cor. 5:11) that Christians should not associate with idolaters,[146] the same apostle's instruction (1 Cor. 10:14) to shun the worship of idols,[147] and his statement (1 Cor. 6:9–10) that idolaters will not inherit the kingdom of God.[148] Karlstadt also, at the very end of his iconoclastic discussion,[149] interprets as a general image prohibition the passage in Paul's Letter to the Romans (1:23) in which the apostle condemns the wicked ungodly who "exchanged the glory of the immortal God for images resembling mortal man or birds or animals or reptiles." Thus Moses and Paul agree.[150]

As we have seen, one of the traditional explanations for the veneration granted images was the argument that the reverence really is not shown to the portrait itself but passes to the person portrayed.[151] Karlstadt rejects this interpretation. If God had wanted Himself and His saints to be honored through images, He would not have prohibited their use as He did.[152] Further, various kinds of evidence can be brought forward to show that men in fact do pay reverence to the actual portraits. First, an analogy: although it may be argued that men show respect to an official who represents their prince primarily on account of him whom the official represents, it is clear nonetheless that they honor the official somewhat in his own right as well. A similar thing happens with the statues and paintings in the churches.[153] Then there is the testimony of practical experience. We observe that pictures are accorded the dignity of being called by the names of the saints whom they portray and thereby become sanctified.[154] Further, as Karlstadt had already noted in his second introductory thesis, images also are

exalted by being placed on the altars where the sacrament of Christ's body is celebrated; that this is a great honor, no one can deny.[155] Finally, men, in an idolatrous fashion, perform acts of homage before these pictures and altars: they light candles before them;[156] they bow or genuflect before them;[157] they remove their hats before them;[158] and they bring them wax figures of limbs they wish to be healed.[159]

Karlstadt in this work repudiates the veneration of the saints, as well as of the statues and paintings in which they might be portrayed. God alone can aid man, and He will not tolerate that anyone or anything be elevated to a place alongside Him.[160] And "if the saints cannot help you, how can their fraudulent images help you?"[161] The saints, for their part, also rejected such worship of themselves. As the radical reformer puts it, "You want to do honor to the saints in images, the same honor which they, in their lives, fled from and forbade."[162] He then cites the incident in the book of Acts (3:12 ff.) where St. Peter prohibited men from venerating him after he had healed a man in Christ's name.[163] Peter and Paul, in their own persons, certainly would never have allowed themselves to be placed on altars.[164]

Perhaps the most important and characteristic rationale given by the western church in the Middle Ages for the use of visual images rested upon a recognition of their educational value. This insight, as we have seen, had been given classical and authoritative expression in the dictum of Pope Gregory the Great that religious art constitutes the Bible of the illiterate.[165] Karlstadt had not referred to this problem in his introductory propositions, but, in fact, his debate with Pope Gregory and the "Gregorians" (Gregeristen) becomes one of the recurring themes of the pamphlet after its initial introduction about a quarter of the way through the text.[166] The radical reformer declares that Gregory truly had not forgotten his "papal manner" when he granted to images the honor that God granted His Word. Christ said that His sheep would hear His voice (John 10:27), not that they would see His image or that of His saints. Gregory, thus, erred in establishing the "popish doctrine" that Christ's followers should use forbidden and deceiving images as books.[167] Karlstadt makes effective use of Habakkuk (2:19) in this context also, when he renders the skeptical second sentence of the

passage as "Is it possible that it [an image] can teach?" (Revised Standard Version: "Can this give revelation?").[168] The implied answer obviously is no. Then images cannot be considered as books, for books teach.[169]

Karlstadt challenges the long-dead Gregory or any of his modern followers to say just what it is that the laity learn from images. Is not the answer that they learn "vain carnal life and suffering," and that the images lead one no further than the flesh?[170] "For example, from the image of the crucified Christ you learn nothing except the physical suffering of Christ, how He drooped His head, and the like. But Christ said that His own flesh is of no avail, rather that it is the spirit which is profitable and makes alive."[171] Crucifixes teach merely how Christ died, not the infinitely more important truth of why He died.[172] Being "deaf and dumb," images signify nothing but the flesh—which is of no value—and therefore they are of no value. "But the Word of God is spiritual and it alone is profitable to believers."[173]

Karlstadt denies, further, that images may properly serve even as an admonition or reminder, for example of Christ's sufferings, leading to prayer or meditation.[174] Citing John 4:24, he affirms that God is a spirit and all those who truly worship God worship in spirit. However, he insists, "all those who worship God in images, worship in lies, and think of God in semblances and external reports."[175] Further, "spiritual prayer is a divine work" and can result only from God's initiative.[176] Images cannot lead to Christ; only God can do that: "That which God alone effects, no image can do. You may not even say that the image of Christ brings you to Christ. For it is always true that no one comes to me [i.e., Christ] unless my father draws him. They who come to Christ must all be taught by God (John 6 [:44–45]) and not be admonished or taught by images to come to Christ. Let all the images on earth join together and still they would not be able to give you one small sigh toward God."[177] Images, far from being an aid to devotion, merely corrupt it.[178]

Karlstadt finally comes to a discussion of the third of his original theses concerning the images, the proposition that "it is good, necessary, praiseworthy, and godly that we abolish them." It is his conviction that this flows as a natural consequence from what he has stated already, but, as he says, he nonetheless will also provide

special evidence for this point from the Scriptures.[179] He then immediately quotes the command extended to the Israelites in the Old Testament book of Deuteronomy (7:5), where they are instructed as to how they are to deal with the surrounding heathen nations: "You shall break down their altars, and dash in pieces their pillars, and hew down their Asherim, and burn their graven images with fire." We too have no godly altars but instead heathenish and human ones, the radical reformer maintains; therefore, the authorities should abolish them. If they do not, Karlstadt promises, they will be punished by God.[180] Would to God that they would act as did the pious temporal rulers of the Jews, such as King Hezekiah (2 Kings 18:3–4). For, according to the Holy Scriptures, they do have the power to act in the church and to abolish that which offends and hinders the faithful.[181] Therefore, "our magistrates should not wait until the priests of Baal [i.e., the Romanist priests] begin to purge their vessels, idols, and impediments. For they will never begin. The secular rulers should take a hand and act."[182] And this act of removal must not be deterred by the fact that what is involved is a question of mere "externals." For outward forms and ceremonies too must be brought into conformity with God's law.[183]

An analysis of the contents of Karlstadt's *Von abtuhung der Bylder* of course does not by any means exhaust the topic of the contribution of the sixteenth century to iconoclastic theology. But this pamphlet was the first major Reformation writing on the subject and among the most important of all in its influence on both the course of events and the evolution of the thought of other Protestant reformers.[184] It is now known, for example, that another spokesman of the radicals, Ludwig Haetzer, drew very heavily upon Karlstadt's tract in the preparation of his own better-organized and more readable treatise, which was published at Zurich in September, 1523.[185] And Haetzer, in turn, contributed significantly to the development of the ideas of Zwingli,[186] who in 1525 gave definitive expression to the theological opposition to visual images as it had evolved in the pre-Calvinist stage of the Reformation. Fortunately, the iconoclastic teachings of both Haetzer and Zwingli recently have been analyzed brilliantly by the American scholar Charles Garside, Jr., and no further account of their ideas need be given here. Karlstadt's pioneering pamphlet stands, however, as an important historical work

in its own right and also serves as an aid in understanding the nature of the ultimate reaction to iconoclasm by that other, greater Wittenberg reformer, Martin Luther. For, on the image question, Luther conducted his heated debate, not with Zwingli, but rather with his former faculty colleague and friend.

Iconoclasm in Wittenberg

It was in Wittenberg, cradle of the Reformation and site of the university where both Karlstadt and Luther taught, that the first major episode of iconoclastic destruction deriving from the Protestant movement occurred. If for no other reason than chronological priority, great historical importance would have to be assigned to these events. Unfortunately, although the reform as a whole in that city is relatively well documented, the records are surprisingly fragmentary with respect to the destruction of ecclesiastical art works.[187] Therefore, attempts to reconstruct this story are plagued by a noteworthy lack of agreement among modern historians—indeed, often on the most basic factual details, such as the date and circumstances of the major iconoclastic riot.

This first great outburst of sixteenth-century iconoclasm erupted as part of what is known as the Wittenberg Movement of 1521–22,[188] a rapid sequence of reform-inspired events taking place in the old electoral town while Luther was absent at Wartburg Castle to which he had been spirited away for safekeeping after his dramatic appearance at the Diet of Worms. Up until this time, even in Wittenberg, the Reformation had made little difference in the religious worship of the common man. Now, in Luther's absence, other leaders came to the fore who labored to translate the doctrinal innovations into effective institutional structures. As it turned out, these were men who not only lacked the great theologian's commanding stature and personal authority but also were unable to agree among themselves with respect to the proper policy and tactics.

The most radical of the Wittenberg evangelicals was one of Luther's fellow Augustinians, a man named Gabriel Zwilling. Upon Luther's departure for Worms, Zwilling had taken over his preaching position at the Augustinian convent.[189] Born near Annaberg in Saxony,[190] and not in Hussite Bohemia, as the older biographies

have it,[191] Zwilling had studied at Erfurt, Wittenberg, and perhaps at Prague.[192] Although allegedly somewhat unstable personally,[193] Zwilling apparently was a powerful and fiery preacher. In light of his gifts in this area, some called him a "second Luther."[194] He emerges from the documents as an activist by temperament, one extremely impatient with delay.[195] Theologically speaking, Zwilling was a legalist or rigorist. He upheld the view that abuses and erroneous worship practices must be abrogated immediately, rather than tolerated for the time being out of deference to the weak.[196]

Another figure of great importance for our story is that of Andreas Karlstadt, who, as we have seen, was the first great theorist of Reformation iconoclasm. He approached the question of reform strategy from his own perspective and with a somewhat more moderate temperament than that of Zwilling, and the two must not be indiscriminately grouped.[197] Karlstadt himself insisted that he disapproved of tumult and violence,[198] and there is a strong possibility that he was indeed much less directly involved in the actual iconoclastic destruction than his contemporary critics and many modern historians have assumed.[199] In any case, with his preaching and writing he provided the theological basis for the criticism of religious imagery.

Finally, in Luther's absence another faculty colleague, the brilliant but somewhat youthful and inexperienced Philipp Melanchthon, assumed a leadership position of some importance. Melanchthon's failure during this period to deal decisively with a group of visiting agitators known as the "Zwickau prophets" is a familiar part of the Reformation story.[200] It appears that also in relation to the image and iconoclasm issue the young scholar played a rather ambivalent role. He was strongly attracted to the eloquence of Zwilling, regularly attending his sermons,[201] and did not disavow the radical monk even after the latter had promoted overt iconoclastic activities.[202] Melanchthon's own position with respect to religious images at that time seems to have been closer to that of Zwilling and Karlstadt than to the later views of Luther.[203] Although not inclined to encourage unsanctioned destructive violence,[204] he was not a person well suited by either outlook or temperament to curb effectually the activities of his more zealous associates. Indeed, he appears to have remained largely silent on this issue.[205] The ab-

sence of strong leadership by moderate theologians thus resulted in a situation in which the initiative shifted to those of a more resolute will.

The iconoclastic episodes of the winter of 1521–22 must be understood as the climax of a rising crescendo of agitation and outright violence. Excitement had already begun to mount in Wittenberg in early autumn of 1521. An important public incident during the first week of October revealed the anticlerical mood that would be apparent in many of the subsequent proceedings. When the hermits of St. Anthony came to the city on one of their accustomed rounds of alms begging, the students threw dung and stones at them and interfered with their preaching and ceremonies.[206] Verbal attacks on the Mass resulted in its cessation at the Augustinian cloister sometime in mid-October.[207] Stimulated by the impassioned preaching of Zwilling, the monks there began to abandon their vows and cowls. By the end of November, fifteen of the forty inmates had departed.[208] Students and townsmen intimidated those who remained; violence was feared and the Prior complained that he no longer could go abroad safely in the streets of the city.[209]

Then, at the beginning of December, a small-scale riot occurred. Again, students played a prominent role, although elements of the town population participated also.[210] The former were reinforced and perhaps spurred on by youths from the university at Erfurt,[211] where the preceding summer riotously anticlerical demonstrations had taken place.[212] The action in Wittenberg began in the early hours of the morning of December 3, when priests celebrating Mass in honor of the Virgin in the city parish church were pelted with stones.[213] Later in the day a mob, believed to be carrying knives under their cloaks, burst into the same church, seized the missals, and drove the officiating clergy from the altar.[214] Worshipers engaged in private devotions to the Virgin had stones thrown at them.[215] The following day, a group of students broke into the Franciscan church during the worship service, abused the monks with mockery and ridicule, and almost completely demolished a wooden altar.[216] When the rumor began to spread that the mob intended to storm the cloister that night, the town authorities quickly reinforced the watch.[217] A crowd demonstrated in front of the church again on December 6.[218]

Some reckless talk also was reported at this time, to the effect that the stones of the idolatrous altars might better be used to build gallows.[219] The same source speaks of the smashing of the windows of certain canons and priests associated with the local collegiate church of All Saints (Castle Church), where the full cycle of liturgical rites was still being observed.[220]

The next important eruption of destructive activity in the Wittenberg churches occurred on Christmas Eve. This time the excitement of the populace seems to have been stimulated, in part at least, by an action of Karlstadt's. Although his prince, the Elector Frederick the Wise of Saxony, had expressly ordered that no modifications of the Mass be undertaken for the time being, the reformer on December 22 announced that on New Year's Day he would hold a public communion service in both kinds. When the Elector sent word to his officials to intervene, Karlstadt forestalled him by proclaiming on December 24 that he had traded turns for conducting Mass with another priest and now would hold the evangelical observance on Christmas Day instead.[221] To offer communion in both kinds was not exactly a novelty, as it had been done semiprivately several times in Wittenberg in the preceding months. "But," as Gordon Rupp observes, "that it should be done on a public feast day, in witting defiance of the Elector, was an act of revolutionary leadership and was recognized as such."[222] The aroused people, in any case, celebrated the eve of Christmas Day noisily and tumultuously. Crowds roamed the streets, many of whom were, as Rupp suggests, "no doubt primed for the occasion."[223] A mob burst into the parish church, smashed the lamps, threatened the priests, and bellowed out ribald songs. Upon leaving the church, they for a time entertained themselves by howling a parody of the choir from the courtyard.[224]

The first really significant iconoclastic episode of the Wittenberg Reformation, however, did not take place until January 11; the action occurred in the Augustinian cloister and was led by Zwilling. The inflammatory preacher seems to have been absent from the city during the month of December, although he had not thereby avoided involvement in revolutionary turbulence. Following a series of immoderate sermons he delivered against the Mass in the town of Eilenburg, a gang of rowdies had expressed their displea-

sure at the conservatism of the local priest by smashing the windows of the parsonage.[225] Now Zwilling was back in the thick of things at Wittenberg and preaching against images. On the day after the conclusion of a meeting of the general chapter of their order, some of the more radical Wittenberg Augustinians joined their former monastic brother in overturning and removing from the cloister chapel all the altars except one and smashing or burning the statues and paintings.[226] A momentous precedent certainly had been set with respect to the question of the disposition of religious imagery,[227] although there seems insufficient evidence to support Bainton's statement that Zwilling "had led an iconoclastic riot."[228]

Less than two weeks later, on January 24, the city council of Wittenberg issued one of the most important and interesting documents of the period, a reforming ordinance that has been characterized by a modern scholar as "the first attempt of the civic authority to introduce an evangelical form of worship."[229] The council, though cognizant of the Elector's opposition to further innovations at the moment, apparently acted in order to avert the growing threat of another eruption of popular violence.[230] One of the provisions of the ordinance dealt directly with the question of ecclesiastical art, decreeing that, in order to avoid idolatry, the images and all but three plain altars were to be removed from the city parish church.[231] Organized begging on behalf of new ecclesiastical construction was forbidden, since there were already more than enough churches.[232] And reference was made to an inventorying of the vessels of the monastic churches.[233]

Scholars have disputed over the question of who should get the credit (or blame) for this set of ordinances. The provisions it contained actually appear to have been the result of some compromise agreements. The document arose from joint consultations between the municipal council and a committee from the university. Among the members of the latter, the most important were Karlstadt and Melanchthon. Karlstadt's sympathetic modern biographer, Hermann Barge, gives him most of the credit.[234] Other scholars have pointed to significant echoes of earlier demands made by Luther in his tracts.[235] As for Melanchthon, he had by now turned somewhat more cautious and conservative, the growing turbulence of the movement having disturbed his retiring and scholarly tempera-

ment. He apparently labored to tone down the radicalism of some of the proposals.[236] Another moderating force was the important role played by Dr. Christian Beyer, former burgomaster of Wittenberg, who was scheduled to be elected to that post once again during the last week of January, 1522. Beyer, who was also, significantly, an electoral counselor, seems to have argued in the meetings for the retention of at least the crucifixes. His report to the electoral officials also implies that the images were not to be removed all at once.[237] But when all this has been said, the great influence of Karlstadt still remains obvious and unmistakable, precisely in the provisions of the ordinance most relevant to our concern here, i.e., those pertaining to worship and religious imagery.[238]

Three days after the issuing of the ordinance Karlstadt published his famous pamphlet on images, one of the most influential of all of his writings.[239] His intention, in part, seems to have been to make clear the implications of the ordinance.[240] However, along with his theological arguments against the images, he expressed his concern over the delay of the authorities in executing their removal from the local churches. He said that indeed God had softened the hearts of the rulers and begun His work in them, so that they had undertaken the necessary reformation.[241] But let them not stop now, he urged, before the idols are actually removed.[242]

Perhaps acting under the prodding of Karlstadt and Zwilling, both of whom continued to preach on the subject,[243] the municipal regime finally bestirred itself and unwisely announced a firm date (unknown to us) for the orderly removal of the statues and pictures.[244] What happened next is not entirely clear in the records. This much, however, can be said: at some point, most likely in the first week of February,[245] an excited crowd of townspeople, apparently acting in impatient anticipation of the city council's implementation of its decision to abolish the images,[246] burst into the parish church and engaged in a rampage of destruction. Statues and paintings were torn down, smashed, and burned. It is said that even some gravestones were despoiled.[247]

Even though the magistrates themselves already had resolved to take action on this matter, such an overt transgression of the law obviously could not be condoned. Both the city council and the Elector quickly condemned the violence and disorder. The trans-

gressors, or at least those not lucky enough to escape, were arrested and punished. Judging from the records on one of the offenders, a textile worker, monetary fines were imposed.[248]

One last but important lacuna in our knowledge, resulting from the insufficiency of the surviving documentation, pertains to the question of the actual extent of the devastation or removal of ecclesiastical art works. One of the demands of the Elector, as he pressed for a restoration of order and a slowdown of the reform, was that the images should be allowed to remain until such time as a final decision could be made by the appropriate authorities on this and other questions.[249] It would be natural to interpret this statement as signifying that not all of the statues and paintings had been taken down or destroyed. However, it is difficult to judge just how well informed the Elector and his officials were at that time with respect to such details. Specifically, can we infer from this directive the continued existence of a sizable body of visual imagery, or should we interpret the order to retain the art works as simply an effort to insure that there be no further destruction of such few monuments as might have survived?[250] One thing, at least, is clear—there is little left today in the city parish church in the way of medieval art works.[251]

Luther finally returned to the electoral town during the first week in March and almost immediately preached a famous series of sermons vigorously denouncing destructive violence against the images.[252] It would seem that not even then were all Wittenbergers fully converted from their predilection for image smashing, for there is evidence of active involvement of certain residents of the city in an iconoclastic incident recorded in one of the neighboring towns later that spring.[253]

2

Luther's Theology and Religious Art

The Development of Luther's Thought on Images[1]

N DECEMBER, 1524, in his *Letter to the Christians at Strassburg in Opposition to the Fanatic Spirit,* Martin Luther boasted that his own writings had "done more to overthrow images than he [Karlstadt] ever will do with his storming and fanaticism."[2] In a much longer discussion written at almost the same time, contained in his treatise *Against the Heavenly Prophets in the Matter of Images and Sacraments,* Luther complained that Karlstadt "blames me for protecting images contrary to God's Word, though he knows that I seek to tear them out of the hearts of all and want them despised and destroyed. . . . I have allowed and not forbidden the outward removal of images, so long as this takes place without rioting and uproar and is done by the proper authorities."[3] If these were the only lines on the subject that we possessed from the pen of the Wittenberg reformer, we might well surmise that he advocated a moderately iconoclastic policy, similar to that pursued in Zurich by Zwingli. In fact, the story of Luther's views on religious imagery is much more complex; a considerable evolution also is to be observed in the development of his mature position. He moved from an originally critical, even somewhat negative, evaluation of church art to an ultimately rather positive one—finally providing an endorsement that laid the theological foundation for the creation of an important tradition of Protestant religious art.[4] No

classic treatise on the subject ever appeared, however. Luther's viewpoints on the problem of religious images, as on so many other topics, found expression largely in occasional writings, biblical commentaries, and didactic sermons or tracts. His longest and most systematic work on the subject is contained in the above-mentioned *Against the Heavenly Prophets*, which in the standard modern edition of the original German text devotes only seventeen pages directly to the matter at hand.[5] We shall examine this, plus several of his additional writings, as much as possible allowing the reformer to speak for himself on the question of religious art.

Luther's early utterances reflect a certain skepticism about the value of art for religious worship, plus a considerable social concern that the financial expenditure lavished upon it might well constitute poor Christian stewardship of funds.[6] In his revolutionary series of *Lectures on Romans* (1515–16), he states that it does not pertain to the "new law" of Christianity "to build such and such churches and to adorn them thus and so. . . . Nor are organs, altar decorations, chalices, or pictures required, and whatever else we now find in the houses of worship. . . . All these things are mere shadows and tokens of reality; indeed, they are childish things."[7] The epoch-making manifesto known as the *Ninety-five Theses*, which inaugurated the Reformation in 1517, does not mention the problem of liturgical art as such; however, it strikes a characteristic note when Luther complains there that the pope, by condoning the sale of indulgences, "redeems an infinite number of souls for the sake of miserable money with which to build a church," a reason "most trivial."[8] In the *Church Postils* of 1522 the reformer in one passage defines true worship as that in which one abandons all self-reliance and places his complete trust in God. He then elaborates, "See, that is the proper worship, for which a person needs no bells, no churches, no vessels or ornaments, no lights or candles, no organs or singing, no paintings or images, no panels or altars. . . . For these are all human inventions and ornaments, which God does not heed, and which obscure the correct worship, with their glitter."[9]

In a sermon from the same period as the *Ninety-five Theses*, Luther instructed his auditors that if they wished to donate money they must first of all give it to the poor; only when the last needy person in their community had been cared for might they think of

dedicating money to the financing of churches and ornaments, altars, and chalices.[10] The same point is made in the *Explanations of the Ninety-five Theses* (1518) in the commentary on thesis 41: "The first and foremost [of several types of good works] consists of giving to the poor or lending to a neighbor who is in need and in general of coming to the aid of anyone who suffers, whatever may be his need. This work ought to be done with such earnestness that even the building of churches must be interrupted and the taking of offerings for the purchase of holy vessels and for the decoration of churches be discontinued."[11] In his *Long Sermon on Usury* (written late in 1519, published at the beginning of 1520), Luther complained:

The way things are now, they bestow the lofty title of "alms" and of "giving for God's sake" solely on giving for churches, monasteries, chapels, altars, towers, bells, organs, paintings, images, silver and gold ornaments and vestments, . . . and the like. . . . Not what Christ has commanded, but what men have invented, is called "giving for God's sake"; not what one gives to the needy, the living members of Christ, but what one gives to stone, wood, and paint, is called "alms." . . . Now we would not disallow the building of suitable churches and their adornment; we cannot do without them. And public worship ought rightly to be conducted in the finest way. But there should be a limit to this, and we should take care that the appurtenances of worship be pure, rather than costly. . . . It would be satisfactory if we gave the smaller proportion to churches, altars, vigils, bequests, and the like, and let the main stream flow towards God's commandments, so that among Christians charitable deeds done to the poor would shine more brightly than all the churches of wood and stone.[12]

In that same work he mentioned, approvingly, that "St. Ambrose and Paulinus at one time melted down the chalices and everything that their churches had, and gave it to the poor."[13] In the *Advent Postils* of 1522 Luther explained, "A good work is good for the reason that it is useful and benefits and helps the one for whom it is done; why else should it be called good? . . . Whom does it help if you put silver and gold on the walls, wood and stone in the churches? . . . Who is better for it, if every church had more silver, pictures, and jewelry than the churches of Halle and Wittenberg? That is altogether vain fool's work and production."[14]

In addition to the above-mentioned considerations, the young

Luther also had begun to make passing references to art-related matters in his growing critique of the traditional veneration of the saints. In one of the most critical of his early discussions of this issue, the *Sermons on the Ten Commandments* (1518),[15] he focused his attention particularly upon the cult of St. Christopher and complained that the devotees of this particular saint were often guilty of attributing to mere wooden or painted images honor that should be granted to God alone.[16] In the address *To the Christian Nobility of the German Nation* (1520) attention was directed especially to the abuses associated with pilgrimage sites and their miraculous images:

The chapels in forests and the churches in fields, such as Wilsnack, Sternberg, Trier, the Grimmenthal, and now Regensburg and a goodly number of others which recently have become the goal of pilgrimages, must be leveled. Oh, what a terrible and heavy reckoning those bishops will have to give who permit this devilish deceit and profit by it. . . . The miracles that happen in these places prove nothing, for the evil spirit can also work miracles, as Christ has told us in Matthew 24 [:24]. If they took the matter seriously and forbade this sort of thing, the miracles would quickly come to an end.[17]

Even after the challenge posed by destructive iconoclasm had been forcefully met, and even after Luther had begun not only to appreciate the pedagogical value of religious imagery but to employ the visual arts himself for this purpose, the Wittenberg reformer continued at times to make statements that seemed to reflect at least a certain ambivalence on the subject. In addition to those quotations used to introduce this chapter, the following may be adduced: "I approached the task of destroying images by first tearing them out of the heart through God's Word and making them worthless and despised. . . . For where the heart is instructed that one pleases God alone through faith, and that in the matter of images nothing that is pleasing to him takes place, but is a fruitless service and effort, the people themselves willingly drop it, despise images, and have none made."[18]

Already in 1522 Luther, however, had also begun to outline a somewhat more positive position with respect to religious imagery. In early March of that year he had felt it necessary to make a speedy return to Wittenberg from his temporary seclusion at Wartburg

Castle in order to intervene in a reform movement, the current direction of which he did not approve. The reformer preached a series of eight powerful sermons in the city church, March 9 through 16. In two of them he took up the problems of images and iconoclasm. Fortunately, the sermons were transcribed and published, so that a record of them is preserved. They apparently contain the results of the earliest serious and systematic (if brief) treatment of the subject by Luther.[19]

It is very possible that the extremely busy reformer would not have focused on the matter even then had he not felt that the troubled circumstances required immediate clarification of a vexed issue.[20] Luther seems never to have been as susceptible to the temptation of image idolatry as Karlstadt confessed himself to have been; thus he probably felt less need of liberation from this particular form of bondage.[21] He also indicated in a somewhat later writing his belief that "the matter of images is a minor, external thing"; minor, that is, until "one seeks to burden the conscience with sin through it, as through the law of God"—then "it becomes the most important of all."[22] Thus, it was not simply that a socially conservative Luther hoped to throw his weight on the side of law and order and the preservation of property; he felt that the new legalism that he perceived in Karlstadt's iconoclastic teachings posed a grave spiritual threat to his parishioners.

For the images themselves, Luther in 1522 obviously still experienced no great surge of enthusiasm. He says in his sermons that he is "not partial to them," that they "are unnecessary," and that "it would be much better if we did not have them at all."[23] He goes on to argue that "it should have been preached that images were nothing and that no service is done to God by erecting them; then they would have fallen of themselves."[24] Further, he says that "because of the abuses they give rise to, I wish they were everywhere abolished."[25] Images must not be allowed to become the occasion of idolatry; "if they are worshipped," he maintains, "they should be put away and destroyed."[26]

Luther, however, was much less likely than Karlstadt, Haetzer, or Zwingli to think of idolatry—at least in the conventional sense—as the major danger to result from the use of images. As he stated, "I suppose there is nobody, or certainly very few, who do not

understand that yonder crucifix is not my God, for my God is in heaven, but that this is simply a sign."[27] The real "idolatry" (*abgötterey*), in his estimation, resulted from the fact that "whoever places an image in a church imagines he has performed a service to God and done a good work."[28] The donation of art works to the churches had become but another example of that works righteousness in religion that the Wittenberg reformer was attacking with all of his awesome strength.[29] By approaching the problem from this perspective, Luther made perhaps his most original contribution to the Reformation debate over images.[30] But even this abuse in itself "is not sufficient reason," he says, "to abolish, destroy, and burn all images."[31] Unfortunately, the tendency to works righteousness also gets in the way of Christian love. The devil says, "Yes, I help the poor, too; cannot I give to my neighbor and at the same time donate images?" This is not so, however, "for who would not rather give his neighbor a gold-piece than God a golden image . . . if he did not believe, as he actually does, that he was doing God a service."[32] Christians, Luther insists, "would do better to give a poor man a gold-piece than God a golden image."[33]

But when all this has been said, Christians nonetheless "are free to have them [images] or not."[34] They are "neither here nor there, neither evil nor good, we may have them or not, as we please."[35] Citing a historical example drawn from the great iconoclastic controversy of the eighth century, Luther states that "the emperor held that he had the authority to banish the images, but the pope insisted that they should remain, and both were wrong. . . . They wished to make a 'must' out of that which is free. This God cannot tolerate."[36]

Luther also contended that the mere fact that a practice can be misused does not invalidate the practice itself. Just because "they [images] are abused, nevertheless we must not on that account reject them, nor condemn anything because it is abused."[37] Such a policy would end in utter confusion. After all, "wine and women bring many a man to misery and make a fool of him"; we do not for that reason "kill all the women and pour out all the wine."[38] Then, too, it must be admitted that "there are still some people who hold no such wrong opinion of them, but to whom they may well be useful, although they are few," and "we cannot and ought not to

condemn a thing which may be any way useful to a person."[39] "I cannot deny," he says, "that it is possible to find someone to whom images are useful."[40]

Luther, finally, urges that the premature attempt to eradicate idolatry in the violent outward manner of the Wittenberg iconoclasts will simply result in the images being all the more firmly established inwardly, in men's hearts.[41] Or, as he says on a later occasion, "such legalism results in putting away outward images while filling the heart with idols."[42] Christians should "let the Word alone do the work";[43] "outward things" can "do no harm to faith, if only the heart does not cleave to them or put its trust in them."[44]

Between March, 1522, and December, 1524, when Luther wrote what was to be his fullest discussion of the image problem (*Against the Heavenly Prophets*), the reformer touched on the matter in passing at least twice. The first of these two treatments came about as a part of his *Lectures on Deuteronomy*, a series that he had begun delivering in February, 1523, a portion of which appeared in print in 1524, although the completed text was not published until 1525.[45] Surprisingly enough, he makes only a brief remark about images in his consideration of Deut. 5 (which contains the Ten Commandments); he reserves the bulk of his discussion for the passages devoted to the exegesis of Deut. 7:1–2, where he indeed labels his remarks a digression.[46] Since almost all the arguments advanced here are also found in either the 1522 Wittenberg sermons or the treatise *Against the Heavenly Prophets*, they need not be rehearsed separately. The second instance, during the intervening period, is in the *Letter to the Christians at Strassburg in Opposition to the Fanatic Spirit*. It seems that Karlstadt's writings were circulating in that Alsatian city, and the Protestant clergy there had written Luther for advice concerning the controversy that was brewing between the radical theologian's followers and those adhering to Luther. When Luther became aware of the extent to which Karlstadtian ideas were being received, he decided that a mere letter would not be adequate. He wrote the letter, as a preliminary warning against the errors of his rival, but reserved most of his material for a lengthier rebuttal soon to follow. The section of the letter dealing with images constitutes but one paragraph, which concludes with the promise, "of this we will treat further in our answer."[47]

This brings us to the treatise *Against the Heavenly Prophets.* Although not entirely completed until January, 1525, the first part (that dealing with images) was ready by the end of December, 1524.[48] As mentioned earlier, the section on images here is the longest and most thorough discussion of the topic ever written by Luther.[49] Even so, it is quite brief, as compared with a work such as Zwingli's *Answer to Valentin Compar.* The difference in length is probably a fairly reliable index to the relative importance attached to the question by the two theologians, at least insofar as it was a matter of image abuse and iconoclasm.[50] That Luther should have discussed religious imagery again at all, and in a somewhat more approving fashion, reflects how his views on the subject and the manner of their utterance were strongly shaped in their evolution by the reformer's continuing controversy with the iconoclastic radicals.[51]

Although it was now more than two years since the first illustrated edition of Luther's translation of the New Testament had appeared, the reformer could still deny that he wishes "to defend images."[52] Once one has instructed and enlightened consciences on the matter, then beyond this, Luther says, "Let the external matters take their course. God grant that they may be destroyed, become dilapidated, or that they remain. It is all the same and makes no difference, just as when the poison has been removed from a snake."[53] He still is unwilling to condemn those who in an orderly fashion have destroyed paintings and statues that gave rise to false worship: "The destruction and demolishing of images at Eichen, in Grimmetal, and Birnbaum, or places to which pilgrimages are made for the adoration of images (for such are truly idolatrous images and the devil's hospices), is praiseworthy and good."[54] Far more emphatically and explicitly than in 1522, however, Luther now insists that if there is to be any iconoclasm it must be carried out only by duly constituted authority, not by mob violence. Such is the case with all of the examples we find in the Old Testament.[55] For if the masses are empowered to smash the idols, they are also justified to take into their own hands the execution of all of God's commands, including the killing of adulterers, murderers, and so on.[56] Doing away with images in a Karlstadtian manner is but "to make the masses mad and foolish, and secretly to accustom them to revolution."[57] Great care must be taken, Luther insists, "lest accustomed

to rebellion in connection with the images, the people also rebel against the authorities."[58] For, as he colorfully adds, "The devil does not care about image breaking. He only wants to get his foot in the door so that he can cause shedding of blood and murder in the world."[59] Echoes of the early phases of the Peasants' Revolt and Thomas Müntzer's iconoclastic and insurrectionary campaigns obviously are to be heard here.

Moving to a more theoretical plane, Luther begins the theological analysis by taking issue with those who would extend the Old Testament prohibition of images to the life of the Christian community. Even in the Mosaic code, he believes, the prohibition had applied only to "an image of God which one worships."[60] In other words, the phrase "You shall not make yourself a graven image, or any likeness" is to be interpreted in light of the preceding command "You shall have no other gods before me." The latter, he affirms, "is the central thought, the standard, and the end in accordance with which all the words which follow are to be interpreted."[61] Luther concludes from this that where "images or statues are made without idolatry, then such making of them is not forbidden, for the central saying, 'You shall have no other gods,' remains intact."[62] He explicitly affirms that a crucifix is not prohibited under this commandment.[63]

Furthermore, the image proscription, like the Sabbath regulations, belongs to the ceremonial aspect of Judaic law that no longer is binding for the Christian church. As Luther puts it, "The reference to images in the first commandment is to a temporal ceremony, which has been abrogated in the New Testament."[64] Or, again, "Moses' legislation about images and the sabbath, and what else goes beyond the natural law, since it is not supported by the natural law, is free, null and void, and is specifically given to the Jewish people alone."[65] The reformer insists that "God has given neither commands nor prohibitions to the effect that we may not have images, churches, or altars."[66]

Involved here was a spiritual freedom of the Christian man that Luther took very seriously. "This matter of Christian liberty is nothing to joke about. We want to keep it as pure and inviolate as our faith," he commented.[67] He argued, further, "There is to be freedom of choice in everything that God has not clearly taught in the

New Testament."[68] "Where doing or to refrain from doing is in question, and concerning which God has taught, commanded, and forbidden nothing, there we should permit free choice as God himself has done. Whoever though goes beyond this by way of commandments or prohibition invades God's own sphere of action, burdens the conscience."[69] With respect to claims that Christ Himself did not practice or teach the use of images, it seems appropriate to cite here an argument offered by Luther later in the treatise, in the context of a discussion of the permissibility of retaining the custom of the elevation of the sacrament:

We are of the opinion that it is not necessary to do or refrain from doing all that Christ has done or refrained from doing. Otherwise we would also have to walk on the sea, and do all the miracles that he has done. Furthermore, we would have to refrain from marriage, abandon temporal authority, forsake field and plow, and all that he has refrained from doing. For that which he would have us do or not do, he has not only done or not done himself, but in addition he has explained in words that command and forbid what we are to do and refrain from doing. . . . Therefore we will admit no example, not even from Christ himself, much less from other saints, for it must also be accompanied by God's Word, which explains to us in what sense we are to follow or not to follow it.[70]

He even went so far as to assert that, in order to make a point against the new legalism of certain of his left-wing opponents, a Christian should do some of the very things that were being prohibited by the more rigorous.[71]

Luther, indeed, seems to argue that, however men may feel about it, images (at least of the mental sort) are in fact inevitable. He viewed image making as a natural part of the psychological processes of man. Men, of necessity, picture to themselves that about which they think.[72] The applicability of this to religious art is then made clear by the example that he provides:

Of this I am certain, that God desires to have his works heard and read, especially the passion of our Lord. But it is impossible for me to hear and bear it in mind without forming mental images of it in my heart. For whether I will or not, when I hear of Christ, an image of a man hanging on a cross takes form in my heart, just as the reflection of my face naturally appears in

the water when I look into it. If it is not a sin but good to have the image of Christ in my heart, why should it be a sin to have it in my eyes? This is especially true since the heart is more important than the eyes.[73]

Religious art, however, is not only a natural extension of man's inherent tendency to form mental images, the reformer avers, but it is also of positive value: "Images for memorial and witness, such as crucifixes and images of saints . . . are not only to be tolerated, but for the sake of the memorial and the witness they are praiseworthy and honorable, as the witness stones of Joshua [Josh. 24:26] and of Samuel (I Sam. 7 [:12])."[74] Coins bearing images of Caesar were used by both Christ and the disciples in the New Testament, Luther points out, and he adds, "Now we do not request more than that one permit us to regard a crucifix or a saint's image as a witness, for remembrance, as a sign as that image of Caesar was. Should it not be as possible for us without sin to have a crucifix or an image of Mary, as it was for the Jews and Christ himself to have an image of Caesar who, pagan and now dead, belonged to the devil?"[75]

Luther finds a certain irony in the fact that his iconoclastic opponents obviously are using his own illustrated translation of the New Testament. With this as a point of departure, he develops what is the most positive endorsement of religious art to be found in the entire treatise:

Pictures contained in these books we would paint on walls for the sake of remembrance and better understanding, since they do no more harm on walls than in books. It is to be sure better to paint pictures on walls of how God created the world, how Noah built the ark, and whatever other good stories there may be, than to paint shameless worldly things. Yes, would to God that I could persuade the rich and the mighty that they would permit the whole Bible to be painted on houses, on the inside and outside, so that all can see it. That would be a Christian work.[76]

Luther's attitude toward religious art, particularly of the type most directly associated with worship and its liturgical setting, was not yet in 1524–25 as positive as it eventually would become. But the reformer had issued a major rebuttal of the iconoclastic argument. Further, he had propounded what must be viewed as at least a qualified endorsement of Christian visual imagery.

Although he never again wrote a treatise on the subject, Luther continued occasionally to express views on the matter of religious art.[77] In his 1528 *Confession Concerning Christ's Supper*, he informed his readers as follows: "Images or pictures taken from the Scriptures and from good histories . . . I consider very useful yet indifferent and optional. I have no sympathy with the iconoclasts."[78] In the introduction to an illustrated portion of the 1529 Wittenberg edition of his *Personal Prayer Book*, he provided an even warmer endorsement, observing that especially children and simple folk are "more apt to retain the divine stories when taught by picture and parable than merely by words or instruction."[79] Continuing, he inquired:

And what harm would there be if someone were to illustrate the important stories of the entire Bible in their proper order for a small book which might become known as a layman's Bible? Indeed, one cannot bring God's words and deeds too often to the attention of the common man. Even if God's word is sung and said, preached and proclaimed, written and read, illustrated and pictured, Satan and his cohorts are always strong and alert for hindering and suppressing God's word. Hence our project and concern is not only useful, but necessary—in fact, very badly needed. I don't care if the iconoclasts condemn and reject this. They do not need our advice and we don't want theirs, so it is easy for us to part company. I have always condemned and criticized the misuse of [religious] pictures and the false confidence placed in them and all the rest. But whatever is no misuse of pictures I have always permitted and urged the use of for beneficial and edifying results.[80]

In his *Sermons on Deuteronomy* of the same year, Luther affirmed his approval of "pictures in which one sees merely past events and things, as in a glass"; to do otherwise, he insisted, would be to make even a common mirror impermissible.[81] Mention should also be made of the fact that the widely used *Small Catechism* and the *Large Catechism*, also brought out in 1529, significantly retained the medieval enumeration of the Ten Commandments. Like the Roman church of his day, the reformer organized the Decalogue in such a way as to include the proscription of images in the explanation of the first commandment (thus dividing the section on covetousness and regarding it as constituting the last two commandments).[82] Compared with the later Calvinist practice, this had the effect of de-

emphasizing the divine injunction against images by denying it the full status of a separate and independent (second) commandment.[83]

By 1530 Luther was ready to propose (in his *Commentary on Psalm 111*) appropriate subject matter for Protestant altar panel paintings:

Whoever is inclined to put pictures on the altar ought to have the Lord's Supper of Christ painted, with these two verses written around it in golden letters: "The gracious and merciful Lord has instituted a remembrance of His wonderful works." Then they would stand before our eyes for our heart to contemplate them, and even our eyes, in reading, would have to thank and praise God. Since the altar is designated for the administration of the Sacrament, one could not find a better painting for it. Other pictures of God or Christ can be painted somewhere else.[84]

Luther's earlier expression of preference for a table-type altar,[85] which would have eliminated the altar panel entirely as a setting for Christian art, thus did not bear lasting fruit. His singling out of the Last Supper theme was eventually to have momentous consequences for the iconographical development of early Lutheran altar art. His statement also reveals the untenability of an interpretation that would assert that the reformer's doctrine excluded the visual arts from any place in the liturgy.[86]

Luther's Theology and the Uses of Religious Art

A chronological analysis of Luther's writings reveals a considerable development in his thought on the subject of religious imagery. It is not possible, however, by employing such an approach to do justice to the full implications of his theology for Christian art. None of his treatises on the subject is exhaustive or completely comprehensive; they all reflect the limitations of occasional pieces, which is what they are. Relevant ideas are scattered throughout many of his other writings, from both early and late in his career. To gain a better appreciation of what Luther's teachings meant for the development of Protestant art, we shall now turn from the chronological-exegetical to an analytical approach, examining his thought under three headings: (1) art in worship, (2) the pedagogical function of Christian art, and (3) religious art and the means of grace.

Art in Worship. Medieval Roman Catholic teaching and practice had assigned to religious art as one of its foremost functions an important role in the worship of the church. Luther himself approached the problem of religious art partly, at least, from the perspective of one attempting to carry out a liturgical reform in harmony with his newly discovered principle of justification through faith by grace.[87] The task here was to apply the "Protestant principle" to the "Catholic substance" of medieval cultus, to use the terminology of Paul Tillich and Jaroslav Pelikan.[88] One of the issues involved was the problem of tradition. Although Luther was by no means uncritical of the received church practices of his day and believed that the Romanists were too insensitive to the very real distinction between *the* "Tradition" and various particular "traditions," he nonetheless attributed a positive value to the accumulated wisdom of the past.[89] Some of his comments could easily be interpreted as endorsing the view that because God works in and through history, practices not contrary to Scripture ought to be conserved. For example, he stated in 1528 that "we should not discard or alter what cannot be discarded or altered on clear scriptural authority. God is wonderful in his works. What he does not will, he clearly witnesses to in Scripture. What is not so witnessed to there, we can accept as his work. We are guiltless and he will not mislead us."[90]

The liberty that Luther was prepared to exercise in his application of the "Protestant principle" to the inherited "Catholic substance" is well illustrated in the policies of the early Lutheran church with regard to the place of the Virgin and the traditional saints in the liturgy and ecclesiastical art. To be sure, the reformer remained quite critical of the abuses associated with the cult of the saints. In 1523 he observed that "there is nothing in the Scriptures about the intercession of dead saints, nor about honoring them and praying to them. And no one can deny that hitherto through services for these saints we have gone so far as to make pure idols out of the mother of God and the saints."[91] In 1541 he argued, "You will not find this [saint worship] in the writings of the apostles, nor in the nascent church, which in former times would not even allow pictures of the saints—and a lot of blood was spilt over this—not to mention invocations or prayers to them, things that belong to God

alone."[92] He also criticized the manner in which some of the saints or the Virgin were portrayed in art.[93] In 1537 he complained:

In the papacy artists have pictured the Virgin Mary as showing the Lord Christ the breasts at which He had nursed, as gathering emperors, kings, princes, and lords under her cloak, as protecting them and pleading with her dear Son to drop His wrath and penalties over them. Therefore everybody called upon her and honored her more than they did Christ. In this way the Virgin Mary turned into an abomination or into an idol and an offense, though without her fault.[94]

Early in his reforming career (1523) he recommended the suppression of all holy days except Sunday, or, at least, their transference to Sundays.[95] Yet Luther did not entirely heed his own advice. His own liturgical formulas preserved the church year with many of its festivals. The early Lutheran church retained even special observances of nonbiblical saints, and certain feast days of the Virgin were also in some cases celebrated by sixteenth-century Lutherans.[96]

Luther's position in this regard did not lack ambiguity. He was well aware that excessive devotion paid to the saints could only divert attention from Christ, the sole mediator allowed by his theology.[97] Further, as moral or religious examples, not all of the traditional saints portrayed in the medieval church were considered fully worthy of imitation.[98] An even more substantial objection emerged from his doctrine of vocation.[99] Because all Christians are called to specific situations and responsibilities in life, the only saint who properly could be an object of imitation would be one who had precisely the same set of life relationships as the worshiper. But no one has ever stood in the same place where another now stands. To wish to imitate is to betray a false and self-serving urge to be as holy as someone else one knows, rather than the proper motive of self-sacrificing service to others in the concrete and particular situations of life.

And yet (as we have seen), as early as 1524–25, in his controversy with the iconoclasts, Luther began to contend for the positive value of saints' images as a witness, remembrance, and sign.[100] The Augsburg Confession of 1530—the creedal foundation of historical Lutheranism—contains the following positive evaluation of the

commemoration of the saints: "It is also taught among us that saints should be kept in remembrance so that our faith may be strengthened when we see what grace they received and how they were sustained by faith. Moreover, their good works are to be an example for us, each of us in his own calling."[101] The Augsburg Confession, to be sure, was written not by Luther but by his Wittenberg associate, Philipp Melanchthon.[102] In 1535, however, the reformer himself had the following to say:

Next to Holy Scripture there certainly is no more useful book for Christendom than that of the lives of the saints, especially when unadulterated and authentic. For in these stories one is greatly pleased to find how they sincerely believed God's Word, confessed it with their lips, praised it by their living, and honored and confirmed it by their suffering and dying. All this immeasurably comforts and strengthens those weak in the faith and increases the courage and confidence of those already strong far more than the teaching of Scripture alone, without any examples and stories of the saints. Although the Spirit performs His work abundantly within, it nonetheless helps very much to see or to hear the examples of others without.[103]

According to Jaroslav Pelikan, "Luther's own activity in the pulpit suggests that . . . he actually continued the custom of commemorating the lives of the saints and of other men of God, especially men spoken of in the Bible." As he explains, "Luther described the careers of such men of God in order to give his hearers an awareness of the grace of God, by which these men had been constituted as saints and by which the experiences of these hearers could participate in the communion of saints."[104] In any case, there can be little doubt that the continued observance of the church year with many of its festivals and the relatively positive evaluation still placed upon an acquaintance with the lives of the saints strengthened tendencies toward a conservative attitude with respect to the traditional ecclesiastical art. Medieval and Renaissance portraits of the saints adorn many German Lutheran churches to this day. Similarly, the demise of representations of the Virgin occurred only slowly in Lutheran art, and throughout the remainder of the sixteenth-century examples occur in Protestant book illustration where the halo is accorded to the figure of the Blessed Mother, sometimes being denied to the apostles themselves.[105]

The Augsburg Confession links the conservation of "holy days, festivals, and the like" with maintenance of "good order" in the church.[106] This suggests another important consideration in early Lutheran theology. It is not merely that ceremonial and display are free and permitted, not having been forbidden. They are that.[107] But Luther also was concerned to preserve a minimum of liturgical uniformity and godly decorum in the church. As the Augsburg Confession expresses it, "Nothing contributes so much to the maintenance of dignity in public worship and the cultivation of reverence and devotion among the people as the proper observance of ceremonies in the churches."[108] Here some of the implications of the reformer's doctrine of Christian liberty become clear. Man is free, with respect to attempts to appease God, but he at the same time is bound in service and love toward his neighbor.[109] In the matter of forms of worship, this meant, as Luther expressed it in his 1544 Torgau sermon, "We are always obliged in our whole Christian life to use our liberty in these external things in love and for the service of our neighbor, so in this matter also we should be in harmony and conformity with others."[110] Thus the foremost modern authority on Luther's theology of worship, Vilmos Vajta, speaks of the "freedom of faith" and the "order of love" as the underlying principles governing the reformer's use of all worship practices.[111]

True worship of God, according to Luther, can take place at almost any time and almost anywhere.[112] It is a concern for convenience and the common good that dictates regularly appointed worship services at regularly appointed places.[113] Similarly, while love does not require any particular set of rites, it does necessitate worshiping according to some stated forms. And the choice of these forms is not a purely personal matter but results from the needs of one's fellowmen.[114]

Luther did, indeed, advocate a certain moderation in ceremony in order that Christians not become excessively absorbed in external rites and aesthetic considerations.[115] He was "fundamentally suspicious of form for form's sake," as Pelikan observes.[116]

And yet Luther, particularly in his mature years, showed an increasing awareness of the importance of decorum, reverence, and solemnity in worship and the treatment of the church building. The sanctuary was not to be the scene of frivolous behavior; altar, chan-

cel, and choir areas were to be respected.[117] He advised that the clergy, when conducting the service and celebrating the sacraments, wear vestments and not appear in common street garb—in order that the dignity and special office of the pastor (if not a special "priestly" status) be enhanced and distinguished from that of the other worshipers.[118] Even altar lamps were permissible, he stated in 1528;[119] and indeed, to take one example, the eternal light was kept burning in St. Sebald Church in Nuernberg until at least the 1540s.[120] This approving stance toward ceremony and serious concern for the proprieties of public worship helped to create a religious atmosphere in which a liturgical art remained an open possibility.

Luther's theology permitted other opportunities for the use of visual arts in the worship life of the church. Praise of God constituted for him a central aspect of worship;[121] the works of the artist provide one suitable means for rendering that praise and thanks to God. The implications of this insight were most fully worked out in connection with music,[122] but also were recognized in relation to painting and sculpture—as reflected in Luther's statement on the Last Supper as a theme for altarpieces.

Art, in the early Lutheran context, also served to express and witness to the faith of the Christian congregation. It has been rightly observed that the Wittenberg altar panels by Cranach, portraying the reformers engaged in preaching and administering the sacraments, represent not only proclamation but also a confession of belief in the reality of the church.[123] In this way they, too, contribute to the task of worship.

The Pedagogical Function of Christian Art. Worship shades off into pedagogy in Lutheran theology.[124] The Augsburg Confession states that "the chief purpose of all ceremonies is to teach the people what they need to know about Christ."[125] As a popular educator, Luther possessed great awareness of the value of rites and observances for the simple and weak in faith.[126] The church year, in fact, had been retained partly out of consideration for its instructional usefulness.[127] What, then, is the pedagogical value of religious art?

That Luther should have devoted increasing attention to such a question is not at all strange if one considers his vast concern for

education in general. He conceived of teaching as one of the very most important requirements of the religious transformation. It has been pointed out by Harold Grimm that "the mature Luther devoted virtually all his time to teaching" and that he "wrote more about education than any other Reformer of the sixteenth century."[128] Included in this zeal for instruction was a fine appreciation of the value of the visual arts as a pedagogical device.

As suggested earlier, Luther viewed man as inherently given to visualizing and image making. Thus, it is not surprising that as an educator he should have insisted upon the importance of illustrations and concrete examples.[129] The Bible itself, he maintained, uses visually conceived examples to enforce its teaching, and he referred to Jesus' reliance on parables.[130] Luther once remarked that "ordinary people are caught more easily by analogies and illustrations than by difficult and subtle discussions; they would rather look at a well-drawn picture than a well-written book."[131] At another point he observed that "external images, parables, and signs are good and useful: they illustrate a thing so that it can be grasped and retained."[132]

In addition, art was thought to serve the needs of religious education by aiding the memory and recalling doctrinal truths to mind.[133] Luther accepted as a generally valid educational principle the need for constant repetition,[134] and he cherished the visual arts as one more means of improving men's retention of a saving knowledge of the biblical message.

It has been maintained that Luther viewed religious art primarily as a visualization or extension of the Word.[135] This raises the question: Must the Word of God take an exclusively verbal form? Although the reformer never addressed himself to this problem as directly as have some modern theologians, it is worth noting that when speaking about religious art themes he often specified that the representation should be accompanied by an inscription.[136] According to some scholars, the scriptural and related texts really may have constituted the major component in some early Lutheran art works,[137] occupying as much as one-sixth of the picture space in a few extreme instances.[138] In any case, the picture and the written Word were seen as complementary and mutually reinforcing,[139] and together they offered a yet more effective way of propagating the Gospel.

Religious Art and the Means of Grace. If Christian art is useful in worship and constitutes an important instrument in religious education, can it also be said that, for Luther, visual images attain to the rank of one of the means of grace—those media specifically chosen by God as the channels of His saving activity? It might be observed, first of all, that the reformer wrote no systematic treatise on the means of grace nor is the term itself prevalent in his theology.[140] Further, his own list of the means of grace did not remain constant.[141] Yet, the English translation of the Augsburg Confession speaks of the Gospel and sacraments as "means" through which God gives the Holy Spirit,[142] and the doctrinal concept underlying the terminology is in no sense foreign to the intent of Luther's theology.

The possibility of a doctrine of the means of grace arises from the Lutheran insight that although all of creation (including art) is a good gift from God, this fact does not, as Vajta observes, "erase the differences between the gifts of God by which he preserves our earthly life and those by which he grants life eternal."[143] God, having dominion over all creation, can and does choose certain specific media to convey the gifts of the spirit.[144]

It is central to an understanding of Luther's theology that one perceive the importance for him of outward or creaturely forms as vehicles of that divine grace to be inwardly received. God chooses to meet man through externals:

Now when God sends forth his holy gospel he deals with us in a twofold manner, first outwardly, then inwardly. Outwardly he deals with us through the oral word of the gospel and through material signs, that is, baptism and the sacrament of the altar. Inwardly he deals with us through the Holy Spirit, faith, and other gifts. But whatever their measure or order the outward factors should and must precede. The inward experience follows and is effected by the outward. God has determined to give the inward to no one except through the outward.[145]

This emphasis upon outward means reflects a central characteristic of Luther's thought, that is, a firm rejection of any type of body-spirit dualism. Spirituality is not conceived of as divorced from matter. The essential polarity, rather, is that of faith and unbe-

lief, the "new man" and the old.[146] Thus, in dealing with the terms "flesh" and "spirit" in Paul's Epistle to the Romans, the reformer explained that "Paul calls everything 'flesh' that is born of the flesh—the whole man, with body and soul, mind and senses." " 'The spirit,' " on the other hand, "is the man who lives and works, inwardly and outwardly, in the service of the Spirit and of the future life."[147] Ultimately, this insight rests upon Luther's conception of the doctrine of the Incarnation. In the form of God-become-flesh, the Creator condescended to meet humanity on the earthly level and hence now also extends His gift to man in earthly forms.[148]

What are the external media that, for Luther, serve as means of grace? Sometimes, in his more unguarded moments, he spoke almost as if one of the arts, i.e., music, might meet the required conditions: "The Holy Ghost himself honors her [music] as an instrument for his proper work when in his Holy Scriptures he asserts that through her his gifts were instilled in the prophets."[149] Or, "God has preached the gospel through music, too."[150]

Roman Catholics sometimes have claimed for works of visual art an efficacy that might well seem to class them as a means of grace. Luther, for his part, was not insensitive to the potential of religious art as a stimulus to personal devotion. He affirmed once the value of visual images such as that of the resurrected Christ in reminding and admonishing people concerning the Saviour's suffering and wounds.[151] One of the reformer's followers also records in the *Table Talk* how the sight of an image of the Virgin and Child could evoke from Luther himself a poignant lament at the way in which sinful man disregards the marvelous mercy shown by God in the Incarnation.[152]

In order to assess correctly Luther's own position on this question, however, it becomes necessary to analyze somewhat more carefully his full view on the means of grace themselves. He insisted that the Christian Gospel, understood as the Word, is the chief means of grace.[153] Traditional Lutheran theology speaks in terms of "Word and Sacraments," but in a sense baptism and the Lord's Supper derive their sacramental nature only by their participation in the Word.[154]

Other than in the sacraments, in what forms does the Word of

God express itself? Debate in the Lutheran context, as a matter of fact, has centered on the question not of visual or verbal, but rather of oral or written proclamation. For the reformer himself, it was above all the spoken or preached Word that really constituted the chief means of grace: "The Holy Ghost normally gives this faith or His gift to no one without preaching, or the oral word."[155] In a sense, he elevated the office of preaching to the status of a sacrament—the sacrament upon which all other sacraments depended.[156] Modern interpreters of Luther even speak of a "Real Presence" or Incarnation in the oral proclamation of the Word.[157]

Why this elevation of the oral above the written Word? First of all, because it corresponds more closely to the nature of the God who chooses to reveal Himself through it. Luther viewed God as active, dynamic, as one who addresses His people in direct discourse. As Pelikan observes, the reformer's picture of God is that of a God who speaks.[158]

Second, Luther's understanding of the character and purpose of divine revelation suggested to him an advantage of oral over other forms of proclamation. He once remarked that "printed words are dead, spoken words are living."[159] And God wishes not to impart mere knowledge through His Word,[160] but rather to establish a vital relationship with man. Due to the "inherent vivacity" of the spoken Word, to borrow Joseph Sittler's phrase, it is singularly well adapted to communicating the quality of livingness Luther ascribed to the Gospel.[161]

Another related advantage of the spoken Word, in the context of Luther's theology, resides in its power to make the Christian message contemporaneous. If the divine Word truly is to be revelation and not to remain as mere recorded history, then the past tense must be overcome. The printed page tends to suggest the dead past; preaching constitutes an event of the present. Through oral proclamation, the Word of the Scriptures is made contemporary and becomes the Gospel.[162]

The superiority of the oral Word, further, lies in its personal nature. Luther believed the central question to be not what is in the Bible, but what does it mean to me?[163] An individual can read a book without really applying its message to himself; when addressed by a living voice he knows that he is the one addressed.[164] Therefore,

since it is God's purpose to establish a personal relationship between Himself and man, the Word must be spoken personally.[165]

Finally, the oral Word establishes community. God chooses to step into contact with man through other men.[166] As it is intended to create fellowship, the living Word must be passed from mouth to mouth.[167]

Reversing, thus, a long-standing tradition,[168] Luther insisted on the priority of hearing over sight.[169] "Do not look for Christ with your eyes," he said, "but put your eyes in your ears."[170] Or, at another point, "The Kingdom of Christ is a hearing kingdom, not a seeing kingdom."[171] The reformer, in his inimitable manner, could even refer to the church as a "mouth house" and not a "pen house."[172] He liked to remind his followers that although the apostles were great preachers, they wrote but little, and Christ nothing at all.[173]

What, then, is the function of the written Word? Luther saw the written recording of the Gospel in the first place as an emergency measure—one intended to maintain the purity of the verbal message, which had threatened to become lost.[174] The Scriptures thus serve to sustain the oral proclamation and preserve it from error.[175] But it is in being transposed into preaching that the written Word once again becomes fully an instrument of grace.[176]

The relationship of religious art to the means of grace must be seen finally within the context of this larger question of the nature of the Word and its expression. Visual images for Luther indeed are useful instruments for conveying the message of the Gospel. They assist in making the Word manifest by providing additional media—with their own particular type of pedagogical effectiveness—for its proclamation. But, ultimately, the fine arts cannot claim for themselves a full equivalence with preaching and the sacraments as channels of divine, saving grace.[177] For they not only share the disabilities of the merely written Word (as compared with living oral proclamation), but they also suffer from an inadequacy at the point of indicating explicitly and without further elaboration what the true content of God's message is.[178] Luther most probably would have agreed with the modern Protestant theologian Emil Brunner that "in this respect the human word is not simply one method among others, for human speech alone can indicate quite

unambiguously God's thought, Will, and Work."[179] Even the Incarnation would have remained incomprehensible to man had it not been verbally explained.[180]

Although Luther indeed affirmed that certain types of art works may help to inspire religious devotion, he never developed a theory of sacred art that emphasized, as in medieval thought, the unique emotional or affective power of visual images—one that gave them a force and function quite independent from the Word in its verbal form.[181] More typical of the characteristic direction of his thought were utterances such as "God has decreed that no one can or will believe or receive the Holy Spirit without that Gospel which is preached or taught by word of mouth."[182]

Conclusion

Luther's theology obviously called for a somewhat more discriminating use of religious imagery than had characterized the Roman Catholic church in the later Middle Ages. Yet it is equally clear that the reformer by no means intended to eliminate the contribution of the artist to the worship and teaching of Christendom. The essential requirement was that everything be done to praise and glorify God and in loving service to one's fellow man.[183] As he had already expressed it in 1524, "Nor am I of the opinion that the gospel should destroy and blight all the arts, as some of the pseudo-religious claim. But I would like to see all the arts, especially music, used in the service of Him who gave and made them."[184] It may well be, as the above quotation would suggest and as many modern scholars have claimed, that the most important artistic legacy of Luther's Reformation is to be sought in the field of music, not in the areas of painting and sculpture. And yet it would be a mistake to overlook the fact that within at least this one branch of Protestantism remained considerable scope and incentive for the creation and employment of works of the visual arts. As we shall see in a later chapter, this fact had important consequences.

3

Further Iconoclasm and
Its Significance

N THE FIRST CHAPTER we examined some of the
theological considerations involved in the origins of Refor-
mation iconoclasm and then traced their impact upon the
course of events in Wittenberg, the cradle of the Protestant move-
ment. In the second chapter, an analysis was provided of the gene-
sis and ultimate configuration of Luther's views on religious imag-
ery. Now the time has come to treat in more detail some of the
further consequences of these developments in terms of the preser-
vation or destruction of ecclesiastical art in other German-speaking
communities.[1] We shall focus primarily upon the period of the
1520s and early 1530s, the critical early phase of the Reformation.[2]

Nuernberg

Despite the moderate stance that Luther adopted with respect to
the question of religious imagery in the churches, further iconoclas-
tic destruction nonetheless occurred in various parts of Germany
where a Protestant movement bearing his name was introduced. To
understand this, we should recall that the first few years of the
Reformation were very turbulent. It was a time of great upheaval
and experimentation, far from the settled, state-church Lutheranism
of the following decades. Traditional anticlericalism, radical new
theological teachings, and the aspirations of the common people for

social change all combined to provide the driving force for varieties of protest and reform that were often quite uncongenial to Luther himself. Under such circumstances, it is not at all surprising that iconoclastic disturbances, often of a very destructive nature, should occur,[3] sometimes erupting in urban situations when a popularly based Reformation movement encountered the resistance of a conservative city council.[4] Major instances are the outbursts recorded in the Hanseatic cities of Stralsund (1525)[5] and Braunschweig (1528).[6] However, it generally is conceded by historians, even by scholars otherwise critical of the Lutheran Reformation, that considerably less devastation of religious art usually occurred in areas falling under the influence of the Wittenberg reformer than in Zwinglian or Calvinist lands.[7] A good example of this conservative aspect of early Lutheranism is provided by the record of events in the great imperial city of Nuernberg.[8] This story is unusually interesting because Nuernberg was recognized everywhere as a leading center of German art in the immediate pre-Reformation period, its pious and wealthy citizens having endowed the local churches over the years with a remarkable collection of masterpieces.[9]

Most of these ecclesiastical monuments were left unmolested in Nuernberg during the Reformation, with the result that even today the two large parish churches, St. Sebald and St. Lawrence, are a virtual showcase for the glories of late medieval and Renaissance art. To imply, however, as some have,[10] that even Nuernberg entirely escaped the problem of iconoclasm is to oversimplify the story somewhat. The danger of art destruction does seem to have been quite real, at least for a brief period in the early years of the Reformation. Quite apart from the officially authorized removal of a small group of monuments from the churches, the evidence indicates that, had not the authorities acted as promptly and vigorously as they did, a more widespread devastation might well have taken place. Although the religious revolution in general resulted in little outright violence and anarchy in the city, a certain amount of social unrest inevitably accompanied the upsetting of established customs. A spirit of unruliness and disregard for law and order appeared for a time among certain elements of the population.[11] The official adoption of Lutheranism by the city council in March, 1525,[12] clarified the situation considerably, but the leaders of the

local Reformation still were left with a decision of what to do about the existing ecclesiastical art. The wholesale destruction of these works would have amounted to a cultural catastrophe. This, however, did not happen, for while the city's political authorities were suppressing radical teachings and maintaining civic order in a manner conducive to the preservation of the art monuments from physical destruction, the local religious leaders were adopting a theology that permitted their permanent retention in the churches.

There can be no doubt that iconoclastic ideas circulated in Nuernberg in the 1520s.[13] Teachings of several sectarian and spiritualist reformers with such views are known to have found at least a foothold in the city. In recent years several studies have been devoted to the problem of the Radical Reformation on the local level, and it is now possible to reconstruct the story with some degree of confidence. For a brief period in the mid-1520s it appeared that Nuernberg, along with other imperial cities such as Augsburg and Strasbourg, might become a center of left-wing religious agitation.[14] Several of the leaders of the young movement made appearances in the city, conventicles were held, and the radicals were even said to have their own printing press.

With regard to the question of iconoclasm, it is of great significance that the theological views of Karlstadt, Ludwig Haetzer, and Thomas Müntzer are known to have made an impact in the city. Karlstadt appears to have had many friends there, and the authorities showed great concern over the fact that his works were widely discussed among the citizenry. In December, 1524, the city council decided that all of Karlstadt's books, as well as those of Müntzer, should be confiscated.[15] Despite this step, the government continued throughout 1525–26 to worry about the secret dissemination of his ideas.[16] Evidence of this anxiety can be found in a letter written by Christoph Scheurl, Nuernberg jurist and legal consultant to the city, to a friend in Genoa in late January, 1525: "Everything is quiet here in Germany except that the followers of Karlstadt are increasing. These deny that the body of Christ is in the host and combat the baptism of infants. They destroy the images and interpret Scripture for themselves."[17]

Haetzer, another of the major iconoclasts of the Radical Reformation, also exerted some influence in the city. Although he appar-

ently did not come to Nuernberg in person until a short stay in August or September, 1527,[18] his report on the Second Zurich Disputation (October, 1523), in which he had personally participated and in which there had been a vigorous denunciation of images by Leo Jud, Conrad Grebel, and Balthasar Hubmaier, as well as by Haetzer himself,[19] was known in Nuernberg.[20]

Müntzer's iconoclastic sentiments have not been emphasized by modern historians as much perhaps as those of Karlstadt or Haetzer. He made his position clear enough, however, in the notorious "Sermon Before the Princes" (July, 1524): "For he [God] himself commanded the same through Moses (Deut. 7:5f.) where he says: Ye are a holy people. Ye ought not to have pity on account of the superstitious. Break down their altars, smash up their images and burn them up, that I be not angry with you. These words Christ has not abrogated. . . . God cannot say yes today and tomorrow no, but rather he is unchangeable in his Word."[21] Earlier that same year a group of Müntzer's followers from Allstedt, in his presence, had burned a chapel at Mallerbach containing a shrine with a miracle-working image of the Virgin.[22]

Müntzer is known to have had adherents active about this time in Nuernberg as well. Among the most important was his friend Heinrich Pfeiffer, who spoke to gatherings in the imperial city and arranged disputations in order to recruit followers for Müntzer's ideas.[23] Müntzer himself came to the city for a short stay in early April, 1524,[24] although he denied in a later letter having engaged in any seditious activity.[25]

The radical reformers, of course, were by no means the only people at the time opposed to religious imagery. Under Zwingli's leadership the city council of the Swiss city of Zurich removed all paintings and statues from the local churches in June and July, 1524.[26] And Zwinglian ideas also circulated in Nuernberg. Franz Kolb, a young follower of the Zurich reformer who we know shared Zwingli's iconoclastic views,[27] resided in the free imperial city for a time beginning in 1522 and corresponded with his mentor concerning the reception there of Zwinglian teachings.[28] The danger to the new Lutheran orthodoxy was considered great enough to warrant official proscription of all of Zwingli's writings in 1526.[29]

To the influence exerted by the writings and visits of these well-

known leaders must be added the impact of native radical preachers and agitators. One Diepold Peringer, the so-called peasant from Wöhrd, attracted large crowds to his street-corner sermons early in February, 1524. Along with his attack on image idolatry, Peringer also denounced the Mass and freedom of the will. Although he finally was banished from Nuernberg territory, traces of his influence lingered for some time.[30]

Another Nuernberg street-corner preacher who has attracted the attention of modern scholars is the painter and publicist Hans Greiffenberger.[31] Little is known of his personal life or social status other than his trade and the fact of his participation in the religious revolution. Greiffenberger incurred the disciplinary censure of the city council for some pictorial caricatures of the papacy that he had published and for the propagation of his allegedly Zwinglian interpretation of the Eucharist. The authorities finally demanded from him a public confession of his errors and forbade him to preach thenceforth. One of his tracts, dated 1524, contains the following significant assertion: "A true Christian should look to his neighbor, and ought no longer to crown and to adorn the idols of the saints with candles and with garments. Is that not really gruesome blindness that we have dressed up all these images and have left the statues of Christ naked and suffering? My God! What a horrible business; it is downright inhuman."[32]

That the dissemination of teachings of this nature did not result in a more widespread destruction of religious art than actually occurred may be explained by several factors. For one thing, despite the promise shown early in the movement, and the corresponding apprehension of the city fathers, the Radical Reformation never succeeded in establishing a strong base in the city. The absence of gifted and sustained local leadership, the apparent satisfaction of the majority of the populace with the Lutheran faith, and the hostility and coercion of the government may be taken as causes of this arrested development.[33]

Then, too, by no means all of the Nuernberg radicals advocated a destructive iconoclasm. For much of the early period the most scholarly and respected of the local sectarian religious leaders was the quietistic spiritualist Hans Denck. Until his expulsion from the city in January, 1525, this humanist schoolmaster exerted a deep

influence on the direction of heterodox thinking in the community. Denck, as is well known, eschewed all forms of revolutionary violence. The recent publication of his biblical exegetical writings makes possible an evaluation of his position with regard to the specific question of ecclesiastical art.[34] In a fashion reminiscent of Luther, Denck argues that eradication of idolatry from the heart is more important than physical destruction of images themselves. Although he disapproved of their use, as lacking in scriptural warrant, he refrained from advocating forcible removal.

Finally, the strict policy of surveillance and disciplinary action pursued by the civic officials must be credited with playing a large part in discouraging iconoclastic violence. There were several reasons for the implementation of such a policy. For one thing, the officials held themselves accountable for maintaining general peace and order in the municipality, and mob action of any kind immediately raised fears of civil insurrection as well as religious radicalism. Second, and a point easily overlooked, the patrician city councilors themselves, and their forefathers, had endowed the local churches with a large number of the art works that they contained. Indeed, as we shall see, even in Zwinglian Zurich provision was made for the original donors or their descendants to retrieve privately financed paintings and statuary from the churches.[35]

But more was at stake here than mere property rights. As we have noted, during the course of the later Middle Ages sponsoring ecclesiastical art had become for the urban middle class a widely used means of establishing claims to social status and acquiring enduring family renown.[36] Altars and statuary placed in the churches and even clerical vestments commonly bore the armorial bearings of the donating family. The coat of arms designated the donor and functioned as a symbol of intense family pride.[37]

Something of the importance attached to such a practice by the leading families of the city is indicated by the contentious spirit in which they often disputed for the honor of providing works of ecclesiastical art to the major local churches. Among the more important examples was a case that arose at St. Sebald Church in August, 1514.[38] The provost, Melchior Pfintzing, along with other unspecified donors, wished to replace the tabernacle or *Sakramentshaus* located above the St. Nicholas altar with a newer, more elabo-

rate one that would cost as much as a thousand gulden.[39] The descendants of the original donors protested to the city council on the grounds that the existing work with its identifying coats of arms was in effect a family memorial and that they alone should retain the right to improve or replace it.

The reply given by the council is typical of its general policy over the years; the provost and his associates were advised to give up their plans. Almost invariably, when controversies of this sort were brought to the attention of the city government, the decision went to the family of the original donors. In some instances a prospective new benefactor was even given permission to replace an altar panel or stained-glass window only on the condition that he leave the previous armorial bearings in place.[40] Such a spirit of class and family pride apparently could easily get out of hand. Reforming clergy and authors of the later Middle Ages and Renaissance already had complained of the vanity and unchristian nature of the practice of crowding the churches with heraldic devices.[41]

But these family traditions were not easily forgotten even after the Reformation. An attractive piece of visual evidence in support of this assertion can be found in a full-page illumination in the "Hallerbuch," an illustrated genealogical registry of Nuernberg's leading families commissioned by the city council in the mid-1530s.[42] Two fifteenth-century members of the Volkamer family are portrayed kneeling before an altar that is suitably emblazoned with the family coat of arms, which they had donated in the St. Lawrence Church. The patricians of the post-Reformation period apparently continued to view with some pride the ecclesiastical endowments of their forefathers.

Nuernberg's ruling citizens thus had ample reasons, even from a purely secular point of view, for resisting any efforts at image destruction or plundering. Nonetheless, the surviving records make it possible to catch a glimpse of incidents suggesting the danger, or at least the fear, of actual iconoclastic violence. One of the most severe casualties of Reformation iconoclasm in many areas was the destruction of magnificent medieval stained glass. Early in 1523 several incidents involving the throwing of stones through church windows prompted the city council to post stern warnings against the desecration of monasteries and houses of worship.[43] The memoirs

of Charitas Pirckheimer, abbess of St. Clara's convent and sister of the distinguished Nuernberg humanist Willibald Pirckheimer, provide illuminating insight into the impression made by these tumults upon the minds of those committed to upholding the old order. They also verify the continuation of the disturbances into the succeeding years, 1524–25:

> Daily they threatened to expel us, or to plunder or burn the monastery. At times rowdies loitered about the convent, and threatened our servants [that] this very night they would attack the convent, so that we were in great dread and need, and slept but little for fear. . . . Each day we heard such deplorable, terrible things, how the peasants destroyed so many monasteries and drove the inmates of the convents away in misery from all they had. . . . We could scarce hold divine services or ring the bells in the choir; for when anything was heard from us, cursing and abuse resounded and shouting in the church, directed at us; stones were thrown into our choir and the windows broken in the church.[44]

In Nuernberg, as in other places, the dissolution of the monasteries was accompanied by instances of illegal plundering and looting of liturgical furnishings.[45]

The Nuernberg archives provide another interesting, if indirect, evidence of the iconoclastic danger. In a letter of late August, 1524, to a Nuernberg city councilman from a knight, Hans Lamparter von Greiffenstein, advice is requested concerning the disposition of a sculptured sepulchral monument. The epitaph, in honor of the deceased father of the writer, the imperial counselor Gregor Lamparter von Greiffenstein, had been commissioned from an Augsburg sculptor and was intended for installation in a church in Nuernberg—a city that, the knight asserted, both father and son had honorably served. It apparently was a fairly monumental work, consisting of the figures of Christ on the cross, Mary, saints John and Gregory, and the portrait of the deceased in a posture of prayer.[46] But Lamparter mentions hearing rumors that ecclesiastical art is endangered in the city and fears that the work might be destroyed: "They are saying here now that my lords at Nuernberg no longer wish to tolerate images in the churches, but, on the contrary, intend to remove them. If the epitaph . . . finally should be destroyed by mischief-makers, it would be a pity, on account of the good work-

manship and wasted expenditure, together with the mockery in-
volved."[47] Apparently the monument never was delivered to Nu-
ernberg but ended up instead in the parish church of Krumbach,
where the Lamparters owned property.

With the benefit of historical hindsight and fuller information
than many such contemporaries had at their disposal, we can now
see that the long-range prospects for the preservation of ecclesiasti-
cal art in Nuernberg indeed were much better than might have been
judged at the time. For, in addition to the good personal and politi-
cal reasons that the municipal councilmen had for opposing icono-
clasm, there was implicit in the doctrinal position then being
adopted by the city's preachers a possible theological rationale for
the retention of religious imagery.

Like Luther, the Nuernberg reformers arrived at the view that
religious art falls in the realm of Christian freedom, or, to speak more
theologically, is a question of *adiaphora*.[48] Images were not to be
adored or worshiped but nonetheless might be used, the one excep-
tion being art work whose theme was blatantly unscriptural. Altars
or statues portraying nothing more than dubious legends or "good
for nothing other than that people pray and burn lights before
them," it was judged, might better be removed by the authorities.[49]

This decision, however, did not lead to the wholesale abolition
of art works depicting the lives and deeds of the traditional saints of
the church. A careful distinction was made between showing exces-
sive devotion to these holy men and women of past ages and merely
paying them due respect, and warnings were issued in Nuernberg
against speaking about the pious dead in such a manner as to cast
dishonor upon them.[50] Indeed, it was recognized that, understood
in a proper evangelical sense, the stories of the saints might even
serve the Protestant worshiper as a useful example of lives led in
faith and under grace.[51] To many of the common people, such
stories were more accessible through visual representations than
through the written word. Significantly, the older view of Christian
art as an illustrated book for the illiterate remained in force among
the Nuernberg reformers, as with Luther.[52]

The continued observance of the liturgical calendar in Nuern-
berg also strengthened the case for the retention of much traditional
ecclesiastical art. Although certain saints' days were abolished, the

custom per se of commemorating the lives of the saints, especially those mentioned in Scripture, was by no means entirely discontinued. Thus, the *Agendbüchlein* or liturgical manual of the local pastor, Veit Dietrich, carefully specified the remaining church festivals that were to be proclaimed and observed by abstinence from work and attendance at divine services.[53]

Apart from explicitly iconographical or thematic art such as altar panels and statuary, there remained a large body of liturgical accouterments often possessing considerable artistic significance. The critical fact here is that Luther, as we have seen, did not share with Zwingli and many other Protestants a radical suspicion of all visual adornments of the liturgy. Further, the concern of the Wittenberg reformer to preserve the gravity and solemnity of public worship and the inviolability of the sanctuary provided added stimulus for a more positive assessment of the role of liturgical art. With this as a background, we are not surprised to find that the Nuernberg leaders also should have decided to preserve many more of the existing church furnishings than did, for example, the leaders of Zwinglian Zurich. An ordinance of 1533 listed liturgical garments, altar hangings, altar vessels, and lights all as externals to be viewed under the heading of Christian freedom. Therefore, it was ruled, they should be preserved.[54] The "eternal lamp" in St. Sebald Church, as mentioned earlier, was not extinguished.[55]

Indeed, the officially approved removal of religious art from the churches for purely theological reasons seems to have been very limited in extent. In October, 1529, the city council decreed that an image of the Virgin (*Maria pild*) be taken from the Church of Our Lady due to continued misuse and idolatry (*missbrauch und abgötterei*).[56] In a somewhat related action it was decided to leave permanently covered the huge wood carving of the Annunciation created by Veit Stoss and donated by burgomaster Anton Tucher to the St. Lawrence Church in 1518. This work, made in the form of a giant rose garland with figures of the angel and the Virgin enclosed therein, hung suspended from the ceiling of the church. Even before the Reformation it was kept concealed throughout most of the year, to be shown only on certain festivals. According to popular tradition, the denunciations of the Lutheran preacher Andreas Osiander resulted in the final deletion of its use in the liturgical

calendar. The demise of the cults of the Virgin and the rosary no doubt played a part in bringing about this decision.[57]

The Roman Catholic practice of reserving the eucharistic Host in ornamental tabernacles—the so-called *Sakramentshäuser*—presented particular problems. From the point of view of art history, the question possesses some importance, for the late Gothic works erected for this purpose are among the glories of European art. The towering and majestic structure created by Adam Krafft for Nuernberg's St. Lawrence Church was destined to become entirely superfluous if the practice were abandoned. Indeed, it was even possible that it might be destroyed, as an unwelcome reminder of previous idolatry.[58] Nuernberg chroniclers describing local attitudes of almost a century later mention the continued practice of some citizens referring to Krafft's masterpiece as an idol.[59]

The "Nuernberg 23 Articles of Faith," drawn up in 1528 by Osiander, equivocate somewhat on the theological point involved here.[60] After first affirming that this matter also falls under the heading of Christian freedom, Osiander goes on to state that after sufficient instruction the practice of reserving the Eucharist should be dropped, as it serves neither faith nor love. That there was some slight disagreement among the Nuernberg clergy on this issue is indicated by a statement of Dominicus Schleupner, from the same period, insisting that Scripture adequately reveals the correct form of the Lord's Supper and that this does not permit retention of the former usage under the guise of Christian freedom—in fact, the practice might better be termed an abuse.[61] But in either case, it is clear that this element of Roman Catholic practice was destined to disappear from Protestant Christianity. Significantly, the great stone tabernacle of St. Lawrence Church suffered no harm as a result of the theological reorientation.

Similarly, the authorities took no action regarding the great metal Shrine of St. Sebald in St. Sebald Church. This monumental sarcophagus, a work of the famed Peter Vischer foundry from the immediate pre-Reformation years, housed the remains of Nuernberg's major patron saint. The council indeed recognized that considerable reverence for this particular figure persisted in local popular piety. In fact, it was so concerned not to give occasion for the revival of an uncritical veneration that, when during the 1548 In-

terim the city for a brief time was forced to restore to its liturgical calendar observance of the anniversaries of some of the previously deleted saints of the church, care was taken not to include the Feast of St. Sebald.[62] Nonetheless, his shrine remained untouched.

But if the new Lutheran theology per se did not require the alienation or destruction of the great bulk of ecclesiastical art, it is also true that the needs of corporate worship and personal devotion for such visual symbols and adornment were now much less pressing than before. Given the emergence of any good reason for their removal, it was likely that a reconsideration of policy would occur. One such cause stemmed from the eminently practical desire to make more efficient use of the space available in the church buildings. The focal point of the new Protestant worship in Nuernberg— as elsewhere—was the sermon.[63] It became imperative that the congregation be able to see clearly and, above all, to hear well. Thus many of the numerous and now somewhat superfluous altars lining the churches were viewed as constituting a positive hindrance, since they obstructed the vision of the participants in the divine service and made it difficult for the spoken word to be heard.[64]

A series of actions initiated by the city council in the 1540s may be taken as indicative of the new policy. Since an Imperial Diet was soon to be held in the free city, the authorities in July, 1542, decreed the removal of three altars from St. Sebald Church. The paintings or upper panels went into storage, while the altars themselves were dismantled. The change was made discreetly and quickly, in order that all of the work might be completed before the opening of the Diet.[65] At the same time a crucifix was moved into the choir from its location near the pulpit.[66]

In October and November of the following year a number of similar changes were made. St. Sebald Church lost another altar and St. Lawrence Church two. A free standing sculpture (or painting?) and two altars were removed from St. Giles Church. The dismantling by municipal workmen of four altars in the Hospital Church of the Holy Ghost, if we may believe the account of a Nuernberg chronicler, took place in the still of the night. Apparently the council wished to avoid arousing the ire of the populace, if at all possible.[67]

In some cases the original donor had requested the return of the works given to the local churches. The Imhof family, for example,

asked for and was granted a group of vestments donated to St. Lawrence Church for use in celebrating the Feast of St. Rochus, now discontinued.[68] The dyers' guild obtained permission to melt down and make into a beaker the chalice and other liturgical devices formerly used by their religious brotherhood in services held in a local monastic church.[69] The council also permitted the now financially hard-pressed Dominican brothers to sell some of the order's treasure: monstrances, plate, and a costly reliquary shrine, which went to Cardinal Albrecht, archbishop of Mainz.[70]

The monetary value of the silver and gold holdings of the local churches, of course, was fully appreciated by everyone. Problems of safe storage and preservation had become especially acute with the dissolution of several of the monasteries and the transfer of their property to the municipal government. A series of entries in the city records reflects the concern of the authorities over the years to see that all of these items were inventoried and properly safeguarded.[71]

The council quite early began to consider the possibility of melting down or selling some of the silver and gold in its possession. An entry of February, 1530, records the decision to postpone any action of this nature for the time being.[72] Later, in 1536, the authorities discussed whether or not to sell some monstrances from St. Sebald Church. Again it was decided to wait,[73] but the exigencies of a costly and ruinous war with Margrave Albrecht Alcibiades of Brandenburg-Kulmbach finally induced the council to dip heavily into its holdings. In September, 1552, plate with a total value of almost sixteen thousand gulden was gathered into the city hall from the three Nuernberg parish churches[74] and then taken to the smelter.[75] And yet enough remained to make large sales during ensuing decades and centuries. Whatever one may think of such a disposal of church wealth, it should be understood that it was not a uniquely Protestant problem. As G. G. Coulton has pointed out, Roman Catholics had recourse to the same measures during the sixteenth-century French civil wars.[76]

In conclusion, it must be admitted that even in Nuernberg time and the new theology undoubtedly did take their toll in ecclesiastical art. But the teachings of the Protestant divines and the firm policies espoused by the city council at least prevented the worst ravages of iconoclastic destruction.

Strasbourg

The conservative Lutheran solution to the problem of ecclesiastical art, as exemplified at Nuernberg, was not the only precedent or model available to law-abiding Protestant communities from the mid-1520s onward. Zwinglian Zurich provided another. As a creative and independent theological thinker, Zwingli had elaborated a distinctive doctrinal position of his own on the question of religious images—one that borrowed from the ideas of such radicals as Karlstadt and Haetzer but at the same time firmly renounced all forms of popular iconoclasm or unauthorized mob violence. Zwingli's teachings fairly rapidly found acceptance by the city fathers of Zurich, where, between June 20 and July 2, 1524, the municipal authorities in an orderly and systematic manner had virtually every trace of religious imagery removed from the local churches.[77]

This official purging of the Zurich churches concluded an agitation on the image question that had lasted many months. In 1519, Zwingli had already launched an attack on the cult of the saints soon after his arrival in the Swiss city.[78] Beginning most likely in late 1522, the Zurich reformer preached against the images themselves.[79] Then on September 1, 1523, Zwingli's clerical associate and intimate friend Leo Jud delivered a sermon in which he not only denounced the veneration of statues and paintings, but perhaps for the first time in public argued that they actually ought to be removed from the churches.[80] This preaching was followed in the ensuing weeks by a series of iconoclastic incidents in and around Zurich,[81] events that gave forceful expression to the growing frustration among many of the populace at the fact that as yet the verbal assault on popish idolatry had issued in no practical, visible consequences.[82] It was these disturbances, in fact, that constituted the principal reason for the calling of the Second Zurich Disputation (October 26–28, 1523),[83] where the public debate on images led to a victory for Zwingli and his fellow reformers; the need for abolishing images from the local churches was approved in principle.[84]

Yet the Zurich city council, for the time being, was unable to act decisively on the matter because of lingering divisions within its ranks. A committee appointed to study ways to effect removal of the images from the city churches reported to the magistrates in early

November, 1523, that while citizens who had donated paintings and statues should be allowed to remove them if they wished, the remaining images ought to be left standing, while people were further instructed on the question.[85] In the following month, the council moved a step further by implementing Zwingli's suggestion that all paintings with moving panels be closed and that other images no longer be carried about in processions.[86] By the latter part of May, 1524, continuing apprehension about possible unauthorized destruction by an aroused populace caused the city government to take still another step. This time, drawing upon a new committee report written by Zwingli himself, the council made public throughout the city a decree containing a number of provisions: private donors of images were given one week to retrieve them from the churches; those not thus removed were to be taken out by the church wardens and stored among the church possessions; works originally made from funds provided by the church as a whole were to be subject to a decision of the entire membership, or majority thereof, as to whether they were to remain or be removed; no new images were to be created or installed; if the congregation decided to allow the images to stand, no candles or incense was to be burned before them or other reverence shown; crucifixes were to be allowed to remain.[87]

This still cautious and moderate policy was finally and abruptly reversed upon the death of the conservative burgomaster, Marcus Roist. On the very day of his death, June 15, 1524, a new decree was issued announcing the complete removal of the images remaining in the churches of Zurich.[88] To implement this decision, during the next five days a special task force was appointed, consisting of twelve councilmen, each representing a different guild; the city architect; a number of masons, smiths, carpenters, and workmen of various kinds; and three clergy, including Zwingli himself.[89] By June 20 they were ready. The process is best described by Garside, from his admirable study, *Zwingli and the Arts:*

The committee as a body went into every church in Zurich. Once inside, they locked the doors behind them, and then, free from all disturbance from the curious crowds without, began to dismantle the church. The work was done quietly and efficiently by the various experts who had been

selected by the constable for that purpose, and as a result no unnecessary damage or useless destruction was reported. Every standing statue was removed from its niche or its base and, together with the base, taken out of the church. It was then either broken up by the masons, if made of stone or plaster, or burned, if made of wood. Every painting was taken down from the altars and burned outside. All murals were chipped away or scraped off the walls. The altars were stripped of all images and vessels, all votive lamps were let down and melted outside, and all crucifixes were removed. Even the carved choir stalls were taken up and burned. Then the walls were whitewashed so that no traces whatsoever of the old decorations and appointments might be seen. That done, the whole group went on to another church and repeated the process. The entire operation took only thirteen days, from Monday, June 20, through Saturday, July 2. By Sunday, July 3, 1524, scarcely a statue, a painting, a crucifix, a votive lamp, a reliquary, a shrine, or image or decoration of any sort was to be seen anywhere in the Zurich churches.[90]

In Zurich there had been no iconoclastic riots or mass disturbances,[91] yet the churches had been effectively stripped of all religious art. As in Nuernberg, great concern had been shown for the maintenance of civic order and respect for governmental authority, yet the outcome was very different in terms of the visual setting henceforth provided for Christian worship.

During the 1520s and early 1530s, most of the south German and Swiss towns adopting the Reformation followed to a greater or lesser degree the example of Zwinglian Zurich rather than that of Lutheran Nuernberg with respect to the removal of religious images from the churches.[92] Without exception opposed to self-initiated and unauthorized iconoclastic destruction, the city councils nonetheless generally found themselves forced by the pressures of clerical petition and popular opinion, and sometimes the need to forestall mob violence, to take steps of their own to eliminate the sources of image idolatry. One of the first major centers in this region to embark on such a policy was the free imperial city of Strasbourg.[93]

The story of the abolition of images in that large and cosmopolitan Alsatian town is perhaps most instructive for its illustration of just how complex the process could be for a Reformation community. The series of events there was long and protracted—at least in

comparison to the relatively rapid resolution of the problem in Zurich. In Strasbourg, popular iconoclasm and a partial official removal of images both occurred in 1524, yet the final decision to clear the churches once and for all of what had come to be viewed as emblems of popish idolatry was not taken by the municipal councilors until 1530.

Several different factors were responsible for the delay. First, the leading Protestant theologian of the city, Martin Bucer, who had adopted a position on the image question that showed important similarities to that of Zwingli,[94] never acquired the kind of influence with the local municipal authorities that the latter had come to enjoy in Zurich.[95] Further, the magistracy of Strasbourg pursued an unusually cautious and even temporizing course with respect to the formal adoption of the Reformation. Celebration of the Roman Catholic Mass, for example, was not completely proscribed within the city walls until February, 1529.[96] This hesitation was due partly to a prudent concern for the political ramifications of such a move on the diplomatic front; the city councilors believed it necessary continually to calculate the possibilities of intervention by an imperial government intent on enforcing the anti-heresy provisions of the Edict of Worms.[97] But there were other considerations as well. The magistrates differed among themselves on the religious question. Some councilmen opposed the reforms and nonetheless continued to play an active role in the town government throughout the period under discussion.[98] A preoccupation with maintaining civic and religious peace also motivated many of them.[99] Only when they had become convinced that abolishing the traditional rites was the best way to achieve this unity and harmony were they prepared to act decisively.[100] Miriam Chrisman aptly summarizes the situation when she argues that in Strasbourg the magistrates "did not snatch at the reform, seize the initiative, and set about to bring the church under its jurisdiction." Rather, "policy was made from crisis to crisis, from incident to incident, and the *Rat* [city council] accepted new responsibilities and functions irresolutely and with reluctance."[101] A study of the treatment of the image question would seem to bear out this judgment.

Still another complicating factor with respect to the disposition of religious art in Strasbourg was the important role played in the

ecclesiastical life of the city by the five local chapters: the Cathedral, St. Thomas, New St. Peter's, Old St. Peter's, and All Saints.[102] The canons of these chapters generally were drawn from noble or patrician families and lived somewhat aloof from city affairs behind their chapter walls.[103] As might be expected, many of them opposed the introduction of the Reformation. After the Latin Mass had been abolished in all the parish churches, in 1525, it continued to be sung in the chapter churches.[104] As late as 1530 some of the canons were requesting from the city magistrates an exemption for their images and choirs from the general mandate for the abolition of ecclesiastical imagery.[105]

Working against delay, however, were a number of powerful forces for change, forces responsible for bringing enough pressure on the municipal authorities to necessitate eventual action. The Protestant clergy of the city continued to appeal for the abolition of images. Petitions to the same effect were presented to the magistrates by groups of burghers claiming to speak for the broader populace—or at least the more enlightened portion thereof.[106] And the geographical proximity of the Swiss Reformed cities, most of which were quicker in coming to a final resolution of this problem, was certainly significant. This was not simply a question of offering a model and precedent, though that was important too,[107] but it most likely became in the end a consideration in diplomatic relations as well, at the point when Strasbourg was negotiating a defensive alliance with her sister Protestant cities. The continued toleration of what most south German and Swiss evangelicals by then thought of as popish idolatry was probably understood to be offensive to those communities whose political support Strasbourg needed.[108] In this way, one diplomatic consideration, the need for Protestant alliances, eventually offset and triumphed over another, i.e., the concern to avoid antagonizing the imperial government.

The issue of visual imagery in the churches first became critical in Strasbourg in 1524. By then the reform movement had begun tangibly to affect the worship life of the community. The German Mass and communion in both kinds initially were introduced in April of that year.[109] Equally important, the citizenry began to emerge, sometimes with tumultuous results, as an independent stimulus for religious change, the initiative up until this point having come largely

from the Protestant clergy.[110] The reform preachers for some time had been declaiming against the images and related abuses;[111] now people began to feel that it was time for action. The first major eruption of popular iconoclasm seems to have occurred in the early days of September, when there was a tumult in the city and a number of images in the churches and street-side shrines were torn down and demolished.[112] The timing of these outbursts may have been influenced by the fact that, just a few days before, a number of canons of three of the chapters (St. Thomas, Old St. Peter's, New St. Peter's), alarmed at the increasingly riotous atmosphere and concerned to protect their property, had fled the city and taken ecclesiastical treasure—vessels, monstrances, reliquaries, and the like—with them.[113] Some of the laity apparently reasoned that if the Roman clerics themselves could remove silver idols, why should they not complete the task and abolish those of wood and stone?[114] The civic authorities, however, refused to accept this logic and those among the perpetrators of the destruction who were apprehended were thrown in the tower and fined for their part in these outbursts.[115] The offenders included a certain Seckler, who was a fuse maker, a tailor living in the Steinstrasse,[116] and others not named in the documents.[117] The magistrates responded further with a stern mandate against anyone's on his own initiative pulling down or taking away images of the saints. The preachers were summoned and instructed that the mandate was meant to be enforced and that they should admonish the people accordingly in their sermons.[118] On the other hand, the municipal authorities decided to make provisions of their own for the abolition of religious imagery. It was ruled that "all the paintings and statues from the columns and walls" were to be removed "in all the churches and monasteries" of the city, with the exception that the altars and their panels were to be left standing.[119] The intent of this decree, as Chrisman suggests, may well have been to prevent further destruction and violence.[120] It is quite clear, however, that the order was not fully or systematically carried out. Apparently, in addition to certain relics and reliquaries, only those images considered especially conducive to idolatrous veneration were affected.[121] Further, implementation occurred at first only in the great cathedral (Münster) and one or two other churches (primarily Bucer's own church of St. Aurelia).[122] The incomplete execution of the task may have resulted

from a number of considerations: a tendency to shrink from extreme measures and to revert to a more typical policy of temporizing once the immediate threat of widespread popular iconoclasm had subsided,[123] a desire to receive more theological advice and think the matter through more thoroughly,[124] and, most likely, an awareness of the resistance the program was encountering from conservative citizens.[125] The mandate may have been partly intended, in the first place, as a means of testing public sentiment.[126]

Many of the citizens obviously felt less hesitant on the question of image removal than did the city government. This is apparent from the events at St. Aurelia Church. Bucer informed Zwingli in a letter of October 31 that there it had been the members of his own congregation who themselves, though without tumult, had removed all the idols (*idola*) except the wall murals and an image of Christ on the main altar.[127] They had been able to do this, he explained in a slightly later writing,[128] because the congregation had been of one mind on the question and had not had to encounter opposition from the canons of St. Thomas, the most reform-minded of the chapters, who controlled this parish.[129]

It is not entirely clear just how much credit or blame for these events should be attributed to the urgency and effectiveness of Bucer's preaching.[130] Judging from the character of his congregation, his parishioners did not require a great deal of prodding. St. Aurelia was the church to which the members of the gardeners' guild belonged, the largest and perhaps the most proletarian workers' association in Strasbourg.[131] This group has been characterized by Chrisman as "a particularly vocal and unruly lot," reflecting "the dissatisfaction and restlessness of the peasantry within the walls of the city."[132] Their call of Bucer as their preacher had been somewhat irregular in the first place, and they continued to play an active and aggressive role in the local Reformation, partly by joining other guilds in petitioning the city government and partly by more direct action, such as the refusal to pay tithes and the involvement of at least a few of their number in outright violence, including an attack at one point on the city treasury building.[133]

The gardeners also enjoyed the unique distinction of having among their own membership a lay theologian of iconoclasm, the interesting Clement Ziegler. Ziegler has been termed "the most

unusual and distinctive figure in the Radical Reformation in Alsace."[134] He certainly developed an amazingly original theology,[135] for a presumably untutored laborer, which he combined with a strong Christian passion for social justice.[136] In June, 1524, Ziegler had published a pamphlet in which he assembled the biblical passages against images.[137] It has been asserted that his influence, along with that of Karlstadt's writings, was responsible for the unauthorized general iconoclasm that appeared in September, 1524.[138]

Even more probable is Ziegler's contribution to the campaign against images in his own parish, including an event that took place in late November, 1524, mentioned by almost all the Strasbourg chroniclers:[139] the destruction by the gardeners of St. Aurelia of the tomb and shrine of the saint of that name, which was located in their church.[140] Bucer, in a treatise entitled *Grund und Ursach* (December, 1524), went to some trouble to explain the circumstances of this incident, along with other changes that had been brought about by the Reformation in Strasbourg thus far.[141] According to medieval legend, St. Aurelia had been one of the famed eleven thousand virgins and had died of fever as the procession passed by Strasbourg, consequently being buried in the local church. Miracles had come to be associated with the shrine; in one instance, the saint reportedly had caused some soldiers who attempted to plunder her tomb to go mad so that they ate their own fingers and hands and thus died. The monument eventually became a very popular pilgrimage site, particularly for people seeking relief from fever.[142] An altar with a wooden image of the saint, which people were accustomed to adorn and decorate, had been erected near the tomb. Clearly this was, from the evangelical point of view, another of the idols that must be abolished. Therefore, writes Bucer, after sufficient instruction in God's Word, his parish congregation did away with the tomb. At first the votive offerings and image were taken down, the saint's bones exhumed, and the burial vault merely closed. When these measures did not bring an end to the idolatrous practices, the sarcophagus was completely removed and the entire grave sealed off.

Also in 1524 there began in the Strasbourg churches the replacement of the traditional retable altars with bare communion tables.[143] This new policy too Bucer felt obliged to explain and defend

in his treatise *Grund und Ursach*. Several reasons were given for the departure.[144] First, the use of the table permitted the clergyman officiating at the celebration of the Eucharist to face the congregation so that the people could better understand him. Second, reference was made to St. Paul, who in Scripture speaks of "the table of the Lord" (1 Cor. 10:21) and not an altar. Finally, removal of the now superfluous and excessively numerous consecrated altars was justified by the superstitions associated with them and the fact that they represented an unwise expenditure of funds that might better have gone to the poor.

The first important steps in the purging of the idols from the Strasbourg churches thus had already been taken in 1524. In the opinion of many citizens, however, not nearly enough had been done. In March, 1525, a group of six burghers presented to the magistrates a list of grievances deploring the incompleteness of the local Reformation. One of these directly concerned the problem of imagery in the churches:

It also troubles us, since no scriptures say it is right, that there is that evil idol in the choir of the cathedral, which is not only a blasphemous offence to many of our people in the city, but to all people in the whole region. For every day one sees people kneeling before it, and praying to it, while these same people obstinately refuse to pay attention to God's Word as it is preached to them. And the silver idol behind the altar in the choir is also evil, and the idols in the entrance to the cathedral, which were recently made into rubble, and now, more than ever, people light candles in front of them during the day, which is a travesty against God and pious customs. In sum we see all images as evil, for they appeal not to the perfected Christians but to the weak and those whom the Word has not yet possessed. All idols are against the Word of God, and no good fruit can come from them.[145]

The signers of the petition were Menschen Jacob der Jung, a fisherman; Andres Siferman, a carpenter; Christman Kenlin, a member of the drapers' guild who is described by Chrisman as "in close touch with the peasants and their revolt"; and three otherwise unidentified men with the names Fultzen Hans, Meinolf Dannenföls, and Peter Sigel.[146] Apparently, these evangelicals were following the advice of Bucer, who, in his *Grund und Ursach*, had suggested that

Christian congregations ought earnestly to implore their ruling authorities for the removal of the idols.[147]

Although the magistrates' injunction of early autumn, 1524, against tumult and unsanctioned removal of images was repeated at intervals, incidents of popular iconoclasm continued to surface during the middle years of the 1520s. On December 27, 1524, the canons of three of the chapters complained to the city council that on the preceding day a group of burghers had stormed into New St. Peter's Church, torn down an image of the Virgin and another of St. Anne, and thrown them into the charnel house. A gardener also reportedly desecrated a Host that he had removed from the monstrance and contemptuously eaten in the presence of a Roman priest. After further destruction of lamps in the church, the iconoclasts menacingly demanded of the clergy that they cease their bawling and sing the offices in an orderly manner.[148] The records for 1525 show the gardeners once again involved in unauthorized activity, this time the dismantling of a cross standing before the city gate called the White Tower, which controlled access to their quarter of the town.[149] And in 1527, court documents reveal that a person named Zuner Andres, who may have had ties with the local Anabaptist movement, was interrogated with respect to his dashing to pieces some panel paintings in the cathedral.[150]

Although disposed to move with great caution and deliberation, the city government did not remain totally unresponsive to popular opinion on the image question during this period. One policy that evolved during these years consisted of a gradual suppression of many of the cultic or devotional acts traditionally associated with religious art. In the spring of 1525, the magistrates ruled that contrary to custom there would be no veiling of altars, images, or crucifixes with the Lenten veil or "hunger cloth" (*hungertuch*) during this Passion season.[151] Two years later they forbade anyone to burn candles before the reserved Host or images.[152] To insure compliance, provision was made for emptying the monstrances in the churches.[153]

In their own hesitant, piecemeal manner the magistrates also advanced somewhat further during the mid-1520s in the direction of clearing the local houses of worship of remaining statues and paintings. On April 1, 1525, for example, they decreed the removal

of a miraculous weeping image of the Virgin from the Chapel of Our Lady in the cathedral.[154] At the end of that same year (December 16), also at the command of the municipal authorities, an altar and image dedicated to Our Lady was withdrawn from under the rood loft of the Münster and replaced by a wooden table surrounded by an iron railing.[155] Then in December of the following year, a great gilded crucifix to which some people attributed wondrous powers was taken down from its position behind the high altar in the choir of the cathedral and destroyed.[156] It was, apparently, at this same time that a colossal, thirty-six-foot-tall figure of St. Christopher that stood in the Münster was dismantled. According to a contemporary chronicle, this statue was so large that the feet, each of which by itself filled a wagon, had to be detached before the remainder could be taken from the cathedral.[157]

By the late 1520s, therefore, a number of additional steps had been taken by the magistrates of Strasbourg to appease public sentiment in the city with respect to the persistence of image idolatry. Again, as before, however, the measures completed clearly were not considered adequate by the more advanced elements of Protestant opinion. Thus, the ultimate resolution of the problem in 1530 by a final purging of the temples was preceded by yet another round of petitions to the city council and acts of unauthorized destruction in the years 1528 and 1529.

One of these appeals was presented to the city government in March, 1528, by six burghers who, claiming to speak on behalf of the evangelical populace of Strasbourg, requested that the remaining masses in the city be abolished along with the appertaining altars and images in order that the honor of God might be advanced.[158] At least twice in the following year the Protestant clergy added their own voices to the campaign. In the first of these clerical petitions Bucer, Caspar Hedio, and Matthew Zell averred that idolatry was still being practiced before the remaining altars and images and that, therefore, they ought to be removed. The magistrates, noncommittally, promised to consider their request.[159] Not to be put off, Bucer and Hedio presented to the city council a renewed appeal, reaffirming their view that Scripture forbids idols and images in those places where man is supposed to honor God. To their demand for the abolition of the idolatrous pictures they now added

the suggestion that those family coats of arms, which had been hung in a "heathenish manner" and merely for the sake of worldly honor, ought also to be taken down from the church walls.[160] The magistrates, in a decision dated October 31, 1529, consented that superstitious images before which people continued to perform acts of veneration indeed be removed. On the other hand, pictures that were not idolatrous, such as those providing a representation of the sufferings of Christ, were to be left. The coats of arms, for the time being, also were to remain undisturbed.[161]

Meanwhile, events once again had begun to overtake the snail-paced progress of the municipal councilors. This time the leading agent of image reform was the Protestant preacher at Old St. Peter's Church, Diebold Schwartz.[162] The background for Schwartz's action appears to have been the decision by the *Schöffen* (the largest and most representative of the Strasbourg city councils) on February 20, 1529, finally and completely to abolish the Mass. Three days later, Schwartz, together with a number of his parishioners, on his own initiative demolished and cleared out the altars and images in his church and whitewashed the walls to cover the mural paintings. For his trouble, Schwartz was severely rebuked by the magistrates.[163] In addition, a notice was sent down to all the guilds in the city that no one henceforth was to take such matters in his own hands.[164] Throughout 1529 the Strasbourg council manifestly continued to resist any drastic solution to the still-unresolved problem of ecclesiastical art.

When the decision to remove the remaining images from the churches was finally made by the Strasbourg magistrates, the impetus seems to have been provided by political and diplomatic considerations. On January 5, 1530, Strasbourg joined with Zurich, Bern, and Basel in the Christian Civic Alliance, one of the modest fruits of Zwingli's largely unsuccessful attempt to construct a vast anti-Catholic and anti-Habsburg league stretching across the face of Reformation Europe.[165] The failure of Lutheran-Zwinglian talks at the Colloquy of Marburg (October, 1529) had doomed any hopes of a grand Protestant coalition. Strasbourg, for her part, also found it impossible to accept the Schwabach Articles, which had been proposed as a theological basis for political cooperation by certain German Lutheran statesmen.[166] Feeling isolated and "being unable to

face the wrath of the emperor alone,"[167] the city naturally gravitated toward Zurich and the other allied Swiss towns. According to Erasmus,[168] it was the union with these powerful evangelical communities, all of which had previously purged their churches of popish idolatry,[169] that prompted the Strasbourg magistrates at last to remove the offensive images—a judgment concurred in by modern historians.[170] It is not clear whether the Swiss city-states actively brought pressure on the Strasbourg government or whether the city councilors acted on their own initiative in order to eliminate a potential source of mistrust and disharmony. The delayed timing of the decision might seem to support the latter supposition.

In any case, on St. Valentine's Day, 1530, the fateful step was taken.[171] The Strasbourg temples at last were to be cleansed of the remaining inducements to image idolatry. Even at this point, however, private property rights were not to be disregarded. As had been permitted in earlier years, the original donors were allowed to retrieve art works in the churches if they desired.[172] Otherwise, the magistrates' decision was that "because the images are in the highest degree contrary to God and His commandment," all paintings, statues, crucifixes, baptismal fonts, and altars must be removed from all the Strasbourg churches. The decree was to be put into effect by the *Kirchenpfleger*, city councilmen entrusted with supervision over specific local churches; where these did not wish to act, the *Almosenherren*, magistrates responsible for poor relief, were to assume direction of the process. A last-minute attempt to intervene, made by the Roman Catholic bishop of Strasbourg, came to nothing. His request that action on the images be delayed, in view of the imminent arrival of the emperor, was countered with a decision to push ahead as decreed and with the affirmation that the councilmen intended so to conduct themselves in this matter that they might be able to answer for their deeds on the basis of divine Scripture.[173]

At the outset, the magistrates apparently did envision at least one exception to their mandate. The same decree ordering the removal of the images also contains a provision that the canons of the cathedral chapter merely be advised to close their folding altar panels in the choir of the Münster.[174] The canons at New St. Peter's obviously hoped to benefit from a similar exemption, for they then

addressed a petition to the magistrates requesting that the choir of their church, which they claimed contained a painting (*taffel*) worth more than a thousand gulden, plus their papers and treasure, be spared. They promised to keep the choir locked to prevent incidents and, if necessary, to wall up the windows. The response of the city council to this request and a similar one from the canons of Old St. Peter's was negative. The canons were told that in view of the fact that the images were idolatrous, contrary to Scripture, and vexatious, and in order that henceforth no one take offense at them, the magistrates could no longer tolerate them, and they would have to be removed in an orderly fashion.[175]

Although some of the chronicles speak of men working through the night to take down the panels and other art works in the cathedral,[176] the overall program of removal in fact seems to have proceeded rather slowly. In mid-April the city government again had to affirm its policy of dismantling the altars in all the churches and monasteries in order that uniformity be maintained.[177] Given the delay, it is not surprising that the magistrates should be plagued to the very end by eruptions of popular iconoclasm. During this period it was necessary that perpetrators of vandalism at the convent of St. Nicholas be brought before the council.[178] Not only that, but the authorities at this late date also had to issue a special prohibition against the smashing of stained-glass windows in the churches.[179]

It would be interesting to know more about the final disposition of the images cleared from the Strasbourg churches during that winter and spring of 1530—whether a significant number of private donors took advantage of the opportunity to salvage family monuments and whether any of the more portable art works such as paintings and wood carvings not so claimed nonetheless made their way into private collections. In any case, the chronicles make clear what we otherwise would have expected, that is, that large numbers of altars, panels, statues, tabernacles, and crucifixes simply were destroyed.[180] In order that the scars not remain as too visible a reminder of where the art works had stood, the interiors of the churches were whitewashed.[181] Two years later, the now-luminous walls of the great cathedral were also adorned at various places with gold gilding and "lovely inscriptions."[182]

Basel

If it was Zurich that established the precedent in Switzerland and south Germany for the official removal of ecclesiastical art, and if Strasbourg was one of the first centers to begin to follow—however hesitatingly—that example, it was in Basel that the most dramatic episodes of art destruction in the early Reformation occurred.[183] Certainly in terms of popular involvement and passions aroused and perhaps also in the extent of the total destruction, Basel's iconoclastic riots in 1529 exceeded anything that had yet been seen in sixteenth-century Europe.[184]

For a cultured community so notoriously open to new ideas, the Reformation came rather late to this German-speaking Swiss city on the Rhine. Perhaps this tardiness accounts in part for the violence when it did finally achieve a breakthrough. But the large, busy, and cosmopolitan town, as one might expect, for several years had been exposed to the teaching, preaching, and writings of a number of those reformers who opposed the traditional religious imagery. Through both printed treatises and personal contacts, the ideas of several of the leading iconoclasts of the Reformation must have been known locally. Karlstadt's *Von abtuhung der Bylder* very likely was reprinted in Basel in 1522.[185] Other tracts of Karlstadt's, including one rehearsing his dispute with Luther's moderate views on images, were circulated there in the autumn of 1524 when the Saxon radical's brother-in-law, Gerhard Westerburg, visited the city.[186] Karlstadt himself stopped in Basel briefly in November, 1524, following his expulsion from Saxony.[187] During the winter of 1524–25 both Thomas Müntzer, whose iconoclastic teachings we have briefly examined, and Balthasar Hubmaier, the radical reformer who initiated the removal of the images in Waldshut in 1524,[188] put in an appearance in Basel.[189] We know too that Lorenz Hochrütiner, one of the first active iconoclasts to appear at Zurich in 1523, was engaged in sectarian activities in Basel in August, 1525, and again the following summer.[190] Even Ludwig Haetzer, whom we have encountered as the chief link between Karlstadt and the iconoclastic theology of Zwingli, lived there for a period in 1525–26, during which he labored to translate into German the writings of Johannes Oecolampadius,[191] who was the leading magisterial reformer of Ba-

sel.[192] Oecolampadius himself had adopted a fundamentally critical view of religious imagery[193] and preached vigorously from his pulpit at St. Martin's Church ("the inner citadel of the Basel Reformation") against the idolatry connected with it.[194] In his sermons from the mid-1520s he also appealed to the municipal magistrates for an orderly removal of the offending idols.[195]

Although the destruction of images on a large scale did not occur in Basel until comparatively late, the iconoclastic ideas circulating there obviously did affect certain lay adherents of the reform movement. Words eventually were followed by action, as is revealed by a number of incidents mentioned in the civic records for this period. For instance, a burgher by the name of Hans Bertschi was temporarily imprisoned in early November, 1525, because he was found in the vicinity of the great cathedral (Münster) when some windows were smashed there.[196] Then, in mid-July, 1526, one Fridlin Yberger "von Schwitz" was permanently banned from the city for removing a crucifix from the chapel near the St. Alban's Gate and trampling it to pieces.[197] Similarly, the authorities found it necessary to take action against a certain Caspar Nusboum who in February, 1527, was incarcerated for overturning a holy-water receptacle in front of the Münster.[198] And in September of that same year, an innkeeper by the name of Urban Schwartz also suffered brief detention, plus the imposition of a sworn oath to keep the public peace, for tearing down a crucifix before another of the city gates, taking it home, and burning it.[199]

Thus, it can come as no great surprise that finally in April, 1528, the Basel magistrates found themselves confronted with the news that a major, if illegal, campaign of image removal had been launched in the city. The timing perhaps was influenced by the Protestant successes at the Bern Disputation in January of that year.[200] Not only had the attack on images figured prominently in the theological discussions there, but the Bern magistrates had carried out a systematic policy of the removal of ecclesiastical art as a part of the sweeping reforms launched in that Swiss city almost immediately upon the conclusion of the colloquy.[201] The Basel evangelicals had returned home no doubt exhilarated by the Protestant triumphs just achieved but also probably more frustrated than ever at the painfully slow progress of significant reform in their own

community,[202] where the city council was pursuing a very cautious and procrastinating approach to the Reformation.[203] In addition to the fact that the council's inner ranks included several influential members strongly inclined to the preservation of the old faith,[204] it also represented something of an upper-middle-class and patrician point of view,[205] somewhat out of touch with the ardent and increasingly aggressive espousal of Protestantism by the craft guilds and lower elements of the population.[206]

To be sure, a decree had been issued in May, 1523, providing for solely scriptural preaching in the Basel churches.[207] Aside from the opening thus created for the activities of the evangelical party, however, nothing dramatic immediately resulted. In early autumn, 1527, the council went a step further and endorsed what was intended as a compromise concession: the Protestants were to be allowed to dispense with the Mass in three churches (St. Martin's, St. Leonhard's, and the Augustinian cloister). Elsewhere, there was to be no innovation.[208] Such was the situation when the Basel delegates returned from Bern. A month later (February 29, 1528), the Basel city fathers passed an edict according to which every person should be free to abide in his own faith and to believe whatever he considered necessary for the salvation of his soul.[209] This tolerant but fundamentally conservative approach could not satisfy the more zealous or activist-minded partisans of the reform movement, and a few of them apparently began to believe that it was time to take things into their own hands.

Purging the temples of idols, as it turned out, was a way for even a simple layman to strike a blow for the evangelical cause. Thus, on Good Friday, April 10, 1528, and then on the following Monday, April 13, this step was taken in St. Martin's (Oecolampadius' church) and the church of the Augustinian cloister in Basel by a group of iconoclasts who seem to have belonged mostly to the reform-minded and somewhat radical guild of carpenters and masons (*Spinnwettern*).[210] These men clearly were not content with such compromise solutions as the mere covering up of the existing images, as had been practiced in St. Martin's, at least, from as early as autumn, 1525.[211] Their impatience led to the first large-scale iconoclasm of the Basel Reformation.

Our knowledge of these events comes largely from the records of

the hearing later held to determine responsibility for this breach of the public peace.[212] The leaders of the iconoclasts, judging from these documents, were Hans Erni, a carpenter; Hans Zirkel, a cooper; Hans Ob, a joiner; and Galli Steinmetz, a potter. According to the testimony of Erni, the action had been contemplated and discussed by many people for several weeks beforehand. Erni seems to have actively recruited Zirkel for the enterprise, and Zirkel in turn went to the house of his neighbor Ob and urged him to accompany them. It is not clear if more than these four men were involved in the first episode, the attack on the idols at St. Martin's Church.[213] Oecolampadius, who more than once had affirmed his opposition to unsanctioned image destruction,[214] appears to have had no foreknowledge of their plans.[215]

According to the testimony of Steinmetz, who seems to have thrown in with the group only after they had entered the church, the iconoclasts had not bothered to bring much in the way of equipment with them to accomplish their purpose. When Erni at this point asked Steinmetz to join them, the latter responded that, without tools, what they had in mind would not be an easy task. Erni supposedly replied that the crowbar he had along with him would be adequate. Furthermore, according to Steinmetz, they took the long cable from which the candelabra hung suspended and used it to pull down the great crucifix standing in the church. Steinmetz himself claimed to have wanted to remove only two altars at the front of the sanctuary and to leave the others, plus the great crucifix, unmolested. Erni and Zirkel, however, allegedly were not satisfied with this halfway measure. Ob, Zirkel, and Erni all testified that as they were almost finished with their work of dismantling, the sacristan of the church came up to them and inquired what they were doing. And then when the sacristan lamented that he did not know how he would answer for this vandalism, Zirkel, by his own testimony, spoke up with a prompt theological defense; he asserted that what they were doing there that day was done "to the honor of God and the edification of their neighbors."

All of the four except Hans Ob were also present in the Augustinian church three days later when it too was liberated of its images. Apparently the action here followed the evening worship service of the day. According to Zirkel, a number of the evangelical

party in attendance had been talking amongst themselves concerning whether they should not carry on the good work begun at St. Martin's on the preceding Friday. Erni, who asserted that in this case it was he who was approached by Zirkel, acknowledged that he immediately agreed with this point of view and ran home for his crowbar. According to Erni, altogether, as many as thirty men finally engaged in the operation. In addition to a number of bare names, we are given the occupations of two or three of the additional participants: a mason, a shoemaker, and a tailor.

These incidents of unauthorized destruction of ecclesiastical property represented a direct challenge to the authority of the city council, something that the magistrates could not overlook.[216] Therefore, Erni, Zirkel, Ob, and Steinmetz were apprehended and imprisoned. The Spinnwettern guild at this point unsuccessfully demanded their release, arguing that the prisoners had done nothing wrong or against God but were merely obeying His oft-repeated prohibitions of such idols. Their failure to secure the men's freedom became the signal for a minor revolt. Hundreds of guildsmen, on the morning of April 15, streamed into the marketplace and began to menace the city hall. The council was unable to avoid negotiations and requested that the guildsmen select a committee to represent them in a conference. The deliberations lasted the whole day. The guildsmen waited at the hall of Spinnwettern, where feelings were running high. Finally, that evening, the consultations came to an end.

According to the terms of the agreement, the prisoners were to be released without fine or penalty (though after swearing an oath to keep the peace)[217] and a municipal mandate issued.[218] The mandate contained the following stipulations: (1) Every man is free in his faith and should believe accordingly as he has been granted grace from God. (2) Since the images in St. Martin's, St. Leonhard's, the Franciscan and Augustinian churches, and in the Hospital Church are offensive and intolerable to the citizens and residents who worship in those places, they shall be taken down and the church interiors rearranged as requested, but by workmen authorized by the city—and by no one else.[219] The choirs of two of these five, however—St. Leonhard's and the Franciscan church—along with their side chapels, are to retain their furnishings, in order that

those still celebrating Mass there might continue to perform their devotions. These choirs, however, are to remain closed during evangelical services in these particular churches. (3) All other churches in the city shall remain as they are. (4) No one should abuse or slander the remaining images, nor should anyone undertake to remove any further ecclesiastical furnishings, under pain of heavy punishment by the city.[220]

The Basel populace was temporarily pacified by these concessions, but the moderation and tolerance of the city council inevitably failed permanently to satisfy the proponents of a more thorough reform.[221] In mid-May, a certain Hans Beck had to be disciplined for some provocative language to the effect that "before Pentecost comes all the saints and altars must be thrown out of the cathedral just as in the other churches."[222] Throughout the year, agitation in the city continued to grow and to find expression especially in the guilds.[223] On December 23, 1528, more than three hundred citizens met at the gardeners' guild and approved of a strongly worded petition to the city council in which they demanded that the magistrates abolish the Mass and the divisive (i.e., Roman Catholic) preaching that continued in the city.[224] The action was supported by twelve of the fifteen Basel guilds. After some delay, the council responded, after a fashion, by agreeing to negotiate with committees representing the Protestant and Catholic factions.[225] The adherents of the reform and old-church parties in the meantime continued to hold popular assemblies, the former at the Franciscan church and the latter at the Dominican church.[226] By now the Protestants clearly predominated; we learn from the report of the Bernese envoys present in the city that on January 4 the evangelicals assembled over three thousand armed burghers, while their opponents mustered not more than four hundred.[227] The final outcome of the discussions was another municipal mandate, of January 5, 1529, which, in addition to repeating the conditions of the preaching mandate of 1523, announced a public disputation and vote of the citizenry, to be held on May 30, concerning the question of continuing the Mass. In the meantime, only three masses a day were to be sung in the city, one each in the Münster, St. Peter's Church, and St. Theodore's Church.[228]

But the magistrates ultimately were unsuccessful in their at-

tempt to buy still more time. Passions continued to run high and there was excited talk of plots and conspiracies. The Catholics were believed to be evading the restrictions of the most recent mandate, while the authorities were accused by the Protestants of passivity and inaction.[229] The eruption came on February 9, following the issuing of an ultimatum by the citizenry to the council. Early in the morning of Monday, February 8, eight hundred men had gathered in the Franciscan church. They had demanded not only the replacement of remaining Romanist clergy with evangelical pastors and the expulsion from the city council of twelve leading Catholics, but also a reform of the municipal constitution, particularly in the election procedures.[230] Religious revolution now had become political revolution.[231] That afternoon, while the council still deliberated, the crowd moved from the church to the marketplace in front of the city hall, the men stopping off at their homes to pick up weapons.[232] The streets leading to the marketplace and city hall were chained off, several confiscated municipal cannons were wheeled into position in strategic locations, and the city gates were closed and guarded by men delegated by the aroused populace. No final decision having been reached, the city spent a fitful and uneasy night.

Negotiations began anew at the city hall early the next morning, Tuesday, February 9.[233] An even larger armed crowd, numbering in the thousands this time, gathered again in the adjoining marketplace. The people became increasingly impatient and resentful as afternoon came and still no announcement was forthcoming. A portion of the shivering and restless populace began to seek some activity. A group, described as about forty strong, began to traverse the city, perhaps with the intention of checking up on the gate watches. Coming to the great Münster, they decided to go in and walk through. One of the men apparently struck an altar with his halberd—whether accidentally or as a jest is unknown—causing a painting or carving to fall to the pavement and break into pieces. The procession apparently did not stop, however, despite the protest this destruction aroused from the clergy present. Passing from the cathedral and moving down the street, the original group soon encountered coming toward them from the city square a much larger force, variously described as two or three hundred in num-

ber, which apparently had already begun to hear reports of a confrontation at the Münster. At this juncture, someone cried out that since the council was delaying so long they should return to the cathedral and complete the image removal begun at St. Martin's and the Augustinian church the preceding year. Responding to this proposal, the crowd hurried back to the Münster, where they found that all the entrances had been locked by the terrified priests. The aroused multitude smashed through one of the doors and stormed into the church.

It is not clear from the sources just how much leadership or preconceived plan the iconoclasts may have had at this point. On the basis of a somewhat ambiguously worded document written a couple of months later,[234] one modern historian tentatively attributes the initiative for the assault on the cathedral to a citizen of the Junker class named Heinrich von Ostheim.[235] At any rate, this event signaled the beginning of the great devastation of the religious art of ancient Basel. The altars in the Münster—including the high altar with its great alabaster retable depicting the crucified Christ and the twelve apostles—were hastily pulled down and demolished,[236] statues knocked from their pedestals and smashed into pieces, painted panels slashed and hacked, lamps and candelabra dashed to the ground, stained glass broken from the windows, and even the murals or wall paintings defaced with knives.[237] Several contemporary accounts state specifically that a huge crucifix was pulled down from the rood screen and tumultuously dragged by a rope through the streets of the city with an accompanying chorus of derision and mockery. It finally was burned in the marketplace.[238] The destruction was not restricted to the interior of the Münster. A figure of the Virgin was toppled from its post in the central portal of the west facade and the relief sculpture of the tympanum obliterated.[239] The vessels and treasure stored in the sacristy of the cathedral, however, were left undisturbed, lending some substance to the claim of Oecolampadius and Fridolin Ryff, the Protestant chronicler of the Basel Reformation, that the iconoclasts clearly were not after plunder.[240]

Both the city council and the evangelical commission engaged in negotiations with the council sent deputations to the Münster in order to attempt to dissuade the crowd from its destruction. But to

no avail. All the idols were to be removed, once and for all.[241] The mood of the iconoclasts is suggested by the answer that, according to Oecolampadius, they gave in repulsing the magistrates' request to cease and desist: "In three years of deliberations you have effected nothing; in one hour we will complete everything."[242] Finished at the cathedral, the multitude (undoubtedly much expanded by now) broke into a number of smaller groups, one of which reportedly was led by Meister Jakob, the town hangman, and another by the knight Balthasar Hiltprant, and burst "like bellowing lions" into those remaining parish churches, cloisters, and chapels of the city still containing images, where scenes similar to that at the Münster were reenacted.[243]

Having completed their destructive work, the crowds returned at the end of the afternoon to the city hall where the council was still sitting.[244] But the magistrates were no longer able to hold out against the aroused populace. They heard with considerable alarm that some of the men in the marketplace were saying, "Now that the idols are all dashed to pieces, we will wait no longer but rather fetch a decision ourselves from the council chambers."[245] Faced with the threat of overwhelming force and the passive acquiescence of the intimidated Catholic minority remaining in the city,[246] the council finally capitulated that evening of February 9. The Catholic members departed, and the religious and constitutional reforms were conceded.[247]

The next morning Basel looked out upon a scene that, according to one chronicler,[248] resembled a battlefield after a war. The images lay everywhere in and about the churches, some with heads missing, others with hands, arms, or legs lopped off. The authorities could do little beyond attempting to legitimize and regularize what had already occurred. City workmen were dispatched to the cathedral and other churches, where they systematically removed and demolished all the remaining cult objects overlooked by the iconoclastic mob and whitewashed the walls.[249] Erasmus, at this point still resident in Basel, later complained to a correspondent that neither costliness nor artistic worth had availed to save anything at all.[250] At first an attempt was made to provide the poor with firewood from the debris of the destroyed art works. When this led to tumultuous and unseemly strife over the spoils, it was decided that

the flammable portion of the rubble might better be heaped up and immediately incinerated in an orderly manner by the city work crews.[251] Large numbers of these piles, perhaps as many as a dozen at the Münster alone, were ignited and burned in the courtyards of the various churches on this February 10, which by strange coincidence was Ash Wednesday. According to contemporary observers, the pyres burned for two days and nights.[252] On the same day that the municipal workmen were sent to finish clearing the Basel churches, a mandate was issued decreeing the abolition of both the Mass and the images in the entire territory under the jurisdiction of Basel, i.e., the outlying land and villages as well as the city itself.[253] And then three days later, February 13, a municipal decree granted a mass amnesty to all citizens and residents who had been involved in the iconoclastic riots of the previous Tuesday.[254]

While the Catholics bitterly lamented and protested the devastation of the Basel churches,[255] the local Protestant leaders were generally pleased with the outcome. Oecolampadius expressed some relief that the matter had been decided so swiftly and without loss of life.[256] And well he might. Whereas it was being reported in Basel that in another episcopal city, Magdeburg, some eight hundred people had been killed in Reformation-related riots,[257] the only human casualty resulting from the iconoclastic upheaval in the great Swiss metropolis seems to have been a journeyman goldsmith who was severely wounded in the melee that followed upon the somewhat delayed (February 14) destruction of the images in Klein Basel,[258] that still predominantly Catholic and also partially autonomous portion of the community lying across the Rhine.[259] But the Basel reformer could not resist exulting over what an extremely sad spectacle the destruction of the idols had been for his superstitious opponents; as he remarked, "they could have wept blood."[260] He himself, and his fellow Basel Protestants, were finally able in their great Reformation ordinance of April 1, 1529, to affirm piously that their churches contained no traces of idolatry and, with God's help, never would again.[261] The diehard Catholics and the Basel cathedral chapter put it rather differently. They bitterly observed that the newly purged ecclesiastical edifices of the city now looked more like horse stables than houses of God.[262]

The Significance of Iconoclasm in the German Lands

Thus far in this chapter detailed case studies of the Reformation in certain selected cities have been provided, with particular attention devoted to the question of how the image problem was resolved in each. Brief reference also has been made to the appearance of a destructive iconoclasm in numerous other centers in the empire and German-speaking Switzerland where Protestant movements were introduced. It has become clear that large numbers of religious paintings, sculptural works, and other church furnishings perished during these years. We are left now with the problem of assessing the significance of this iconoclasm, that is, establishing the meaning of these events for contemporaries as well as for modern man.

There can be little doubt that people in the sixteenth century interpreted the significance of these events primarily in either religious or political terms. To be sure, evidence can be found that certain contemporaries, including some supporting the Reformation, were conscious of the visual beauty or venerable antiquity of the objects being obliterated before their eyes.[263] It seems apparent, however, that in the minds of the vast majority of persons living at the time the greatest importance of iconoclasm lay not in its consequences for preserving or destroying an artistic and historical legacy but rather in its implications for Christian worship and the question of public authority.

Sixteenth-century populations, as a whole, clearly placed a great deal more weight upon religious than upon aesthetic or purely cultural values. This is illustrated by the somewhat curious fact that even a few of the artists themselves favored the destruction of the offending images.[264]

In the eyes of a great many of those influenced by the reform, religious images clearly had come to be seen as inducements to idolatry and superstition. This was true not only of theologians such as Karlstadt, Zwingli, Bucer, and Oecolampadius, but also of many of the laity, as evidenced by the 1525 petition of the Strasbourg burghers.[265] In a matter such as this, where men's eternal salvation was believed to be at stake, one simply could not afford to compromise. The decision to discard the images no doubt was made easier for most by the still-common tendency to interpret

religious painting and sculpture in functional rather than aesthetic terms.[266] But even if the modern understanding of these objects as works of art had been more widespread, it probably would not have lessened the urgency of their destruction once they had been perceived to promote false piety.[267]

But the abolition of paintings and sculpture had an additional religious purpose beyond elimination of the idolatry believed to be connected with the images themselves. In towns such as Basel and Strasbourg, iconoclasm played an important part in what might be called the protestantization of the community.[268] As the 1528 petition of the Strasbourg citizens reveals, there was a clear appreciation of the intimate relation between images, the Mass, and indeed the whole liturgical practice of the old church.[269] The Roman Catholicism of the time was a religion heavily based on ritual. A blow struck at images, the most visible and tangible aspect of this ceremonial system, was in fact an attack upon the whole. And beyond this, iconoclasm might easily be understood as also forming a part of the general assault against the church hierarchy responsible for supporting this manner of worship. In a recent book dealing with the fate of religious art in the English Reformation, the author points out how in such situations the mental act of association often plays an important part and how "images suggestive or representative of despised ideas or institutions" naturally become the objects of the iconoclasts' zeal. The visual images indeed were extremely numerous at the time of the reform, and their "ubiquitous presence . . . identified them with the church that was under attack."[270] Therefore, just as demolishing a statue or painting might be conceived of as part of the campaign against the Mass, so too was it a contribution toward liberation from the hated pope and Romanist clergy.

However, as is well known, in the unified Christian civilization inherited from the Middle Ages the church was closely bound up with the state. To what extent was it possible to engage in an assault on the one without endangering the other? Was the entire fabric of sixteenth-century society likely to be rent by acts of violence such as iconoclastic sentiment often fostered?[271] This suggests another prominent concern of a number of contemporaneous observers that ought to be taken into account in our analysis of the

significance of Reformation iconoclasm, that is, its implications for the maintenance of public order.

As evidence of this concern the views of Luther may be cited. Although the Wittenberg reformer once remarked that the image question in itself was a relatively minor issue, as long as men's consciences were not being needlessly bound,[272] he apparently considered iconoclastic riots a very serious matter. In his tract of 1525 *Against the Heavenly Prophets in the Matter of Images and Sacraments*, he complained of the "Karlstadtian manner" of doing away with images, which was "to make the masses mad and foolish, and secretly to accustom them to revolution."[273] In this same treatise he expressed his concern "lest accustomed to rebellion in connection with the images, the people also rebel against the authorities."[274] Luther, as we know from other writings, was not the only contemporary observer who seemed to note some connection between image destruction and insurrection.[275]

One factor that seems to emerge from every consideration of iconoclastic incidents in sixteenth-century Germany is the consistent and universal concern of the civic authorities to keep control of events in their own hands. This effort was not always successful, as the Basel riots reveal, but every magistrate during this period appears to have regarded unauthorized or unregulated destruction of church furnishings, even if they were understood to be idols, as seditious. In part, no doubt, this attitude stemmed from a respect for the rights of private property. In many communities, as we have seen, some provision was made for donors to retrieve their endowments from the churches.[276] But there was also a realistic regard for more purely political considerations. It was clearly understood that mobs which gathered to abolish images and purge the churches might well end by menacing an unpopular regime, as indeed happened at Basel. Governing authorities were certainly no more sympathetic then than now to the idea of rule being exercised from the streets. For reasons that perhaps shall become clearer in a moment, few issues in the Reformation period were more likely to stimulate mass activism than the image question. To many men living at the time, therein lay one of the chief reasons for its importance.

This suggests an interesting modern interpretation of sixteenth-century iconoclasm, particularly the popular variety, one that fo-

cuses upon its value as a reflection or indicator of the degree of mass involvement in the broader Reformation movement.[277] Much of the original impetus for lay hostility to ecclesiastical imagery no doubt derived from the sermons and writings of the reforming clergy.[278] But the image question is one for which, in some instances at least, the impact of evangelical preaching upon the people can be gauged with some confidence, since it issued in overt behavior.

In order to accept the validity of this kind of approach one need not ignore the existence of other forms of causation than the purely religious one. Popular iconoclasm in the Reformation no doubt resulted from a variety of motives. Along with genuine aversion to idolatrous devotional practices and papal tyranny, other elements may well have entered in, such as class hostility against the social pretensions of the donors who had contributed the ornate ecclesiastical furnishings.[279] We know that iconoclasts sometimes made a point of destroying coats of arms hung on church walls.[280] In other instances a desire for loot and plunder no doubt operated.[281] And one would not want to discount entirely the importance of the merely irrational, e.g., the urge to vandalism or the effects of mob psychology.[282]

Nonetheless, it is difficult to avoid the impression that at the level of conscious motivation the main moving force behind most popular image destruction in the Reformation was a genuine hatred and fear of the sway exercised by Roman Catholic ritual over men's religious life. And this is why such phenomena as iconoclastic disturbances can be useful as an index of the degree of public support for the reform. When large groups of people have been moved to participate personally in activities directed toward a radical alteration of the inherited forms of worship and piety, there can be little doubt of the nature of the Reformation as a mass movement. The images, of course, were a natural target for attack, since they were highly visible and tangible physical objects and thus vulnerable to the wrath of ordinary laymen. In communities where the final stage of the religious transformation was so long delayed, as in Basel, the frustrated populace could do little else. They could not themselves complete the abolition of the Mass. But they could, as it turned out, on their own initiative remove or destroy the images.[283] And they

could persuade themselves that their violent deeds were legitimized by the magistrates' failure to act.[284]

In addition to the socioreligious interpretation just described, another approach also attracts the interest of modern scholarship on iconoclasm—that is, the problem of ascertaining its consequences for the historical and artistic heritage of our western civilization. Here, two questions in particular seem pertinent: (1) What impact, if any, did the destruction of images in the Reformation have upon later sixteenth-century art production? (2) To what degree has the cultural legacy of modern man been permanently impoverished in terms of actual physical artifacts irrevocably lost to later aesthetic enjoyment and scholarly study? The first question is dealt with in a later chapter of this book that discusses the causes of art decline in Germany. As for the second, the answer would seem to be that Reformation iconoclasm in the German lands was not so great a cultural catastrophe as might be imagined or as was in fact the case elsewhere.[285]

To be sure, the sixteenth-century reformers never conceived of the policy adopted much later by certain of the more thoughtful of the iconoclasts of the French Revolution, i.e., to preserve the proscribed monuments by removing them from the original settings with their strong emotional and intellectual associations and installing them in neutral museums where, torn from their cultural context, they might be regarded as mere "art."[286] No public museums existed at the time of the Reformation,[287] and the religiously aroused men of that era showed little interest in retaining for purely aesthetic or historical purposes objects that were still viewed largely in terms of rival schemes of salvation.

And so the destruction proceeded apace; the total number of art works that perished must have been enormous. Some communities were almost completely denuded of religious imagery. Garside has pointed out that almost nothing is known today about the local tradition of medieval sculpture in Zurich, since "not a single statue has survived" and "scarcely a tenth of the pre-Reformation painting has been preserved."[288]

And yet, when due allowance has been made for the magnitude of the losses, care must be taken not to overstate the case, for if one considers the Protestant German-speaking lands as a whole, a great

deal of the inherited religious art has come down to us. The reasons
for the survival of ecclesiastical imagery at the time of the Reforma-
tion are numerous. In some areas we probably owe the preservation
of art works to the vigilance of governmental officials who hastily
removed them from the churches to protect them from the wrath of
destructive mobs;[289] in other regions, to the lax enforcement of
iconoclastic policy.[290] Undoubtedly, some of the donors of altar pan-
els and other types of monuments took the trouble to retrieve these
artifacts before they were destroyed.[291] In a large and cultured city
such as Basel, there apparently were at least a few disinterested per-
sons aware of the purely artistic value of works by leading masters
such as Holbein who made it their business to rescue some of these
from the iconoclastic storms.[292] Loyal adherents to the old church
also may be credited with saving numbers of religious images,
through either daring personal intervention or later purchase. For
example, during the iconoclastic disturbances in Basel, one Theobald
Hylweck, abbot of Lützel, reportedly carried through the streets to
safety a statue of the Virgin that he had removed from a street-side
chapel.[293] As to purchase, the records would suggest that one source
for this type of acquisition was through the agency of goldsmiths to
whom pictures originally had been consigned for the purpose of
salvaging the gold leaf with which they were adorned.[294]

And so the devastation of art in the Reformation often was not as
complete as one might have expected, even in some communities
where the opposition to religious imagery would seem to have pre-
vailed—for instance Strasbourg, where the churches were purged a
number of times. Despite all the destruction, a great amount of
stained glass and a number of ecclesiastical furnishings, including
important examples of late medieval stone carving, have survived
there.[295] It appears that the iconoclasts of the French Revolution, who
in this instance were not at all moderate, demolished more sculpture
on the Strasbourg cathedral than did those of the Reformation.[296]

Religious art, of course, was most likely to be left unmolested in
those Protestant areas that adhered to strict Lutheranism. The
lengths to which followers of the Wittenberg reformer sometimes
were willing to go in retaining the traditional imagery may be illus-
trated by a report from the Saxon town of Bischofswerda, where a
Mariological cycle including a scene of the coronation of the Virgin

apparently was allowed to stand in the local church until well into the seventeenth century.[297] A city such as Nuernberg, as noted above, preserved an unusually large portion of its pre-Reformation ecclesiastical furnishings, with the rather paradoxical result that one can find more religious art of the Middle Ages in its churches than in many areas that remained Roman Catholic, where Gothic works later were often replaced by baroque creations.[298]

In summary, then, as grievous as the losses occasioned by the Reformation undoubtedly were, they manifestly did not signify for Germany on the whole a catastrophe of the same order as that in a land such as Scotland. Historian David McRoberts has pointed out recently that for that country the sixteenth-century devastation of its ecclesiastical art, which "represented almost the entire cultural heritage and achievement of the nation," was "a national calamity of the first magnitude."[299] He concludes, "So thoroughgoing has this destruction of liturgical accessories been that it is more difficult to find illustrative material showing the religious ideas and habits prevalent in Scotland five hundred years ago than to illustrate, from material evidence, the customs of ancient Egyptians or Babylonians."[300] All that the modern reader need do to assure himself that such was not the case in most areas of Germany is to inspect certain of the churches mentioned here, or, better yet, visit one of the country's many museums with their numerous and well-stocked exhibits of late medieval ecclesiastical art.

4

Early Lutheran Art

F THE REFORMATION in Germany resulted in the tragic destruction of countless ancient monuments, it also was partly responsible—at least in Lutheran areas—for the creation of a significant and interesting body of new art objects: Protestant Bible and book illustrations, panel paintings, altarpieces, epitaph memorials, and other types of ecclesiastical furnishings. With the possible exception of the Bible and book illustrations, most of these works remain virtually unknown in the English-speaking world. And yet, unless one has some acquaintance with them, it is futile to attempt to discuss the overall impact of the Reformation upon the fine arts.

The initial printing of Luther's German translation of the New Testament, which appeared in 1522, contained only about twenty woodcut compositions. Later editions of the Scriptures brought out by the reformer, however, included a much larger number of pictures, and by the mid-1530s an impressive new school of Protestant Bible illustration had arisen in Wittenberg.[1] It is clear from the evidence that Luther himself not only endorsed this development but also played some part in it. We know from his own marginal notations that, when a portion of his text of the Old Testament was being prepared for publication in 1524, he personally designated several of the episodes that he wished to be depicted.[2] There is also the testimony of a proofreader who worked for the Hans Lufft Press in Wittenberg during Luther's lifetime, a man named Christoph Walther. After the reformer's death Walther affirmed that in

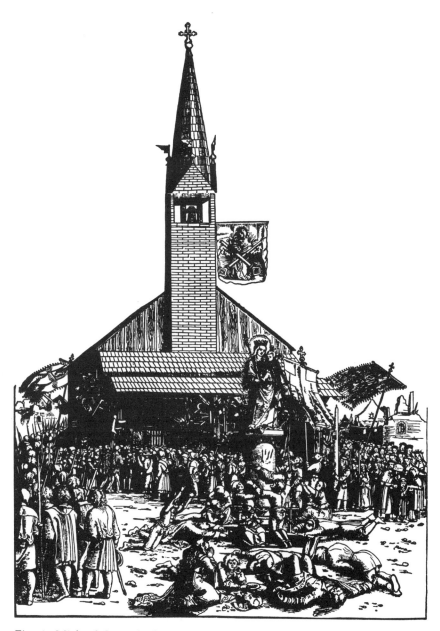

Fig. 1. Michael Ostendorfer, *The Pilgrimage to Mary the Beautiful at Regensburg*, ca. 1520. From Alfred Stange, *Malerei der Donauschule* (Munich: F. Bruckmann, 1964), fig. 34. Reproduced by permission.

Fig. 2. Lucas Cranach the Elder, *The Law and the Gospel*, 1529. Schl
seum, Gotha.

Vom Teüffer
Sihe das ist gottes Lamb das der welt sünde tregt
Sant Johannes Baptist Johannis·2·
In der heiligung des geists zum gehorsam vnd besprẽg
ung des bluts Jesu Christi amen·1·petri·1·

Von Tode vnd Lamb
Der Tod ist verschlungen ym sieg Tod wo ist dein spiß
Helle wo ist dein sieg, danck hab Gott der vns den sieg gibeñ
hat durch Jesum christum vnsern herren·1·Corinth·15·

114

Fig. 3. Workshop of Lucas Cranach the Elder, *The Law and the Gospel*, 1529. National Gallery, Prague.

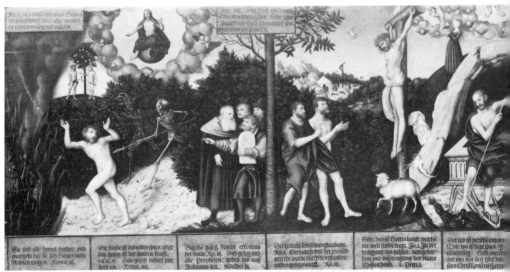

Fig. 4. Workshop of Lucas Cranach the Elder, *The Law and the Gospel*, n.d. Kunstsammlungen zu Weimar, DDR, Sammlung der Gemälde.

Fig. 5. Lucas Cranach the Elder, *Christ and the Adulteress*, 1532. Museum of Fine Arts, Budapest.

Fig. 6. Lucas Cranach the Elder, *Christ Blessing the Children*, n.d. St. Wenzelskirche, Naumburg. From Max J. Friedländer and Jakob Rosenberg, *Die Gemälde von Lucas Cranach* (Berlin: Deutscher Verein für Kunstwissenschaft, 1932; Gesamtherstellung von F. Bruckmann AG., Munich), pl. 179. Reproduced by permission.

Fig. 7. Lucas Cranach the Elder, Schneeberg Altar, 1539, predella panel. St. Wolfgangskirche, Schneeberg. Photo Foto-Brüggemann.

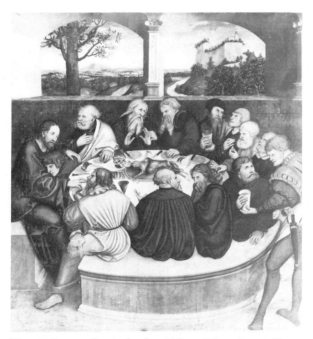

Fig. 8. Lucas Cranach the Elder, Wittenberg Altar, 1547, central panel. Stadtkirche, Wittenberg. Photo Foto-Brüggemann.

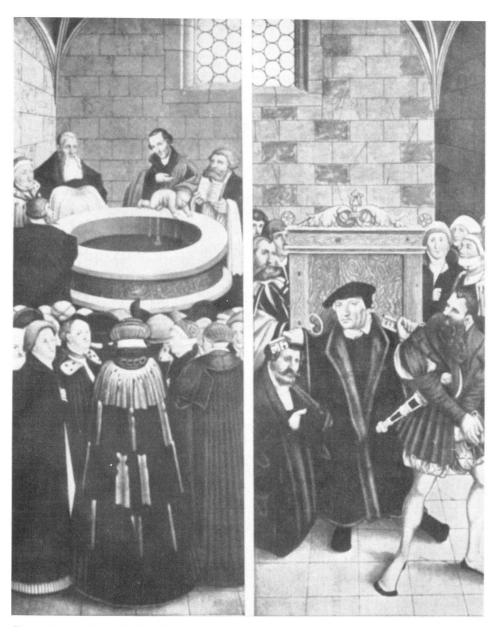

Fig. 9. Lucas Cranach the Elder, Wittenberg Altar, 1547, wing panels. Stadtkirche, Wittenberg. From Oskar Thulin, *Die Lutherstadt Wittenberg und ihre reformatorischen Gedenkstätten* (Berlin: Evangelische Verlagsanstalt, 1968), fig. 30. Reproduced by permission.

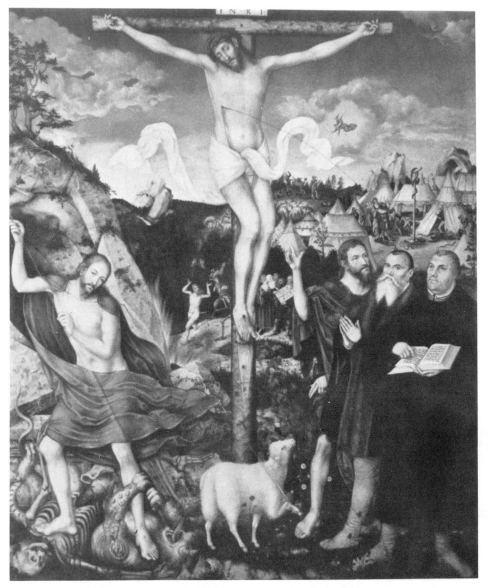

Fig. 10. Lucas Cranach the Younger, Weimar Altar, 1555, central panel. Stadtkirche, Weimar. From Max J. Friedländer and Jakob Rosenberg, *Die Gemälde von Lucas Cranach* (Berlin: Deutscher Verein für Kunstwissenschaft, 1932; Gesamtherstellung von F. Bruckmann AG., Munich), pl. 352. Reproduced by permission.

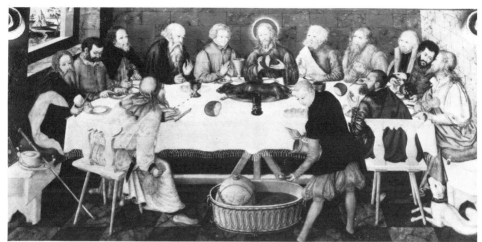

Fig. 11. Lucas Cranach the Younger, Kemberg Altar, 1565, predella panel. Stadtkirche, Kemberg. Photo Foto-Brüggemann.

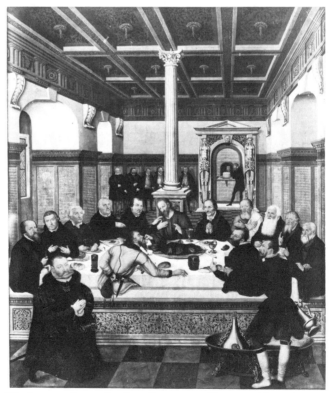

Fig. 12. Lucas Cranach the Younger, Dessau Altarpiece, 1565. Schlosskirche, Dessau. Photo Foto-Brüggemann.

Fig. 13. Epitaph for Petrus Weitzke (d. 1585). St. Gotthardtkirche, Branden-burg. Photo courtesy St. Gotthardt Church.

Fig. 14. Lucas Cranach the Younger, Epitaph for Michael Meyenburg, 1558. Formerly Blasiikirche, Nordhausen; now destroyed. From Oskar Thulin, *Cranach-Altäre der Reformation* (Berlin: Evangelische Verlagsanstalt, 1955), fig. 97. Reproduced by permission of the Staatliche Museen zu Berlin.

Fig. 15. Albrecht Dürer, *The Four Apostles*, 1526. Bayer. Staatsgemäldesammlungen, Munich.

addition to selecting some of the narrative events to be portrayed in the Wittenberg Bible Luther also had given certain directions concerning the manner of their representation, emphasizing in particular the importance of simplicity and fidelity to the text.[3] Thus it is clear that in the reformer's view the Bible illustrations, being far more than mere decorative ornament, served an important pedagogical purpose.

It would seem that the care devoted by Luther and his artistic collaborators to the preparation of pictorial matter to be included in the German Bible was wisely expended. For these visual aids very likely exerted an appreciable influence upon many of the multitudes of lay Christians who just then were studying the Scriptures for themselves for the first time, the woodcuts shaping in significant ways such readers' understanding and appreciation of Holy Writ.[4]

In fact, if considered from the standpoint of the numbers of people exposed to them, the Bible and book illustrations would no doubt have to be judged the most important of the early Protestant art forms. Luther's German Bible in particular was very widely circulated, and hundreds of thousands of readers must have pored over the extensive visual material in its numerous editions.[5]

From the standpoint of iconographical interest, however, the most noteworthy of the early Lutheran artistic creations are not the Bible illustrations, but the less well-known panel paintings, altarpieces, and funerary memorials. In the selection of subject matter for these works, there was no necessity of adhering to a prescribed literary text. Therefore, the artists—or their theological advisers and patrons—enjoyed greater freedom to give visual expression to whatever they deemed most important in the realm of religious teaching and piety. Thus if a specifically Lutheran art did emerge during this period, it seems most likely to be found in this area. Furthermore, the major arts of painting and sculpture employed in the production of these monuments normally occupy a larger place in the debate over the decline of sixteenth-century German aesthetic culture than do the graphic media used in the illustration of books and Bibles.[6] With these considerations in mind, we now turn to a discussion of the early Lutheran panel paintings, altarpieces, and epitaph memorials.

Panel Paintings

The first oil paintings created by artists in direct personal contact with the Wittenberg reformers and reflecting a Protestant point of view apparently were not intended as altarpieces. Instead, they took the form of independent panels. Most important among them iconographically are three groups of works entitled, respectively, *The Law and the Gospel, Christ and the Adulteress,* and *Christ Blessing the Children.* All three figured prominently in the religious art produced by Luther's close friend, the painter Lucas Cranach the Elder.

The Law and the Gospel. Among the independent panel paintings, the doctrinal potential of pictorial art was realized most fully in a series of compositions that we may title *The Law and the Gospel.*[7] Although some uncertainty remains concerning the origins of this theme, it was closely associated with Cranach and his workshop.[8] The oldest known paintings of the subject by the Wittenberg artist are a pair of small panels completed in 1529. Whether these were intended to be hung in a church is not known for certain, although that may have been the case; it has been suggested that the conception of the Law and Gospel theme probably occurred at this time partly as a consequence of the liturgical and ecclesiastical consolidation that just then was taking place in Electoral Saxony.[9] In view of the broader significance of this compositional motif for the topic of early Protestant art, it deserves an exhaustive monographic treatment. No such definitive study can be undertaken here, of course, but at least some indication must be given of the nature and widespread popularity of this iconographical innovation. It is indeed the most characteristic and complete expression of Lutheran theology in sixteenth-century art. It also can be viewed as the rendering of Reformation doctrine in the medium of folk art. As one modern author puts it, "The purpose of these dogmatic-symbolical paintings was to tell a story in clear forceful language and to give form to Luther's ideas."[10] From Wittenberg, the motif quickly spread over most of east, central, and north Germany, and variations were employed in an astonishingly wide range of different types of art works: independent panel paintings, altarpieces, epitaphs, Bible illustrations, single-leaf woodcuts, pulpit decorations,

stained glass, book bindings, and even wedding chest carvings, to mention the most important.[11] In the form of Bible illustrations the theme appeared in several foreign lands—Denmark, Poland, England, and the Netherlands.[12] A woodcut version also was produced by the French artist Geoffroy Tory.[13]

The first of the 1529 Cranach paintings of the Law and Gospel theme to be considered here is the panel now in Gotha (fig. 2). In this important work, the picture space is divided down the middle by a tree, perhaps intended to suggest the biblical Tree of the Knowledge of Good and Evil and the Tree of Life,[14] dead on the left side and living on the right. The left side of the panel contains scenes that in Luther's theology are essentially reminders of man's lost condition and alienation from God, or man as he stands condemned under the Law: in the middleground, the Fall of Man into Sin, represented by the Temptation of Adam and Eve; also in the middleground, level with, but behind the Fall, the Hebrew Encampment in the Wilderness and the Brazen Serpent; at the top, seemingly remote and inaccessible, Christ is depicted as Judge of the World, sitting on a globe in the sky;[15] in the foreground, adjacent to the tree, there is a group of four Old Testament Prophets, one of whom, Moses, is holding and pointing to the Tablets of the Law; immediately to their right, symbolic figures of death and the devil drive an unclothed man toward the flames of hell.[16]

On the right side of the panel is portrayed the saving message of the Gospel. In the foreground, just to the right of the tree, the figures of "representative" man,[17] again naked,[18] and St. John the Baptist. "The Baptist," in the words of Donald Ehresmann's fine description, "holding a book in his left hand, points out the Crucifixion with his right hand to the naked man, who is shown gazing at the Crucifixion in an attitude of prayer." Ehresmann continues:

The Crucifixion takes place in far right of the panel in front of an open rock-cut tomb containing a sarcophagus. A stream of blood issues from the side of the crucified Christ in the direction of the naked man; the dove of the Holy Ghost glides along the stream of blood. Below and in front of the Crucifixion the Holy Lamb holds the banner of triumph as it tramples on the bodies of death and devil, while above the Crucifixion the ascending Christ blesses with His right hand and holds the banner with His left. In

the right middleground the Annunciation to the Shepherds is taking place; further back is a gothic city, probably symbolic of the New Jerusalem.[19]

Finally, running across the base of the entire panel is a row of six rectangular compartments containing inscriptions in German based on selected texts from the Bible.[20]

If the composition just described is correctly labeled as depicting the Law and the Gospel, it might be well to raise the question of what these terms mean in Luther's theology. Fortunately, the reformer often commented on the matter, and we need only to reproduce a few of his most characteristic statements to convey something of his meaning:

According to the apostle, Rom. 1:1–3f., the Gospel is the message about the incarnate Son of God, who was given us without our merits for salvation and peace. It is the Word of salvation, the Word of grace, the Word of comfort, the Word of joy. . . . But the Law is the Word of perdition, the Word of wrath, the Word of sadness, the Word of pain, the voice of the Judge and the accused, . . . and it is a Law of death (Rom. 7:13). [1518][21]

The Law is the Word in which God teaches and tells us what we are to do and not to do, as in the Ten Commandments. Now wherever human nature is alone, without the grace of God, the Law cannot be kept, because since Adam's fall in Paradise man is corrupt and has nothing but a wicked desire to sin. . . . The other Word of God is not Law or commandment, nor does it require anything of us; but after the first Word, that of the Law, has done this work and distressful misery and poverty have been produced in the heart, God comes and offers His lovely, living Word, and promises, pledges, and obligates Himself to give grace and help, that we may get out of this misery and that all sins not only be forgiven but also blotted out. . . . See, this divine promise of His grace and of the forgiveness of sin is properly called Gospel. [1522][22]

Before receiving the comfort of forgiveness, sin must be recognized and the fear of God's wrath must be experienced through the preaching or apprehension of the Law, that man may be driven to sigh for grace and may be prepared to receive the comfort of the Gospel.[23]

In view of these statements by Luther, a minimum of commentary should suffice to explain the significance of the symbolism of

the Gotha panel.[24] The barrenness of the left portion of the central tree may be interpreted as symbolizing the penalty of death under which unredeemed mankind stands. The motif of Moses and the Tablets of the Law calls attention to the fact that it is for man's failure to fulfill the obligations of the Law that he is condemned. Man is unable to meet the just requirements of the Law because of the consequences of original sin, the result of the Fall. Christ the Judge, as Craig Harbison notes, "rules over a world apparently governed by the sin which his judgment condemns."[25] As for the right portion of the panel, the vitality of the tree on that side no doubt is intended to symbolize the promise of life granted the Christian through the Gospel. In pointing out the way of salvation to the naked man, John the Baptist fulfills the role assigned him in Scripture, where he exclaims "Behold, the Lamb of God, who takes away the sin of the world!"[26] The stream of blood flowing from the crucified Saviour's side indicates that it is through the sacrifice of God's Son that man's sin is washed away.[27] The triumph of the Lamb over death and devil displays the ultimate result of Christ's atoning act: "Death is swallowed up in victory."[28] And, finally, the resurrected and ascending Lord, through His gesture of blessing, renders explicit the divine favor extended to mankind.

A panel now in Prague, judged by some scholars to be a workshop production,[29] constitutes the other important Cranach painting of the Law and Gospel theme from 1529 (fig. 3). The Prague composition, however, differs in certain significant respects from the Gotha work. Moses is shown here kneeling in the upper background of the left side, in the act of receiving the Tablets of Law from the hands of God, which extend down from the clouds. On the Gospel side of the panel, serving as a counterpart to Moses,[30] we see "the Virgin receiving the infant Christ" who "glides out of an opening in the sky towards her."[31] The motif of Christ sitting in judgment is omitted from the left side, as are the figures of death, the devil, and the naked sinner being driven to hell. Instead of the latter, we see a corpse lying in an open grave. On the right side of this work we note that it is the victorious, resurrected Christ, rather than the Lamb, who tramples underfoot the forms of death and Satan. Another difference, finally, between the two panels is that, although both devote a certain amount of space at the bottom to

rather lengthy biblical inscriptions, the Prague version also employs single words or short phrases as identifying labels at the appropriate places in the composition itself (*law, sinner, death*).[32]

But the most important variation in the two panels is that deriving from the treatment of the group shown at the very center of the Prague composition. Naked, "representative" man here sits on a stump near the base of the tree, with his body facing toward the symbols of judgment and death on the left, but with his head turned to gaze at the saving events to which John the Baptist refers him on the right.[33] The single Old Testament Prophet found in this work (just left of the tree) also gestures toward the Crucifixion, rather than facing toward his own side of the panel, as the Prophet figures do in the Gotha composition. The result is that we find in the Prague work a less sharp division of the picture space: instead of the two separate figures of condemned man on the left and potentially saved man on the right, the single naked figure appears in the center, shown in a situation that seems to require his decision as to whether he will choose the way of the Law, with its just but heavy demands, inevitable failure, and consequent judgment, or that of the free gift of grace made known through the Gospel proclamation of Christ's sacrifice and victory. Harbison, who believes that the Prague work is based on an earlier conception of the theme, suggests that in the Gotha painting we find that "for the first time two clearly different paths are portrayed, one ending in terrifying judgment, the other leading to salvation through faith." Thus, he concludes, "the Gotha panel represents a more intensified and aggressive statement."[34]

A format much like that of the Gotha work is found in three panels by the Cranach workshop now in Weimar (fig. 4), Nuernberg, and Königsberg.[35] These closely related paintings, however, also manifest certain noteworthy departures: (1) In a manner similar to that of the Prague example each includes a figure of the Virgin receiving the infant Christ, as well as depicting the resurrected Christ, rather than the Lamb, trampling death and devil underfoot, and (2) in contrast to both the Gotha and the Prague versions, the Brazen Serpent motif in every instance has been transposed to the right side of the picture space. The Brazen Serpent traditionally was regarded as an Old Testament prototype of the Crucifixion, the serpent—like

Christ—having been raised up on a cross for man's salvation. The Lutherans, however, seem to have reinterpreted the motif as a sign of justification by faith, for, as Ehresmann notes, the ancient Israelites "were cured from the bite of the fiery serpents by believing in the Word of God embodied in the brazen serpent."[36] Viewed in this light, the transference of the Old Testament theme from its original location to the realm of the Gospel seems entirely logical.[37]

Like the Brazen Serpent, most of the individual motifs incorporated into these compositions can be regarded as traditional.[38] What was new was their combination in this particular manner so as to illuminate and expound the fundamental Lutheran teachings of the futility of human works performed under the Law and the necessity of a justifying faith in the free gift of divine grace as revealed in the Christian Gospel. That these two doctrines of Law and Gospel must be properly understood, and above all clearly distinguished, constituted a message that Luther never ceased to proclaim:

This difference between the Law and the Gospel is the height of knowledge in Christendom. Every person and all persons who assume or glory in the name of Christian should know and be able to state this difference. If this ability is lacking, one cannot tell a Christian from a heathen or a Jew; of such supreme importance is this differentiation. [1532][39]

Where these two teachings, the Law and the Gospel, stay bright and clear and are correctly understood, there the sun and the moon, the two great lights which God has created to rule the day and the night, send forth their rays. There light and darkness can be distinguished. . . . As long as these two lights shine, one can distinguish day from night, light from darkness. But when these two lights are gone, nothing but night and blindness and darkness prevail. [1534][40]

To know this doctrine of the difference between the Law and the Gospel is necessary because it contains the gist (*summa*) of all Christian doctrine. Therefore let everyone who cultivates piety earnestly strive to learn to distinguish these two, not only in words but also in life and experience, that is, in his heart and conscience. [1531][41]

Luther clearly believed that both the Law and the Gospel must be forcefully and effectively proclaimed by the church. And that is

manifestly what these rather didactic art works were intended to do. Their popularity among sixteenth-century German Protestants suggests that they must have accomplished the purpose.

Christ and the Adulteress. To judge from some comments by Luther, the Law and Gospel concept may also be reflected—somewhat to our surprise perhaps—in the second category of independent panel paintings to be considered here, those titled *Christ and the Adulteress.* In this instance we are dealing with a group of compositions that, with their seemingly straightforward representation of an episode narrated in the New Testament, would seem less well suited than those just described for the portrayal of specifically Protestant doctrine. As we shall see, however, this motif too probably functioned in the Reformation context as a reminder of certain theological teachings that were of special importance to Luther and his followers.[42] Indeed, this would seem to be the most likely explanation for the widespread acceptance that the theme appears to have found among the German Protestants.

The Christ and the Adulteress motif was not at all new in Christian art.[43] Although it was rarely depicted in late medieval German painting,[44] enough examples are known from the graphic arts of the pre-Reformation period to render untenable the recent suggestion that Cranach's treatment of it be viewed as an instance of his "resurrection of old and forgotten subjects."[45] And, despite the fact that the theme seems to have become extraordinarily popular among the Wittenberg artist's Lutheran clientele,[46] it never was transformed into an exclusively Protestant subject—as is made clear by the existence of later paintings of the same subject by such artists as Tintoretto, Rubens, and Poussin.[47] Nonetheless, the prominence of the motif in Cranach's artistic output from the Reformation years is so striking as to suggest that the *Christ and the Adulteress* panels must have acquired a special significance for the followers of Luther. The Friedländer and Rosenberg catalog of Cranach's paintings lists fourteen panels depicting this biblical episode,[48] the earliest dating from about 1520[49] but the majority stemming from after 1535.[50] The motif also was one of those used to adorn the pulpit in what has been called the "first Protestant church building," the 1544 Castle Chapel at Torgau.[51]

The story on which the paintings are based is found in the Gospel of John 8:3–11:

The scribes and the Pharisees brought a woman who had been caught in adultery, and placing her in the midst they said to him, "Teacher, this woman has been caught in the act of adultery. Now in the law Moses commanded us to stone such. What do you say about her?" This they said to test him, that they might have some charge to bring against him. Jesus bent down and wrote with his finger on the ground. And as they continued to ask him, he stood up and said to them, "Let him who is without sin among you be the first to throw a stone at her." And once more he bent down and wrote with his finger on the ground. But when they heard it, they went away, one by one, beginning with the eldest, and Jesus was left alone with the woman standing before him. Jesus looked up and said to her, "Woman, where are they? Has no one condemned you?" She said, "No one, Lord." And Jesus said, "Neither do I condemn you; go, and do not sin again."

In the typical Cranach portrayal of the theme, we see a gesturing Christ and the woman standing in the center of the composition, surrounded by the scribes and Pharisees, one or more of whom grasp large stones in their hands.[52] In some cases we find at the top of the panel, in German, the phrase "Let him who is without sin among you be the first to throw a stone at her."[53] Cranach's use of a wide but shallow format that reveals the figures in only half or three-quarter length apparently is new in German art (fig. 5).[54] Also noteworthy is the exclusion of extraneous narrative detail. It may be supposed that this rather compressed treatment was intended to encourage a strict concentration of the viewer's attention upon the central actors in the drama and therefore also upon the spiritual significance of the event.

When we turn to the question of interpreting this group of paintings in their Reformation context, we naturally are led to inquire concerning Luther's theological understanding of this particular biblical episode.[55] The reformer spoke at some length on this topic in one of a series of sermons on the Gospel of John, which he delivered in Wittenberg in early autumn, 1531.[56] In his discussion of the incident concerning Christ and the adulteress, Luther provided the following analysis:

This story is related to show the clear distinction between the Law and the Gospel, or between the kingdom of Christ and that of the world. The Pharisees had heard that Christ had preached much about the kingdom of God in His sermons, stating that it was a kingdom of grace in which forgiveness of sin held sway. On the other hand, the Jews had Moses' Law, which held nothing but anger, displeasure, and the punishment of God over the heads of those who transgressed His commandments. Thus the civil government is invested with the power and the duty to punish gross vices and sins, and not to forgive them. These two things seem to run counter to each other. In Christ's realm no punishment is to be found, but only mercy and forgiveness of sins, whereas in the realm of Moses and the world there is no forgiveness of sins, but only wrath and punishment; for he who sins is to be stoned and killed.[57]

Thus there appears once again that polarity with which we are by now thoroughly familiar, the tension between the Law and the Gospel. From Luther's point of view, of course, the proper concern of the individual sinner is not simply to be intellectually cognizant of the two opposing realms but to escape from the oppression and condemnation of the one into the spiritual freedom and salvation of the other. The reformer obviously believed that the biblical event depicted in this group of paintings demonstrates the possibility of such a redemption. For, according to him, the story of the adulteress is "a fine illustration of Christ's mercy," wherein "Christ gives factual proof of His power over the Law."[58]

Judging from Luther's sermon it would appear that even the inscription placed on certain of these paintings was meant to convey a message that relates closely to the Law-Gospel concept. The inscription, it will be recalled, reproduces the words of Christ: "Let him who is without sin among you be the first to throw a stone at her." On first thought the inclusion of this particular text might seem to have been intended as an attack on that Pharisaical self-righteousness that results in an unloving condemnation of one's fellow sinner. So interpreted, the statement could be understood here as an exhortation to the viewer to reconsider his attitude toward others, and, above all, to display a greater Christian charity toward his neighbor. Indeed, there is some evidence that this lesson was one that the reformer wished to be learned from this story.[59] It is more in line with the basic thrust of Luther's exegesis,

however, to construe this saying of Jesus as directed at changing the viewer's attitude toward himself, i.e., through the reminder that under the Law absolutely no one escapes the indictment of sin. Thus the first response that the onlooker properly ought to make is to attend to the state of his own soul. In speaking of Jesus' rebuff to the Pharisees, those "very holiest" of men,[60] the reformer declared that "with these words Christ laid bare their hearts and revealed a record of their sin, causing them to forget the sins of others."[61]

In Luther's judgment, Jesus' message was not intended merely for the Pharisees of biblical times: "Christ's words are addressed to everybody: 'Let him who is without sin among you be the first to throw a stone at her.' He says that no one is exempt from the wrath of God, from death, sin, hell, and eternal damnation."[62] So, "Christ reduces all men to sinners," but does not stop there "for then He absolves them."[63] As the Wittenberg preacher told his listeners, "If you have tasted the Law and sin, and if you know the ache of sin, then look here, and see how sweet, in comparison, the grace of God is, the grace which is offered to us in the Gospel. This is the absolution which the adulteress receives here from the Lord Christ."[64]

Another idea closely related to the doctrine of the Law and Gospel, as has been noted, is the classic Reformation teaching of justification by faith alone. This tenet too, most likely, found expression in these panels. For in the case of the adulteress, there could be no question of salvation through human merit or works of righteousness. If she were to be saved, it could occur only through her reception of God's gift of free grace.[65] As Luther expressed it, "So a living saint and member of Christ stands here, made out of an adulteress who had been infested with sin but whose sin is now forgiven and covered."[66]

Although the themes of Law and Gospel, sin and grace may be the primary message of Cranach's panels dealing with the story of the adulteress, special attention ought to be called to another feature of these works also, i.e., the image of a compassionate Christ that they present to the viewer. For we know that in portraying such a Christ image they accorded well with Luther's insistence that the Saviour be characterized to the world as a merciful Redeemer rather than as a wrathful, condemning Lord. The reformer complained of the tendency in much medieval art to picture Christ in the terrifying

role of judge over man, as in the numerous doomsday composi-
tions.[67] The story depicted in these Cranach paintings provided an
excellent opportunity to offer a very different conception of Jesus.
That may be another reason why it, along with the theme of Christ
and the little children to be discussed next, was so popular in six-
teenth-century Lutheran art.

Christ Blessing the Children. A third compositional motif in Prot-
estant painting before the period of the great altarpieces and epi-
taph monuments is that of Christ Blessing the Children.[68] As with
the two iconographical themes previously discussed, this subject
also became a favorite among German Lutherans[69] and seems soon
to have spread from that land into the Low Countries, where it
attained a somewhat similar status.[70] Friedländer and Rosenberg, in
their aforementioned Cranach catalog, list thirteen paintings based
on this biblical episode.[71] This number is all the more remarkable
when one realizes how infrequently the theme appeared in medi-
eval art, especially during the two or three hundred years preceding
the Reformation.[72] Although the Wittenberg master may not have
been the first sixteenth-century German artist to employ this
motif,[73] his numerous portrayals of it must have contributed greatly
to popularizing the subject and securing for it a more prominent
place in the western iconographical tradition.

It is not known for certain just when Cranach began to paint this
subject. No records have been found that document the commission
for the first such picture.[74] It may have been in 1529, although the
once-suggested dating of what has sometimes been assumed to be
the earliest version of the theme in that year is questioned by more
recent art historical scholarship.[75] According to Friedländer and Ro-
senberg, the majority of the surviving examples date from after
1537.[76] In any case, by the later years of the decade of the 1530s, the
subject had become a favorite one in German Lutheran circles. We
know that Cranach's patron, the staunchly Lutheran Elector of Sax-
ony, John Frederick the Magnanimous, bought paintings of the
theme in 1539, 1543, and 1550.[77]

The story upon which these paintings are based is recounted in
all three of the synoptic Gospels (Matthew 19:13–15; Mark 10:13–16;
and Luke 18:15–17). Since the version by St. Mark is partially

quoted in the inscriptions to some of the Cranach panels,[78] it will be reproduced here: "And they were bringing children to him, that he might touch them; and the disciples rebuked them. But when Jesus saw it he was indignant, and said to them, 'Let the children come to me, do not hinder them; for to such belongs the kingdom of God. Truly, I say to you, whoever does not receive the kingdom of God like a child shall not enter it.' And he took them in his arms and blessed them, laying his hands upon them." A modern art historian, Christine Kibish, notes how the typical Cranach treatments of this theme "follow a scheme in which a group of densely crowded figures is placed against a flat background. The surrounding frame cuts very low above the heads of the figures thus increasing the effect of closeness and density."[79] To this might be added the observation that in the Cranach portrayals we characteristically find Christ, holding one infant in His arm and caressing another, shown in the center of a crowd of women and children who press in about Him. In the upper left corner of the composition appears a group of disciples (fig. 6).[80]

A question quite naturally arises concerning the reason for the great interest shown by the artist and his religious associates in this heretofore rare theme. According to Kibish, its sudden prominence in Reformation art derives primarily from the wish of the early Lutherans to buttress and give visual expression to their arguments in favor of retaining infant baptism.[81] This particular practice, and the doctrine underlying it, were—as is well known—just then being vigorously challenged by the Anabaptists. The members of this sectarian movement argued that there was not adequate scriptural warrant for this traditional rite and that its continued usage subverted the need for a mature, conscious commitment on the part of the individual coming to Christ.[82] Luther countered with the claim that the sacrament of baptism rested upon God's promised grace, not the spiritual attainments of men, and thus could as well be administered to infants as adults:

Whoever allows himself to be baptized on the strength of his faith, is not only uncertain, but also an idolater who denies Christ. For he trusts in and builds on something of his own, namely, on a gift which he has from God, and not on God's Word alone.

Christ commands the children to come and to be brought to him, and, in Matt. 19 [:14] says that theirs is the kingdom of God. The apostles baptized entire households [Acts 16:15]. John writes to little children [I John 2:12]. St. John had faith even in his mother's womb, as we have heard [Luke 1:41]. If all of these passages do not suffice for the enthusiasts, I shall not be concerned. They are enough for me, to stop the mouth of anyone from saying that child baptism does not mean anything.[83]

The reformer thus appealed to the biblical episode depicted in these paintings as support for his interpretation of the sacrament. Further, he incorporated the relevant scriptural passage from Mark's Gospel into the Lutheran baptismal liturgy.[84] In view of these facts and our acquaintance with the otherwise rather common practice of reflecting doctrinal and even polemical concerns in Reformation art, an explanation such as Kibish's is not without considerable plausibility.[85] If viewed, however, as the sole reason for the popularity of this iconographical motif, it fails to account for its continued prevalence in later periods when the threat of the Anabaptists was no longer so great and, even more important, its frequent appearance on art works (such as epitaphs commemorating the deaths of small children) where sectarian polemics would seemingly be out of place.[86] This theme, as an expression of the especial receptivity of Jesus to little children, obviously was felt to be particularly appropriate for use on this latter class of monuments, i.e., funerary monuments to youth and infants. It is possible that the development and utilization of this motif was a two-stage process. It may have been conceived at first largely with an eye to its polemical possibilities, and perhaps only later was it adopted for use as a nonpolemical, consolatory theme on children's epitaphs.[87] But it also seems possible that, from the very beginning, the intention had been as much to portray a good example of the simple, childlike trust in God implied in Luther's doctrine of salvation by faith alone as it had been to support or defend the reformer's position with respect to infant baptism.[88]

Altarpieces

By the time of the Reformation the altar area had long since established itself as one of the most important places in the church

for the display of religious visual imagery. Thus the position adopted by the reformers with respect to such questions as the continued use of the altar and the form that it should take was bound to have important consequences for the development of a Protestant art. As to the utility of an altar of some sort, Luther had no doubt; it served as the setting for the celebration of the Lord's Supper or Holy Communion.[89] Whether it should be a simple table or an elaborate retable altar was not so clear. At one point fairly early in his career, in 1526, the reformer expressed a preference for a simple table-type altar, in order that the officiating clergyman might face the congregation.[90] Four years later, he implied his approval of the retable altar when he prescribed as the ideal subject matter of altar paintings a representation of the Lord's Supper.[91] The latter type of structure, in fact, became standard among German Lutherans, except in certain southern and western regions that were subject also to Zwinglian and Calvinist influences.[92] The size and form of these retable altars varied considerably, but many were large, imposing constructions. The triptych design continued for a time to be popular.[93] One of the earliest of the surviving Lutheran altars, the Schneeberg altar of 1539, was a double-winged triptych with both sides of the four wing panels painted, thus providing (including the two predella panels, front and back) a total of twelve picture spaces. Altars with painted panels such as this were at first the most common type, but in the last third of the sixteenth century altars with stone or wood relief sculpture were also used.[94] Although not the most numerous of early Protestant ecclesiastical art works, since Lutheran worship generally required only one altar,[95] the altarpieces quite naturally are regarded as occupying the first rank artistically among the monuments to be discussed here.[96]

Of course, by no means every Lutheran church or chapel acquired a new altar or new altarpieces during the period immediately following the introduction of the Reformation. It was entirely in keeping with the rather conservative spirit on such matters that the inherited ecclesiastical furnishings were very often retained.[97] Nonetheless, a sizable number of altarpieces were commissioned in Lutheran areas of Germany during the sixteenth century,[98] some by princes, others by municipalities or by private donors, both clerical and lay.[99] A few of the Cranach altar panels known to have

been created for Protestant churches have been intensively ana-
lyzed and are fairly well known, at least to specialists. This class of
art monuments as a whole, however, never has been systematically
cataloged or exhaustively studied.[100] Such a task cannot be under-
taken here, of course. What shall be attempted is a description of a
few of the better-known or more adequately investigated works,
with a concluding section devoted to a comparative iconographical
analysis. Because of their importance in early Lutheran art, the
Last Supper panels shall be examined in greater detail than the
others.

The Schneeberg Altar. This work, the earliest of the monumen-
tal Cranach Reformation altars, was installed in St. Wolfgang's
Church in Schneeberg in April, 1539.[101] Judging from the donor
portraits at the base of the left and right wing panels when com-
pletely opened, the massive triptych was a gift of the Elector of
Saxony, John Frederick, and his half brother, John Ernest.

The predella panel, the only picture space always visible from
the front regardless of how the wings were disposed, contains a
painting of the Last Supper (fig. 7). Christ is shown at the left end
of a rectangular table, extending the morsel of bread to Judas. The
other disciples, with the exception of St. John, St. Peter, and a third
unidentified figure, are grouped in a cluster around the right end of
the table, where they almost seem more interested in the refilling of
the wine glasses than in the exchange between the betrayer and his
Lord. Artistically, it is not one of Cranach's better works, lacking as
it does both spatial and psychological unity.[102]

When the wing panels are completely closed, the scenes visible
above the predella are *Lot and his Daughters* (Sodom and Gomorrah)
and *The Flood.* Taking the two paintings together in this way, the
thematic sequence would seem to be (1) divine judgment (the
Flood; Sodom and Gomorrah), (2) deliverance (Noah; Lot and his
Daughters), and (3) fall into sin once more (Lot's Daughters).[103]

With the opening of the first set of wings, there appears a com-
posite presentation made up of the four panels that, taken together,
depict the Law and Gospel theme. Iconographically, the work is
closely related to the aforementioned panel paintings in Weimar,
Nuernberg, and Königsberg. The Schneeberg altar, however, appar-

ently contains what was the first really large-scale representation of the by-now-familiar motif.[104]

When the second wings are opened, the central panel of the altar displays a large and crowded painting, the *Crucifixion.* On the left wing we see, above the portrait of Elector John Frederick, *Christ in the Garden of Gethsemane;* and on the right, above the portrait of John Ernest, the *Resurrection of Christ.* Thus, the three scenes carry us from the beginning of Christ's Passion through to the triumph over death.[105]

On the back of the altar, we find in the central panel the *Last Judgment* and on the predella, the *Resurrection of the Dead.* For purposes of iconographical analysis, these paintings probably should be combined with the compositions on the outer side of the first two wing panels, which most likely were normally open, thus facing toward the back. These, it will be recalled, are *Lot and his Daughters* and *The Flood.* The doctrinal accent of the back of the altar, viewed as a whole, would thus seem to be an emphasis on divine judgment.[106]

The Wittenberg Altar. This large triptych was installed in the Wittenberg City Church in April, 1547.[107] It was paid for from municipal funds, and thus it may be viewed as a commission of the city congregation in its communal form.[108] The work often is attributed to Lucas Cranach the Elder,[109] although there is a strong likelihood of some participation by Lucas the Younger.[110] The iconography probably was worked out in close consultation with Luther and other Wittenberg theologians.[111]

The central panel of the Wittenberg altar displays what appears to be the first truly monumental treatment of the Last Supper theme on a Lutheran altar (fig. 8). The painting shows Jesus (again on the left) and the disciples seated at the Passover meal around a circular table; the theme depicted seems not to be, as one might have expected, that of the institution of the Eucharist, but rather that of the betrayal. Jesus is portrayed in the act of proffering a morsel of food to Judas,[112] and the shock and distress of the other disciples is manifested in their gestures and expressions. Among the details worthy of note is the unmistakable portrait of Luther as the disciple who accepts the cup of wine from the servant, perhaps an allusion to the Lutheran

doctrine of communion in both kinds.[113] Another is the inclusion of the paschal lamb, which in earlier paintings often was omitted from this scene.[114] This concern for historical accuracy is characteristic of much early Lutheran art and reflects, in part, the seriousness with which the reformers took the scriptural message.[115]

The two wing panels depict on the left the *Sacrament of Baptism*, with Philipp Melanchthon officiating; on the right *Confession*, being heard by John Bugenhagen, pastor of the City Church (fig. 9).[116] Thus the saints traditionally found on side panels have been replaced by two of Luther's fellow reformers: Melanchthon, in the place of John the Baptist, and Bugenhagen, shown holding the keys, in place of St. Peter.[117] The predella painting shows Luther preaching to a congregation, while pointing with his right hand like John the Baptist[118] to the large figure of Christ, who hangs on the cross between the preacher and his auditors.

The pictorial ensemble on the front side of the altar, when viewed in its entirety, may be interpreted on many different levels. It is, with its portraits of the reformers, a memorial to the Reformation.[119] It is, in another sense, a depiction of the Lutheran conception of the sacraments, for it will be recalled that at times Luther spoke of absolution also as a sacrament.[120] It is, further, a proclamation in visual form of the Lutheran doctrine of the church—the church, in the words of the Augsburg Confession, "as the assembly of all believers among whom the Gospel is preached in its purity and the holy sacraments are administered according to the Gospel."[121] It may also be seen as a confession of faith on the part of this *particular* congregation, in the reality of the true church in their own midst.[122] Here the Gospel is being preached in all its purity and the sacraments properly administered. And not only is the congregation itself given tangible form in the predella scene, but on each of the wings a group of its members stands as participants in or representative observers of the saving events taking place there.[123] Bugenhagen served as pastor of this congregation for many years, and Luther himself, of course, did much of his preaching from the pulpit of this very church where the altar is located.[124] Finally, the great reformer's inclusion here among the disciples partaking of the original Lord's Supper may be interpreted as an attempt to assert the validity of the Lutheran rite of the sacrament of

the altar,[125] the sacrament of Holy Communion as it was celebrated by this congregation, itself a partial concretization of the communion of the saints.[126]

The Weimar Altar. Located in the City Church of Weimar, this altarpiece was a donation of the sons of John Frederick, former Elector of Saxony.[127] The central panel and the predella inscription both bear the date 1555.[128] Although the work may have been begun by Cranach the Elder, it cannot have been finished by him, since the aged master died in 1553. Art historians generally have attributed the completion of the work to Lucas Cranach the Younger.[129] Because of the inclusion of the elder Cranach's portrait in the central panel, the altarpiece sometimes is seen as a memorial to the artist, as well as to John Frederick and his family.[130]

The central panel of this altarpiece depicts a variant form of the Law and Gospel theme (fig. 10).[131] In this instance the careful spatial segregation of Law and Gospel elements has virtually been abandoned, although many of the familiar iconographical details have been preserved. The first thing one notices when examining this work is that the customary tree standing in the center and dividing the composition into two compartments has been replaced here by a large figure of Christ on the cross, extending from near the base to the very top of the picture space.[132] At the foot of the cross appears the Lamb with the banner. To the left we see in the immediate foreground a large figure of the risen Christ trampling upon death and the devil. Behind Him, there are much smaller figures of sinful man being pursued by death and Satan. To the right of the cross, proceeding from top to bottom, are representations of the Annunciation to the Shepherds; the Hebrew Encampment in the Wilderness and the Brazen Serpent; a group of Old Testament Prophets, including Moses with the Tablets of the Law; and a group of three very large figures in the foreground, easily identified as St. John the Baptist pointing to Christ on the cross, Lucas Cranach the Elder standing with his hands in an attitude of prayer, and Martin Luther, who holds an open book with one hand and with the other points to a scriptural text inscribed upon one of its pages.[133] A stream of blood spurting from the wound in the Saviour's side falls upon the head of the artist.

Although this painting perhaps is the most impressive, aesthetically, of all the Cranach Law and Gospel compositions, whether it preserves the doctrinal clarity and precision of the earlier panels may be questioned.[134] On the other hand, through the incorporation of the Luther portrait, this work relates the theme to the Reformation more explicitly than any of the others.

The central panel of the Weimar altarpiece is flanked by wing panels depicting a combined portrait of John Frederick and his wife, and a group portrait of John Frederick's three sons. Their inclusion here can be taken to mean that the altar is not the confession of faith of Cranach alone, but also that of the princely family.[135] When the wing panels are closed, we see another pair of compositions revealed: the *Baptism of Christ* and the *Ascension of Christ*. Oskar Thulin has pointed out that while on the Gotha version of the Law and Gospel theme the Ascension of Christ motif is included in the series of New Testament episodes as the last earthly appearance of the Lord, here the motif has been separated from the others and made the independent subject of a wing panel.[136] When the Ascension of Christ is placed with the Baptism of Christ, the two scenes depict the beginning and concluding occurrences in the public ministry of Christ on earth. For it was Jesus' baptism that became the occasion for the full revelation of His divinity.[137] The predella of this altar contains only the dedication inscription.

The Kemberg Altar. This work, in the parish church of the town of Kemberg, was donated in all probability by the incumbent church provost, Matthias Wanckel. It was executed by Lucas Cranach the Younger and his workshop and bears the Cranach insignia and the date 1565.[138]

The altar has one set of fixed wings and another set of movable wings. The paintings on the fixed wings are *The Fall* and the *Brazen Serpent*. Coiled around the stem of the Tree of the Knowledge of Good and Evil is the serpent that tempts Adam and Eve to their tragic disobedience. Elevated on the T-cross of the opposing composition is the Brazen Serpent, upon the form of which the Hebrews in the wilderness were instructed to look in order that they might be saved.[139] Both show man placed in a moment and place of decision: to obey and live or to disobey and suffer the penalty of

death.[140] When the movable wings are closed, the central area of the altar reveals two additional compositions: *The Flood* and *Lot and His Daughters*. These two themes also, as we have seen, suggest man's sin and divine deliverance.

When the movable wings are opened, three more paintings appear, all portraying subject matter that we have previously encountered: the *Crucifixion* (central panel), the *Baptism of Christ*, and the *Resurrection of Christ*. In this case, unity again is achieved through the common christological emphasis: (1) Christ's sacrifice, i.e., Crucifixion; (2) God's acknowledgment of His Son, i.e., in the Baptism event; and (3) the overcoming of the power of death in Christ's Resurrection.[141] It should be pointed out that although all three of these motifs were used in earlier Cranach altars, this particular combination is not found previously in Lutheran altar art. Although the Cranach workshop operated on an almost mass production basis and frequently repeated subject matter, it never produced works, either individual panels or altar ensembles, that were exact copies of earlier ones. There was always something new or different about each monument.[142] A further striking and novel feature in the Kemberg altar is the group of portraits of contemporary figures included as witnesses in the Baptism of Christ scene, providing yet another example of the frequent Cranach practice of disregarding the problem of historical anachronism and bringing his own coreligionists into direct association with the personages and events of the New Testament.[143] Here a large group of men observe the baptismal episode—or rather, two groups: one made up of the probable donor, the Kemberg church provost Matthias Wanckel, and a figure perhaps intended to represent his brother; and the other, containing the figures of Luther, Melanchthon, Bugenhagen, Justus Jonas, and Bartholomew Bernhardi (Wanckel's father-in-law and predecessor as provost), to mention the most important.[144]

The predella of the Kemberg altar depicts the Last Supper (fig. 11). Thulin says that it too contains contemporary portraits, although he does not identify them.[145] Here Christ sits in the center of a long rectangular table. He is shown in the act of breaking the bread. As we shall see, this is the only one of the four Last Supper compositions found on Cranach Reformation altarpieces where the motif of Christ proffering the morsel to the mouth of Judas is not portrayed.

The Dessau Altar. This altarpiece, intended for the Dessau Castle Church, was painted for Joachim, Prince of Anhalt, by Lucas Cranach the Younger in 1565.[146] The construction of this church had been completed in 1554.[147] The altarpiece itself has been called by Thulin "the last of the great Cranach altars of the Reformation."[148]

The Dessau altar contains only one painting, a representation of the Last Supper (fig. 12). As in the Kemberg predella, the figure of Christ is shown at the center of the composition. As in the Schnee-berg predella and the Wittenberg central panel, Christ is engaged in offering the bite of food to His betrayer. But here the similarities with other works end, and several noteworthy features of the panel claim our attention. First, the event takes place in a decidedly Renaissance architectural setting. Second, we become aware of the presence of an explicit donor portrait, the figure of Joachim of Anhalt kneeling in the left foreground. But most significant is the discovery that virtually all the disciples seated at the table with their master bear the features of sixteenth-century reformers. To Jesus' right we see George of Anhalt (a brother of Joachim who had become a Lutheran clergyman, here in the role of St. John),[149] Luther, Bugenhagen, Jonas, and Caspar Cruciger. On Jesus' left are Melanchthon, Johann Forster, Johann Pfeffinger, George Major, and Bernhardi. One disciple has not been identified.[150] Judas sits isolated on the side of the table nearest the viewer. An interesting attempt has been made recently to see in him too a contemporary personality.[151] The cupbearer serving the wine wears a ring bearing the Cranach insignia; he has been recognized as the younger Cranach himself.[152]

The painting probably should be interpreted as a confession of adherence by the house of Anhalt to the Lutheran Reformation.[153] The ruling princely family seems to have had unusually close connections with the great reformer. Joachim had stood as godfather to Luther's daughter Margarete; Luther had performed the same honors for the son of Joachim's brother Johann.[154] Ties with Melanchthon also were strong. George of Anhalt, the clergyman brother shown next to Jesus, was renowned for his religious piety.[155] Another concern, one of an apologetic nature, may also have been expressed here. In response to the Catholic accusation that the Lutherans were no true church, we here see their leaders, just as the original disciples, in direct and genuine communion with the Lord of the

church.[156] As Thulin states, "The Lord's Supper, as the ever new primordial cell of the church, is the theme of the altar at Dessau."[157]

It has been observed that the artist here has gone unusually far, even for the Renaissance perhaps, in making the meal a contemporaneous event.[158] Only Jesus and Judas lack sixteenth-century clothing, and, as has been mentioned, even the Judas figure may have been intended to suggest a living personality. The prominence given the Renaissance architectural backdrop might be thought to lend the painting an almost secular air. In any case, it is one of the most complete group portraits of the Wittenberg reformers that we possess.[159] In a sense it is a consummation of that trend begun with the inclusion in ecclesiastical art of the single figures of Luther, Melanchthon, and Bugenhagen on the Wittenberg altar, the figures of Luther and Cranach on the Weimar altar, and the small group of identifiable reformers on the Kemberg altar.[160]

The Regensburg Altar (1553–1555). The only altarpiece to be discussed here that was not executed by the Cranachs, the Regensburg altar, was painted by Michael Ostendorfer for the Neupfarrkirche (New Parish Church) in that city.[161] This relatively small but iconographically very interesting altar was commissioned from Ostendorfer by the Protestant municipal government.[162] The church for which it was destined had been closed since the proclamation of the Augsburg Interim in 1548, and when it was reopened in 1552, the city fathers and congregation apparently decided it needed a new altar that would reflect their Lutheran views.[163]

The Regensburg altar is a triptych altar with movable wings painted on both sides. When the wings are closed and the outside paintings displayed, the following scenes appear: *Annunciation to the Virgin* (upper left); the *Crucifixion* (lower left); *Birth of Christ* (upper right); *Entombment of Christ* (lower right). When the wings are opened, first of all, the central panel with its two-part composition can be seen. In the upper portion of the picture space we find the *Holy Trinity and the Dispatching of the Apostles.* Between the figure of God the Father and the group including Christ and the apostles, two scrolls appear, borne aloft by baby angels, which contain biblical inscriptions (e.g., Mark 16:15: "Go into all the world and preach the gospel to the whole creation").[164] In the lower,

somewhat smaller portion, is portrayed a theme that might be called Repentance and Forgiveness. In the center appears a Protestant congregation; at the left, a preacher admonishes his hearers to repentance (near him a scroll with an inscription based on Mark 1:15, "Repent, and believe in the Gospel"); at the right, a Lutheran pastor hears confession (above this scene a scroll bears an inscription based on Luke 7:48, "Your sins are forgiven").[165] On the inner side of the left wing we find three separate compartments, each with its own composition (from top to bottom): *Circumcision of Christ, Baptism of Christ,* and the *Sacrament of Baptism.* And, finally, on the inner face of the right wing panel appear the *Passover Meal of Christ and the Disciples,* the *Last Supper,* and the *Lutheran Celebration of Holy Communion.* No predella panel is extant.

Although Ostendorfer probably never saw any of the Cranach Lutheran altars,[166] the Regensburg artist was very likely indebted to the Wittenberg master for iconographical inspiration, through either personal channels or the medium of the graphic arts.[167] The Ostendorfer altar is reminiscent of the Wittenberg altar in its reflection of the Lutheran view of the church as the body of believers who, penitently acknowledging their sins and receiving absolution, respond to Christ's commission to go out and preach the Word in its purity and to administer the sacraments according to the Gospel.[168] Again like the Wittenberg altar, the Regensburg work, particularly when seen open, is in another sense an elaboration of the Lutheran view of the sacraments: the scenes on the left wing all pertaining to baptism, those on the right wing all pertaining to Holy Communion, and the central composition displaying a representation of repentance and confession.

Yet the Regensburg master appears to have added an important new feature of his own, in the manner in which he brings together in a vertical sequence the three related compositions on each of the inner wing panels.[169] In both instances we find portrayed three different references to the one particular sacrament being treated: the typological or prefigurative (Circumcision of Christ, Passover Meal), the New Testament or historical (Baptism of Christ, the Last Supper), and the contemporary or liturgical (Sacrament of Baptism, Holy Communion).[170] Of course, there is nothing at all new about the typological or historical motifs that Ostendorfer employed in

these wing panels. The Circumcision of Christ appears on many late medieval altars; these earlier compositions, further, often contain visual references, such as the baptismal font, to the parallelism between this particular rite and Christian baptism.[171] Similarly, the Baptism of Christ was not an unheard-of motif for German altar panels; more than this, it was traditional in Christian thought that this event should be understood as the prototype of all later baptisms.[172] To combine both scenes with another portraying the Lutheran rite of infant baptism, however, was an intelligent and, from the standpoint of early Protestant altar iconography, creatively innovative step. It also provided an opportunity to re-emphasize Luther's view that the link between circumcision and baptism strengthened the theological argument underlying his practice of administering the latter sacrament to infants.[173]

Much the same can be said of the eucharistic compositions portrayed on the right side. The Lutherans claimed that in distributing the elements of the Holy Communion to the laity in both kinds, they were following Christ's intention and re-establishing apostolic practice.[174] The depiction of the Last Supper together with a representation of the contemporary sacrament was no doubt intended in part to reaffirm this assertion.[175] Showing the Passover meal here as a prefiguration of the original Lord's Supper (in itself a common enough practice),[176] in effect, pushed the pedigree warrant of the Lutheran practice even further into the remote past and reinforced the claim to be following the authentic tradition.[177]

Iconographical Analysis. Having examined individually at least a few of the earliest and best-known Lutheran altars, we now need to direct some attention to a study of the subject matter portrayed in these and similar works, for it is apparent that the new altarpieces differed from their late medieval forerunners not so much in construction or format as in iconography.[178]

We may begin by examining, for purposes of comparison with the Cranach and Ostendorfer altars, the findings of the German scholar Hans Carl von Haebler, who has analyzed a sample of thirty east German Protestant altars dating from the period 1560–1660.[179] The iconographical data resulting from his research can be reduced to the following form:

Theme	Frequency of Use
Last Supper	30
Crucifixion	23
Birth of Christ	17
Resurrection of Christ	14
Ascension of Christ	10
Other	151
Total	245

Perhaps the most striking fact to emerge from such a comparison is the predominance of the Last Supper motif in early Lutheran altarpiece art. The only Cranach altar without it is that in Weimar, and even that one contains an unusually explicit eucharistic reference in the motif of the stream of blood flowing from the side of the crucified Saviour onto the head of Lucas Cranach the Elder.[180] Of the remaining four Cranach altars, two—Wittenberg and Dessau—present the Last Supper theme in the central panel, while the other two, Schneeberg and Kemberg, put it in the predella panel.[181] Ostendorfer, on the other hand, used the motif on a wing panel of his Regensburg altar. All thirty of the altars cited by von Haebler contain a representation of the Last Supper—twenty-three as the motif employed on predellas, where it more often came to be placed,[182] and seven as the theme of the central panel of the first tier above the predella. This predominance of the Last Supper can be confirmed by citing yet another, entirely different sample of early Lutheran altars—in this case all dating from the sixteenth century (1559–98). Of some fourteen such altars (not including any thus far discussed or tabulated) on which the *Reallexikon zur deutschen Kunstgeschichte* provides iconographical data, at least ten include a depiction of the Last Supper.[183] Five of the compositions appear in the central panel, two on the predella, one on a wing panel, and the location of the remaining two is unspecified.[184] It might also be noted that Last Supper compositions apparently were sometimes added as a central panel or predella to older altars, in order to adapt them to Lutheran worship.[185]

This preference for the Last Supper motif is especially noteworthy in view of the fact that the theme appeared relatively infre-

quently in previous altar art. In support of this assertion may be adduced the evidence presented in the appendix of this book, in addition to the statements of numerous scholars writing on the subject.[186] Of the 441 late medieval German religious paintings tabulated in the appendix, only four depict the Last Supper. It has not been possible to establish the original purpose or location of all of the 441 panels, but it is known that, at the very least, somewhat more than half of them formed parts of altarpieces.[187] If the Last Supper motif had been popular as a theme for altarpiece painting, one certainly would have expected it to appear more than four times in a sample of this size.

It would seem that in the later Middle Ages surprisingly little use was made of the eucharistic potential of the Last Supper motif as a subject for altarpiece art.[188] The reasons for this are not yet entirely clear, particularly in the case of Germany.[189] Certain scholars have made a few interesting suggestions, however, which, when applied to the German scene, may help to explain this rather unusual development. Klaus Lankheit has proposed that one reason for the relatively infrequent use of the Last Supper motif as a eucharistic reference in the medieval west may derive from the fact that over the centuries the communal meal symbolism of the sacramental liturgy had been more and more subordinated to the sacrificial concept of the Mass.[190] If this is true, perhaps there were other iconographical themes that more effectively suggested this latter doctrine, such as, for instance, the Crucifixion scenes.

In his recent study of the Last Supper in Italian Renaissance art, Creighton Gilbert has made certain observations that also may prove relevant here. First, he notes, "At this period in Italy paintings in chapels, i.e., altarpieces, do not so much function to assert that they are on an altar, as to assert the dedication of their altar differentiated from other altars. They state more emphatically that this is the altar of Saint Lucy than that this is a consecrated table." He continues, "We seem to find Last Suppers on altars when the dedication of the particular altar is appropriate, rather than as an element of altars in general."[191] Apparently we may conclude from this that in the later Middle Ages a Last Supper altarpiece might well have been prepared if the altar in question was dedicated to the Feast of the Corpus Christi or the eucharistic rite, as for example

that upon which Dieric Bouts' famous panel rested in Louvain,[192] but probably not if the altar was dedicated to the Virgin or some other saint. It should be remarked in this context, however, that the artists and churchmen of the pre-Reformation period did have at their disposal several other iconographical motifs with a recognized eucharistic reference, which could be employed when and if there was a wish to portray specifically sacramental symbolism on the altarpiece: the Deposition of Christ, the Entombment of Christ, the Mass of St. Gregory, to name but a few.[193]

In any case, the contrast between late medieval usage and early Lutheran altar art is so great as to force one to raise the question: Wherein lies the significance of the Last Supper motif for the German reformers and their successors? One obvious explanation is that Luther himself on at least one occasion singled out this theme as especially suitable for use on altars. Although his statement has been quoted in an earlier chapter, it is sufficiently important in this particular context to justify reproducing it again. The comment was made in the text of his 1530 treatise entitled *Commentary on Psalm 111:*

Whoever is inclined to put pictures on the altar ought to have the Lord's Supper of Christ [*abendmal Christi*] painted, with these two verses written around it in golden letters: "The gracious and merciful Lord has instituted a remembrance of His wonderful works." Then they would stand before our eyes for our heart to contemplate them, and even our eyes, in reading, would have to thank and praise God. Since the altar is designated for the administration of the Sacrament, one could not find a better painting for it. Other pictures of God or Christ can be painted somewhere else.[194]

If the theme were in itself unsuitable for Lutheran altars, it might be questionable if even Luther's endorsement would have been adequate to insure its great popularity. But, of course, it was not in the least unsuitable; indeed, it might be thought to be uniquely appropriate to the expression of certain fundamental tenets of early Lutheran eucharistic theology. As von Haebler suggests, these might be summarized as follows:[195] (1) Placed directly over the altar, the Last Supper painting designates the former as the table of the Lord, serves as an invitation to commune, and suggests that those participating in Holy Communion are in a sense an extension of the original circle of disciples. (2) In the original Lord's Supper, as in Protes-

tant worship, no priest or intermediary officiates; rather, Christ Himself appears as the distributor of the sacramental elements.[196] (3) Communion in both kinds, when celebrated before such an altarpiece, can be understood as participation in the Last Supper of Christ and requires no further theological justification than such manifest evidence as is provided in this portrayal of the original event.

The somewhat polemical or, at any rate, apologetic tone of the last two points is clear enough. Given the contentious climate of Reformation Europe, this factor alone may help to explain the popularity of the Last Supper theme in early Lutheran iconography. Or perhaps it is to be accounted for in part merely by the new prominence given to eucharistic theology by the debates of the Reformation.

Luther's own statement, however, contains no polemical or apologetic overtones, and one is forced to inquire just how adequately the early Lutheran altar paintings of the Last Supper reflect his expressed intentions. In his comment, two emphases seem to emerge: (1) a reminder that the theme is above all appropriate because it stands on the altar, that place designated for the administration of the sacrament, and (2) a reference to Christ's institution of the sacrament, as "a remembrance of His wonderful works." Are the early Lutheran artists, above all the Cranachs and Ostendorfer, guided by Luther's suggestions? Or by the scriptural accounts of the Last Supper? Or by the artistic tradition? And if the last, by which elements of the iconographical tradition?

If one carefully studies the biblical texts describing the original Lord's Supper, it is possible to distinguish at least five different events: (1) the common sharing of the Passover Meal, (2) Christ's announcement that one of them will betray Him, (3) the disciples' reaction to this statement, (4) Christ's designation of Judas as the one who will betray Him, and (5) Christ's institution of the sacrament.[197] In late medieval art, the Passover meal theme generally is combined with other motifs and in some instances may be suggested by the inclusion in the composition of the Passover lamb.[198] Christ's announcement, however dramatic, is in itself not well suited to visual portrayal; therefore, this act commonly is implied in the artistic representation of either the disciples' reaction to the statement, as in Leonardo's brilliant psychological interpretation, or

the traitor designation. The designation-of-Judas motif was especially prominent in German art tradition.[199] Compositions depicting the institution of the sacrament, although growing in popularity in the later Middle Ages,[200] were much less common than those portraying the betrayal theme.[201]

How do the Cranach and Ostendorfer Last Supper altar panels correspond to the biblical themes and artistic traditions? The Passover meal motif definitely is suggested, most explicitly by the inclusion of the paschal lamb (Wittenberg, Kemberg, Dessau). Eating utensils also appear (Wittenberg, Kemberg, Dessau, Regensburg). The reaction of the disciples to the announcement of the betrayal is suggested at least on the Wittenberg and Dessau altarpieces. In three of the four Cranach compositions (Schneeberg, Wittenberg, Dessau), Christ is shown extending the morsel to the lips of Judas; thus we have a representation of the motif of the designation of the betrayer. In the fourth (Kemberg), the scene shown is that of Christ breaking the loaf of bread. In western art this motif had come to signify the institution of the sacrament.[202] In the Ostendorfer panel, finally, Christ is depicted holding the chalice in His left hand, while He extends the right in a gesture of blessing. This too, clearly, is intended to suggest the institution of the sacrament.[203]

Thus, it is clear that the Cranachs (if not Ostendorfer) for the most part adhered to the traditional Judas-designation motif. Was this merely unthinking conservatism? How appropriate is the emphasis upon this particular incident for use on altar panels? It is clear, first of all, that when employed as part of Passion cycles, as sometimes found in late medieval altar painting, the theme is most fitting.[204] The early church fathers had described Judas' betrayal itself as one of the most grievous sufferings that Christ had to bear.[205] And it was, of course, this treacherous act that led to Christ's arrest and crucifixion. But what of altar panels in which the scene does not appear in the context of the Passion narrative and in which the intention might be thought to be more strictly eucharistic in nature? Here, certain things about the liturgical and iconographical traditions must be said. First, the medieval liturgical texts, which were important as a source for the artists, drew heavily upon the account as found in the Gospel of John.[206] John alone of the Gospel writers had provided the following detail concerning the

identity of the betrayer (13:26): "Jesus answered, 'It is he to whom I shall give this morsel when I have dipped it.' So when he had dipped the morsel, he gave it to Judas, the son of Simon Iscariot." Also, in his account of the Last Supper, John did not describe the institution of the sacrament. Second, given the associations that had grown up around the Judas-designation motif, it had come to bear a closer relationship to the eucharistic idea than might at first be apparent. Western art generally drew no sharp distinctions between historical and liturgical presentations of the Last Supper theme.[207] The Last Supper was viewed more as a unity, and the historical event was invested with symbolic significance.[208] It might be said that often the institution of the sacrament was intended as the central point, even in compositions where the designation of Judas is portrayed.[209] Indeed, the extension of the morsel of bread to the mouth of Judas often was viewed in the Middle Ages as a part of the distribution of the sacrament.[210] Luther, it is clear, believed that Judas received the Body of Christ in the Lord's Supper.[211] Thus, given the medieval theological, liturgical, and iconographical traditions, it would seem that even the Cranach altar panels focusing on the designation of Judas as the betrayer come closer than a modern viewer might suspect to fulfilling Luther's intention that altar paintings make manifest that "the gracious and merciful Lord has instituted a remembrance of His wonderful works" and that "the altar is designated for the administration of the Sacrament."

One still might question, of course, whether the breaking of the loaf (Kemberg altar) or the blessing of the chalice (Regensburg altar) are not artistic motifs better suited to representing the idea of the institution of the sacrament. It may well be, however, that the latter motif was avoided by the Cranachs because the blessing gesture seemed too suggestive of the priest's actions in the consecration of the Roman Mass, with the attendant doctrine of sacrifice.[212] The chalice, further, had become a symbol of transubstantiation.[213]

It may also be the case, however, that by the time of the creation of most of these altars, other even more overtly confessional or polemical concerns had come to the fore, and that Luther's 1530 statement was not being followed as a complete formulation of all that a Lutheran altar painting of the Last Supper might express. Gerhard Pfeiffer recently has suggested that the 1565 Dessau altar

painting of the Last Supper was intended partly as a warning against apostasy and an unworthy reception of the sacrament.[214] Part of Pfeiffer's argument rests upon an ingenious attempt to identify the Dessau Judas as a portrait of a defector from the Lutheran party to Roman Catholicism. It is not necessary here to go into the details of his evidence. It should be noted, however, that while such a contemporary reference, if indeed intended, would seem to give the iconography a purely local and chronologically limited significance, the theme of the unworthy reception of the sacrament itself was a much more universal one. In the New Testament, for example, we find the following statement (1 Cor. 11:27–29): "Whoever, therefore, eats the bread or drinks the cup of the Lord in an unworthy manner will be guilty of profaning the body and blood of the Lord. Let a man examine himself, and so eat of the bread and drink of the cup. For any one who eats and drinks without discerning the body eats and drinks judgment upon himself." This concept also appears in early Lutheran writings. According to Melanchthon, in the *Apology of the Augsburg Confession*, "Christ says . . . that those who receive [the sacrament] in an unworthy manner receive judgment upon themselves."[215] Luther, in his *Large Catechism*, maintained that "those who despise the sacrament and lead unchristian lives receive it to their harm and damnation."[216] Pfeiffer argues that the fact that Judas was a communicant at the first Lord's Supper had for Luther a significance symptomatic of the fate of the Christian congregation, among whom there unfortunately would be found traitors.[217] Thus, Luther's views of the inevitably mixed (i.e., pure and impure) nature of the visible or institutional church perhaps are reflected here, along with the above-mentioned warning.

Gertrud Schiller, on the other hand, has asserted that panels such as the Dessau Last Supper may have had as one of their purposes to document the correctness of the eucharistic doctrine of the German reformers and especially the Lutheran teaching of the Real Presence of Christ in the sacrament, as over against the Reformed or Calvinist position.[218] Unfortunately, she does not make entirely clear the evidence for her assertion, although she seems to have been thinking of the sanction provided by the honored position accorded the Lutheran reformers in the composition in the place of the original disciples.

Epitaph Monuments

By far the largest single group of art works installed in Lutheran churches in sixteenth-century Germany was that composed of epitaph monuments.[219] The term perhaps requires some explanation.[220] As used in German art history, it does not refer merely to a written funerary text. An epitaph, rather, is an artistically conceived memorial or monument honoring the deceased and normally containing three parts: a portrait, a painted or sculptured representation of a religious theme, and a commemorative inscription. The epitaph need not stand in close proximity to the place of interment; thus, it serves a purpose different from the burial marker or tomb monument. Frequently one finds both a tombstone and an epitaph in honor of the same individual.

Unlike the altar in early Lutheranism, a large number of epitaphs could be installed in the same sanctuary. Even today many churches in Protestant areas of Germany still contain many of these memorials, a significant proportion of them deriving from the sixteenth century. These monuments vary greatly in size, format, placement, and artistic merit. Some consist of little more than plaques adorning a pillar or side wall, while others are ostentatiously large structures, rising as much as twenty-five feet or more in height. Memorials to princely or aristocratic personages typically are of stone, though middle-class Lutherans usually preferred the less costly wood construction.

The epitaph was no new invention of the Reformation period; it arose in the late Middle Ages and continued to enjoy widespread popularity in both Protestant and Catholic lands up to the end of the eighteenth century. The special conditions arising from the introduction of the Reformation, however, combined with the growing Renaissance spirit of self-advertisement as reflected in the portraits and laudatory inscriptions, made the epitaph the most common type of art endowment in sixteenth-century Protestant churches. One reason for the new importance of the epitaph, relative to other forms of ecclesiastical art, can be found in the demise of many of the cultic practices associated with medieval Roman Catholicism. Lutheran worship, as we have seen, required less in the way of liturgical art. Possibilities for further art endowments, it is true, did not entirely

vanish with the coming of the Reformation. Some new church construction, and even more remodeling of existing structures, for example, were undertaken, with a resulting need for ecclesiastical furnishings.[221] Existing works could also be replaced for a variety of reasons. The change in theology brought with it a somewhat altered conception of the importance of certain of the traditional art forms. For example, private donors sometimes responded to the greater emphasis now placed upon preaching by contributing large and impressive pulpits, elaborately carved with sculptural relief in the Renaissance manner.[222] Works, such as altar panels, that in their content did not conform to Lutheran doctrinal standards or piety might be supplanted with new ones. Aesthetic factors also no doubt played a part, for it can be assumed that some sixteenth-century Lutherans, in their desire to adorn God's house with objects of beauty, preferred art works harmonizing with the stylistic tastes of their own time, rather than the inherited monuments. With respect to most of the usual types of ecclesiastical art, however, the nature of the Protestant faith placed certain restrictions upon the opportunities for new benefactions. The use of the epitaph monument offered the greatest potential for growth. The number of these memorials that might be installed in a given church was limited only by the physical space available. One church in the city of Brandenburg to this day contains nine Protestant epitaph monuments dating from the sixteenth century (fig. 13).[223] In a sense, these works perhaps compensated for the earlier side altars and private chapels, at least where the latter had been removed.[224]

An examination of the iconography of the epitaphs reveals the utilization of many of the same themes found also on independent panel paintings and early Lutheran altarpieces. On the other hand, a few motifs seem especially characteristic of the funerary monuments.[225] In both instances, the themes are largely biblical in inspiration. A content analysis of the subject matter of the main or central composition of approximately seventy German Protestant epitaphs (ca. 1540–1600) reveals the following distribution of motifs:[226]

Crucifixion or Crucifix	13
Resurrection of Christ	11
The Law and the Gospel	4

Christ Blessing the Children	3
Baptism of Christ	3
Raising of Lazarus	3
Last Judgment	3
Various Events Related to the Birth of Christ	5
Scenes from the Passion (other than the Crucifixion)	4
Old Testament Themes	4
Other Religious Themes	8
Nonreligious Subject Matter	13

The Crucifixion theme, of course, was a traditional one in Christian funerary art. For early Lutherans, the event took its greatest significance from the fact that the atoning death of Christ stood as the necessary prerequisite for personal salvation.[227] As the Wittenberg reformer expressed it in his widely used *Small Catechism:* "I believe that Jesus Christ . . . has redeemed me, a lost and condemned creature, delivered me and freed me from all sins, from death, and from the power of the devil, not with silver and gold but with his holy and precious blood and with his innocent sufferings and death."[228]

The Resurrection of Christ also is a very common theme on early Lutheran epitaphs. In Luther's theology the individual's expectation of a life beyond death was always based on the fact of the resurrection of the Saviour.[229] Indeed, he liked to remark that the Christian's own resurrection is more than half accomplished already, through that of Christ, the Head.[230] But as an artistic motif it could claim no novelty; it had been commonly employed on epitaphs in the later Middle Ages.

The Law and the Gospel and Christ Blessing the Children are two themes that already have been discussed.[231] When used on funerary art, the former motif presumably was intended to console the bereaved and to warn the religiously indifferent of the fate of those who died under the Law and without coming to an acceptance of the Gospel. An interesting adaptation of the Law and Gospel idea to the epitaph setting was painted by Lucas Cranach the Younger in 1557 in honor of the Badehorn family in Leipzig.[232] A striking feature of this work is that the son of the deceased, who was also the donor, is portrayed twice: once kneeling, together with

his father and five brothers in the left foreground; and again as the nearly naked man being referred to the crucified Christ by John the Baptist. Iconographically, this panel closely follows the Weimar altar prototype.

The subject of the Baptism of Christ seems to have been used about as frequently on Lutheran epitaphs as on altarpieces, although the funerary context very likely gave it a somewhat different meaning.[233] The relevance of this event to death perhaps is not immediately apparent. As an artistic motif it was employed in the early and medieval church as a standard symbol of the Trinitarian doctrine. As André Grabar notes, "It had the advantage of being supported by a phrase of the Gospels which affirms that at the moment of the baptism of Jesus there was a simultaneous theophany of the three Persons: the voice of God the Father was heard descending from heaven; God the Son stood in the waters of the Jordan; and God the Holy Ghost appeared as a dove hovering over the Son."[234] It is not impossible that the intention here too may have been to affirm Lutheran orthodoxy with respect to another doctrine that was being challenged by a few of the more radical spirits in the left wing of the Reformation.[235]

But the Baptism of Christ scene also can be more directly related to the eschatological hope associated with death in Christian theology. From the very beginnings of Christian tradition, as has been mentioned, this event had been understood as the prototype for all later baptisms.[236] And the sacrament of baptism itself, of course, signified for the Christian the ultimate promise of eternal salvation; in his *Small Catechism* Luther includes in the section on baptism the verse from the Gospel of St. Mark (16:16): "He who believes and is baptized will be saved."[237]

In that same section of the *Small Catechism*, however, the reformer provides what may well be another reason for the use of the Baptism of Christ motif on some of these epitaphs. He quotes directly from St. Paul's Letter to the Romans (6:4): "We were buried therefore with him by baptism into death, so that as Christ was raised from the dead by the glory of the Father, we too might walk in newness of life."[238] Thus the themes of baptism and death are linked in a much more than purely formal manner. Luther's meaning is made even clearer by his discussion of the matter in his 1520

tract, *The Babylonian Captivity of the Church:* "Baptism, then, signifies two things—death and resurrection, that is, full and complete justification. When the minister immerses the child in the water it signifies death, and when he draws it forth again it signifies life."[239] Further, the reformer strongly emphasizes that baptism is not merely a once-in-a-lifetime event that loses its significance as the believer progresses in the faith. The Christian lives his entire life in his baptism and then dies in its promise: "The sooner we depart this life, the more speedily we fulfil our baptism."[240] Death also is the fulfillment of God's promise made to the Christian in his baptism, in that his sin is finally and completely put to death.[241] It seems reasonable, therefore, to view the epitaph representations of the Baptism of Christ as an interesting manifestation of the influence of Luther's Pauline theology even upon the iconography of mortuary monuments.

One of the more noteworthy epitaph monuments bearing this Baptism of Christ theme is that painted in 1560 by Lucas Cranach the Younger in honor of John Bugenhagen and located in the choir of the City Church in Wittenberg.[242] In addition to the biblical event in the center foreground, we see the clergyman kneeling with his sons at the left, while his wife and daughters kneel at the right—a common arrangement of the donor's family on epitaphs. Since one of Bugenhagen's special concerns as a theologian had been the defense of the orthodox doctrine of the Trinity,[243] the older meaning of the Baptism of Christ motif may well have figured in the planning of this particular monument.

The theme of the Raising of Lazarus, although sometimes depicted on early Lutheran altars,[244] undoubtedly was found even more appropriate for use on epitaphs.[245] This story of Jesus' restoring a deceased man to life constituted for the church an important New Testament prefiguration of the resurrection of the dead;[246] the motif had appeared in Christian burial art from a very early date.[247] The biblical passage describing this event, quite fittingly, was one of those most commonly read at Lutheran funeral services in sixteenth-century Germany.[248]

A good example of an epitaph (1558) displaying a scene of the Raising of Lazarus is that commissioned from Lucas Cranach the Younger by the widow of Michael Meyenburg, recently deceased

syndic and burgomaster of the free imperial city of Nordhausen (fig. 14).[249] The monument (now destroyed) consisted of two panels: the painting, and a separate plaque containing a remarkably laudatory and rhetorical Latin inscription. In addition to the central participants in the miracle story, and a circle of spectators, portrayed on the left side of the painting is a group made up of Luther, Erasmus, Melanchthon, Bugenhagen, Justus Jonas (who hailed from Nordhausen), and other reformers. The deceased, his two wives, and their children, all pictured in a kneeling position, appear in a row in the foreground. Finally, displayed rather conspicuously at the very base of the panel, are the coats of arms of Meyenburg and his spouses.

The prominence given donor and family portraits, the frequent application of highly visible coats of arms, and, perhaps above all, the nature of the texts of some of the commemorative inscriptions, all testify to the fact that the motives for erecting these epitaph monuments in the sixteenth-century Lutheran churches were by no means always purely religious in nature. And yet it is equally manifest that, along with altarpieces and other ecclesiastical art forms, the epitaphs were intended to help propagate the Lutheran conception of the Gospel message. In addition to providing religious instruction and edification to the onlooker, moreover, these funeral memorials also served as a witness to the faith of the donor and gave expression to the eschatological hope of the Christian community.

Conclusion

Now that we have briefly surveyed the early Lutheran achievement in the realm of religious panel paintings, altarpieces, and epitaph monuments, the time has come for an attempt to assess the historical significance of this body of Reformation art. We shall focus primarily upon a topic that is emphasized throughout this entire chapter—iconography.

First it may be said that, with the exception of the unique combination of motifs brought together in the Law and Gospel compositions, there appears to be relatively little that is strictly new in the subject matter of early Lutheran painting and sculpture. Rather than large-scale iconographical innovation, we typically find the exercise

of a certain discrimination or selectivity in the adoption and employment of motifs already present in the rich artistic heritage bequeathed by the medieval church. The principle guiding this selective process presumably was that scriptural norm that was so central to Luther's theology. In practice this meant the virtually complete exclusion from Protestant art of a number of subjects that were extremely popular in the later Middle Ages but for which the evangelicals could find no biblical warrant, e.g., Mariological motifs and representations of the legends of the medieval saints. In this way the Reformation resulted in a definite contraction of the iconographical legacy.

It appears, however, that while abandoning certain of the traditional artistic motifs, the German Lutherans at the same time gave a new popularity or prominence to others. For example, they devoted more attention to Old Testament themes. This was noted by Erwin Panofsky as a general Protestant phenomenon:

> The Protestant inclination to go back to the sources . . . regarded the Old Testament as a revelation *sui juris* instead of as a mere prelude to, or even a prefiguration of, the New. In Rubens' religious works the ratio between subjects from the Old Testament, on the one hand, and subjects from the New Testament and hagiology, on the other, is about fifteen to one-hundred; in Rembrandt's, it is about forty-two to one-hundred; in his paintings, as opposed to his prints, it even amounts to a full fifty percent.[250]

The artists mentioned by Panofsky, of course, were non-German and worked in the seventeenth century. But there is some evidence of a similar trend during the Reformation period proper. If one turns again to the Cranach altar panels analyzed above, he will find that eight of the thirty-one (or slightly over 25 percent) depict scenes from the Hebrew Scriptures.[251] This ratio is much higher than the proportion of Old Testament themes found in the pre-Reformation paintings of the elder Cranach or probably any other German artist.[252] Luther's enduring preoccupation with the writings of the Old Covenant no doubt provides at least a partial explanation for this dramatic shift in interest.[253]

Even more important for early Lutheran art than the Hebrew Scriptures, of course, was the New Testament. And, as we have seen, many traditional iconographical themes based on the Chris-

tian Bible simply were taken over and repeated by the German Protestant artists. But, at the same time, they assigned a new importance to some that, while not unknown previously, had been employed far less frequently than they came to be after the Reformation. Such was the case with the Christ Blessing the Children and Christ and the Adulteress motifs and even, to a certain degree, the Last Supper theme. The latter, admittedly, had not been as uncommon in later medieval art as the other two. But it had appeared less often than one might expect, and, relatively speaking, it was portrayed much more widely by the early Lutherans than in the immediately preceding age. Indeed it would not be an exaggeration to state that within the scope of German altarpiece art the sixteenth-century Protestants were the first ever to exploit fully the eucharistic symbolism of this subject.

All three of the above-cited New Testament themes also exemplify that, in addition to securing a more widespread popularity for a number of art motifs, the early Lutherans also at times invested them with a new set of meanings. In certain instances this apparently was done for doctrinal reasons; in others, perhaps, for polemical ones. In any case, it is clear that German Protestants did not always employ the inherited iconography for exactly the same purposes as their predecessors. Thus we must not be misled by the seeming familiarity of the subject matter of much early Lutheran art. We should constantly be on the alert for the possibility that ancient religious themes may have been infused with a fresh spirit, that new wine may have been poured into old wineskins.[254] Craig Harbison recently has shown how the Last Judgment motif sometimes took on an altered significance when portrayed in sixteenth-century Protestant art, a consequence of the fact that "for Luther, Christ's judgment often became not so much a means of dispensing God's justice as of displaying God's love."[255] It seems probable that future research will disclose even more examples of the reinterpretation of the older iconographical tradition by Luther's followers. In the meantime, enough has been said here to indicate at least some of the lines along which this transformation proceeded.

Whatever the final verdict on these iconographical questions, one additional comment should be made concerning early Lutheran painting and sculpture: Historians would do well to pay more atten-

tion to the fact that—contrary to the impression often given even in scholarly writing—so much of this ecclesiastical art was created at all. It undoubtedly is true that many of the works discussed here are of somewhat mediocre aesthetic quality. It is equally true that, compared with the thousands of monuments that were prepared for the churches of western Europe during the later Middle Ages, the body of art discussed in this chapter indeed must seem rather modest. And yet this latter group of works, even if relatively small in size, stands as tangible and incontrovertible proof that within sixteenth-century Protestantism the German Lutherans, at least, did not abandon the venerable Christian practice of regarding visual images as a valid and useful instrument for promoting the cause of the Gospel. From this adherence to ancient tradition emerged an interesting corpus of new religious art, a group of paintings and carvings, of which many stand even to this day as abiding witnesses to the faith, doctrine, and ecclesiastical self-awareness of the men who commissioned and created them.

5

The Reformation and the
Decline of German Art

*O*NE OF THE generalizations frequently made concerning the Protestant Reformation asserts that it contributed significantly to a decline of German art. According to this viewpoint, the evangelical movement not only led in many places to a tragic destruction of existing paintings and works of sculpture but also resulted in a set of conditions unfavorable to the continued production of high-quality aesthetic monuments.[1] How valid is such an interpretation?

Concerning the reality of the artistic decline there would appear to be little dispute. Admittedly, efflorescence and decay in the arts are difficult to measure objectively.[2] Nonetheless, modern art historians and critics seem to hold a virtual consensus on the matter under discussion. For example, H. W. Janson, in his book *Key Monuments of the History of Art: A Visual Survey,* includes fifteen works of German art from the period 1480 to 1540, but none at all from 1540 to 1600.[3] Janson's evaluation is not unique. Whether one is concerned with painting,[4] sculpture,[5] or the graphic arts,[6] the verdict is the same: Whereas the creations of German masters occupied a proud and prominent place in the art world of the early sixteenth century, by the end of the Reformation era their contributions had become an almost negligible factor in European aesthetic culture.[7]

The demise of art in the German-speaking lands is agreed upon

by all. More controversial is the explanation for this demise. Some, of course, argue that the occurrence or absence of artistic genius, or even general artistic efflorescence, is always inexplicable. The historian Hugh Trevor-Roper quotes Whistler, the American painter, to the effect that "art happens"; he then adds his own view that "sometimes this seems the best and only possible observation on the subject."[8] Probably only a few are willing simply to let it go at that. And thus this chapter will address the following problem: What responsibility for the decline of the German art tradition must be borne by the Protestant Reformation?

In attempting to sort out the various possible causes for the demise of German artistic excellence, it becomes important first to establish within as narrow a chronological range as possible just when the decline began. Unfortunately, art historians are often content with cautious generalities on this crucial question. It must be admitted, further, that the judgments of the experts do not entirely agree. Yet it is abundantly clear that hardly anyone today follows the lead of certain earlier authors in attributing the blame to the destruction caused by the Thirty Years' War of the seventeenth century.[9] And, indeed, while it perhaps might be inferred from the statements of some modern art critics that the decay really became critical only about the middle of the sixteenth century,[10] other specialists do not hesitate to date the origins of the decline in the 1540s or 1530s,[11] and some find evidence of it for Germany as a whole or individual regions as early as the 1520s.[12] Of some significance here is the fact that if one not only takes into consideration explicit textual statements but also examines the amount of attention devoted proportionately to German art works of the various decades of the sixteenth century, a definite tendency of recent art historians to lean toward an early dating quickly becomes manifest.[13] This observation leads immediately to one important conclusion: The decline in the quality of artistic production followed closely upon a period of considerable economic difficulty for German painters and sculptors.

That the period beginning in the mid-1520s was a time of diminished employment and financial hardship for many sectors of the German art community cannot be disputed.[14] The documents speak clearly on the matter. The artists themselves complained at this time of their increasingly precarious economic situation. In

1525 the painters and sculptors of Strasbourg addressed an appeal to the city council, which observes that since the introduction of the Word of God the veneration of images has declined markedly—not that the artists wish to oppose the council's Protestant policy, for they readily concede that the images were and still are the objects of misuse. But the artists point out that they have not been trained in any but their own crafts, with which they have supported their wives and children. If their source of income should be lost, they would have nothing to look forward to, finally, but financial ruin and the beggar's staff. Therefore, since they want to work, they appeal to the council to provide as many of them as possible with municipal employment. For such, they have heard, has been the policy in some other towns where the Gospel has been restored.[15] A similar appeal appears in the Basel records for the following year (1526): "They [the painters] ask [the council] to consider graciously that they, too, have wives and children, and to see to it that they can stay in Basel, because even so the painter's profession is in a bad way. Several painters," they maintain, "have already abandoned their jobs, and if the situation is not improving in this and other respects, one will have to reckon with more of them giving up."[16] In that same year two Basel sculptors, Martin Hoffman and Hans Dobel, directed a letter to the city fathers in which they complained that the joiners or cabinetmakers were attempting to prohibit them from earning some income by working in that neighboring craft. In the act of defending himself in this jurisdictional dispute, Hoffman reminded the authorities that he had honorably followed his calling in the city for nineteen years, but now, however, found that his own skill and training were totally useless.[17]

The economic hardship was of more than brief duration.[18] In 1538, a Protestant artist, hymn writer, and author from Strasbourg named Heinrich Vogtherr published an artist's pattern book filled with designs to be studied or imitated by other painters, sculptors, goldsmiths, or craftsmen. The work begins with a short preface containing some statements of great interest to the present discussion. According to Vogtherr, God has "by a special dispensation of his Holy Word, now in these our days brought about a noticeable decline and arrest of all the subtle and liberal arts, whereby numbers of people had been obliged to withdraw from these arts and to

turn to other kinds of handicrafts. It might, therefore, be expected," he continued, "that in a few years there would scarcely be found any persons in German lands working as painters and carvers."[19] Vogtherr is concerned lest the arts die out and Christendom decline into barbarism. He has in mind particularly his fellow artists burdened with families and those who for some other reason cannot travel. He thus intends to provide them with some of the means to effect a revival of the arts in German lands.[20]

Faced with a sharply reduced demand for their works, artists in some cities attempted to protect their remaining sources of income by seeking restrictions on the activities of those who would trespass on their accustomed territory. The Basel painters in 1526 complained to the city council that they were being injured by the fact that some shopkeepers had begun retailing certain goods and supplies that the painters themselves had usually sold for profit.[21] In 1531 the Augsburg artists complained to the authorities about competition from the Strasbourg sculptor Friedrich Hagenauer, who was practicing in their community. Reference is made to the great falling off of the arts in the city. Hagenauer's response is no less instructive. He expresses his sympathy with the complainants and says that he himself has lost his income from the same causes and has even been forced to learn a new art, that of medallion engraving. He further affirms that he has not executed one work of monumental sculpture in the five years that he has been in their city.[22] Augsburg, as well as other towns, apparently did institute greater controls on the activities of "foreign" or outside artists.[23] In 1546 the Strasbourg painters were still complaining of the incursion of other, apparently domestic, craftsmen (cabinetmakers, masons) into their domain.[24] In view of their desperation, it is not surprising that the artists demanded vigorous enforcement of those rules protecting their own profession, while at the same time some of them attempted to justify trespassing on the territory of neighboring crafts.[25]

When the need became great enough, some painters, sculptors, and goldsmiths were willing to attempt evasion of yet another type of restriction: the prohibitions against producing art works with explicitly Roman Catholic content, which were put into effect in many south German and Swiss towns. Several instances of such violations from the 1530s and later are recorded in a number of

different communities.[26] The penalties for such a transgression could be fairly severe: temporary imprisonment,[27] confiscation or destruction of the offending work,[28] or the threat of loss of citizenship.[29] That such incidents should continue, in spite of the risks run, can be interpreted as a further indication of the hardships being endured by the artistic community.

There are yet other kinds of evidence, both direct and indirect. Records of tax returns reflect the sharp decrease in affluence experienced by certain artists.[30] Personal bankruptcy was not unheard of.[31] And the dire financial situation manifested itself also in the growing practice of dedicating unsolicited works of art to the ruling authorities in the hope of receiving a monetary reward in return. The custom has been studied in Nuernberg, where the city received a dozen or so such gifts between the mid-1520s and the late 1540s and recompensed the donors with varying amounts ranging as high as the one hundred gulden granted Albrecht Dürer for his famous twin panels known as the *Four Apostles*.[32]

During these difficult times many artists sought supplementary or even alternative employment. Quite naturally, as illustrated by the example of the Basel sculptors mentioned above, some moved into allied trades where their previous training and experience would be of some value to them. When the famed Peter Vischer bronze-casting foundry of Nuernberg fell on hard times in the 1520s because of the lack of a sufficient number of large commissions, one of the sons of this great artist family became a cannon founder for the duke of Prussia;[33] in the 1540s another son abandoned his profession entirely and left the city.[34] Many artists seem to have engaged in innkeeping[35] or to have found service in the mercenary armies of their time.[36] And a fair number apparently were successful in their bid for some form of municipal employment.[37]

A definite exodus of artists from their profession can also be inferred from the fact that over the years fewer and fewer of their names crop up in the municipal records of the Protestant cities. The decline is reflected most dramatically in the lists of the sculptors, although Basel provides an instance of marked decrease in the ranks of painters as well.[38]

Some of those artists who endured in their trade decided to migrate, in the hope of finding more lucrative employment. The

most famous example, of course, is Holbein, who moved abroad. The letter of introduction that Erasmus, then living in Basel, sent along with the artist contains a significant and oft-quoted phrase: "Here the arts are cold; he goes to England in order to scrape together a few angelots."[39]

Thus, there is clear and abundant evidence of the loss of employment and financial hardship suffered by German painters and sculptors from the early years of the Reformation. But as yet the question of how extensively the religious reforms themselves may have affected patronage has not been confronted. Did the coming of Protestantism really bring to an end the long-standing and close alliance between the church and the visual arts? Were there any compensatory factors? The problem is important also from the economic standpoint, for the simple reason that the great majority of art works commissioned or created in the immediate pre-Reformation period still drew their subject matter from the realm of Christian theology. With the exception of portraiture, painting and sculpture with purely secular subject matter were as yet relatively undeveloped, and no strong tradition of patronage for this type of art as yet existed.[40]

It is clear, first of all, that in those regions of Germany or German-speaking lands strongly influenced by Zwinglianism there resulted from the Reformation a virtually complete cessation in the creation of new ecclesiastical art.[41] Zwingli believed that religious images were forbidden in the Bible, and he was strongly critical of the idolatrous potential he felt to be always present in their use.[42] Furthermore, as for the alleged pedagogical value of Christian art, he remained skeptical of both its efficacy and its propriety.[43]

The developments in the Lutheran areas of Germany were more complex in their evolution. In the early stages of his reform activity, Luther at times was fairly critical of various abuses associated with the use of religious imagery. As we have seen, however, he also quite soon advanced a more positive view of its potential value, particularly for instructional purposes. With this theoretical basis, a fairly significant body of Lutheran art began to grow up—even if, with the exception of Bible illustrations, it started rather slowly.

The very first edition of Luther's German New Testament in 1522 contained a modest number of pictorial compositions. Later editions of the Luther Bible were more profusely illustrated, par-

ticularly in the Old Testament. The first complete Bible in Luther's translation, which appeared in 1534, included 117 different woodcuts, not counting the title pages or decorative initials.[44] Altogether, more than 500 pictures were prepared for those Wittenberg editions of Luther's Bible issued during his own lifetime.[45] German artists, it also should be noted, produced yet additional illustrative materials for the numerous editions of Luther's Bible that were brought out in other cities of the empire and Switzerland.[46]

In addition to stimulating the sales of Luther Bibles, the Reformation created a large market for certain types of Protestant religious literature as well, and many of these publications also contained visual aids. Among them might be mentioned Luther's postils or sermon collections, the Wittenberg editions of which began to be illustrated in the late 1520s;[47] Luther's prayer book, adorned with prints in the 1529 and later editions;[48] Lutheran hymnals, certain versions of which began to include pictorial matter either in the late 1520s or in the early 1530s;[49] and the popular Luther catechisms, which began to contain woodcuts in the very first year of their publication, 1529.[50]

It is clear that by endorsing the inclusion of illustrative materials in Bibles and other religious books, the Lutheran reformers helped provide employment opportunities for at least some artists able to create in the graphic media. Even if we knew nothing about the use of the more monumental art forms in the service of early Lutheran worship and teaching, we would have to concede that the Reformation did not completely dry up all sources of work.

It has been demonstrated, moreover, that the early Lutherans did in fact make some use of the more monumental art forms. Independent panel paintings with explicitly evangelical themes appeared beginning in 1529, and Lutheran altarpieces were commissioned at least as early as 1539. Furthermore, Protestant patrons had sizable numbers of artistically conceived epitaph monuments prepared from about 1540 on. Other forms of ecclesiastical art also were created for use by the Lutherans, e.g., pulpits and rood lofts bearing relief sculpture or panel paintings of biblical themes.[51] It should be noted, however, that more of these works seem to stem from the second half of the sixteenth century than from the earlier years of the reform, which suggests a consideration of some importance in

relation to the question of the Reformation's impact upon the patronage of religious art. It would appear that while those areas of Germany adopting Lutheranism indeed eventually did establish their own tradition of using sacred painting and sculpture, this development amounted to too little and came too late to compensate adequately for the large number of commissions presumably lost to the artists during the critical 1520s and 1530s.

To help place in proper perspective our impression of the extent of early Lutheran employment of painting and sculpture for ecclesiastical purposes, it may prove instructive to cite for comparative purposes some data pertaining to the late medieval period. Statistics are most readily available for altars and altarpieces. On the eve of the Reformation the production of this type of religious art must itself have constituted a large-scale industry. According to one chronicle source, twenty-three altars were prepared in Nuernberg alone during the brief span 1488–91.[52] Similar conclusions can be drawn from some figures provided by contemporaries reporting on the losses incurred through Reformation iconoclasm. According to the Protestant chronicler of St. Gall, Johannes Kessler, thirty-three altars were demolished when the great abbey church of his city was forcibly secularized in February, 1529; Kessler also relates that sixty-three altars were removed from the cathedral in Constance.[53] From various other sources, we learn that fifty altars were taken from the great Münster in Ulm and twenty-five from the cathedral in Bern.[54] Viewed in relation to statistics such as these, the corpus of known Lutheran altars dating from the sixteenth century assumes rather modest proportions. These Protestant monuments, to be sure, are interesting works worthy of study, both in themselves and as evidence of the early Lutheran commitment in principle to a constructive use of pictorial representation. However, the Protestant patrons of ecclesiastical art did prove much less reliable and rewarding employers of painters and sculptors than had been the donors of the late medieval church.

The Lutherans simply did not require as much in the way of liturgical accessories as did pre-Reformation Catholicism. For one thing, the increased emphasis upon oral proclamation and the auditory perception of the Word of God had as a consequence correspondingly decreased attention to the visual aspects of worship.

Further, as Johannes Janssen pointed out many years ago, under Lutheranism the incentive to beautify the church building was diminished appreciably because it no longer could be thought of in the traditional sense as the house of the Lord. As he expressed it, "The old Catholic belief in the real presence of the Saviour in the Sacred Host and the custom of preserving the Host in the churches not only led to the production of quantities of Sacrament-houses, but also engendered a feeling of veneration for places of worship as the veritable habitations of God . . . for the adornment of which nothing was thought too costly."[55] This understanding of the sacred building was renounced by the reformers, and with it vanished one of the major reasons for decorating the ecclesiastical edifice with expensive paintings and statues.[56] Then, too, a theology of "good works" no longer existed to stimulate the donation of images by promises of spiritual reward to those performing this type of meritorious service. The Lutherans, to be sure, did not abandon the use of church art. But its relationship to worship was considerably attenuated, and there did not seem to be now such a compelling motive for its creation.

If the Protestants provided a relatively poor market for sacred paintings and carvings during the critical early decades of the reform, their Roman Catholic neighbors may not have done appreciably better. Several historians have suggested the likelihood of a significant decrease, during this very unsettled period, in the number of new art works prepared for even those churches remaining true to the old faith.[57] To summarize, the overall effect of the Reformation upon the patronage of religious art must have been very damaging.

But what about the impact of the Protestant movement upon the patronage of nonsacred painting and sculpture? Is it not conceivable that by diminishing the enthusiasm for religious art, the Reformation might have resulted in a shift of aesthetic interest to works with a secular subject matter? Can the reform perhaps have exercised, in this indirect way, a positive influence upon the growth of portraiture, the more frequent representation of mythological, allegorical, and historical themes, or the rise of genre art?[58] An increased output in these areas does seem to have occurred in the years after the introduction of the new doctrine, if one may judge

from the work of a court painter such as Lucas Cranach the Elder.[59] It would be hard to isolate or to measure the part played by the Reformation in such an increase, however, since an expansion in the market for these modes of art also could have resulted from other factors, such as the growth in popularity of Renaissance ideals among the German upper classes that coincided chronologically with the religious reform in Germany. Whatever the final verdict might be on such a question, it seems apparent that the production of paintings and sculpture with nonsacred subject matter did not expand sufficiently in the 1520s and 1530s to offset the severe losses suffered in the realm of religious art—which, after all, constituted the great bulk of all work undertaken on the eve of the Reformation. If it were otherwise, why did the artists suffer the grievous financial hardship so fully documented here? There can be little doubt, then, that the reform occasioned a sharp contraction not simply in the market for religious art but also in the total volume of art patronage.

At this point one might well ask whether this diminishing of patronage is to be associated only with the consequences of the Reformation, or with other causes as well. What of political and economic factors?

It is perhaps not without significance that Germany acquired a nonresident ruler, Emperor Charles V, just a few years before the crisis in the arts became apparent. Elected in 1519, Charles spent only eight of his fifty-eight years in the empire, visiting it nine times but never remaining as long as two years on any visit until those of the 1540s and 1550s.[60] His major art commissions were given in Spain and Italy.[61] Charles's lack of a permanent capital or fixed residence in Germany, according to one recent art historian, "prevented him from promoting artistic enterprises, let alone planning them himself, as his grandfather [Maximilian I] had done."[62] The result, according to the same scholar, was that the empire no longer had any real center of "active patronage of the arts."[63] In contrast, the stimulating and beneficent effect that consistent and generous royal patronage could have upon the development of northern art in the sixteenth century may be illustrated from the careers of Charles's rivals, Francis I and Henry II of France. Under the aegis of these Valois sovereigns not only did important schools of Franco-Italian architecture, sculpture, and painting flourish, but

also the foundation for an impressive national contribution in the fine arts was laid.[64]

Although the absence of large-scale royal sponsorship of the arts in Germany during this critical period must be considered significant, with the exception of the decline in demand for religious art, the overall structure of art patronage and the art market did not change radically during the 1520s and 1530s. Both princes[65] and townsmen[66] continued in their traditional capacity as commissioners and purchasers of painting and sculpture, while, on the other hand, the age of the great connoisseurs and secular art collections was not to dawn until the second half of the century.[67]

Nor does the evidence suggest that the difficulties of the artists can be accounted for by any general economic decline in Germany at this time. Modern historians first speak of commercial and industrial stagnation in connection with the period following the middle of the sixteenth century.[68] And, as has been pointed out by several scholars recently, the amount of money that a society devotes to artistic enterprises probably has less to do with overall economic affluence than with sociocultural considerations and the shape of political and tax structures.[69] If economic recession does not bring an end to the concentration of funds in the hands of those few who are accustomed to patronizing culture, it need not result in an immediate curtailment of aesthetic creativity. When economic decay did appear in Germany, families with great accumulated wealth apparently were able to preserve for a long time their traditionally high standard of living and costly habits of consumption.[70]

Much the same can be said concerning the waning vitality of the German cities. It probably would be a mistake to make too much of the admittedly striking coincidence of a peak period of urban economic and political influence with the greatest artistic efflorescence that the German lands perhaps have ever known.[71] If painting and sculpture flourished in a particularly brilliant fashion in the late fifteenth and early sixteenth centuries, it was for a variety of reasons, among which the type of religious piety cultivated at the time played just as important a part as did socioeconomic factors.[72] Further, the slow erosion of the position of the towns came too late and was too gradual a process to account for the intense crisis of the arts in the 1520s and 1530s.[73] About the most that can be said is that the

eventual exhaustion of urban productive energies probably helped to inhibit a later revival of certain of the arts, such as occurred so spectacularly in the prosperous and Protestant Netherlands of the seventeenth century.

When one has assessed the various factors involved in the economics of art production in the early and mid-sixteenth century in Germany, it is difficult to avoid the impression that the financial and occupational distress suffered by the painters and sculptors was caused largely by the coming of the Reformation.

One objection, perhaps, might be that most of the material presented thus far in this chapter is somewhat beside the point. For the question posed originally was concerned with a decline in the quality of artistic endeavor, and what, one might ask, has the reduction in employment or the number of new art commissions to do with such a matter? Are these not quantitative rather than qualitative factors?[74] What in all of this would prevent the gifted painters and sculptors of that age from continuing to execute great works of art?

The answer, of course, is that for a time, and to a diminished extent, German artists did do just that. And yet, in those days, art production without patronage was not easy. The great majority of oil paintings and sculptural works still resulted directly from commissions.[75] Such creations were costly to produce, in terms of both labor and materials invested. As yet no really significant market for independent works of art existed,[76] and few artists were willing to prepare a piece that might be difficult to sell. Thus the lack of a contract or order meant, in effect, no artistic masterpiece. As one recent art historian states it, "What the time lacked was not great artists, but great commissions."[77]

With the death of the towering leaders of German art, the problem also became one of attrition. Why were these masters not followed by new generations of equally gifted painters and sculptors? It does not suffice to speak simply, as some do, of a "great dying" of German artists beginning in the 1520s, implying that some kind of biological predestination was at work.[78] For while some mortals were passing from the scene, others were being born, and among them, presumably, many with native artistic ability. The question is, why was this potential not more fully developed?[79]

Forces undermining the economic vitality of a trade or profes-

sion most likely do exert an adverse effect on the recruitment and training of that younger talent necessary to maintain quality of output. In the decades preceding the Reformation, when so many had been encouraged by favorable employment opportunities to cultivate the skills related to various kinds of artistic production, it is not surprising that at least a few with great talent should have arisen from their ranks.[80] The sharp contraction in the market for art goods probably brought an end to this favorable situation. And to this might be added the observation that within the thinned ranks of the remaining artists there can no longer have been the same degree of invigorating competition and fruitful exchange of ideas that had existed earlier.[81]

It would be a mistake, however, to focus too exclusively upon purely economic considerations, however important they may have been. The emotional and psychological effects of the Reformation must have been considerable. It has become almost an article of faith in modern times that the creative personality is a more than ordinarily sensitive individual, who feels acutely the stresses and strains of life.[82] The German artists, in particular, have often been characterized by art historians as highly emotional.[83] There may be some truth, historically, in Myron Gilmore's suggestion that "great artists have been able to work in periods of political and social disturbance," but it is even more to the point to note, as he himself indicates, that "a psychological sense of security is more important than the actual physical security of the individual."[84] The theological controversies and political upheavals accompanying the religious reform must have affected the attitudes and outlook of artists in a variety of ways.[85]

It has been suggested, for example, that certain creative individuals may have been disturbed sufficiently by the teachings of the iconoclastic theologians voluntarily to abandon their art.[86] On the other hand, the outright destruction of images, wherever it occurred, must have resulted not only in the loss of irreplaceable art works, which could have served as models in the training of new generations of artists,[87] but also in damage to the morale of many other practicing painters and sculptors.[88] One can easily imagine the anger and despair especially of those masters not themselves wholeheartedly committed to the eradication of image piety. We

know from a comment in Dürer's letter to one of his patrons advising him on the proper care of a recently painted altarpiece that the interest of the artist in his work extended beyond the monetary reward received upon its completion: "If a thing, on which I have spent more than a year's work, were ruined it would be grief to me."[89]

Certain historians have speculated that painting and sculpture may have been adversely affected simply by the great preoccupation of men just then with the religious and political issues of the Reformation.[90] It is no doubt too strong to say, as Johannes Janssen does, that "there was no longer time or inclination left for art."[91] Yet perhaps it is not absurd to concede that the religious excitement and turbulence of the period may have absorbed or siphoned off spiritual energy and emotional tension that might otherwise have been released in artistic creativity. One would not expect to find much literary documentation of this possibility, but there is at least one tantalizing piece of historical evidence. The early seventeenth-century art historian Carel van Mander reports that in 1519 when Jan Scorel went to Nuernberg to study, he soon decided "to proceed elsewhere because he found Dürer so preoccupied with the 'teachings by which Luther had begun to stir the quiet world.' "[92]

On occasion, the disturbances accompanying the Reformation went beyond the psychic realm and involved dislocation or even an element of physical danger in the lives of individual artists. Some of these men, quite understandably, were out of harmony, on the religious question, with their rulers, whether the latter had become Protestant or remained Roman Catholic. While in certain instances such disagreement might lead only to minor harassment, such as Holbein's encounter with the Protestant authorities of Basel over the meaning of the Lord's Supper,[93] in others it resulted in actual religious persecution. Another Basel painter, Hans Herbst, was temporarily imprisoned for his diatribes on the Sacrament of the Altar; he was released only after he agreed to express publicly his apology and recantation before the congregation.[94] Involuntary exile befell others, such as Georg Pencz and the two Beham brothers, Sebald and Barthel, the so-called godless painters, who were expelled from Nuernberg for their religious and political radicalism.[95]

Several artists were swept up in the brutal reprisals that fol-

lowed the disastrous peasants' uprisings in the mid-1520s. The painter Jörg Ratgeb was quartered alive by horses for his part in the episode.[96] Tilmann Riemenschneider, the highly gifted wood carver, had his arms and hands broken by the hangman;[97] Mathis Grünewald apparently escaped punishment only by moving to another city.[98] We know, too, that some artists—Hans Leu the Younger, for example—were among those who fell in battle during the religious wars, which, especially in Switzerland, followed quite soon upon the introduction of the Reformation.[99]

The effect of these unsettled conditions upon artistic creativity cannot have been beneficial. One art historian comments that the political and religious troubles extending on into the years of the midcentury "were unfavourable to bigger projects, to the founding of workshops and local schools." There was, he continues, "a lack of time and means to form new traditions. . . . Thus art in the Empire was extremely confused in style and had no definite points of reference or standard set up by the individual artists, who were always on the move."[100]

This study so far has touched upon some of the ways in which the Reformation apparently was implicated in the decline and fall of German art. Other links, with varying degrees of plausibility, have been suggested over the years.[101] There is neither space nor need to evaluate all of them here, but it would be profitable to examine at least one of the more important, the assertion that early Protestantism was excessively utilitarian and didactic in its approach to art. It has been said that, because of a basic ignorance of and insensitivity to the limits of successful artistic expression, Luther and his fellow reformers made subject-matter demands upon Protestant artists that could be met only at the expense of aesthetic integrity.[102] A preoccupation with doctrinal content led to tragic consequences in the area of artistic form.[103]

It must be admitted at the outset that Luther, like the humanists and other German intellectuals of his day,[104] did approach aesthetic questions more in the spirit of the scholar than that of the connoisseur. Although he took a personal interest in portraiture and willingly acknowledged the legitimate use of the fine arts for ornamental or decorative purposes,[105] as a religious reformer his view of them was, indeed, largely utilitarian. For Luther, the work of the

painter and sculptor exists above all to praise and glorify God or to be used in loving service of one's fellowman. The Wittenberg theologian was strongly committed to the position that one of art's chief potential contributions lies in the area of religious pedagogy.

Further, certain of Cranach's religious paintings, e.g., *The Law and the Gospel* compositions, do attempt to present rather complex allegories or schematic renderings of abstract theological doctrine. The extent of the resulting aesthetic failure will be estimated differently by different observers, although few probably would bother to deny that, from a purely formal point of view, these panels do not place among the most satisfying of Cranach's works.

And it certainly is true, finally, that this, the most characteristically Lutheran iconographical invention to come out of the Wittenberg workshop of Cranach, did exert a vast influence in that it was imitated for decades by Protestant artists scattered over a very large area of east, central, and northern Germany. Whether, if left on their own, these painters, carvers, and engravers would have been more successful in developing independently an aesthetically satisfying Protestant imagery seems at least questionable. The areas where Cranach's influence was determinative were mostly somewhat provincial culturally, and not generally known for the strength or creativity of their artistic traditions at that time. It also seems obvious that the difficulties experienced by art and artists in southern and western Germany, and, indeed, even in the period before Cranach's Protestant compositions became known, cannot very well be explained by the aesthetic problems inherent in Wittenberg iconography, whatever they may have been. One might also simply point out that the production of works with specifically Lutheran subject matter by no means absorbed all of the time or creative energies of even the Cranachs in the period after the introduction of the Reformation. Apart from satisfying a large and growing demand for portraits and other secular compositions, these artists and their assistants continued to produce many religious paintings with a more or less traditional iconography.

However, the Reformation did play a major part in bringing about conditions that caused the decline of German art. Religious reform was achieved at the expense of some cultural loss. The conviction of that great historian Jacob Burckhardt comes to mind

here—that the "golden ages" in history "were not times of happy adjustment, but were epochs in which the magnificent achievements of man in one regard were paid for by terrible costs in another."[106] This is not, of course, to suggest that the German reformers made a conscious decision to sacrifice culture to religion and even less to propose that it was their goal to destroy the arts. Luther specifically denied having such an intention.[107] That it should have happened, nonetheless, must be viewed as one of the many unforeseen and unintended consequences with which history is filled. Luther could not have been surprised by the ambiguity of men's actions; he once spoke of that which the "experience of life proves, that no man's purposes ever go forward as planned, but events overtake all men contrary to their expectation."[108]

Excursus: Dürer's *Four Apostles*
—A Reformation Painting

*C*HE FOLLOWING essay presents a detailed analysis of Albrecht Dürer's *Four Apostles*, a famous but controversial painting mentioned only briefly in the main text of this volume. This great work has been much discussed in previous writings, for it was perhaps the supreme creative achievement of a man generally acknowledged to have been the most gifted and versatile artist of his generation in northern Europe.[1] The aesthetic stature of the painting has insured that it continues to receive serious attention from art critics and art historians. The subject matter or iconography of the composition, however, and the lengthy accompanying inscriptions necessitate that it be carefully considered also by those with a special interest in the relationship of the Reformation to the fine arts. For this painting is a monument that appears to offer in visual forms and colors as well as in written language a powerful commemoration of a principle central to the whole Protestant movement, that is, adherence to the Word of God as expressed in the Christian Bible.[2] Furthermore, this picture was dedicated by the artist himself to the magistracy of his native town, the same city council that a year and a half earlier had adopted Lutheranism as the legally established religious creed of the community.

Given these circumstances, a consideration of the *Four Apostles* is clearly of great potential interest to anyone who wishes to deal in depth with the question of the interaction of the Reformation with

art in sixteenth-century Germany. However, not all those who have studied the painting from this perspective have been able to agree on the ultimate significance of the work. For despite the obvious impact of Luther's teachings upon the artist and his creation, some aspects of this composition are not easily explained in a manner capable of compelling universal assent. And so the lengthy debate over the meaning of the *Four Apostles* continues even now. The debate at times becomes intricate and complex as scholars grapple with problems arising from a body of historical documentation that proves inadequate and at times ambiguous.[3] The purpose of the following discussion is twofold: (1) to provide a synthesis of some of the findings of previous research, and (2) to offer the author's own interpretation of the picture in relation to its historical setting. The thesis to be developed here is that the *Four Apostles* composition may be understood best as a memorial painting of the Reformation.[4]

Before taking up the issues involved in the interpretation of Dürer's *Four Apostles,* we shall first of all describe the painting and then indicate the known facts concerning the circumstances of its presentation to the city. The work consists of two tall, matching panels, the left one of which represents in larger than life size the figures of St. John and St. Peter, while the other depicts St. Paul and St. Mark (fig. 15). As Mark was not actually an apostle, the commonly accepted name for the work is not strictly accurate.[5] Two of the holy men are immediately recognizable from the traditional personal attributes with which they are portrayed: Peter holds a key and Paul a sword. Much less obvious to the casual viewer is the fact that Mark grasps a scroll bearing the name of that Gospel of which he was the author.[6] John, for his part, stands reading from a volume open to the first chapter of his own Gospel, in which, as the art historian Ludwig Grote notes, "Dürer has written the opening words in Luther's magnificently concise version: 'Im Anfang war das Wort' " (In the beginning was the Word).[7] The four personages also can be identified by means of the lengthy inscriptions painted at the base of the panels, which, for the most part, are selections from their biblical writings.

The dominant figures from the standpoint of size and placement are those of John and Paul, whose heavily robed forms are depicted in the foreground in full length, turned inward and nearly in profile. Grote observes that St. John "wears a soft cloth mantle, whose

vermilion dominates the picture." St. Paul, his counterpart on the other panel, "wears a mantle of white with blue shading, holding it so that it falls in deep, majestic folds."[8] Many art critics have called attention to the manner in which the latter apostle stares out at the viewer of the painting with his left eye, "almost menacingly," directing toward the beholder a "hypnotic" gaze.[9] On the impact of this gaze, Heinrich Wölfflin says, "Anyone who has once felt the power of this apostle's eye knows that not only has a new conception of a saint been represented, but a new idea of human greatness as such."[10] Also noteworthy is the huge closed Bible that St. Paul carries on his outstretched lower left arm. In contrast to the forms of John and Paul, those of St. Peter and St. Mark are almost completely hidden, with only their heads and upper torsos showing, in a frontal view, the remainder of their bodies merging into the dark background. As in Italian panels with which Dürer was familiar, there is a lowering of the perspective toward the subordinate, inner figures standing at the back.[11] The panels are linked together compositionally by the symmetrical arrangement of the two leading personages, who stand facing each other, and by the fact that the horizontal elements used to break up the almost unrelieved vertical thrust—the forearm of John with which he holds his tucked-up mantle and the Bible-holding left hand of Paul—meet on the same level and thus reinforce each other.[12]

As mentioned, as an integral part of the original painting, an inscription was included at the base of each of the two panels.[13] Apart from the opening passage and the brief lines used to introduce each scriptural quotation, all apparently of Dürer's own authorship,[14] the texts are taken from the biblical writings of the four men represented and are given in the German translation of Luther's first 1522 edition of the New Testament.[15] Running across the entire width of the left panel we find, first of all, the opening statement—reproduced here in the standard modern English translation by William Martin Conway:

All worldly rulers in these dangerous times should give good heed that they receive not human misguidance for the Word of God, for God will have nothing added to His Word nor taken away from it. Hear therefore these four excellent men, Peter, John, Paul, and Mark, their warning.[16]

And then, beneath the figure of St. John:

Peter says in his 2nd epistle in the 2nd chapter: There were false prophets also among the people, even as there shall be false teachers among you, who privily shall bring in damnable heresies even denying the Lord that bought them, and bring upon themselves swift destruction. And many shall follow their pernicious ways; by reason of whom the way of truth shall be evil spoken of. And through covetousness shall they with feigned words make merchandise of you: whose judgment now of a long time lingereth not, and their damnation slumbereth not.[17]

Still on the left panel, below the figure of St. Peter, is the following:

John in his 1st epistle in the 4th chapter writes thus: Beloved, believe not every spirit but try the spirits whether they are of God: because many false prophets are gone out into the world. Hereby know ye the Spirit of God: Every spirit that confesseth that Jesus Christ is come in the flesh, is of God: and every spirit that confesseth not that Jesus Christ is come in the flesh, is not of God: and this is that spirit of antichrist, whereof ye have heard that it should come; and even now already is it in the world.[18]

On the right panel under the figure of St. Mark is written:

In the 2nd epistle to Timothy in the 3rd chapter St. Paul writes: This know also, that in the last days perilous times shall come. For men shall be lovers of their own selves, covetous, boasters, proud, blasphemers, disobedient to parents, unthankful, unholy, without natural affection, truce-breakers, false accusers, incontinent, fierce, despisers of those that are good, traitors, heady, high-minded, lovers of pleasures more than lovers of God; having a form of godliness, but denying the power thereof: from such turn away. For of this sort are they which creep into houses, and lead captive silly women laden with sins, led away with divers lusts, ever learning, and never able to come to the knowledge of the truth.[19]

And, finally, also on the right panel, is written beneath the figure of St. Paul:

St. Mark writes in his Gospel in the 12th chapter: He said unto them in his doctrine, Beware of the scribes, which love to go in long clothing, and love salutations in the market-places, and the chief seats in the synagogues, and

the uppermost rooms at feasts; which devour widows' houses, and for a pretence make long prayers: these shall receive greater damnation.[20]

In early autumn, 1526, the painting just described was dedicated by Dürer to the magistrates of his native Nuernberg. The work was accompanied by a letter explaining the reasons for the gift:

Prudent, honourable, wise, dear Masters. I have been intending, for a long time past, to show my respect for your Wisdoms by the presentation of some humble picture of mine as a remembrance; but I have been prevented from so doing by the imperfection and insignificance of my works, for I felt that with such I could not well stand before your Wisdoms. Now, however, that I have just painted a panel upon which I have bestowed more trouble than on any other painting, I considered none more worthy to keep it as a reminiscence than your Wisdoms.

Therefore I present it to your Wisdoms with the humble and urgent prayer that you will favourably and graciously receive it, and will be and continue, as I have ever found you, my kind and dear Masters.

Thus shall I be diligent to serve your Wisdoms in all humility.
> Your Wisdoms' humble
> Albrecht Dürer[21]

In the municipal records for October 6, 1526, is revealed the reaction of the council to this donation.[22] The city fathers were pleased with the gift but insistent that Dürer be suitably rewarded for his contribution. What the artist might desire as a remuneration was to be ascertained, and in the event that he made no request, this too was to be reported to the councilors in order that an appropriate honorarium might be granted. Ultimately, Dürer was awarded a payment of one hundred gulden plus twelve gulden for his wife and two for his servant.[23]

Having described the *Four Apostles* painting and presented the facts concerning its dedication, we are now faced with the problem of attempting to assess the meaning of the work and ascertaining the nature of Dürer's intentions in presenting it to the city. To take up this problem is immediately to encounter a large body of scholarly interpretation, much of it contradictory. Historians have dis-

agreed, to varying degrees, on the answers to the following ques-
tions: (1) In what sense is the painting to be understood as a
"remembrance," recalling the wording used in Dürer's letter of
dedication? (2) Why would Dürer, normally a thrifty or even frugal
man,[24] give such a costly work to the city—or was it really a sale? (3)
What is the significance of the subject matter or iconography of the
painting? (4) What was Dürer's purpose in having these particular
inscriptions placed at the base of the panels, and what do the in-
scriptions tell us about the meaning of the panels themselves?

To begin with, there is Dürer's reference to the presentation of
his picture as a "remembrance" (gedechtnus). Taken at face value,
the letter of dedication might seem to indicate that the gift of the
painting was intended as the artist's personal memorial, his final
legacy to his native city. Dürer speaks here of his longtime inten-
tion to present a work to the council. When he finally did so, he
was already within two years of his death. The wording of the city
records, moreover, definitely implies that the gift was viewed as a
work created to be a monument to Dürer's own memory ("ein tafel
mit vier billden zue seyner gedechtnus gemacht").[25] Thus it is not
surprising that Dürer's presentation has been viewed by a scholar
such as Grote as the first example of a northern master's dedicating
his artistic testament to the secular authorities rather than to the
church. Inspired by the ideals of the humanists, the great artist
allegedly strengthened his claim to worldly immortality by arrang-
ing that his greatest work be hung in a place of honor in the city
hall, to be seen by the leading men of the community.[26]

This interpretation, it must be added, has not found universal
acceptance.[27] Gerhard Pfeiffer, in an important study, rejects it on
the grounds that rather than intending the work as a personal me-
morial Dürer wished to commemorate certain persons and events
that played an important part in Nuernberg's history in the 1520s.[28]
In response to this objection, however, one might perhaps ask
whether it is not possible that Dürer meant the painting to serve
both purposes. It would not seem that the one must necessarily
exclude the other.

The second question posed concerned whether Dürer's presenta-
tion of the painting to the city should be viewed strictly as a gift or
as in some sense a sale of the work. To the art historian Wölfflin,

the answer seems to have been clear enough: "Nobody had commissioned the pictures, nobody bought them."[29] Some scholars, nonetheless, have not been persuaded that the matter necessarily was this simple. Relevant in this regard is the striking and often noted similarity of the shape of the twin panels to that of wing sections found in a triptych of the traditional medieval type. Drawing upon this and other observations, Erwin Panofsky argued that the *Four Apostles* probably were begun originally as part of a large altarpiece and then presented to the council in a somewhat different form only after the initial project was abandoned. Presumably the introduction of Protestantism resulted in the loss of the commission, and Dürer was left to dispose of the uncompleted portions.[30]

It is true that Panofsky's thesis generally has been rejected by more recent scholarship, on a number of different grounds.[31] But certainly he was correct at least in his suggestion that in the absence of art galleries, museums, or an established art market in this period of history, an artist might well turn to the governing authorities in the hope of securing a customer for one of his works.[32] For modern research has demonstrated that such an established custom did operate at the time.[33] Both writers and artists, including Dürer himself, had come to look upon the dedication of works to rulers or prominent personages as a legitimate way in which to secure patronage. Thus, whatever Dürer's primary motives for the creation and presentation of the painting might have been, he could not have been very surprised at the city council's decision to award him a handsome remuneration for his gift. To point this out, of course, is in no way to lessen the importance of proceeding in our attempt to ascertain the true nature of the content of this work. For there certainly is no contradiction between the fact that an artist accepts payment for his composition and the likelihood of his intention that the work convey some important meaning to its recipients or viewers.

Thus we come to the question of what meaning it was that Dürer wished to convey. At this point we return to the matter of the visual content of the panels—partly because this would seem the most obvious place to begin in analyzing a work of art and partly because the paintings, on the whole, are somewhat easier to interpret than the inscriptions.

Anyone familiar with the art or religious history of the sixteenth

century cannot doubt the impact of Reformation ideas upon the subject matter of this work. First, there apparently was no iconographical tradition for portraying these four figures together in such a manner.[34] Indeed, Wölfflin speaks of the "strange selection of apostles" employed here.[35] The selection is "strange," certainly, in the sense that the most important role, from a compositional point of view, is not granted to the two traditionally treated as the leading apostles, Peter and Paul, but rather to John and Paul.[36] The explanation for this important transposition, it would seem, must lie in the special importance assumed in the Reformation by just these two biblical authors.[37] Paul, indeed, has been called *"the* Apostle of the Reformation,"[38] and the early Protestants sometimes were designated "Paulines."[39] This apostle's message, in particular, had served as the main point of departure for the development of Luther's evangelical theology,[40] and the reformer expressed on numerous occasions his high regard for its author. "Paul was the wisest man after Christ," he once stated.[41] He also affirmed of this apostle that he was "the very best teacher" whom the Lord has had on earth.[42] In one of his writings Luther further observed that "St. Paul's epistles are more a Gospel than Matthew, Mark, and Luke; for these offer little more than the history of the works and miracles of Christ. But of the grace which we have through Christ no one writes with such emphasis as St. Paul."[43] John, on the other hand, is known to have been Luther's favorite evangelist,[44] particularly because of his christological teachings on the nature and person of the Saviour.[45] The Wittenberg preacher lauded John as "a master above all other evangelists"[46] and designated his as "the one fine, true, and chief Gospel."[47] A modern theological interpreter of Luther indeed goes so far as to assert of the reformer that "his way of teaching the faith is at least as much Johannine as it is Pauline."[48]

While John and Paul are exalted in Dürer's painting, the figures of Peter and Mark appear to be subordinated. The treatment accorded to St. Peter, the "Prince of the Apostles,"[49] especially requires comment. In view of the great importance of the debate over papal authority in the Reformation, the diminished stature seemingly assigned to the reputed founder of the Roman episcopal seat must strike one as noteworthy.[50] Ludwig Grote goes so far as to say of Dürer that "by showing St. Peter, the first Bishop of Rome and

the rock of the old Church, reading the Gospel according to St. John, he is saying in plain Lutheran language that the only valid authority in the government of the Church is the Word of God—not the Fathers, Popes, or Councils of the Church."[51]

This reference to the Word of God suggests another key Reformation concept that appears to be strongly emphasized in the painting. Three of the four figures depicted here are shown holding Scripture—the source of the Word—in one form or another: John, who gives up his traditional personal attribute of the chalice in favor of the text of his Evangel,[52] open to the first chapter wherein he proclaims the eternity of God's Word, that Word considered by the reformers to be the foundation of their religious renewal;[53] Mark, who clutches in his right hand the scroll bearing a portion of the text of his Gospel; and Paul, who grasps in his left hand a large bulky volume that most certainly is intended to be a Bible.

Thus far our analysis of the subject matter of the *Four Apostles* suggests that the artist Albrecht Dürer must have had a more than casual interest in the Lutheran Reformation. Just how much do we know about this topic? Fortunately, a fair number of written historical documents have been preserved that shed considerable light on this question and provide explicit information that cannot be gained from the study of art works alone.[54] By examining the more important of these now we not only will be able to acquire a better appreciation of the context and intent of the iconographical features just discussed, but also prepare ourselves for taking up at length the rather complex and still debated issues of the correct interpretation of the inscriptions and the ultimate meaning of the work as a whole.

The first literary evidence we have linking Dürer with Luther consists of a letter written by the Wittenberg reformer in March, 1518, to Christoph Scheurl, a Nuernberg compatriot of the artist.[55] In it Luther asked Scheurl to convey his thanks to the artist for a gift sent him earlier, probably a set of woodcuts or engravings.[56] In the following year Scheurl relayed, in a letter to a follower of Luther at Wittenberg, Dürer's request for a German translation of one of the reformer's Latin writings.[57] And then, in 1520, Dürer wrote a revealing epistle to Georg Spalatin, court chaplain to Luther's prince, the Elector Frederick the Wise of Saxony. The relevant portion of this crucial document reads as follows:

So I pray your worthiness . . . to beseech his Electoral Grace to take the praiseworthy Dr Martin Luther under his protection for the sake of Christian truth. For that is of more importance to us than all the power and riches of this world; because all things pass away with time, Truth alone endures for ever. God helping me, if ever I meet Dr Martin Luther, I intend to draw a careful portrait of him from the life and to engrave it on copper, for a lasting remembrance of a Christian man who helped me out of great distress. And I beg your worthiness to send me for my money anything new that Dr Martin may write.[58]

Dürer, unfortunately, never was to have an opportunity to portray the reformer from life since these "the two greatest Germans of their time never met face to face."[59] But the artist continued to concern himself with Luther and his movement. A list has survived, in his hand, of sixteen of the reformer's writings from the years 1518–20, works either in the master's possession or, perhaps, as Dürer's modern translator suggests, "recommended to his attention by some friend, and written down for reference."[60] The famous diary that Dürer kept of his Netherlands journey in 1520–21 contains entries that make it clear that he continued to purchase writings of the reformer and had others given to him.[61]

This same diary contains another, better-known passage, that has been cited again and again because of its eloquent testimony of the artist's great esteem and concern for Luther. It is the so-called *Lutherklage,* the anguished and heartfelt outburst of the artist upon learning of the mistaken report that the reformer had fallen into the hands of his enemies during his return home from the Diet of Worms. The critical portions of this passage are reproduced here:

On Friday (17 May) before Whitsunday in the year 1521, came tidings to me at Antwerp, that Martin Luther had been so treacherously taken prisoner; for he trusted the Emperor Karl, who had granted him his herald and imperial safe-conduct. But as soon as the herald had conveyed him to an unfriendly place near Eisenach he rode away, saying that he no longer needed him. Straightway there appeared ten knights and they treacherously carried off the pious man, betrayed into their hands, a man enlightened by the Holy Ghost, a follower of the true Christian faith. And whether he yet lives I know not, or whether they have put him to death; if so, he has suffered for the truth of Christ and because he rebuked the unchristian

Papacy, which strives with its heavy load of human laws against the re-
demption of Christ. And if he has suffered it is that we may again be
robbed and stripped of the fruit of our blood and sweat that the same may
be shamefully and scandalously squandered by idle-going folk, while the
poor and the sick therefore die of hunger. But this is above all most griev-
ous to me, that, may be, God will suffer us to remain still longer under
their false, blind doctrine, invented and drawn up by the men alone whom
they call Fathers, by whom also the precious Word of God is in many places
wrongly expounded or utterly ignored.

. .

And if we have lost this man, who has written more clearly than any that
has lived for 140 years, and to whom Thou hast given such a spirit of the
Gospel, we pray Thee, oh heavenly Father, that Thou wouldst again give
Thy Holy Spirit to one, that he may gather anew everywhere together Thy
Holy Christian Church, that we may again live free and in Christian man-
ner, and so, by our good works, all unbelievers, as Turks, Heathen, and
Calicuts, may of themselves turn to us and embrace the Christian faith.
But, 'ere Thou judgest, oh Lord, Thou willest that, as Thy Son, Jesus Christ,
was fain to die by the hands of the priests, and to rise from the dead and
after to ascend up to heaven, so too in like manner it should be with Thy
follower Martin Luther, whose life the Pope compasseth with his money,
treacherously towards God. Him wilt Thou quicken again.

Every man who reads Martin Luther's books may see how clear and trans-
parent is his doctrine, because he sets forth the holy Gospel. Wherefore his
books are to be held in great honour and not to be burnt; unless indeed his
adversaries, who ever strive against the truth and would make gods out of
men, were also cast into the fire, they and all their opinions with them, and
afterwards a new edition of Luther's works were prepared. Oh God, if
Luther be dead, who will henceforth expound to us the holy Gospel with
such clearness? What, oh God, might he not still have written for us in ten
or twenty years!

Oh all ye pious Christian men, help me deeply to bewail this man, inspired
of God, and to pray Him yet again to send us an enlightened man. Oh
Erasmus of Rotterdam, where wilt thou stop? . . . Hear, thou knight of
Christ! Ride on by the side of the Lord Jesus. Guard the truth. Attain the
martyr's crown.[62]

Admittedly, the authenticity of this particular passage in the Dürer diary has been questioned in recent years, most notably in a pair of articles by Heinrich Lutz, who raises the possibility that the *Lutherklage* may be a later interpolation in the text.[63] However, other scholars have proposed what no doubt will appear to many as sufficiently good reasons for continuing to regard the entry as a genuine and moving expression of the artist's feelings about Luther.[64]

Luther's name is specifically mentioned, in surviving writings by Dürer, for the last time in 1521.[65] Nonetheless, references to the contemporary religious situation continue to appear. In 1523 the Nuernberg artist jotted down a personal comment on a copy of that woodcut by Michael Ostendorfer depicting the veneration of the shrine of Mary the Beautiful at Regensburg mentioned in an earlier chapter of this book: "This specter has risen against Holy Scripture at Regensburg with the permission of the Bishop, and has not been abolished because of worldly usefulness. Lord help us that we should not dishonor his dear Mother by separating her from Christ Jesus. Amen."[66] It has been pointed out recently that this notation of Dürer's is rather similar to a passage in Luther's 1520 address *To the Christian Nobility of the German Nation*.[67] In this treatise the reformer specifically mentioned Regensburg while attacking the bishops for permitting and profiting from the traffic to the new pilgrimage sites.

The last item in this series of documents is the letter written by Dürer on December 5, 1524, to Nikolaus Kratzer, a German astronomer at the English court whom the artist had met previously in Antwerp. Kratzer had included in his earlier epistle of October 24, sent from London, the following statement: "Now that you are all evangelical in Nürnberg I must write to you. God grant you grace to persevere; the adversaries indeed are strong, but God is stronger and is wont to help the sick who call upon him and acknowledge him."[68] To this Dürer replied from Nuernberg:

We have to stand in disgrace and danger for the sake of the Christian faith, for they abuse us as heretics; but may God grant us his grace and strengthen us in his word, for we must obey Him rather than men. It is better to lose life and goods than that God should cast us, body and soul,

into hell-fire. Therefore may He confirm us in that which is good, and enlighten our adversaries, poor, miserable, blind creatures, that they may not perish in their errors. [69]

It perhaps should be pointed out here that this last statement by Dürer was written almost on the eve of the formal adoption of Lutheranism in Nuernberg, which occurred in March, 1525, [70] at a time when, in fact, many of the concrete changes in worship accompanying the Reformation already had been introduced into various local churches. It would appear, to judge from the artist's letter, that he affirmed those changes and thus the religious reform itself as it had developed to that point. [71]

We come now at last to the problem of analyzing the inscriptions that Dürer placed at the base of his twin panels. As a rule, it might seem reasonable to expect that when written matter is included on a painting it should help explicate the meaning of that which is visually represented in the composition. It soon becomes obvious, however, that these particular texts are not simply explanatory labels. They clearly were designed to constitute in themselves an important part of the message to be conveyed. [72] Unfortunately, the inscriptions do not contain sufficiently explicit information on how the scriptural selections quoted there are to be understood and to whom or what they are supposed to be applied. It would seem likely that their intended signification was known to Dürer's contemporaries, [73] or at least those to whom the composition was dedicated. But no record of what they perceived that meaning to be has survived. [74] Modern scholars faced with the problem of explaining the *Four Apostles*, therefore, have had a difficult task of interpretation. So far it has not been possible to dispel completely the uncertainty either by appealing to the surviving literary sources of the period or by turning to a consideration of the historical context from which the painting emerged. Thus it should occasion no great surprise that on this matter historians and students of art have found it difficult to reach a consensus.

The disagreement begins with respect to the proper understanding of the passage with which Dürer introduces the scriptural texts. The wording of this introduction runs as follows, in Conway's English translation:

All worldly rulers in these dangerous times should give good heed that they receive not human misguidance for the Word of God, for God will have nothing added to His Word nor taken away from it. Hear therefore these four excellent men, Peter, John, Paul, and Mark, their warning.

How is this passage to be understood? It will be noted that Conway in his version gives the last line an imperative construction. This interpretation was emphasized strongly by the German scholar Ernst Heidrich, in his important study *Dürer und die Reformation* (1909). Heidrich urged that not only the last sentence but in fact this entire introduction should be understood in the sense of an imperative—an admonition to the city council, in these "dangerous times," to resist the temptations against which the four apostle figures issue a warning in their statements to follow. [75] The interpretation given the introductory passage by such scholars as Conway and Heidrich for many years was very influential in Dürer studies. [76] More recently, however, Gerhard Pfeiffer has challenged this understanding of the text. He has noted that from a grammatical point of view the German verb that previously was considered a second person plural imperative might equally well be read as a third person plural indicative or as a present participle. Thus, for the last line of the introductory inscription, Pfeiffer proposes the following rendition: "Accordingly these four excellent men heed the warning of Peter, John, Paul and Mark." [77]

But who are the "four excellent men," if they are not the apostles themselves? [78] This brings us to Pfeiffer's own ingenious attempt to reinterpret the meaning of the entire painting, which he sees as containing a set of likenesses of four contemporaries of Dürer who were instrumental in the establishment of a new municipal educational institution in Nuernberg in 1525–26. Pfeiffer argues that the painting was intended primarily as a memorial to the founding of an evangelical secondary school subsequently named after Philipp Melanchthon. He does not believe that an artist even of Dürer's stature either would or could presume to issue warnings to the highly authoritarian and patrician magistrates of his city. [79] Instead, Pfeiffer prefers to build upon an older tradition of associating the features of Dürer's apostle John with those of Melanchthon and then proceeds to identify the remaining three apostle representations as

likenesses of other men associated with the Wittenberg humanist in the setting up of the new academy.[80] Thus Paul and Peter allegedly bear the traits, respectively, of Joachim Camerarius and Michael Roting, the rector and one of the teachers selected for the school by Melanchthon, while the features of Mark suggest those of Hieronymus Paumgartner, a young Nuemberg patrician who had been particularly effective in this enterprise as a personal link between Melanchthon and the Nuemberg city council. The introductory inscription is intended to mean, according to Pfeiffer, that the contemporary figures, i.e., the "four excellent men" portrayed in biblical guise in the panels, do heed the Word of God as expressed in the writings of the four apostles and thus merit inclusion in an art work intended to commemorate for the city fathers the creation by the municipality of a new school in which a purified religious instruction will be based directly on the Scriptures.[81]

It is not necessary here to evaluate the validity of Pfeiffer's fascinating interpretation of the painting, which in fact has met with a somewhat mixed reception.[82] It might be noted in this context, however, that in a subsequently published study another scholar has once again proposed that the introductory inscription be understood in the imperative case.[83] Thus the problem obviously has not been fully resolved.[84]

If the effort to interpret the meaning of the introductory passage to the inscriptions on the *Four Apostles* painting has led to disagreement and inconclusive results, attempts to explicate the biblical texts that follow it have fared no better. What is the intended message of these excerpts with their references to "false prophets," "damnable heresies," immoral men who will appear during the "perilous times" of the last days, "having a form of godliness, but denying the power thereof," and the "scribes, which love to go in long clothing"? Against whom is the "warning" directed? Some scholars have understood all four of these biblical texts to point toward one and the same foe of the Reformation in Nuemberg. Heidrich, as we shall see, applied them to the radical religious reformers and social agitators to the left of the Lutherans.[85] Ludwig Grote, on the other hand, in his recent book on Dürer seemed to suggest that the inscriptions as a whole should be considered an attack on the Roman church.[86] Another solution has been to read

them as directed against enemies on both the left and the right of the moderate Nuernberg Reformation. Moriz Thausing, in his important nineteenth-century monograph on Dürer, proposed that the passages were intended as both "a plain protest against the innovators, the radical sectaries, the Anabaptists, and the Deists" and a warning against "more powerful enemies . . . the adherents of the old faith . . . immoral priests and opinionative humanists."[87] Panofsky, in his classic study of the artist, appeared to echo this judgment when he said of the passages that "they were meant to castigate radicals and Papists alike."[88] As we shall see, even this catalog of divergent explanations does not exhaust the list of conflicting interpretations one encounters in the scholarly literature on this painting.

It may prove helpful in analyzing the biblical inscriptions to divide them into pairs. Heidrich noted many years ago that the two on the left panel deal mainly with doctrine and those on the right with morals or behavior.[89] Taking a cue from this helpful distinction, we shall begin with the Petrine and Johannine texts. A number of attempts have been made to discover in the religious writings of the day possible literary sources for Dürer's usage of these particular biblical passages.[90] On the whole, such efforts have led to inconclusive results. It can be shown that the scriptural selections were used by both reform-minded and traditionalist authors of Dürer's period.[91]

What, then, of seeking an explanation for the Petrine and Johannine verses in the historical context, the religious and political events of the 1520s in Nuernberg? A great contribution in this direction was made by the ground-breaking study of Heidrich mentioned earlier. Heidrich called particular attention to the christological emphasis of the Johannine text, which he saw as an extension and refinement of the rather generalized reference to false prophets in the preceding Petrine passage.[92] John counsels his readers to "try the spirits whether they are of God": "Hereby know ye the Spirit of God: Every spirit that confesseth that Jesus Christ is come in the flesh, is of God: and every spirit that confesseth not that Jesus Christ is come in the flesh, is not of God." Who in these years was denying Christ?[93] With this question we come to one of the most interesting incidents in the history of the Reformation in Nuern-

berg, the trial of the so-called godless painters in January, 1525.[94] In that month the brothers Sebald and Barthel Beham, as well as Georg Pencz, all onetime students or co-workers of Dürer,[95] were apprehended and brought to a hearing by the city government on the accusation that they had indulged in some loose talk reflecting unorthodox religious sentiments. One of the questions put to them during their inquisition concerned their views about christology. Both Barthel Beham and Pencz answered in such a fashion as to suggest that they did not believe in Christ.[96] The authorities, duly horrified, soon decided to expel all three artists from the city.

But the concern aroused did not end there. It was scarcely to be assumed that such relatively unlettered men could have, on their own account, dreamed up such radical and unconventional views. Their heretical aberrations must have received inspiration from other sources. Indeed, one of the artists had reported conversations with Hans Denck,[97] the schoolmaster whom we have encountered before in our discussion of iconoclasm in Nuernberg. Denck, as has been noted, was a religious thinker of some consequence and generally is recognized today as one of the more significant personages in the early years of the Radical Reformation.[98] Although one cannot assume that the rash and unsophisticated statements of the young painters accurately reflected Denck's own views, the latter also was unable to satisfy the Nuernberg authorities with respect to his theological orthodoxy, and he too was exiled from the city.[99] One of the suspicions harbored against Denck was that, with his mystical emphasis upon the inner Word, he subverted reliance upon the written text of the Bible.[100] Significantly, two of the godless painters had indicated an inability to believe in the authority of the Scriptures.[101]

Although these radicals were quickly expelled from Nuernberg, Heidrich believes that citizens such as Dürer probably continued to view extreme sectarian theology as a threat to the religious stability of the community.[102] And Heidrich's further suggestion should also be noted here—that Dürer may have had rather personal motives as well: specifically, to clear himself of any suspicion of sympathy or involvement with these radical artists by making a public testimony of his own position and views in the form of the *Four Apostles* panels.[103]

Heidrich's application of the Petrine and Johannine selections to Denck and the godless painters, though influential, has not been accepted by all scholars as the last word on the matter. Pfeiffer recently has called attention to the reference in Peter's text to the false prophets who introduce "ruinous sects" (*verderbliche seckten*), or "damnable heresies," as it reads in the English translation quoted above. Pfeiffer says of this wording that it "points directly" to the Nuernberg city council's proclamation of July, 1526, on "enthusiasts," which was a strong warning against those who disparaged the sacrament of the Eucharist and disrupted the religious unity of the city, especially the followers of Karlstadt, Oecolampadius, and Zwingli.[104] Gottfried Seebass, on the other hand, on the basis of his study of the writings of Luther and the Nuernberg Lutheran preacher Andreas Osiander, has argued that this allusion to "ruinous sects" can refer only to the monastic orders of the old church.[105]

What about the inscriptions on the right panel of the *Four Apostles*? As in the case of those on the left, attempts to establish literary sources for Dürer's choice of these Bible verses have not led to definitive results.[106] Heidrich, however, by resorting here also to an analysis of the historical events of the 1520s, concluded many years ago that these passages too refer to the left-wing opponents of the Lutheran Reformation.

Here it must be recalled that the early Reformation period in Germany witnessed not only great theological turmoil, but political and moral upheaval as well, the most dramatic expression of which was the Peasants' Revolt of 1524–25. As a consequence, many men feared political anarchy and the overthrow of the social order. For a person of conservative or even moderate views it might well have seemed that radical theology was bearing dangerous practical fruits.[107] And, once again, we must note the impact made in Nuernberg by the proceedings against the godless painters.[108] For the radicalism of these young men embraced more than simply religious matters. During the course of the hearings, each of the dissenting artists had been asked the following question: "Does he believe in worldly authority and does he recognize the Council of Nuernberg as lord over his body, his goods, and all that is material?" The deposition of Pencz's reply reads: "He recognizes no lord

but God alone." Barthel Beham, whose replies on the whole were even more radical, answered a simple and defiant "No."[109]

It is in this context, according to Heidrich, that we must understand the texts from Paul and Mark.[110] The reference in 2 Tim. 3:1 to the "perilous times" that would occur in the "last days" was intended to call to mind the Peasants' Revolt. In the long catalog of sins that St. Paul enumerates in this passage, we are to see reflected the moral decay accompanying radical religious dissent and civil insurrection. Paul thus functions in this painting not simply as a reminder of the Protestant doctrine of justification by faith, but also as *Strafapostel,* that is, the apostle of judgment and condemnation. Visually, Heidrich proposes, Dürer calls attention to Paul's wrath by his depiction of the apostle's left eye, which stares out "almost menacingly" toward us.[111] The inclusion of this particular biblical author assumes still further significance, Heidrich argues, when we remember that it is his Epistle to the Romans that contains perhaps the best-known passage in all of the New Testament concerning the duty of obedience to properly constituted authority.[112]

But what about the selection from Mark with its caution to "beware of the scribes"? This, Heidrich insists, is a specific reference to the person and character of Hans Denck.[113] In his choice of scriptural texts, Dürer here proceeds from the general to the particular, just as in the other two inscriptions on the left panel.[114]

On the whole, Heidrich's interpretation of the inscriptions on the right panel has held up less well than his explanation of the Johannine and Petrine passages on the left. Seebass has objected that the Heidrich viewpoint does violence to what we otherwise know of the character of Denck, who more typically is depicted as a quiet and unassuming man, and also to the historical reputation of many others active in the left wing of the Reformation, e.g., the Anabaptists, who were acknowledged even by some of their opponents to lead blameless lives.[115] Heinrich Lutz, on the other hand, has judged it unlikely that the overbearing manner attributed to the scribes in Mark 12:38–40 could be accepted in 1526 as descriptive of the public behavior of the sectarian radicals, who by then were being persecuted and repressed everywhere.[116] In an interesting switch, these two scholars suggest that the texts on the right panel really were meant to refer to certain of the leading Lutheran preachers of the city,

particularly Osiander.[117] Seebass, who is himself the author of a major study on Osiander, contends that the great Nuernberg preacher had a reputation for displaying a number of personality traits that are more likely to be reflected in the passages at hand than those of Denck, among them such qualities as avariciousness, a love of luxury and high living, and arrogance.[118] Osiander apparently even was accused of defrauding a widow of her house,[119] a charge that is significant when we recall one of the criticisms of the scribes in Mark's Gospel. In sum, Seebass contends, such men as Dürer felt that Osiander was guilty of manifesting an unfortunate contrast between his lofty words and his actual deeds; the result is the indirect attack on him found in the inscriptions to the *Four Apostles*.[120]

On first consideration it might seem somewhat strange that such a man as Dürer, who as recently as 1524 had endorsed the Nuernberg Reformation, should less than two years later be covertly attacking one of its clerical leaders. One is bound to inquire whether any other historical evidence exists to support such an interpretation. Directly involved here is the larger question of Dürer's views on the course taken by the religious reform subsequent to its formal adoption in Nuernberg. As mentioned above, there is no reference to Luther's name in the artist's surviving writings from this late period. After 1524, in fact, Dürer's literary remains provide little in the way of conclusive and reliable evidence concerning his attitude toward the disputed religious issues and ecclesiastical factions of the day.[121] It no doubt would be natural to assume that the artist persevered to the end in his previous loyalty to Luther were it not for a letter written after his death by a close friend, the noted Nuernberg humanist Willibald Pirckheimer. In this undated letter of 1529 or 1530 to Johann Tschertte,[122] a mutual friend of Pirckheimer and Dürer, the humanist mentions the artist in the course of a bitter condemnation of the discrepancies he believes he has noted in the Protestant camp between faith and works:

It is, therefore, perhaps good that one can detect how far the Lutheran word and work are from each other. Without doubt there are many pious honorable people around about you whom you hear speak sweetly about faith and the holy Gospel; deem it to be pure gold that glitters, but it is hardly brass. I confess that I, too, was at first a good Lutheran, like our

sainted Albrecht. Then we hoped that the Roman rascality, likewise the roguery of the monks and priests would be corrected. But as one observes, the situation has grown worse, so that the evangelical knaves make them pious. I can well imagine that this sounds strange to you, but if you were here with us and would see the shameful, wicked, and criminal manner in which the priests and apostate monks conduct themselves, you would be very amazed. The former ones betrayed us with hypocrisy and cunning, but these want to lead a scandalous and criminal life openly and blind the perceptive people by saying that one cannot judge them by their works, although Christ taught us differently.[123]

Although the wording of the passage where Dürer's name is brought up may seem somewhat ambiguous,[124] Pirckheimer's letter understandably has been interpreted by many as evidence that the artist shared with his humanist friend not only the initial enthusiasm for the reform but also the later disenchantment with certain of its consequences. Seebass, for his part, argues that Dürer's disillusionment with the failure of Lutheranism to bring about a greater ethical renewal is better appreciated if one notes that a strong concern for Christian living is apparent throughout the artist's life.[125] Along with certain other scholars, Seebass strongly emphasizes the importance of humanistic ideals in the makeup of Dürer's religious philosophy,[126] which naturally predisposed him to favor a type of evangelical reform that would be ethically fruitful as well as doctrinally pure.[127] When his hopes along this line were not fulfilled, it was understandable that such a man as Osiander became the target of his resentment, since this preacher combined with his new clerical preeminence in the city a manner of personal conduct that many persons found objectionable. The result, according to Seebass, is that Dürer expressed his indignation and his warning in the form of the biblical inscriptions written at the base of the right panel of the *Four Apostles.*[128]

Finally, to return to and round out our discussion of these verses from Paul and Mark, it should be recalled that at one time or another, several other scholars have preferred to apply the verses to the adherents and defenders of the old Roman hierarchy. Thausing advanced this view in the nineteenth century, and the anti-papal interpretation has been adopted and repeated in the period since by authors such as Panofsky.

And so the debate continues. It does not appear that a scholarly consensus has yet emerged with respect to the meaning of the written inscriptions to Dürer's painting. In the last twenty years alone, four distinguished German scholars—Hans Rupprich, who apparently endorses Heidrich's interpretations,[129] Grote, Seebass, and Pfeiffer—have proffered four different and at least partially contradictory views. The problem may never be completely resolved, unless computer studies of Dürer's linguistic usage help to establish in a more definitive manner the meaning of his introductory inscription or new and hitherto unknown historical documents that have a direct bearing on the matter are discovered.[130] The scholarship devoted to the question up to this point certainly has not been fruitless. The historical context of Dürer's work has been profitably illuminated and some of the various possibilities with respect to the interpretation of the biblical texts greatly clarified. But it would seem hazardous at this point to base one's understanding of the overall meaning of the painting too solidly upon one or the other of the explanations given for the inscriptions.

Having considered some of the numerous problems of interpretation associated with Dürer's *Four Apostles,* we must now determine in what regard the Nuernberg master's great work may properly be referred to, in accordance with the theme announced in the introduction to this essay, as a memorial painting of the Reformation. An argument will be presented here to show that one may legitimately so designate the work, provided that the concept of memorial painting is understood in a comprehensive sense.[131]

The *Four Apostles* may be considered a memorial painting, first of all, because Dürer apparently intended the work as a monument to his own artistic achievement.[132] To be sure, only with great difficulty can one imagine that the painter would have produced a composition so charged with ideological significance solely for the purpose of demonstrating his professional skill or insuring his worldly reputation. There obviously is much more to the dedication than this. But the designation of the work in the letter of presentation as a "remembrance," when combined with the entry in the municipal records referring to it as a monument to Dürer's own memory, would seem to indicate that, at one level of meaning at least, the

painting was intended by the master as his personal legacy and artistic testament to his native city.

The *Four Apostles* may be viewed as a memorial painting also in the sense that it served as an appropriate monument to Dürer's enduring belief in the validity of a Christian art.[133] It perhaps is true, as Craig Harbison has argued, that in the period prior to the undertaking of this work the artist engaged in some deep soul-searching on the question of whether the use of religious imagery truly was compatible with his new evangelical faith.[134] But, if so, he must have resolved his doubts by 1525. For in that year he offered an explicit written defense of the religious value of art. Taking issue with those who reviled painting and said that it was a servant to idolatry, Dürer responded, "For a Christian would no more be led to superstition by a picture or effigy than an honest man to commit murder because he carries a weapon by his side. He must indeed be an unthinking man who would worship picture, wood, or stone. A picture therefore brings more good than harm, when it is honourably, artistically, and well made."[135] In an apparent reference to the iconoclastic destruction of his own day, Dürer in this same context pointedly remarked that "arts very quickly disappear, but only with difficulty and after a long time can they be re-discovered." The very foundations of religious art were under heavy attack during the Reformation period. It is clear from his writings that Dürer felt obliged to make a response to those critics who threatened its existence. Most probably, one form that response took was the creation and dedication of the artist's own superb example of an "honourably, artistically, and well made" religious painting, the *Four Apostles.*

The third sense in which Dürer's panels may be understood as a memorial painting derives from the probability of their being presented by the artist to the city council as a monument to the orderly and constructive way in which the Reformation had been introduced into the community.[136] Perhaps the painting can even be thought of, in Grote's terms, as the artist's "token of homage" to the magistrates for the commendable manner in which they had conducted these affairs.[137] For whatever the precise nature of Dürer's views concerning the various religious and political factions existing in Nuernberg at the time of the dedication, it is clear that he must have agreed fundamentally with the general direction taken

by the reform there. Otherwise, he scarcely would have given a work such as this to the very governing authorities who were responsible for the policies that had been adopted. From the standpoint of one in sympathy with the outcome of the Nuernberg Reformation, it might be said that in instituting a religious renewal based on the unadulterated Word of God the magistrates *had* acted in a manner worthy of commemoration. The councilmen *had* shown themselves to be responsible rulers who were careful not to receive "human misguidance" in the place of divine revelation. In dealing decisively with the dangers posed by sectarians and sacramentarians, as well as the lingering vestiges of papalism, they *had* protected the population from "false prophets" and "damnable heresies." They *had* persevered in their implementation of the reform, even when confronted with the disappointments of immoral behavior and hypocrisy.[138] Thus Dürer may well have intended not so much to "warn" the city fathers, in any narrow sense of the term, as respectfully to exhort them to continue in the good work that they already had so auspiciously undertaken. In assuming for themselves supervision of how the Word of God was to be taught and administered in the community, a transfer of religious authority tacitly acknowledged in Dürer's introductory inscription,[139] the magistrates had shouldered an awesome responsibility. The presence in the city hall of the four apostolic figures along with the selections from their biblical writings might serve as a reminder to the councilmen of the seriousness and importance of these new duties.[140]

Finally, the *Four Apostles* painting may be seen as a memorial to Dürer's own evangelical faith at a point near the end of his career.[141] It perhaps is proper to speak of evangelical faith rather than "Lutheranism" or "Protestantism," for despite the decisive ecclesiastical transformation that occurred in Nuernberg in 1525 the hard and fast denominational boundaries of modern church history had not fully solidified in the artist's lifetime.[142] The term *evangelical* is preferable in this case also in that it better allows for the possibility that the artist may have become somewhat alienated from a portion of the Lutheran leadership of his city in his last years—without, however, abandoning Reformation theology or returning to Rome.

As with the inscriptions to his great painting, the matter of Dürer's ultimate religious loyalties is a topic of some dispute.[143]

Some modern scholars, pointing to the lack of specific written evidence from the last years and emphasizing the importance of Pirckheimer's letter to Tschertte, suggest that Dürer really should not be considered an adherent of the Lutheran Reformation at the end.[144] This would seem, however, to be an example of making too much of an argument from silence. No evidence, in fact, has been presented to show that the artist ever repudiated the evangelical movement. Even when full weight is given to the importance of Pirckheimer's testimony,[145] it says only that Dürer became disillusioned with the behavior of certain local Lutheran leaders. No reference is made to doctrine. And if the artist rejected certain Lutheran clergy, he is known to have remained on good terms with others. At the time of Dürer's death in 1528, a memorial poem in his honor was written by a Nuernberg Lutheran preacher named Thomas Venatorius.[146] Venatorius, as it happens, also was close to Pirckheimer.[147]

The importance of this network of personal relationships has been stressed recently by certain scholars who argue that in the absence of written evidence concerning Dürer's last loyalties we must look to the circle of his friends at that time.[148] In Nuernberg in the later 1520s lived a group of men who combined evangelical theology with a humanistic concern for ethical renewal and good scholarship. Dürer apparently was a member of this group. The hero or model of many of these men was Melanchthon, the humanist theologian from Wittenberg.[149] With the independent perspective of their scholarly and ethical concerns, these evangelical humanists were able to take a somewhat critical attitude toward the new ecclesiastical establishment in the city. They were not inclined to be overly tolerant of clergy—of whatever party—who did not practice what they preached.

Dürer's membership in this humanist group may help to account for his refusal to cast a blind eye toward the failings of prominent Lutheran leaders such as Osiander. It does not, however, suggest that the artist in any way experienced a diminished commitment to his belief in a Christian faith and life patterned on the rediscovered Word of God. If the *Four Apostles* painting itself may be brought in as evidence, it would appear that in 1526 this conviction was as strong as ever.

Religion was a vital and central part of Albrecht Dürer's existence. Despite his association with leading humanist scholars, the Reformation had never been simply a matter of intellectual concern for him, nor had it been merely a movement of ethical renewal. His response to Luther shows that he felt profoundly and in a very personal way the religious crisis of his age. Luther's theology of justification by faith evidently had brought him freedom from an oppressed conscience, a spiritual liberation for which the artist was enormously grateful.[150] Such a commitment to evangelical Christianity as would result from this type of experience surely was not of the sort to be destroyed through disappointment with the outward behavior of men,[151] even if those men were in some instances leaders of the evangelical movement.

Unless new and conclusive evidence to the contrary is presented, we must assume that Dürer persevered to the end in his evangelical faith, a faith grounded on his belief in the authority of the Word of God. And it is the primacy of the Word, above all, that is the message of the *Four Apostles*. These two panels therefore stand as Dürer's religious testament, just as they constitute his artistic legacy.[152] They represent the personal witness of the artist for his biblically based Christianity.[153]

Appendix

The following chart contains the results of a tabulation of the iconographical themes represented in a sample of 441 German religious paintings from the years 1495–1520. For a list of the ten artists whose works have been inventoried, plus an explanation of some of the procedures used, see my article "The Reformation and the Decline of German Art," *Central European History* 6 (1973):231–32, app. C.

The categories employed in this table have been chosen not only with a consideration for the subject matter of the tabulated art works themselves, but also with the intention of providing a useful basis for comparison with the iconography of early Lutheran art. This principle has resulted in the inclusion of some themes that otherwise might not seem justified, e.g., Christ Blessing the Children and Christ and the Adulteress.

It has not been possible to ascertain the original purpose or location of all 441 religious paintings included in this table. The sources used, however, do explicitly label more than half of them as altarpieces, that is, as central panels, wing panels, or predella panels.

Old Testament Themes	20
Birth of Christ and Related Events	55
Madonna and Child	43
Other Mariological Themes	39
Baptism of Christ	2
Christ Blessing the Children	0
Christ and the Adulteress	1
Last Supper	4
Crucifixion of Christ	18
Other Scenes Related to the Passion of Christ	62
Resurrection of Christ	8
Other Events from the Life of Christ	10
Christological Dogma	9
Holy Trinity	5
Apostles	18
Saints	125
Other	22
Total	*441*

Abbreviations

CR *Corpus Reformatorum* (Halle, Braunschweig, Berlin, Leipzig, Zurich, 1834 ff.). Contained in the *CR* are the following series of volumes cited in this book:
Philippi Melanthonis Opera (Halle, Braunschweig, 1834 ff.)
Huldreich Zwinglis Sämtliche Werke (Berlin, Leipzig, Zurich, 1905 ff.)

LW *Luther's Works* (St. Louis, 1955 ff.; Philadelphia, 1957 ff.)

RDK *Reallexikon zur deutschen Kunstgeschichte* (Stuttgart, Munich, 1937 ff.)

Rott Hans Rott, *Quellen und Forschungen zur südwestdeutschen und schweizerischen Kunstgeschichte im XV. und XVI. Jahrhundert.* Vol. 1: *Bodenseegebiet,* Part 1: *Text* (Stuttgart, 1933), Part 2: *Quellen* (Stuttgart, 1933); Vol. 2: *Alt-Schwaben und die Reichsstädte* (Stuttgart, 1934); Vol. 3: *Der Oberrhein,* Part 1: *Text* (Stuttgart, 1938), Part 2: *Quellen,* 1: *Baden, Pfalz, Elsass* (Stuttgart, 1936), Part 3: *Quellen,* 2: *Schweiz* (Stuttgart, 1936)

WA *D. Martin Luthers Werke,* Kritische Gesamtausgabe (Weimar, 1883 ff.; "Weimarer Ausgabe")

Notes

Chapter 1

1. For late medieval piety in Germany, see Bernd Moeller, "Piety in Germany around 1500," in *The Reformation in Medieval Perspective*, ed. Steven E. Ozment (Chicago, 1971), pp. 50–75; Willy Andreas, *Deutschland vor der Reformation: Eine Zeitenwende* (Stuttgart and Berlin, 1932); Joseph Lortz, *The Reformation in Germany*, trans. Ronald Walls, 2 vols. (London, 1968), 1:109–43; Steven E. Ozment, *The Reformation in the Cities: The Appeal of Protestantism to Sixteenth-Century Germany and Switzerland* (New Haven, Conn., 1975), pp. 15–46. Also useful is John P. Dolan, *History of the Reformation* (New York, 1965), pp. 184–99.
2. Moeller, pp. 51, 53; Lortz, 1:109–10, 113. Cf. Johan Huizinga, *The Waning of the Middle Ages*, trans. F. Hopman (Garden City, N.Y., 1954), pp. 177–78.
3. Dolan, p. 185. Cf. Huizinga, pp. 159, 161, 178, 180–81.
4. Moeller, pp. 52, 60; Lortz, 1:110, 125–26; Rudolf Stadelmann, *Vom Geist des ausgehenden Mittelalters* (Stuttgart–Bad Cannstatt, 1966; rep. of Halle, 1929 ed.), p. 10; Hermann Heimpel, "Das Wesen des deutschen Spätmittelalters," *Archiv für Kulturgeschichte* 35 (1953):49–50.
5. Moeller, pp. 52, 58; Andreas, pp. 140–41.
6. Andreas, pp. 149 ff.; Lortz, 1:113, 120; Immanual Schairer, *Das religiöse Volksleben am Ausgang des Mittelalters nach Augsburger Quellen* (Leipzig and Berlin, 1914), pp. 125–26.
7. Andreas, pp. 144–45; Schairer, p. 121; Dolan, pp. 185, 188–89.
8. Andreas, pp. 146, 610; Lortz, 1:110. For a local example (Zurich), see Charles Garside, Jr., *Zwingli and the Arts*, p. 86.
9. Andreas, p. 142; Moeller, p. 57; Dolan, p. 184.
10. Moeller, pp. 52–53; Heimpel, p. 49. Cf. Ozment's comment that "the surge in lay piety on the eve of the Reformation is manifest by every measure" (p. 21).
11. Lortz, 1:112, 120, 129. Cf. Moeller, pp. 53, 63; Andreas, p. 147; Heimpel, pp. 32, 50; Schairer, p. 130; Dolan, pp. 185, 198.
12. Lortz, 1:97–98.
13. Gordon Rupp, *Patterns of Reformation* (Philadelphia, 1969), p. 51.
14. Eric W. Gritsch, *Reformer without a Church: The Life and Thought of Thomas Muentzer* (Philadelphia, 1967), p. 20.
15. The phrase in quotation marks is from Lacey Baldwin Smith, "The Reformation and the Decay of Medieval Ideals," *Church History* 24 (1955):216. Cf. Moeller, p. 56; Andreas, p. 147; Lortz, 1:120–21; Dolan, pp. 185, 198; Huizinga, p. 154.
16. Moeller, p. 59; Schairer, p. 129.
17. Hans Preuss, *Die deutsche Frömmigkeit im Spiegel der bildenden Kunst*, p. 122.

18. Edwyn Bevan, *Holy Images*, pp. 125–26; Ernst Kitzinger, "The Cult of Images in the Age before Iconoclasm," *Dumbarton Oaks Papers* 8 (1954): 132; Hans Frhr. v. Campenhausen, "Die Bilderfrage als theologisches Problem der alten Kirche," in *Das Gottesbild im Abendland*, ed. Günter Howe (Witten and Berlin, 1957), pp. 87–88; Johannes Kollwitz, "Bild und Bildertheologie in Mittelalter," in *Das Gottesbild im Abendland*, ed. Günter Howe (Witten and Berlin, 1957), pp. 109, 121, 127.

19. Hermann Siebert, *Beiträge zur vorreformatorischen Heiligen- und Reliquienverehrung* (Freiburg i. Br., 1907), p. 21; Johannes Janssen, *History of the German People at the Close of the Middle Ages*, trans. A. M. Christie and M. A. Mitchell, 16 vols. (London, 1896–1910), 1:42–43; Andreus, p. 142; Lortz, 1:111.

20. Rudolf Berliner, "The Freedom of Medieval Art," *Gazette des Beaux-Arts* 28 (1945): 263–88 *(passim)*; Alfred Peltzer, *Deutsche Mystik und deutsche Kunst* (Strasbourg, 1899), p. 90; Campenhausen, "Die Bilderfrage als theologisches Problem," p. 88; Kollwitz, pp. 127, 130; Bevan, p. 116; Kitzinger, p. 137.

21. Siebert, p. 22.

22. Hartmann Grisar, S.J., *Luther*, trans. E. M. Lamond, 6 vols. (London, 1913–17), 5:222; Janssen, 11:39–40.

23. Janssen, 1:8 and 11:40; Grisar, 5:222; Andreas, pp. 147–48; Schairer, p. 132.

24. Moeller, p. 55; Andreas, p. 148; Ozment, pp. 12, 20.

25. Garside, *Zwingli*, p. 86.

26. See Gene A. Brucker, *Renaissance Florence* (New York, 1969), p. 108.

27. For a characterization of the religion of the period as one of fear, see Dolan, p. 185. For the great religious uncertainty of the period as reflected in the preoccupation with death, see Moeller, p. 55; Andreas, pp. 193 ff.; Schairer, pp. 70, 90; Preuss, pp. 112–13; Dolan, pp. 185–86.

28. Irmgard Höss, "Das religiös-geistige Leben in Nürnberg am Ende des 15. und am Ausgang des 16. Jahrhunderts," *Miscellanea Historiae Ecclesiasticae*, vol. 2, Bibliothèque de la Revue d'Histoire Ecclésiastique, fasc. 44 (Louvain, 1967), p. 19.

29. Schairer, p. 131.

30. Peltzer, p. 91.

31. Carl C. Christensen, "Iconoclasm and the Preservation of Ecclesiastical Art in Reformation Nuernberg," pp. 213–14; Andreas, p. 148; Preuss, p. 135; Peltzer, p. 91.

32. Moeller, p. 53; Andreas, p. 147.

33. Christensen, "Iconoclasm," p. 213; Lortz, 1:123; Andreas, p. 147; Heimpel, p. 50. Zwingli, in his major treatise on the subject, implies that these considerations in themselves almost suffice to make the images intolerable in the churches. *Huldreich Zwinglis Sämtliche Werke*, vol. 4 *(CR*, 91):108.

34. Andreas, p. 147. This was true also of patrician societies in some towns. Fritz Rörig, *The Medieval Town* (Berkeley and Los Angeles, 1967), p. 130.

35. Moeller, pp. 53, 56; Huizinga, pp. 152, 156.

36. Lortz, 1:119, 123, 129, 136, 140–41; Andreas, p. 149; Dolan, pp. 184–85; Ozment, pp. 19, 20.

37. For Savonarola, see Smith, pp. 216–17; for Erasmus, see Roland H. Bainton, *Erasmus of Christendom* (New York, 1969), pp. 60–61, 213–16.

38. Andreas, p. 144; Preuss, p. 119; Garside, *Zwingli*, pp. 92–93; Dolan, p. 186.

39. Richard C. Trexler, "Florentine Religious Experience: The Sacred Image," *Studies in the Renaissance* 19 (1972): 10.

40. Adolph Franz, *Die Messe im deutschen Mittelalter* (Darmstadt, 1963; rep. of Freiburg i. Br., 1902 ed.), pp. 100–105; Moeller, p. 56; Trexler, p. 34; Dolan, pp. 190, 196.

41. Dolan, p. 190.
42. Moeller, p. 56; Lortz, 1:123; Ozment, p. 19; Trexler, p. 34.
43. Huizinga, pp. 152, 200.
44. For Luther's emphasis upon the oral Word, see chap. 2.
45. Siebert, pp. 40–41.
46. Preuss, p. 108.
47. Siebert, p. 41.
48. Andreas, pp. 152–70; Moeller, p. 54; Lortz, 1:131; Dolan, p. 189.
49. Heiko A. Oberman, *The Harvest of Medieval Theology: Gabriel Biel and Late Medieval Nominalism* (Cambridge, Mass., 1963), pp. 281–322; Andreas, p. 159.
50. William Gilbert, "Sebastian Brant: Conservative Humanist," *Archiv für Reformationsgeschichte* 46 (1955): 149; Lewis W. Spitz, *The Religious Renaissance of the German Humanists* (Cambridge, Mass., 1963), p. 104; Höss, p. 24.
51. E. Jane Dempsey Douglass, *Justification in Late Medieval Preaching: A Study of John Geiler of Keisersberg* (Leiden, 1966), pp. 189–99; Siebert, pp. 2, 14, 29; Lortz, 1:111; Schairer, p. 86.
52. Siebert, p. 48.
53. Preuss, pp. 90, 103–4; Andreas, p. 600.
54. The figure of 137 was computed by combining categories two, three, and four of the table in this appendix.
55. Siebert, p. 9.
56. Moeller, p. 55.
57. Andreas, p. 158; Lortz, 1:112; Siebert, pp. 14, 29, 39; Preuss, p. 103; Schairer, p. 104; Dolan, p. 185.
58. Oberman, pp. 309–12; Douglass, pp. 191, 194.
59. For an interesting example of the creation of a new, apparently completely fictitious saint in late medieval Germany, see Wolfgang Stammler, *Wort und Bild: Studien zu den Wechselbeziehungen zwischen Schrifttum und Bildkunst im Mittelalter* (Berlin, 1962), pp. 123–29. For the great vogue of the cult of St. Anne at the end of the Middle Ages, see Andreas, pp. 161–64; Moeller, p. 53; Lortz, 1:112; Siebert, p. 48; Garside, *Zwingli*, p. 85.
60. Siebert, p. 34. For other examples, see Dolan, pp. 189–90.
61. Andreas, pp. 165–66. Cf. J. Dünninger, "Fourteen Holy Helpers," *New Catholic Encyclopedia*, 15 vols. (1967), 5:1045–46.
62. Andreas, p. 599.
63. Siebert, p. 20.
64. Huizinga, p. 165.
65. Bevan, pp. 130, 150, 159; Kollwitz, p. 121.
66. St. Thomas Aquinas, *Summa Theologiae*, Latin text and English translation, 60 vols. (New York, 1964–), 50:201.
67. St. Thomas Aquinas, *Summa Theologiae*, Latin text and English translation, 60 vols. (New York, 1964–), 39:19–21.
68. Quoted in Janssen, 1:52. Cf. Siebert, p. 37; Schairer, p. 103.
69. Trexler, p. 18.
70. Ibid.
71. Siebert, pp. 36–37.
72. Hans Frhr. v. Campenhausen, "Die Bilderfrage in der Reformation," p. 98.
73. Trexler, p. 9.
74. See the passage quoted in Bainton, *Erasmus*, p. 256.
75. *Huldreich Zwinglis Sämtliche Werke*, 4 (CR, 91): 101, 102, 104, 107, 108, 109, 110, 125, 139, 146, 147. Cf. Campenhausen, "Die Bilderfrage in der Reformation," p. 102.
76. WA, $10^{.2}$:337.

77. Siebert, p. 18.
78. Desiderius Erasmus, *The Praise of Folly*, trans. Hoyt Hopewell Hudson (Princeton, N.J., 1941), p. 56. Cf. Siebert, p. 34; Huizinga, p. 172.
79. Siebert, p. 34.
80. Trexler, p. 34.
81. Lortz, 1:114–15. Cf. Moeller, p. 54; Heimpel, p. 49; Dolan, p. 188.
82. Andreas, pp. 180–81.
83. Lortz, 1:115.
84. Andreas, p. 186.
85. Schairer, p. 110.
86. Siebert, p. 54.
87. Andreas, pp. 599–600; Moeller, p. 59; Lortz, 1:131; Preuss, p. 130; Peltzer, p. 158. See also the table in the appendix.
88. For Wycliffite and Hussite iconoclasm, see William R. Jones, "Art and Christian Piety: Iconoclasm in Medieval Europe," in *The Image and the Word: Confrontations in Judaism, Christianity and Islam*, ed. Joseph Gutmann (Missoula, Montana, 1977), pp. 91–94, and the literature cited there. The possible influence of Hussitism and other medieval heresies such as Waldensianism upon iconoclasm in the German Reformation is difficult to ascertain or measure. For a brief discussion of this issue in the Nuernberg context, see Christensen, "Iconoclasm and the Preservation of Ecclesiastical Art," pp. 205–6.
89. For the three different 1522 printings of this treatise, see E. Freys and H. Barge, "Verzeichnis der gedruckten Schriften des Andreas Bodenstein von Karlstadt," *Zentralblatt für Bibliothekwesen* 21 (1904), nos. 87–89 (reprinted in book form: Nieuwkoop, 1965). I have used both a microfilm copy of the first imprint (Freys and Barge, no. 87) and the modern annotated edition brought out by Hans Lietzmann ("Kleine Texte für theologische und philologische Vorlesungen und Übungen," no. 74; Bonn, 1911). All of my citations here shall be to the modern page numbers of the Lietzmann edition, which I shall refer to hereafter simply as *Abtuhung*.
90. Zwingli's major writing on the subject constitutes a lengthy portion of his 1525 treatise entitled *Eine Antwort, Valentin Compar gegeben;* for the standard modern edition, see: *Huldreich Zwinglis Sämtliche Werke*, 4 (CR, 91):84–152.
91. Rupp, pp. 59, 81, 82, 83, 117, 124; Ronald J. Sider, *Andreas Bodenstein von Karlstadt*, pp. 85, 149, 240.
92. For Erasmus's views on religious images, see Erwin Panofsky, "Erasmus and the Visual Arts," pp. 200–227, esp. pp. 207–14; Rachel Giese, "Erasmus and the Fine Arts," pp. 257–79, esp. pp. 271–72, 275, 276–78; Bainton, *Erasmus*, pp. 255–56, 265, 267–68.
93. For Luther's early statements on images, see chap. 2.
94. Rupp, pp. 50, 52.
95. *LW*, 40:188.
96. *Abtuhung*, p. 19.
97. For Luther, see chap. 2.
98. Cf. Hermann Barge, *Andreas Bodenstein von Karlstadt*, 2 vols. (Leipzig, 1905), 1:390–91.
99. Sider, pp. 88, 105; Rupp, pp. 66, 82.
100. Rupp, pp. 76, 80. For the tension between biblicism and spiritualism in his theology, see Friedel Kriechbaum, *Grundzüge der Theologie Karlstadts* (Hamburg, 1967), p. 115.
101. Kriechbaum speaks of Karlstadt's "rigorous legalism" (p. 108) and his "literal adherence to Old Testament law" (p. 115). Sider also acknowledges that in a certain sense, Karlstadt may be called a legalist (pp. 167, 280).
102. Sider, pp. 111, 278–79.

103. Karlstadt apparently never did express himself with real precision concerning the extent to which the old law actually is still normative for the Christian church; but he obviously assumed that to a considerable degree it is (ibid., pp. 111–12, 278–79).
104. *Abtuhung*, p. 11; cf. Sider, p. 167.
105. Sider, pp. 149–52.
106. James S. Preus, *Carlstadt's "Ordinaciones" and Luther's Liberty*, pp. 20–21, 36, 38, 76.
107. Sider, p. 149.
108. Ibid., p. 151.
109. Ibid., p. 149.
110. See Kriechbaum, pp. 11, 111–12; Rupp, p. 117.
111. Roland H. Bainton, *The Age of the Reformation* (Princeton, N.J., 1956), p. 36.
112. For the following, see Hans J. Hillerbrand, "Andreas Bodenstein of Carlstadt, Prodigal Reformer," *Church History* 35 (1966): 386–87; Sider, pp. 198–99, 280. Both studies draw heavily upon Karlstadt's 1524 tract *Ob man gemach faren und des ergernüssen der schwachen verschonen soll*, in which the radical reformer took up this question in some detail.
113. Hillerbrand, p. 387. For the following statement, see Sider, p. 198.
114. This translation of a passage in Karlstadt's *Ob man gemach faren* is quoted from Sider, p. 198.
115. Ibid., p. 199.
116. The passage from Karlstadt's *Ob man gemach faren* given here is quoted from ibid.
117. Ibid., pp. 199, 280; Hillerbrand, p. 387.
118. This translation of a passage in Karlstadt's *Ob man gemach faren* is quoted from Sider, p. 199.
119. C. F. Jäger, *Andreas Bodenstein von Carlstadt* (Stuttgart, 1856), p. 191. The introduction to this pamphlet is dated June 24, 1521, but the work seems not to have been published until October or November, 1521; see Barge, *Karlstadt*, 1:266, 268. For a helpful summary of the argument against images found in this work, see Preus, pp. 35–36.
120. The thesis is printed in Theodor Kolde, "Wittenberger Disputationsthesen aus den Jahren 1516–1522," p. 463 (thesis 12). The date given in my text is that assigned by Barge (*Karlstadt*, 1:480) and accepted by Sider (p. 166, n. 89).
121. See the passage quoted in Jäger, p. 191; for more on this tract, see Preus, pp. 14 ff.
122. See below.
123. *Abtuhung*, pp. 4, 20–21; Barge, *Karlstadt*, 1:386. The preface to the pamphlet also makes manifest Karlstadt's desire that the cultic reform not remain restricted to its Wittenberg setting.
124. *Abtuhung*, p. 4.
125. Sixty-seven of the citations are to Old Testament books, thirteen to books of the New Testament. The editor of the modern edition has been able to identify seventeen other specific scriptural passages implicitly referred to (but not cited) by Karlstadt in his treatise. Twelve of these are drawn from the New Testament, five from the Old Testament.
126. *Abtuhung*, p. 20.
127. Rupp, p. 152.
128. For previous discussions, see Jäger, pp. 263–74; Barge, *Karlstadt*, 1:386–91; Rupp, p. 103; Sider, pp. 110–11, 167; Preus, pp. 36–39. The lengthiest of these treatments, that by Jäger, consists largely of quotation and paraphrase from the original treatise. There are some useful comments on Karlstadt also, of a comparative nature, in Charles Garside, Jr., "Ludwig Haetzer's Pamphlet against Im-

ages," pp. 20–36. See also a work that appeared after the completion of my own manuscript: Margarete Stirm, *Die Bilderfrage in der Reformation*, pp. 38–44.

129. Cf. Barge, *Karlstadt*, 1:388.
130. *Abtuhung*, pp. 6, 7, 14, 16, 18, 20.
131. Karlstadt himself does not give his readers the full text of the passage until the ninth paragraph of his treatise (p. 7). For the origins and later Jewish interpretation of this image prohibition, see Joseph Gutmann, ed., *No Graven Images*, pp. 3–16.
132. *Abtuhung*, p. 7. Thus, as Sider observes, for Karlstadt "the legal prohibition has a rational basis" (p. 167).
133. *Abtuhung*, p. 18.
134. Ibid., p. 4.
135. Ibid., pp. 4–5.
136. Ibid., p. 11.
137. Ibid., p. 10.
138. Ibid.
139. Karlstadt cites Isaiah a total of fifteen times.
140. *Abtuhung*, p. 12.
141. Ibid., pp. 12–13.
142. See n. 125 above.
143. *Abtuhung*, pp. 21–22.
144. Cf. Kriechbaum, p. 25.
145. *Abtuhung*, p. 22.
146. Ibid., p. 9.
147. Ibid.
148. Ibid., p. 10.
149. Ibid., p. 22.
150. Ibid.
151. See above, p. 21.
152. *Abtuhung*, p. 7.
153. Ibid., pp. 7–8.
154. Ibid., pp. 8, 17.
155. Ibid., p. 8.
156. Ibid., pp. 5, 7, 8, 11, 14.
157. Ibid., pp. 5–8, 12, 14.
158. Ibid., pp. 6, 12.
159. Ibid., pp. 5–6. Karlstadt also objects to adorning the images with gold and silver, precious stones, and costly raiment (p. 5).
160. Ibid., p. 13.
161. Ibid.
162. Ibid.
163. Ibid.
164. Ibid., p. 14.
165. See above, p. 15.
166. *Abtuhung*, pp. 8, 9, 11, 12, 14, 17.
167. Ibid., p. 8.
168. Ibid., p. 17.
169. Ibid.
170. Ibid., p. 9.
171. Ibid.
172. Ibid., p. 10. Cf. Sider, p. 152, and Preus, p. 37.
173. *Abtuhung*, p. 9.
174. Ibid., p. 16.

175. Ibid.
176. Ibid.
177. Ibid. However, according to Sider (pp. 118–22), Karlstadt's theology from this period taken as a whole does not deny that God normally utilizes some form of earthly medium (if not images) for the communication of His saving Word. The radical reformer is thinking here above all in terms of oral preaching but also acknowledges the efficacy of written language.
178. Cf. Preus, p. 38.
179. Ibid., p. 20.
180. Ibid.
181. Ibid.
182. Ibid., p. 21.
183. Ibid., p. 20.
184. Cf. Rupp, p. 104.
185. See Garside, "Ludwig Haetzer's Pamphlet against Images."
186. Ibid., pp. 21, 35–36; Garside, *Zwingli*, pp. 147, 149, 180.
187. For a brief discussion of some of the older scholarly literature on the Wittenberg Movement and the problem of documentary sources, see Karl Pallas, "Die Wittenberger Bewegung 1521/22 (Eine Literaturübersicht)," *Thüringisch-Sächsische Zeitschrift für Geschichte und Kunst* 2 (1912): 108–12. The major collection of printed sources is that published in Nikolaus Müller, "Die Wittenberger Bewegung 1521 und 1522." In addition to Müller, I have relied upon the following for documentation: *Philippi Melanthonis Opera*, 1 (*CR*, 1), this volume referred to hereafter simply as Melanchthon; Theodor Kolde, "Gleichzeitige Berichte über die Wittenberger Unruhen im Jahre 1521 und 1522"; Hermann Barge, "Neue Aktenstücke zur Geschichte der Wittenberger Unruhen von 1521/22"; and Emil Sehling, ed., *Die evangelischen Kirchenordnungen des XVI. Jahrhunderts*, vol. 1: *Sachsen und Thüringen, nebst angrenzenden Gebieten*, pt. 1: *Die Ordnungen Luthers. Die Ernestinischen und Albertinischen Gebiete*. This last volume shall be referred to hereafter simply as *Kirchenordnungen*, 1, pt. 1, followed by the page numbers.
188. For secondary literature on the Wittenberg Movement, see Barge, *Karlstadt*, 1:311–460; Karl Müller, *Luther und Karlstadt* (Tübingen, 1907); Hermann Barge, *Frühprotestantisches Gemeindechristentum in Wittenberg und Orlamünde* (Leipzig, 1909); James MacKinnon, *Luther and the Reformation*, 4 vols. (London, 1925–30), vol. 3; Roland H. Bainton, *Here I Stand: A Life of Martin Luther* (New York, 1950); E. G. Schwiebert, *Luther and His Times* (St. Louis, 1950); Wilhelm Maurer, *Der junge Melanchthon zwischen Humanismus und Reformation*, 2 vols. (Göttingen, 1967–69), vol. 2; Rupp, pp. 79–110; Sider, pp. 153–73; and, above all now, the book by James Preus.
189. Maurer, 2:179. It had been suggested earlier that Zwilling may not have had an official call to this position but simply began to preach on his own. Theodor Kolde, "Didymus, Gabriel," *Realencyklopädie für protestantische Theologie und Kirche*, 3d ed., 22 vols. (1896–1909), 4:640.
190. Kolde, "Didymus, Gabriel," p. 639; J. F. Knöpfler, "Didymus, Gabriel," *Lexikon für Theologie und Kirche*, 2d ed., 10 vols. (1930–38), 3:306; R. Jauering, "Zwilling (Didymus), Gabriel (ca 1487–1558)," *Die Religion in Geschichte und Gegenwart*, 3d ed., 7 vols. (1957–65), 6:1951.
191. Plitt, "Didymus: Gabriel D. (Zwilling)," *Allgemeine Deutsche Biographie*, 56 vols. (1875–1912), 5:117; Herzog, "Didymus (Zwilling), Gabriel," *Real-Encyklopädie für protestantische Theologie und Kirche*, 2d ed., 18 vols. (1877–88), 3:591; Schwiebert (p. 834, n. 7) also attributes to him a Bohemian origin. The question is of interest because Bohemia was the home of earlier Hussite iconoclasm.

192. For the possibility of study in Prague, see Kolde, "Didymus, Gabriel," p. 639; Knöpfler (col. 306) accepts this tradition, but it is not mentioned in Jauering (col. 1951).

193. Barge, *Karlstadt*, 1:364; Maurer, 2:212.

194. Kolde, "Didymus, Gabriel," p. 640; Schwiebert, p. 536.

195. See the characterization in Barge, *Karlstadt*, 1:313, 339, 362–64, 376.

196. Maurer, 2:180, 195.

197. Barge, *Karlstadt*, 1, *passim*; Hillerbrand, p. 386; Rupp, pp. 94–95; Williams, p. 41; Sider, p. 169.

198. Müller, "Die Wittenberger Bewegung," no. 83; Melanchthon, col. 545. Cf. Barge, *Karlstadt*, 1:403, 407; MacKinnon, 3:74. Müller, *Luther und Karlstadt*, p. 68, n. 3, argues that Karlstadt's disclaimer of approving tumult proves nothing in this context, since we do not know if he considered unsanctioned image destruction to be such. For Barge's rejoinder, see *Frühprotestantisches Gemeindechristentum*, p. 99, n. 4. Cf. Sider, p. 168.

199. As an example of a historical interpretation that implicates Karlstadt personally and directly in the Wittenberg iconoclastic riots, see Schwiebert, p. 538. For a denial of Karlstadt's participation, see Barge, *Karlstadt*, 1:399; Barge, *Frühprotestantisches Gemeindechristentum*, p. 99. More recently, both Sider (p. 169) and Preus (p. 41) have argued that there is no evidence to support the view that Karlstadt personally led or participated in iconoclastic riots. The documentary basis for such a construction indeed seems to be rather slight; for a relevant document and some comment on its reliability, see Barge, *Karlstadt*, 1:407, n. 207.

200. See Clyde L. Manschreck, *Melanchthon: The Quiet Reformer* (New York, 1958), pp. 77–80; Maurer, 2:205 ff.

201. Maurer, 2:179.

202. Melanchthon, col. 542; Maurer, 2:193–94, 211.

203. Müller, "Die Wittenberger Bewegung," no. 85; Maurer, 2:212; Hillerbrand, p. 386.

204. Maurer, 2:200.

205. Ibid., p. 212.

206. Müller, "Die Wittenberger Bewegung," no. 5; Rupp, p. 94.

207. Bainton, *Here I Stand*, p. 203; Rupp, p. 94.

208. Bainton, *Here I Stand*, p. 200; Rupp, p. 96.

209. Bainton, *Here I Stand*, p. 203; Rupp, pp. 96–97.

210. Müller, "Die Wittenberger Bewegung," no. 32; MacKinnon, 3:52.

211. Barge, *Karlstadt*, 1:342; MacKinnon, 3:52; Rupp, p. 97.

212. Hans Patze and Walter Schlesinger, eds., *Geschichte Thüringens*, vol. 3, *Das Zeitalter des Humanismus und der Reformation* (Cologne, 1967), pp. 63–64.

213. Müller, "Die Wittenberger Bewegung," no. 32; Barge, *Karlstadt*, 1:342; MacKinnon, 3:52.

214. Müller, "Die Wittenberger Bewegung," no. 32; Barge, *Karlstadt*, 1:342; MacKinnon, 3:52; Bainton, *Here I Stand*, p. 205.

215. Bainton, *Here I Stand*, p. 205.

216. Müller, "Die Wittenberger Bewegung," nos. 36, 68; Barge, *Karlstadt*, 1:342; MacKinnon, 3:52–53.

217. Müller, "Die Wittenberger Bewegung," no. 36; Barge, *Karlstadt*, 1:342; Rupp, p. 97.

218. MacKinnon, 3:53.

219. Müller, "Die Wittenberger Bewegung," no. 68; Barge, *Karlstadt*, 1:342.

220. Müller, "Die Wittenberger Bewegung," no. 68.

221. Barge, *Karlstadt*, 1:348–49, 357; MacKinnon, 3:69; Bainton, *Here I Stand*, p. 206; Rupp, pp. 98–99.

222. Rupp, p. 100.
223. Ibid., p. 99.
224. Müller, "Die Wittenberger Bewegung," no. 61; Barge, *Karlstadt*, 1:357; Bainton, *Here I Stand*, p. 206; Rupp, p. 99.
225. Barge, *Karlstadt*, 1:362–63; MacKinnon, 3:70.
226. Müller, "Die Wittenberger Bewegung," no. 72; Kolde, "Gleichzeitige Berichte," p. 332; Sider, p. 169 (see the valuable document provided in n. 106); Müller, *Luther und Karlstadt*, p. 64, n. 5 (containing a citation of additional source materials); Kolde, "Didymus, Gabriel," p. 640; Barge, *Karlstadt*, 1:374; MacKinnon, 3:70.
227. Cf. MacKinnon, 3:70.
228. Bainton, *Here I Stand*, p. 207.
229. MacKinnon, 3:73. Cf. Barge, *Karlstadt*, 1:378; Rupp, p. 101.
230. Müller, "Die Wittenberger Bewegung," nos. 93, 94, 99; Melanchthon, cols. 554, 558–59. Müller, *Luther und Karlstadt*, p. 65, relates this motivation directly to the image-removal provision (cf. pp. 61, 63, 67, and 72, n. 3).
231. The text is in *Kirchenordnungen*, 1, pt. 1, p. 697. Cf. Müller, "Die Wittenberger Bewegung," no. 93; Melanchthon, col. 553.
232. *Kirchenordnungen*, 1, pt. 1, p. 697. Cf. Barge, *Karlstadt*, 1:381; Rupp, p. 102.
233. *Kirchenordnungen*, 1, pt. 1, p. 697. Cf. Müller, "Die Wittenberger Bewegung," nos. 97, 99, 101; Melanchthon, cols. 556, 558; Barge, "Neue Aktenstücke," p. 122.
234. Barge, *Karlstadt*, 1:385; Barge, *Frühprotestantisches Gemeindechristentum*, p. 92.
235. Müller, *Luther und Karlstadt*, pp. 57–58; MacKinnon, 3:73, n. 83; Rupp, p. 102.
236. Maurer, 2:213–15; but cf. Sider, pp. 165–66.
237. Müller, "Die Wittenberger Bewegung," no. 75; Melanchthon, col. 541 (Müller's version of the text would seem to be the more accurate of the two). Cf. Barge, *Karlstadt*, 1:378, 386; Müller, *Luther und Karlstadt*, pp. 58–59; Barge, *Frühprotestantisches Gemeindechristentum*, p. 94; MacKinnon, 3:72, 74; Maurer, 2:213.
238. Barge, *Frühprotestantisches Gemeindechristentum*, p. 93; Müller, *Luther und Karlstadt*, p. 65; MacKinnon, 3:73; Rupp, p. 102.
239. Rupp, pp. 103–4.
240. See above, p. 28.
241. *Abtuhung*, p. 3.
242. Ibid., p. 20. Cf. Barge, *Frühprotestantisches Gemeindechristentum*, pp. 98–99.
243. Müller, "Die Wittenberger Bewegung," nos. 89, 92, 94, 97; Melanchthon, cols. 548, 550, 557; Kolde, "Gleichzeitige Berichte," p. 331; Barge, "Neue Aktenstücke," p. 127. Cf. Müller, *Luther und Karlstadt*, pp. 68–72; MacKinnon, 3:70–71.
244. Müller, "Die Wittenberger Bewegung," no. 92; Melanchthon, col. 550.
245. For the evidence on which I base my dating of the iconoclastic riot, see Müller, "Die Wittenberger Bewegung," no. 87.
246. For the view that the iconoclastic riot occurred before the announced time for the authorized removal of the images, see Müller, *Luther und Karlstadt*, p. 67; MacKinnon, 3:77; Schwiebert, p. 538; Maurer, 2:212; Preus, p. 41. For the view that it occurred in conjunction with this official action, see: Barge, *Karlstadt*, 1:398; Barge, *Frühprotestantisches Gemeindechristentum*, p. 96.
247. Müller, "Die Wittenberger Bewegung," nos. 92, 93, 94; Melanchthon, cols. 550, 553. Cf. MacKinnon, 3:77; Schwiebert, p. 538. Müller, *Luther und Karlstadt*, p. 65, n. 3, affirms Zwilling's involvement in the riot in the city parish church—but provides no documentary evidence.
248. Müller, "Die Wittenberger Bewegung," nos. 93, 94; Melanchthon, col. 553.
249. Müller, "Die Wittenberger Bewegung," nos. 92, 97; Melanchthon, cols. 551, 557–58; Bainton, *Here I Stand*, p. 210. There is some difficulty in the text,

making it unclear whether the Elector is referring here to the Wittenberg churches in general, to the city parish church, or to some other local church. It is possible that the Elector is thinking of the Franciscan church, as is conceded by Müller, *Luther und Karlstadt*, p. 68, n. 1.

250. There also has been some debate over the secondary question of whether the same evidence should be taken as a reflection of the fact that not all of the statues and paintings had been taken down in the first place, or as an implied command to put back up those that had been removed but not destroyed. As Preus notes (p. 44), there apparently was no demand to replace with new works such images as had been destroyed.

251. Ingrid Schulze, *Die Stadtkirche zu Wittenberg* (Berlin, 1966), p. 15. Schulze gives the iconoclasm of 1522 as the reason.

252. See chap. 2.

253. Reinhold Specht, "Wittenberger Bilderstürmer in Zerbst 1522," *Zeitschrift des Vereins für Kirchengeschichte der Provinz Sachsen und des freistaates Anhalt* 31/32 (1936): 66–68.

Chapter 2

1. For some brief comments on Luther's views on nonreligious art, see chap. 5.

2. *LW*, 40:68–69; *WA*, 15:395.

3. *LW*, 40:85; *WA*, 18:68.

4. For previous studies of Luther's attitudes and teachings concerning art, see Paul Lehfeldt, *Luthers Verhältniss zu Kunst und Künstlern*; Christian Rogge, *Luther und die Kirchenbilder seiner Zeit*; Hans Preuss, *Martin Luther der Künstler*; Leslie P. Spelman, "Luther and the Arts"; Hans Frhr. v. Campenhausen, "Die Bilderfrage in der Reformation," and "Zwingli und Luther zur Bilderfrage"; Carl C. Christensen, "Luther's Theology and the Uses of Religious Art." Following the completion of my own manuscript an important new interpretation of Luther's relationship to religious art appeared: Margarete Stirm, *Die Bilderfrage in der Reformation*, pp. 17–129.

5. *WA*, 18:67–84.

6. Cf. Preuss, *Luther der Künstler*, pp. 51 ff.

7. Martin Luther, *Luther: Lectures on Romans*, p. 381; *WA*, 56:493–94.

8. *LW*, 31:32; *WA*, 1:237.

9. *WA*, $10^{,1}$:39 (my translation).

10. *WA*, 1:245–46. Cf. Preuss, *Luther der Künstler*, p. 52.

11. *LW*, 31:199; *WA*, 1:598.

12. *LW*, 45:284–86; *WA*, 6:43–45. Cf. *WA*, $10^{,1}$:257–58.

13. *LW*, 45:289; *WA*, 6:46–47. Cf. Lehfeldt, p. 7; Preuss, *Luther der Künstler*, p. 301; Campenhausen, "Die Bilderfrage in der Reformation," p. 112.

14. *WA*, $10^{,2}$:39–40. The translation is my revision of that found in George W. Forell, *Faith Active in Love: An Investigation of the Principles Underlying Luther's Social Ethics* (Minneapolis, 1954), pp. 102–3.

15. Lennart Pinomaa, "Luthers Weg zur Verwerfung des Heiligendienstes," *Luther-Jahrbuch* 29 (1962): 37.

16. *WA*, 1:413–14. Cf. Pinomaa, pp. 37–38.

17. *LW*, 44:185–86; *WA*, 6:447.

18. *LW*, 40:84; *WA*, 18:67.

19. *LW*, 51:81–86; *WA*, 10^{III}:26–36.

20. Cf. Hartmann Grisar, S.J., *Luther*, trans. E. M. Lamond, 6 vols. (London, 1913–17), 5:210; Campenhausen, "Die Bilderfrage in der Reformation," p. 111.

21. Grisar, 5:210.

22. *LW*, 40:90; *WA*, 18:73.
23. *LW*, 51:81; *WA*, 10II:26. Cf. *WA*, 10I:33–34, where Luther says essentially the same thing in another writing of the same year.
24. *LW*, 51:83; *WA*, 10II:28–29.
25. *LW*, 51:84; *WA*, 10II:31.
26. *LW*, 51:82; *WA*, 10II:28.
27. *LW*, 51:84; *WA*, 10II:31.
28. *LW*, 51:84; *WA*, 10II:31. Cf. *WA*, 10I:34.
29. The Roman Catholic biographer of Luther, Hartmann Grisar, acknowledges that "the belief in the meritoriousness of works had in the past been a stimulus to pecuniary sacrifices and offerings for the making of pious works of art" (5:222).
30. Campenhausen, "Die Bilderfrage in der Reformation," p. 125.
31. *LW*, 51:84; *WA*, 10II:32.
32. *LW*, 51:85–86; *WA*, 10II:34–35.
33. *LW*, 51:85; *WA*, 10II:32.
34. *LW*, 51:81; *WA*, 10II:26.
35. *LW*, 51:86; *WA*, 10II:35.
36. *LW*, 51:81–82; *WA*, 10II:26. As Campenhausen notes, however, Luther does not refer much to this earlier controversy ("Die Bilderfrage in der Reformation," p. 125).
37. *LW*, 51:85; *WA*, 10II:33.
38. *LW*, 51:85; *WA*, 10II:33.
39. *LW*, 51:84; *WA*, 10II:32.
40. *LW*, 51:86; *WA*, 10II:35.
41. *LW*, 51:83; *WA*, 10II:35.
42. *LW*, 40:85; *WA*, 18:68. Cf. *WA*, 16:444.
43. *LW*, 51:83; *WA*, 10II:29–30.
44. *LW*, 51:83; *WA*, 10II:29–30.
45. *LW*, 9:ix–x.
46. *LW*, 9:79; *WA*, 14:620.
47. *LW*, 40:69; *WA*, 15:395.
48. *LW*, 40:76.
49. I shall include in my analysis statements from other parts of the treatise that seem relevant.
50. Cf. Campenhausen, "Die Bilderfrage in der Reformation," p. 114.
51. Cf. Preuss, *Luther der Künstler*, p. 55.
52. *LW*, 40:90; *WA*, 18:73.
53. *LW*, 40:91; *WA*, 18:74.
54. *LW*, 40:91–92; *WA*, 18:74–75.
55. *LW*, 40:89; *WA*, 18:72.
56. *LW*, 40:89; *WA*, 18:72.
57. *LW*, 40:89; *WA*, 18:71.
58. *LW*, 40:90; *WA*, 18:72.
59. *LW*, 40:105; *WA*, 18:88.
60. *LW*, 40:85; *WA*, 18:68.
61. *LW*, 40:86; *WA*, 18:69.
62. *LW*, 40:86; *WA*, 18:69. Luther had already treated of this theme in the 1522 Wittenberg sermons: *LW*, 15:82; *WA*, 10II:27.
63. *LW*, 40:85–86, 91, 96; *WA*, 18:68, 74, 80.
64. *LW*, 40:95; *WA*, 18:79.
65. *LW*, 40:97–98; *WA*, 18:81.
66. *LW*, 40:147; *WA*, 18:137.
67. *LW*, 40:134; *WA*, 18:116.
68. *LW*, 40:127; *WA*, 18:110.

69. *LW,* 40:129; *WA,* 18:112.
70. *LW,* 40:131–32; *WA,* 18:114.
71. *LW,* 40:152; *WA,* 18:142.
72. Cf. Luther's statement that "we must form thoughts and images of that which is conveyed to us in words, and can neither understand nor think of anything without pictures" *(WA,* 37:63, my translation).
73. *LW,* 40:99–100; *WA,* 18:83.
74. *LW,* 40:91; *WA,* 18:74.
75. *LW,* 40:96; *WA,* 18:80. In a sermon on Exodus 20, of September 24, 1525, Luther makes the reference to coins bearing images even more pertinent when he reminds his auditors that contemporary mintings often bore likenesses of Christian saints *(WA,* 16:442).
76. *LW,* 40:99; *WA,* 18:82–83.
77. See Donald L. Ehresmann, "The Brazen Serpent," pp. 43–47.
78. *LW,* 37:371; *WA,* 26:509.
79. *LW,* 43:43; *WA,* 10¹:458.
80. *LW,* 43:43; *WA,* 10ᴵᴵ:458–59.
81. *WA,* 28:677 (my translation). See also Luther's definition of the distinction between idols *(Götzen)* and images *(Bildern)* (p. 678).
82. *WA,* 30ᴵ:130, 243–46. Cf. *WA,* 16:436, where he explicitly labels the image proscription part of the first commandment.
83. See Conrad H. Moehlman, *The Story of the Ten Commandments* (New York, 1928), pp. 108–11.
84. *LW,* 13:375; *WA,* 31ᴵ:415.
85. *LW,* 53:69; *WA,* 19:80.
86. For such an interpretation, see "Liturgical Art," *New Catholic Encyclopedia,* 15 vols. (1967), 8:887; Spelman, p. 172.
87. Campenhausen, "Die Bilderfrage in der Reformation," p. 111.
88. Jaroslav Pelikan, *Obedient Rebels: Catholic Substance and Protestant Principle in Luther's Reformation* (New York, 1964), chap. 1.
89. Ibid., chap. 3. For an interesting contrast of Luther and Zwingli on this point, see Charles Garside, Jr., *Zwingli and the Arts,* pp. 35–36.
90. *LW,* 40:255; *WA,* 26:167.
91. *LW,* 36:299; *WA,* 11:452.
92. *LW,* 41:204; *WA,* 51:496.
93. For additional examples, see Rogge, pp. 15–18; Preuss, *Luther der Künstler,* pp. 28–43.
94. Ewald N. Plass, comp., *What Luther Says: An Anthology* (St. Louis, 1959), 3:1256–57; *WA,* 47:257.
95. *LW,* 53:14, 23; *WA,* 12:37, 209. Cf. Erika Kohler, *Martin Luther und der Festbrauch* (Cologne, 1959), p. 47; Pelikan, *Obedient Rebels,* p. 102.
96. Pelikan, *Obedient Rebels,* pp. 86–87, 102; Vilmos Vajta, *Luther on Worship: An Interpretation,* trans. and condensed U. S. Leupold (Philadelphia, 1958), pp. 183–84.
97. See the statement in the (1537) Schmalkaldic Articles: Theodore G. Tappert, ed., *The Book of Concord,* p. 297; *Die Bekenntnisschriften der evangelisch-lutherischen Kirche,* p. 424.
98. Pelikan, *Obedient Rebels,* p. 102; Lehfeldt, p. 58.
99. Gustaf Wingren, *Luther on Vocation,* trans. Carl C. Rasmussen (Philadelphia, 1957), pp. 181–82.
100. The extent to which Luther could be influenced by the provocations of the radicals is reflected in the following statement: "The festival of St. John we have retained largely on account of the radicals who only wish to be iconoclastic and

destroy things" (quoted in Harold J. Grimm, "Luther and Education," in *Luther and Culture*, ed. Gerhard L. Belgum [Decorah, Iowa, 1960], p. 105).

101. Tappert, p. 46; *Die Bekenntnisschriften*, p. 83b.
102. Melanchthon's *Apology of the Augsburg Confession* contains a lengthier discussion of the problem of the invocation of saints. Tappert, pp. 233–34; *Die Bekenntnisschriften*, pp. 323–24.
103. Plass, 3:1251; *WA*, 38:313.
104. Pelikan, *Obedient Rebels*, pp. 86–87.
105. Hans Preuss, *Die deutsche Frömmigkeit im Spiegel der bildenden Kunst*, p. 159.
106. Tappert, p. 36; *Die Bekenntnisschriften*, p. 69.
107. *WA*, 26:509; Vajta, p. 171.
108. Tappert, p. 49; *Die Bekenntnisschriften*, p. 84.
109. This thesis found classic expression in Luther's famous treatise, *The Freedom of a Christian* (1520).
110. *LW*, 51:339; *WA*, 49:594.
111. Vilmos Vajta, *Die Theologie des Gottesdienstes bei Luther*, 3d ed. (Göttingen, 1959), p. 345. I have used the German edition of this work, in addition to the English translation, which is somewhat abridged.
112. *WA*, 49:591–94; *WA*, 11:444–45; Vajta, *Luther on Worship*, pp. 160–61, 184–85.
113. *WA*, 50:649. Although God does not need special church buildings, it is good for the welfare of the worshiping congregation that they be built (*WA*, 37:439).
114. Vajta, *Luther on Worship*, p. 177.
115. *WA*, 6:355; Ulrich Altmann, *Hilfsbuch zur Geschichte des christlichen Kultus*, Vol. 3. *Zum Kultus der Reformatoren* (Berlin, 1947), p. 19.
116. Pelikan, *Obedient Rebels*, p. 98; cf. Preuss, *Luther der Künstler*, p. 302.
117. *WA*, 24:599; *WA*, 42:72; Campenhausen, "Die Bilderfrage in der Reformation," p. 124; Preuss, *Luther der Künstler*, pp. 71–72.
118. Preuss, *Luther der Künstler*, pp. 78–79. In principle, of course, vestments fell in the realm of Christian freedom, as with other ceremonial matters (Altmann, p. 19).
119. *WA*, 26:509.
120. Bernhard Klaus, *Veit Dietrich: Leben und Werk* (Nuernberg, 1958), p. 135.
121. See the classic definition of public worship in Luther's 1544 Torgau sermon: "That our dear Lord himself may speak to us through his holy Word and we respond to him through prayer and praise" (*LW*, 51:333; *WA*, 49:588).
122. See Friedrich Blume, *Protestant Church Music: A History* (New York, 1974), pp. 9, 10, 13, 14.
123. See chap. 4.
124. Vajta has shown that earlier scholarship stressing the alleged antitheses between the representational and the pedagogical concepts in Luther's theology of worship fails to do justice to the real intent of his doctrine (Vajta, *Luther on Worship*, pp. 19 ff.).
125. Tappert, p. 56; *Die Bekenntnisschriften*, p. 92.
126. Kohler, pp. 47–48, 56.
127. *WA*, 32:431; *WA*, 34¹:401; *WA*, 37:49. Cf. Grimm, p. 104.
128. Grimm, pp. 94, 74.
129. F. V. N. Painter, *Luther on Education* (Philadelphia, 1889), p. 155.
130. *WA*, 10¹¹:458; Rogge, p. 6.
131. *LW*, 26:359; *WA*, 40¹:548.
132. Quoted in Olov Hartman, "Art (Lutheran Concept)," *The Encyclopedia of the Lutheran Church*, 3 vols. (1965), 1:108.
133. *WA*, 18:80; *WA*, 10¹¹:458; Campenhausen, "Die Bilderfrage in der Reformation," p. 117; Rogge, p. 15.

134. Painter, p. 150.
135. Ulrich Gertz, *Die Bedeutung der Malerei für die Evangeliumsverkündigung in der evangelischen Kirche des XVI. Jahrhunderts*, p. 6.
136. *WA*, 10¹:458; *WA*, 31¹:415.
137. Karl Ernst Meier, "Fortleben der religiös-dogmatischen Kompositionen Cranachs in der Kunst des Protestantismus," p. 415; cf. Gertz, p. 44.
138. See the Prague Law and Gospel panel discussed in chap. 4.
139. Campenhausen, "Die Bilderfrage in der Reformation," p. 117; Gertz, p. 44.
140. Jaroslav Pelikan, "The Theology of the Means of Grace," in *Accents in Luther's Theology*, ed. Heino O. Kadai (St. Louis, 1967), p. 124.
141. Ibid., p. 126.
142. Tappert, p. 31; *Die Bekenntnisschriften*, p. 58.
143. Vajta, *Luther on Worship*, pp. 106–7.
144. Ibid., p. 88.
145. *LW*, 40:146; *WA*, 18:136. Cf. *WA*, 6:358–59; *WA*, 23:261; *WA*, 28:576.
146. Campenhausen, "Die Bilderfrage in der Reformation," p. 126. For a discussion of this topic from the standpoint of Luther's doctrine of the Lord's Supper, see Hermann Sasse, *This Is My Body: Luther's Contention for the Real Presence in the Sacrament of the Altar* (Minneapolis, 1959), pp. 177–86.
147. *LW*, 35:371–72; *WA*, Deutsche Bibel, 7:12–13; cf. *WA*, 18:193.
148. Vajta, *Luther on Worship*, p. 15; Preuss, *Luther der Künstler*, pp. 63, 308.
149. *LW*, 53:323; *WA*, 50:371.
150. *LW*, 54:129; *WA*, Tischreden, 2:11. Blume suggests that in the reformer's estimation, music "leads the man who practices it to God, teaches him to understand better God's Word (it is primarily sacred vocal music that Luther had in mind), and prepares him for the reception of divine grace" (p. 10).
151. *WA*, 49:159.
152. *WA*, Tischreden, 5:623.
153. Regin Prenter, *Spiritus Creator: Luther's Concept of the Holy Spirit*, trans. John M. Jensen (Philadelphia, 1953), pp. 101 ff.; Joseph Sittler, *The Doctrine of the Word: In the Structure of Lutheran Theology* (Philadelphia, 1948), p. 24.
154. Pelikan, "Means of Grace," p. 127.
155. The Marburg Articles, 8 (quoted in Sasse, p. 270). Luther found scriptural support for this emphasis on oral proclamation in Romans 10:17 ("So faith comes from preaching . . . "); see Pelikan, "Means of Grace," pp. 127–28; also, Vajta, *Die Theologie des Gottesdienstes bei Luther*, p. 241.
156. Pelikan, "Means of Grace," p. 127.
157. Ragnar Bring, "Luther's Theology," *The Encyclopedia of the Lutheran Church*, 3 vols. (1965), 2:1466; Heinrich Bornkamm, *Das Wort Gottes bei Luther* (Munich, 1933), p. 37.
158. Jaroslav Pelikan, *Luther the Expositor: Introduction to the Reformer's Exegetical Writings* (St. Louis, 1959), p. 50. Cf. the statement that "only very rarely does Luther concede that the Spirit can come to us also through the reading of the written Word": (Willem Jan Kooiman, *Luther and the Bible*, trans. John Schmidt [Philadelphia, 1961], p. 201, n. 4).
160. Kooiman, p. 201.
161. Sittler, p. 23. See *WA*, 5:537.
162. Prenter, *Spiritus Creator*, p. 121; Sittler, p. 23.
163. Vajta, *Luther on Worship*, p. 77.
164. Pelikan, *Luther the Expositor*, p. 64.
165. Kooiman, p. 200; but cf. Ragnar Bring, *Luthers Anschauung von der Bibel* (Berlin, 1951), p. 13.
166. Bring, *Luthers Anschauung*, p. 15.

167. Kooiman, p. 204.
168. See André Chastel, *The Crisis of the Renaissance 1520–1600*, trans. Peter Price (Geneva, 1968), pp. 34–36; Anthony Blunt, *Artistic Theory in Italy 1450–1600* (Oxford, 1940), p. 50, n. 2.
169. Cf. Preuss, *Luther der Künstler*, p. 130.
170. *WA*, 37:202 (my translation).
171. *WA*, 51:11 (my translation).
172. Regin Prenter, "Luther on Word and Sacrament," in *More About Luther*, ed. Gerhard L. Belgum (Decorah, Iowa, 1958), p. 73.
173. *WA*, 5:537.
174. Kooiman, p. 203.
175. Pelikan, *Luther the Expositor*, pp. 68–69.
176. *WA*, 5:537; Pelikan, "Means of Grace," p. 131; Kooiman, p. 203.
177. Pelikan, "Means of Grace," p. 130; Hartman, p. 107.
178. This latter theme is developed, in connection with the music of the Lutheran composer Johann Sebastian Bach, by Jaroslav Pelikan, *Fools for Christ: Essays on the True, the Good, and the Beautiful* (Philadelphia, 1955), pp. 165–66.
179. Emil Brunner, *The Divine Imperative*, trans. Olive Wyon (Philadelphia, 1947), p. 502.
180. Vajta, *Luther on Worship*, p. 70; cf. Preuss, *Luther der Künstler*, p. 34.
181. Cf. Rudolf Berliner, "The Freedom of Medieval Art," *Gazette des Beaux-Arts* 28 (1945): 263–88.
182. *LW*, 22:54; *WA*, 46:582.
183. Hartman, p. 109; Vajta, *Luther on Worship*, p. 61.
184. *LW*, 53:316; *WA*, 35:475.

Chapter 3

1. To my knowledge, there exists no adequate or comprehensive scholarly discussion of the topic of Reformation iconoclasm in the German-speaking lands. Some useful information can be found in the massive work by the Roman Catholic historian, Johannes Janssen, *History of the German People at the Close of the Middle Ages*, trans. A. M. Christie and M. A. Mitchell, 16 vols. (London, 1896–1910); the author, however, is neither impartial nor discriminating enough to be a fully reliable guide. For the German-speaking areas of Switzerland, the following study still has some value: Friedrich Fischer, "Der Bildersturm in der Schweiz und in Basel insbesondere."
2. For later Calvinist iconoclasm in Germany, see Hans Rott, "Kirchen- und Bildersturm bei der Einführung der Reformation in der Pfalz." Cf. J. Sauer, "Reformation und Kunst im Bereich des heutigen Baden," pp. 497 ff.; Janssen, 7:315–16 and 11:33. For destruction of ecclesiastical art occasioned by the confessional hostilities of the 1540s and 1550s, see Hartmann Grisar, S.J., *Luther*, trans. E. M. Lamond, 6 vols. (London, 1913–17), 5:219–21; Janssen, 6:204–5.
3. For a list of seventeen towns in central Germany where monasteries or churches were stormed in 1524–25, see Karl Czok, "Revolutionäre Volksbewegungen in mitteldeutschen Städten zur Zeit von Reformation und Bauernkrieg," in *450 Jahre Reformation*, ed. Leo Stern and Max Steinmetz (Berlin, 1967), p. 131.
4. The example of Lübeck, however, serves to indicate that this particular type of urban Reformation situation need not invariably lead to major iconoclastic disturbances. For the preservation of ecclesiastical art there, see Max Hasse, "Maria und die Heiligen im protestantischen Lübeck."
5. For the iconoclastic riots in Stralsund, see Alfred Uckeley, "Der Werdegang der kirchlichen Reformbewegung im Anfang des 16. Jahrhunderts in den Stadtge-

meinden Pommerns," *Pommersche Jahrbücher* 18 (1917): 1–108, esp. pp. 66–73; Otto Plantiko, *Pommersche Reformationsgeschichte* (Greifswald, 1922), pp. 31–33; Johannes Schildhauer, "Der Stralsunder Kirchensturm des Jahres 1525"; Johannes Schildhauer, *Soziale, politische und religiöse Auseinandersetzungen in den Hansestädten Stralsund, Rostock und Wismar im ersten Drittel des 16. Jahrhunderts* (Weimar, 1959), pp. 177–81.

6. For iconoclasm in Braunschweig, see Philipp J. Rehtmeyer, *Historiae ecclesiasticae inclytae urbis Brunsvigae*, 5 vols. (Braunschweig, 1707–20), 3:47, 49, 55, 61–64; Carl G. H. Lentz, *Braunschweigs Kirchenreformation im sechzehnten Jahrhunderte* (Wolfenbüttel and Leipzig, 1828), pp. 91, 95, 102–5; C. Hessenmüller, *Heinrich Lampe, der erste evangelische Prediger in der Stadt Braunschweig* (Braunschweig, 1852), pp. 55–58, 61; Hermann Hering, *Doktor Pomeranus, Johannes Bugenhagen* (Halle, 1888), pp. 48, 51.

7. See, for example, Grisar, 5:222.

8. As the recipient of a Fulbright grant and a Woodrow Wilson Dissertation Fellowship, I was able to make extended use of the Nuernberg archives. A portion of this research eventually was published as "Iconoclasm and the Preservation of Ecclesiastical Art in Reformation Nuernberg." The following discussion essentially reproduces this essay.

9. For pre-Reformation documents suggesting something of the richness of the furnishings of the local churches, see Albert Gümbel, ed., *Das Mesnerpflichtbuch von St. Sebald in Nürnberg vom Jahre 1482* (Munich, 1929), and *Das Mesnerpflichtbuch von St. Lorenz in Nürnberg vom Jahre 1493* (Munich, 1928).

10. Alfred Stange, *Deutsche Malerei der Gotik*, 11 vols. (Berlin and Munich, 1934–61), 9:1. A more discriminating statement can be found in Gottfried Seebass: "There was no iconoclasm in Nürnberg, in spite of many derogatory statements about images" ("The Reformation in Nürnberg," in *The Social History of the Reformation*, ed., Lawrence P. Buck and Jonathan W. Zophy [Columbus, O., 1972], p. 36).

11. Cf. Seebass, p. 27.

12. Ibid., pp. 29–30.

13. For the possible survival in Nuernberg of Hussite iconoclastic sentiment, see Christensen, "Iconoclasm and the Preservation of Ecclesiastical Art," pp. 205–6.

14. Claus-Peter Clasen, "Nuernberg in the History of Anabaptism," *The Mennonite Quarterly Review* 39 (1965): 25. For a lengthier treatment, see Günther Bauer, *Anfänge täuferischer Gemeindebildungen in Franken* (Nuernberg, 1966), pp. 115–62.

15. Austin Patterson Evans, *An Episode in the Struggle for Religious Freedom: The Sectaries of Nuernberg 1524–1528* (New York, 1924), p. 51; Bauer, p. 119.

16. Clasen, p. 26; Bauer, pp. 120, 123, 124, 126.

17. Quoted in Evans, p. 90.

18. J. F. Gerhard Goeters, *Ludwig Hätzer (ca. 1500 bis 1529), Spiritualist und Antitrinitarier: Eine Randfigur der frühen Täuferbewegung* (Gütersloh, 1957), p. 120; Clasen, p. 29.

19. Charles Garside, Jr., *Zwingli and the Arts*, pp. 129 ff.

20. Georg Baring, "Hans Denck und Thomas Müntzer in Nürnberg 1524," *Archiv für Reformationsgeschichte* 50 (1959): 151.

21. George H. Williams, ed., *Spiritual and Anabaptist Writers*, p. 67.

22. Gordon Rupp, *Patterns of Reformation* (Philadelphia, 1969), p. 196.

23. Bauer, p. 118.

24. Baring, p. 153.

25. His statement is quoted in Evans, p. 43; see also Baring, p. 154.

26. Garside, pp. 159–60.

27. Sauer, pp. 502–3.

28. W. Möller, *Andreas Osiander: Leben und ausgewählte Schriften* (Elberfeld, 1870), pp. 87–88, 530.
29. Arnd Müller, "Zensurpolitik der Reichsstadt Nürnberg: Von der Einführung der Buchdruckerkunst bis zum Ende der Reichsstadtzeit," *Mitteilungen des Vereins für Geschichte der Stadt Nürnberg* 49 (1959):86–87.
30. Baring, p. 151; Evans, p. 29.
31. Thurman E. Philoon, "Hans Greiffenberger and the Reformation in Nuernberg," *The Mennonite Quarterly Review* 36 (1962):61–75.
32. Quoted in Philoon, pp. 70–71.
33. Clasen, p. 36.
34. Hans Denck, *Schriften*, pt. 3: *Exegetische Schriften, Gedichte und Briefe*, pp. 24–25, 76, 83.
35. Garside, pp. 151, 156.
36. Cf. Arnold Hauser, *The Social History of Art*, trans. Stanley Godman, 4 vols. (New York, 1957), 2:43.
37. For the merchant and patrician adoption of armorial bearings in the late Middle Ages, see Klemens Stadler, "Entwicklung und Recht der Familienwappen," *Schwäbische Blätter für Volksbildung und Heimatpflege* 5 (1954): 1–10; Gustav A. Seyler, *Geschichte der Heraldik* (Nuernberg, 1885), pp. 333–37.
38. Staatsarchiv, Nuernberg. Ratsbuch no. 10, fol. 150a, 153b; Theodor Hampe, ed., *Nürnberger Ratsverlässe über Kunst und Künstler im Zeitalter der Spätgotik und Renaissance*, nos. 1010, 1011. For other instances of controversy related to family coats of arms in the churches, see Ratsbuch no. 7, fol. 262b; no. 8, fol. 399b; no. 11, fol. 32a. For the determining role of the city council in all Nuernberg affairs, even ecclesiastical, see Gerald Strauss, *Nuremberg in the Sixteenth Century* (New York, 1966).
39. For sixteenth-century Nuernberg monetary values, see Strauss, pp. 92–96, 203–8.
40. Ratsbuch no. 10, fol. 259b; Hampe, no. 1054.
41. G. G. Coulton, *Art and the Reformation*, pp. 334–35; Seyler, p. 509.
42. Staatsarchiv, Nuernberg. Nürnberger Handschriften no. 211 (Hallerbuch), fol. 301a.
43. Ratsbuch no. 12, fol. 142a, 143b–144a.
44. *An Heroic Abbess of Reformation Days: The Memoirs of Mother Charitas Pirkheimer, Poor Clare, of Nuremberg*, trans. Central Bureau, C.C.V. of A. (St. Louis, 1930), pp. 18–19.
45. See Julie Rosenthal, "Das Augustinerkloster in Nürnberg," *Mitteilungen des Vereins für Geschichte der Stadt Nürnberg* 30 (1931): 31.
46. Norbert Lieb, *Die Fugger und die Kunst im Zeitalter der Spätgotik und frühen Renaissance* (Munich, 1952), pp. 395–96, 457.
47. Staatsarchiv, Nuernberg. Stadtrechnungsbelege, no. 245.
48. *Kirchenordnungen*, 11, pt. 1, p. 134.
49. Ibid.
50. Ibid., p. 168.
51. Ibid.; see also the eloquent personal testament of faith composed by Lazarus Spengler, the influential city secretary, printed in Urban Gottlieb Haussdorff, *Lebens-Beschreibung eines christlichen Politici, nehmliche Lazari Spenglers . . .* (Nuernberg, 1740), p. 495.
52. Veit Dietrich, *Summaria vber die gantze Bibel*, fol. giiijb. I used a microfilm of the British Museum copy of this popular work, parts of which began to appear in print in 1541.
53. *Kirchenordnungen*, 11, pt. 1, pp. 537–38.
54. Ibid., p. 183.
55. Bernhard Klaus, *Veit Dietrich: Leben und Werk* (Nuernberg, 1958), p. 135.

56. Ratsbuch no. 15, fol. 63a; Hampe, no. 1729.
57. Wilhelm Schwemmer, "Das Mäzenatentum der Nürnberger Patrizierfamilie Tucher vom 14.–18. Jahrhundert," *Mitteilungen des Vereins für Geschichte der Stadt Nürnberg* 51 (1962): 26.
58. Tabernacles were destroyed in some Reformation centers: Rott, 1, pt. 2, p. 135; Richard Feller, *Geschichte Berns*, 4 vols. (Bern, 1946–60), 2:162; Sauer, pp. 467, 470, 497.
59. Staatsarchiv, Nuernberg. Nürnberger Handschriften no. 22, fol. 204a; Staatsarchiv, Nuernberg. Nürnberger Handschriften no. 257, fol. 100b.
60. *Kirchenordnungen*, 11, pt. 1, p. 134.
61. Ibid.; see also ibid., p. 138.
62. Fritz Schnelbögl, "Sankt Sebald in Nürnberg nach der Reformation," *Zeitschrift für bayerische Kirchengeschichte* 32 (1963): 160–61.
63. Seebass observes that there was "a shift of the emphasis from visual perception of sacred actions in the liturgy to auditory perception of the Word of Holy Scripture as revealed by the sermon" (p. 37).
64. Similar complaints occasionally were voiced in the pre-Reformation period; see Coulton, pp. 379–80.
65. Ratsbuch no. 21, fol. 37b; Hampe, nos. 2664, 2665.
66. Staatsarchiv, Nuernberg. Nürnberger Handschriften no. 46 (Nürnberger Chronik), fol. 427a.
67. Ibid., fol. 434a–435a.
68. Ratsbuch no. 13, fol. 52b.
69. Ratsbuch no. 12, fol. 292b.
70. Ratsbuch no. 13, fol. 88a–b; Paul Redlich, *Cardinal Albrecht von Brandenburg und das neue Stift zu Halle 1520–1541* (Mainz, 1900), p. 278.
71. Ratsbuch no. 13, fol. 5a, 6a; no. 14, fol. 258b; no. 15, fol. 2a, 32a; no. 21, fol. 196b. Hampe, nos. 1486, 1675, 1944, 2081, 2244, 2248, 2732.
72. Ratsbuch no. 15, fol. 91a.
73. Hampe, no. 2199.
74. Before this, gold and silver from some of the smaller local chapels had been brought to the large churches for safekeeping (Ratsbuch no. 21, fol. 196b; Hampe, no. 2732).
75. Joseph Baader, *Beiträge zur Kunstgeschichte Nürnbergs*, 2 vols. (Nördlingen, 1860–62), 1:91–92.
76. Coulton, p. 411.
77. The definitive study on iconoclasm in Zurich now is provided in the fine book by Charles Garside cited above in n. 19. For Zwingli's teaching on images, see, in addition to Garside, Margarete Stirm, *Die Bilderfrage in der Reformation*, pp. 138–53.
78. Garside, pp. 94–95.
79. Ibid., p. 102.
80. Ibid., p. 104.
81. Ibid., pp. 106–9, 115–25.
82. Ibid., p. 128.
83. Ibid., pp. 125–26.
84. Ibid., pp. 129–45.
85. Ibid., p. 151.
86. Ibid., p. 152.
87. Ibid., pp. 155–58.
88. Ibid., p. 158.
89. Ibid., p. 159.
90. Ibid., pp. 159–60.
91. Ibid., pp. 127, 155.

92. For iconoclasm in Constance, see Rott, 1, pt. 2, pp. 134–35; Sauer, 480–87; Hans-Christoph Rublack, *Die Einführung der Reformation in Konstanz* (Gütersloh, 1971), pp. 74–75; Janssen, 5:146. For Lindau, Rott, 1, pt. 2, p. 196; *Kirchenordnungen*, 12, pt. 2, pp. 6, 182; Janssen, 11:32. For Memmingen, Rott, 2:116–17; *Kirchenordnungen*, 12, pt. 2, pp. 6 and 228; Janssen, 11:32. For St. Gall, Rott, 1, pt. 1, pp. 182–83 and 189; Rott, 1, pt. 2, pp. 256–57; Johannes Kessler, *Johannes Kesslers Sabbata mit kleineren Schriften und Briefen*, pp. 116–17, 231–33, 281–82, 288, 309–14; Werner Näf, *Vadian und seine Stadt St. Gallen*, 2 vols. (St. Gall, 1944–57), 2:238, 269–70, 292–97; F. Fischer, pp. 10–16; Janssen, 5:140–42; Rupp, pp. 372–73. For Ulm, Rott, 2:76; Janssen, 5:337–38 and 11:32.

93. For documentation of Strasbourg iconoclasm, I have relied upon the following primary source materials: L. Dacheux, ed., *La Petite Chronique de la Cathédrale*, hereafter cited as *Petite Chronique*; L. Dacheux, ed., *La Chronique Strasbourgeoise de Sebald Büheler*, hereafter cited as Büheler, *Chronique*; L. Dacheux, ed., *Les Chroniques Strasbourgeoises de Jacques Trausch et de Jean Wencker*, hereafter cited as Trausch and Wencker, *Chroniques*; L. Dacheux, ed., *Les Annales de Sébastien Brant*, hereafter cited as Brant, *Annales*; Rudolf Reuss, "Strassburg im sechzehnten Jahrhundert (1500–1591)," hereafter cited as Reuss, "Imlin Chronicle"; Manfred Krebs and Hans Georg Rott, eds., *Quellen zur Geschichte der Täufer*, vol. 7, *Elsass*, pt. 1: *Stadt Strassburg 1522–1532*, hereafter cited as *QGT*, 7, pt. 1; Martin Bucer, *Martin Bucers Deutsche Schriften*, hereafter cited as Bucer, *Schriften*, followed by volume number; Huldreich Zwingli, *Huldreich Zwinglis Sämtliche Werke*, 8 (CR, 95), hereafter cited as *Zwinglis Werke*, 8; Traugott Schiess, ed., *Briefwechsel der Brüder Ambrosius und Thomas Blaurer 1509–1548*, 1, hereafter cited as *Briefwechsel Blaurer*, 1; A.-L. Herminjard, ed., *Correspondance des Réformateurs dans les pays de langue française*, 1, hereafter cited as *Correspondance des Réformateurs*, 1; Rott, 3, pt. 2, pp. 303–5. For secondary accounts, see Andreas Jung, *Geschichte der Reformation der Kirche in Strasburg* (Strasbourg and Leipzig, 1830); Timotheus Wilhelm Röhrich, *Geschichte der Reformation im Elsass und besonders in Strassburg*, 3 vols. (Strasbourg, 1830–32); Johann Wilhelm Baum, *Capito und Butzer: Strassburgs Reformatoren* (Elberfeld, 1860); Adolf Baum, *Magistrat und Reformation in Strassburg bis 1529* (Strasbourg, 1887); Johann Adam, *Evangelische Kirchengeschichte der Stadt Strassburg bis zur französischen Revolution* (Strasbourg, 1922); Maximilian Hasak, *Das Münster Unserer Lieben Frau zu Strassburg im Elsass* (Berlin, 1927); Hasting Eells, *Martin Bucer* (New Haven, Conn., 1931); Miriam Usher Chrisman, *Strasbourg and the Reform* (New Haven, Conn., 1967).

94. Bucer, *Schriften*, 1:192. Bucer's views deserve further study. For brief comments, see Eells, pp. 37–39, and Hans Frhr. v. Campenhausen, "Die Bilderfrage in der Reformation," pp. 107–8, 116.

95. Chrisman, pp. x, 160–61, 176, 203 ff.

96. Ibid., pp. 150, 155, 172, 176.

97. Ibid., pp. 143, 174, 176.

98. Ibid., pp. 93, 95, 96.

99. Ibid., p. 155.

100. James M. Kittelson, "Wolfgang Capito, the Council, and Reform Strasbourg," *Archiv für Reformationsgeschichte* 63 (1972): 126–40.

101. Chrisman, p. 132. Cf. p. 176. See also Eells, p. 36.

102. Röhrich, 1:205 and 2:6; Kittelson, p. 132.

103. Chrisman, p. 32.

104. Ibid., p. 150.

105. Brant, *Annales*, pp. 265–66.

106. See below.

107. Röhrich, 1:205; Jung, p. 334.

108. See below.
109. Chrisman, pp. 142–43.
110. Ibid., p. 138. For further evidence of popular pressure, see pp. 140, 165–66.
111. Bucer, *Schriften*, 1:269–70; Chrisman, pp. 122–23.
112. Brant, *Annales*, p. 246; Reuss, "Imlin Chronicle," p. 401; Chrisman, p. 144; Jung, p. 332.
113. For disturbances in the city, see Büheler, *Chronique*, p. 73; Chrisman, pp. 141–42. For the canons' withdrawal with their treasure, see Büheler, *Chronique*, p. 73; Chrisman, p. 142; Eells, p. 45; A. Baum, p. 66.
114. Jung, p. 332, n. 18.
115. Brant, *Annales*, p. 246; Chrisman, p. 144; Jung, p. 332.
116. Or, perhaps, a certain Adam Schneider from Mundolsheim; see *QGT*, 7, pt. 1, p. 180, n. 1.
117. Not all of the opposition to religious images came from the lower classes, however. An example of active hostility among the city's ruling group would be the figure of Jacob Meyer. See the document printed in Jung, p. 333, n. 19, and the description in Chrisman, p. 95.
118. Brant, *Annales*, p. 246; Chrisman, p. 144; Jung, p. 332.
119. Brant, *Annales*, p. 246; Chrisman, p. 144; Jung, p. 332.
120. Chrisman, p. 144.
121. Bucer, *Schriften*, 1:269–70; *Zwinglis Werke*, 8:242; A. Baum, pp. 94, 137; Röhrich, 1:239; Adam, pp. 72, 74; Eells, p. 38.
122. Reuss, "Imlin Chronicle," p. 401; Rott, 3, pt. 2, p. 303; *Zwinglis Werke*, 8:242; *QGT*, 7, pt. 1, p. 8, n. 3; A. Baum, p. 94.
123. Cf. Jung, p. 332.
124. Ibid.
125. Cf. Bucer, *Schriften*, 1:270.
126. A. Baum, p. 94.
127. *Zwinglis Werke*, 8:242. Cf. Brant, *Annales*, p. 246.
128. Bucer, *Schriften*, 1:269.
129. For reform sentiment among the canons of St. Thomas, see Chrisman, p. 242; for the chapter's legal rights to control of the parish, see ibid., p. 113. For the opposition of some of the other chapters to removal of images, see Röhrich, 1:205, and 2:6; Kittelson, p. 132.
130. For an interpretation that stresses Bucer's leadership role, see Eells, p. 32.
131. For membership figures on the guilds, see Chrisman, p. 308. For the gardeners' guild as the most proletarian in the city, see George H. Williams, *The Radical Reformation* (Philadelphia, 1962), p. 245.
132. Chrisman, p. 113.
133. For Bucer's call to St. Aurelia, see Chrisman, pp. 113–14; for petitioning the city government, ibid., pp. 145, 169; for the refusal to pay tithes and the attack on the city treasury, ibid., p. 147.
134. Williams, *Radical Reformation*, p. 245.
135. Ibid., pp. 245–48, 328–29, 337–38.
136. Chrisman, p. 183.
137. For published extracts, see *QGT*, 7, pt. 1, pp. 8–10.
138. Williams, *Radical Reformation*, p. 245. The nature and extent of Karlstadt's contribution to the campaign against images in Strasbourg is difficult to determine from the sources. He did not put in an appearance in the city until shortly before mid-October, 1524, when he stayed for only four days: Hermann Barge, *Andreas Bodenstein von Karlstadt*, 2 vols. (Leipzig, 1905), 2:207, 211. It is noteworthy that Wolfgang Capito, shortly after Karlstadt's visit in Strasbourg, published a pamphlet to counter the suggestion of the latter that the populace take

matters into its own hands. The tract contains a significant reference to the image question. "There is an Honorable Council," Capito wrote, "[which] has courageously emptied the cathedral of some of its idols . . . and it will carry on with the same mildness and do away with all the idols as soon as God grants grace. Why then should men rush in and lay a hand on things?" (quoted from Kittelson, p. 129).

139. Reuss, "Imlin Chronicle," p. 401; Trausch and Wencker, *Chroniques*, pp. 34, 153; Büheler, *Chronique*, p. 73; *Petite Chronique*, p. 19. See also Jung, p. 334; Röhrich, 1:205–6; A. Baum, p. 96; Eells, p. 32.
140. For Ziegler's role, see Chrisman, p. 182.
141. Bucer, *Schriften*, 1:273–74. For a summary, see J. W. Baum, pp. 298–99. Cf. A. Baum, p. 137, and Eells, p. 46.
142. See also Trausch and Wencker, *Chroniques*, p. 152.
143. Ibid., p. 34; A. Baum, p. 94. Cf. Reuss, "Imlin Chronicle," p. 402 (1525).
144. Bucer, *Schriften*, 1:241–42. Cf. A. Baum, p. 136; Eells, p. 45.
145. Quoted from Chrisman, p. 148.
146. For these names and identifications, see Chrisman, p. 149.
147. Bucer, *Schriften*, 1:272. In their letter to Luther of November 23, 1524, Bucer and the other evangelical pastors of Strasbourg had expressed their hope that the remaining images would soon be removed (*WA*, Briefe, 3:386); cf. Jung, p. 347.
148. Jung, pp. 335–36; A. Baum, p. 96.
149. Brant, *Annales*, p. 247; Jung, p. 334.
150. *QGT*, 7, pt. 1, p. 138. For further evidence of Anabaptist concern about the image question in Strasbourg (1526), see ibid., p. 64.
151. Büheler, *Chronique*, p. 75; Reuss, "Imlin Chronicle," p. 402.
152. Trausch and Wencker, *Chroniques*, p. 156; Büheler, *Chronique*, p. 77; Reuss, "Imlin Chronicle," p. 408.
153. Trausch and Wencker, *Chroniques*, p. 156. Cf. Brant, *Annales*, p. 249; Büheler, *Chronique*, p. 75; and Reuss, "Imlin Chronicle," p. 402.
154. Brant, *Annales*, p. 250; Trausch and Wencker, *Chroniques*, p. 154; *Petite Chronique*, p. 19; Reuss, "Imlin Chronicle," p. 403; Rott, 3, pt. 2, p. 304; Röhrich, 1:207; Hasak, p. 198.
155. Trausch and Wencker, *Chroniques*, p. 155; *Petite Chronique*, p. 19; Jung, p. 335. See also *Correspondance des Réformateurs*, 1:411.
156. Brant, *Annales*, p. 259; Trausch and Wencker, *Chroniques*, p. 155; Büheler, *Chronique*, p. 76; Reuss, "Imlin Chronicle," p. 407; *Petite Chronique*, p. 20; Röhrich, 1:207.
157. Trausch and Wencker, *Chroniques*, p. 155.
158. Brant, *Annales*, p. 261; paraphrased in J. W. Baum, p. 424.
159. Brant, *Annales*, p. 262. Cf. *QGT*, 7, pt. 1, p. 233.
160. Brant, *Annales*, p. 264. For the preachers' determination to remove the remaining images, see also Bucer, *Schriften*, 2:554.
161. Brant, *Annales*, p. 264; Adam, p. 148.
162. For the following, see Trausch and Wencker, *Chroniques*, pp. 37, 158; Büheler, *Chronique*, p. 78; Reuss, "Imlin Chronicle," p. 411; Rott, 3, pt. 2, p. 305; Röhrich, 2:7; Adam, pp. 147–48; J. W. Baum, p. 453.
163. Schwartz was involved in a further iconoclastic incident later that year (Brant, *Annales*, p. 263).
164. Trausch and Wencker, *Chroniques*, p. 37; Röhrich, 2:7; Adam, p. 148.
165. Harold J. Grimm, *The Reformation Era 1500–1650* (New York, 1965), p. 208; Adam, p. 148.
166. Eells, pp. 97–98; Grimm, p. 203.
167. Eells, p. 98.

168. Desiderius Erasmus, *Desiderii Erasmi Opera Omnia*, 10:1610.
169. For Bern, see Feller, 2:162–64; F. Fischer, pp. 8–10; Janssen, 5:135–37; Eells, p. 52.
170. Röhrich, 2:7–8; Adam, p. 148.
171. For the following, see Brant, *Annales*, p. 265; Trausch and Wencker, *Chroniques*, p. 158; Reuss, "Imlin Chronicle," p. 417; *Petite Chronique*, p. 20; Büheler, *Chronique*, p. 78 (incorrectly dated 1529); Rott, 3, pt. 2, p. 305; Adam, p. 148.
172. This policy emerged quite early in the Strasbourg Reformation. See Brant, *Annales*, p. 247; Rott, 3, pt. 2, p. 304; A. Baum, p. 94; J. W. Baum, p. 453.
173. Brant, *Annales*, p. 265; Adam, p. 148.
174. Brant, *Annales*, p. 265.
175. Ibid., pp. 265–66. Cf. Büheler, *Chronique*, p. 79; Rott, 3, pt. 2, p. 305.
176. Büheler, *Chronique*, p. 79; Rott, 3, pt. 2, p. 305.
177. Brant, *Annales*, p. 267; Adam, p. 149.
178. Brant, *Annales*, p. 266.
179. Ibid.
180. Reuss, "Imlin Chronicle," p. 417; Büheler, *Chronique*, p. 79. Cf. *Briefwechsel Blaurer*, 1:206.
181. Brant, *Annales*, p. 267; Trausch and Wencker, *Chroniques*, p. 158; *Petite Chronique*, p. 20; Adam, pp. 148–49.
182. Trausch and Wencker, *Chroniques*, p. 158; Hasak, p. 198; Adam, p. 149.
183. For ecclesiastical art in Basel on the eve of the Reformation, see Rudolf Wackernagel, *Geschichte der Stadt Basel*, 3 vols. (Basel, 1907–24), 2:748–60.
184. A considerable amount of documentation relevant to the Basel Reformation has been published. I have cited the following: Emil Dürr and Paul Roth, eds., *Aktensammlung zur Geschichte der Basler Reformation in den Jahren 1519 bis Anfang 1534*, vol. 2, *Juli 1525 bis Ende 1527*, hereafter cited as *Aktensammlung*, 2; Paul Roth, ed., *Aktensammlung zur Geschichte der Basler Reformation in den Jahren 1519 bis Anfang 1534*, vol. 3, *1528 bis Juni 1529*, hereafter cited as *Aktensammlung*, 3; Wilhelm Vischer and Alfred Stern, eds., *Basler Chroniken*, 1; August Bernoulli, ed., *Basler Chroniken*, 6; August Bernoulli, ed., *Basler Chroniken*, 7; "Zur Geschichte des Bildersturms von 1529," *Basler Taschenbuch* 5/6 (1855), 193–96 (contains additional chronicle material), hereafter cited as *Basler Taschenbuch*, 5/6; Ernst Staehelin, ed., *Briefe und Akten zum Leben Oekolampads*, 2, hereafter cited as *Briefe und Akten*; Desiderius Erasmus, *Opus Epistolarum Des. Erasmi Roterodami*, 8, hereafter cited as *Erasmi Epistolae*; Paul Roth, "Eine Elegie zum Bildersturm in Basel," hereafter cited as "Elegie zum Bildersturm." For secondary accounts, see Peter Ochs, *Geschichte der Stadt und Landschaft Basel*, 8 vols. (Basel, 1786–1822), vol. 5; Friedrich Fischer, "Der Bildersturm in der Schweiz und in Basel insbesondere"; Wackernagel, 3; Ernst Staehelin, *Das theologische Lebenswerk Johannes Oekolampads* (Leipzig, 1939); Paul Roth, *Durchbruch und Festsetzung der Reformation in Basel* (Basel, 1942); Paul Burckhardt, *Geschichte der Stadt Basel von der Zeit der Reformation bis zur Gegenwart* (Basel, 1942); Rupp; Roland H. Bainton, *Erasmus of Christendom* (New York, 1969).
185. E. Freys and H. Barge, "Verzeichnis der gedruckten Schriften des Andreas Bodenstein von Karlstadt," *Zentralblatt für Bibliothekswesen* 21 (1904): no. 89.
186. Rupp, pp. 23, 137–39.
187. Wackernagel, 3:354; Rupp, p. 136.
188. Sauer, pp. 469–70.
189. Wackernagel, 3:354.
190. *Aktensammlung*, 2, no. 46, p. 33 and no. 455, p. 367; Wackernagel, 3:478. For Hochrütiner's part in early Zurich iconoclasm, see Garside, pp. 115–21.
191. Rupp, p. 24; J. F. Gerhard Goeters, "Haetzer, Ludwig," *The Mennonite Encyclopedia*, 4 vols. (1955–59), 2:623.

192. Rupp, pp. 19, 30, 32, 38.
193. Staehelin, pp. 208, 344–45, 417–18, 559–60.
194. For the phrase in quotation marks, see Rupp, p. 20. For Oecolampadius' preaching against image idolatry, see *Aktensammlung*, 2, no. 654, p. 485; Staehelin, p. 345.
195. Staehelin, p. 417.
196. *Aktensammlung*, 2, no. 197, p. 141.
197. Ibid., no. 439, p. 357. Cf. ibid., no. 539, pp. 414–15.
198. Ibid., no. 593, p. 438; Wackernagel, 3:491.
199. *Aktensammlung*, 2, no. 725, p. 714; Wackernagel, 3:491.
200. Wackernagel, 3:496; P. Burckhardt, p. 17.
201. F. Fischer, p. 9; Feller, pp. 162–63.
202. Rupp, p. 31.
203. Wackernagel, 3:463, 465; Rupp, pp. 31, 35.
204. Wackernagel, 3:464, 467 ff., 509; Rupp, p. 30.
205. Wackernagel, 3:494.
206. For guild support of the Reformation in Basel, see Wackernagel, 3:493, 509.
207. Ibid., p. 358; Rupp, p. 30.
208. Wackernagel, 3:488; Rupp, p. 31.
209. *Aktensammlung*, 3, no. 60, p. 50; Wackernagel, 3:490; Rupp, pp. 31–32.
210. Not the spinners' guild, as Rupp (p. 32) has it; on this question, see *Basler Chroniken*, 1:57, n. 1. For the strongly Protestant sympathies of this guild, see P. Roth, pp. 10, 14; P. Burckhardt, p. 17.
211. Staehelin, p. 418.
212. For the following three paragraphs, see above all *Aktensammlung*, 3, no. 86, pp. 65–66. Also *Basler Chroniken*, 1:57; Wackernagel, 3:496–97; P. Roth, p. 9; Ochs, 5:606–7.
213. Ochs says five men (5:606).
214. Staehelin, pp. 344, 417. Cf. *Aktensammlung*, 2, no. 654, p. 485.
215. Ochs, 5:606, n. 2.
216. For the following paragraph, see *Aktensammlung*, 3, no. 89, pp. 69–70; *Basler Chroniken*, 1:57–58; Wackernagel, 3:497; Ochs, 5:607–9.
217. *Aktensammlung*, 3, no. 89, pp. 69–70; *Basler Chroniken*, 1:58.
218. The text of the mandate is found in *Aktensammlung*, 3, no. 87, pp. 67–68; *Basler Chroniken*, 1:58–60; F. Fischer, pp. 19–21. Cf. Wackernagel, 3:497; P. Roth, p. 9; Ochs, 5:609–10.
219. For the bishop of Basel's complaint against the city over this smashing of altars, see *Aktensammlung*, 3, no. 110a, p. 95.
220. At this same time a complete prohibition of all image removal was published throughout the Basel territory outside the city itself. *Aktensammlung*, 3, no. 88, p. 69; P. Roth, p. 9.
221. *Basler Chroniken*, 1:60; Wackernagel, 3:497–98.
222. *Aktensammlung*, 3, no. 117, p. 108. For examples of iconoclasm in the outlying villages from this same period, see ibid., no. 123, pp. 109–10; no. 133, pp. 115–18; no. 135, p. 119; no. 137, p. 120; no. 145, pp. 123–24.
223. Rupp, pp. 32, 35.
224. *Aktensammlung*, 3, no. 291, pp. 197–201; Wackernagel, 3:502–3; P. Roth, pp. 12–14; Rupp, pp. 35–36.
225. Wackernagel, 3:504.
226. Ibid., p. 506.
227. *Aktensammlung*, 3, no. 331, pp. 232–33.
228. Ibid., no. 333, pp. 234–36; Wackernagel, 3:507; P. Roth, p. 19.
229. Wackernagel, 3:508–9.
230. Ibid., pp. 509–12; Bainton, pp. 219–20.

231. Wackernagel, 3:515.
232. For this sentence and the next, see *Aktensammlung*, 3, no. 374, p. 277, and no. 387, p. 284; *Basler Chroniken*, 1:447; *Erasmi Epistolae*, 8, no. 2158, p. 162.
233. For the following paragraph, see *Basler Chroniken*, 1:86; *Briefe und Akten*, 2, no. 636, p. 281; Wackernagel, 3:513; P. Roth, p. 27; Ochs, 5:648–49.
234. *Aktensammlung*, 3, no. 477, p. 411. Cf. no. 400, p. 301; no. 458, p. 376.
235. P. Roth, p. 27, n. 4.
236. For descriptions of this high altar, see Wackernagel, 2:757; Rudolf F. Burckhardt, *Die Kunstdenkmäler des Kantons Basel-Stadt*, vol. 2, *Der Basler Münsterschatz* (Basel, 1933), p. 22, n. 1.
237. For this sentence, see *Aktensammlung*, 3, no. 375, p. 278; no. 416, p. 328; no. 432, p. 347; no. 448b, p. 364; *Basler Chroniken*, 1:86, 447; *Basler Chroniken*, 6:116; *Basler Chroniken*, 7:156; *Basler Taschenbuch*, 5/6:194–96; *Briefe und Akten*, 2, no. 636, p. 281; *Erasmi Epistolae*, 8, no. 2158, p. 162; "Elegie zum Bildersturm," pp. 133, 136; Wackernagel, 3:513; Ochs, 5:649–50; P. Roth, p. 28.
238. *Basler Chroniken*, 1:447; *Basler Chroniken*, 6:116; *Basler Taschenbuch*, 5/6:194–95; "Elegie zum Bildersturm," pp. 133, 136; Wackernagel, 3:516; Ochs, 5:658.
239. Hans Reinhardt, *Das Basler Münster* (Basel, 1939), pp. 26, 39, 96. For the Virgin statue, see also Ernst Gerhard Rüsch, *Vom Heiligen in der Welt* (Zollikon, 1959), p. 40.
240. *Basler Chroniken*, 1:86; *Briefe und Akten*, 2, no. 636, p. 282; Ochs, 5:649, 656; P. Burckhardt, pp. 19–20. Silverplate from other Basel churches, however, was melted down fairly soon for such purposes as support of poor relief. See Bernhard Harms, ed., *Der Stadthaushalt Basels im ausgehenden Mittelalter*, Erste Abteilung: *Die Jahresrechnungen 1360–1535*, Erster Band: *Die Einnahmen*, p. 508; R. Burckhardt, p. 22. Cf. *Basler Chroniken*, 6:122.
241. *Basler Chroniken*, 1:87; P. Burckhardt, p. 20.
242. *Briefe und Akten*, 2, no. 636, p. 281.
243. *Aktensammlung*, 3, no. 374, p. 277; no. 376, p. 278; no. 385, p. 283; no. 416, p. 328; no. 424, p. 342; no. 432, p. 347; no. 448b, p. 364; *Basler Chroniken*, 1:87; *Basler Chroniken*, 6:116–17; *Basler Chroniken*, 7:432–33; *Basler Taschenbuch*, 5/6:196; *Briefe und Akten*, 2, no. 636, p. 281; *Erasmi Epistolae*, 8, no. 2158, p. 162; "Elegie zum Bildersturm," pp. 133, 136; Wackernagel, 3:513–14; P. Roth, p. 28.
244. For the following paragraph, in addition to the sources listed below, see Wackernagel, 3:514–15; P. Roth, pp. 28–29.
245. *Basler Chroniken*, 1:87; Wackernagel, 3:514.
246. *Aktensammlung*, 3, no. 374, p. 277; Ochs, 5:656.
247. *Aktensammlung*, 3, no. 371, pp. 274–76; no. 372, p. 276; *Briefe und Akten*, 2, no. 636, p. 281.
248. *Basler Chroniken*, 1:447.
249. *Aktensammlung*, 3, no. 382, p. 280; no. 405, p. 303; *Basler Chroniken*, 1:88; *Erasmi Epistolae*, 8, no. 2158, p. 162; Wackernagel, 3:517; P. Roth, pp. 29–30.
250. *Erasmi Epistolae*, 8, no. 2158, p. 162; F. Fischer, p. 39.
251. *Basler Chroniken*, 1:88; *Briefe und Akten*, 2, no. 636, p. 282; Wackernagel, 3:515; F. Fischer, p. 39; Ochs, 5:657–58.
252. *Basler Chroniken*, 1:88; *Basler Chroniken*, 6:116–17; *Basler Chroniken*, 7:433; *Briefe und Akten*, 2, no. 636, p. 282; Wackernagel, 3:515–16; F. Fischer, pp. 39–40.
253. *Aktensammlung*, 3, no. 388, p. 289; *Basler Chroniken*, 1:88; *Briefe und Akten*, 2, no. 636, p. 281; Wackernagel, 3:517; P. Roth, p. 30.
254. *Aktensammlung*, 3, no. 387, p. 287; P. Roth, p. 31.
255. *Aktensammlung*, 3, no. 416, p. 328; no. 432, p. 347; no. 448b, p. 364.
256. *Briefe und Akten*, 2, no. 636, p. 280; Rupp, p. 37.
257. *Aktensammlung*, 3, no. 301, pp. 209–10; P. Roth, p. 16.
258. For these events, see *Aktensammlung*, 3, no. 597, pp. 516–26. Aside from this

incident, there is general agreement as to the absence of human bloodshed (Wackernagel, 3:516; Ochs, 5:656; F. Fischer, p. 39).

259. For Klein Basel, see P. Roth, pp. 33–35.
260. *Briefe und Akten*, 2, no. 636, p. 282; Ochs, 5:658–59; F. Fischer, p. 40.
261. *Aktensammlung*, 3, no. 473, p. 399; Staehelin, p. 485; Rupp, p. 38.
262. *Aktensammlung*, 3, no. 416, p. 328.
263. Kessler, pp. 232, 233, 311, 312; *Basler Chroniken*, 1:88; *Erasmi Epistolae*, 8, no. 2158, p. 162; Janssen, 5:506 and 11:32; F. Roth, p. 344.
264. For the Bern painter Niklaus Manuel Deutsch, see Conrad André Beerli, *Le peintre poéte Nicolas Manuel et l'évolution sociale de son temps* (Geneva, 1953), pp. 275–76; F. Fischer, p. 10. For the Augsburg painter Georg Preu, see Friedrich Roth, ed., *Die Chronik des Augsburger Malers Georg Preu des Älteren 1512–1537*, pp. 13, 44, 75–78. There is an interesting historical parallel in the fact that many artists supported iconoclasm in the French Revolution. See Stanley J. Idzerda, "Iconoclasm during the French Revolution," *The American Historical Review* 60 (1954): 20–21.
265. See above, p. 87.
266. For the utilitarian view of the arts, see Anthony Blunt, *Artistic Theory in Italy 1450–1600* (Oxford, 1940); Katherine E. Gilbert and Helmut Kuhn, *A History of Esthetics*, 2d ed. rev. (Bloomington, Ind., 1954), chap. 6; Paul Lehfeldt, *Luthers Verhältniss zu Kunst und Künstlern*, pp. 25, 31–32; Hans Preuss, *Martin Luther der Künstler*, pp. 82, 187, 302.
267. On this point I concur with John Phillips, *The Reformation of Images: Destruction of Art in England, 1535–1660* (Berkeley, 1973), p. x.
268. For a somewhat similar interpretation of events in England, see Phillips, p. 205.
269. See above, p. 89.
270. Phillips, pp. 4, 41; cf. also pp. 103, 105, 109. Reformation iconoclasm is associated with an anticlericalism resulting from a sense of religious disillusionment and betrayal in Steven E. Ozment, *The Reformation in the Cities: The Appeal of Protestantism to Sixteenth-Century Germany and Switzerland* (New Haven, Conn., 1975), pp. 42–46.
271. Cf. Phillips, pp. 202–3.
272. *LW*, 40:90.
273. Ibid., p. 89.
274. Ibid., p. 90. Cf. Karl Müller, *Luther und Karlstadt* (Tübingen, 1907), pp. 165, 171–72.
275. See the Preu chronicle (p. 44) cited above in n. 264. Also Phillips, pp. 90–91, for the instance of Stephen Gardiner in England who based his views upon his knowledge of events in Germany.
276. For additional examples, see Rott, 2:76 (Ulm); Feller, pp. 162–64 (Bern); Kessler, p. 309 (St. Gall).
277. Bernd Moeller, *Reichsstadt und Reformation* (Gütersloh, 1962), p. 24.
278. This is correctly emphasized by Sauer (p. 503), who then erroneously concludes that the masses could be brought to share in the fanaticism of the preachers only by the prospect of profit to be gained by plundering the churches.
279. For class hostility as a cause of the destruction and mutilation of ecclesiastical art, see Martin Warnke, "Durchbrochene Geschichte? Die Bilderstürme der Wiedertäufer in Münster 1534/1535," esp. pp. 84 ff.
280. See Schildhauer, "Der Stralsunder Kirchensturm," p. 116; Schildhauer, *Soziale, politische und religiöse Auseinandersetzungen*, p. 180; cf. Warnke, pp. 85, 92.
281. Uckeley, p. 71; Schildhauer, "Der Stralsunder Kirchensturm," p. 118.
282. However, I would not place as much importance on mere vandalism as Kenneth Clark, *Civilization: A Personal View* (London, 1969), p. 159. I agree with Natalie Zemon Davis that iconoclastic disturbances, like other forms of religious riot in

the Reformation, did not consist simply of mindless and aimless behavior; the violence was directed at specific targets. See "The Rites of Violence: Religious Riot in Sixteenth-Century France," *Past and Present*, no. 59 (1973), pp. 51–91.

283. For this insight I am indebted to Garside, p. 128.

284. Cf. Davis, pp. 61, 64, 70.

285. Cf. Clark, p. 159.

286. Idzerda, pp. 24, 26.

287. Cf. Otto Fischer, "Geschichte der öffentlichen Kunstsammlung," *Öffentliche Kunstsammlung Basel: Festschrift zur Eröffnung des Kunstmuseums* (Basel, 1936), pp. 7, 27–29.

288. Garside, p. 80, n. 14. Cf. F. Fischer, p. 5, who suggests (p. 8) that the destruction was just as extensive in Bern. For the German Palatinate, see Sauer, p. 502.

289. Cf. F. Fischer, pp. 41, 43; Craig Harbison, *The Last Judgment in Sixteenth Century Northern Europe*, p. 179.

290. Sauer, p. 489.

291. An interesting instance of a work apparently rescued by the donor is the set of wings to the Oberried altarpiece, painted by Hans Holbein the Younger. See Paul Ganz, *The Paintings of Hans Holbein* (London, 1950), p. 221.

292. Heinrich A. Schmid, *Hans Holbein der Jüngere*, 2 vols. (Basel, 1945–48), 1:34, 36, 188, 190, 195. Cf. O. Fischer, p. 12.

293. Wackernagel, 3:109*. Janssen relates a similar episode (5:137, n. 1).

294. Rott, 2:224.

295. See Hans Reinhardt, *La cathédrale de Strasbourg* (Paris, 1972); Madeleine Klein-Ehrminger, *The Cathedral of Strasbourg* (Lyons, n. d.); Hasak, *passim*.

296. Hasak, pp. 208–12; Klein-Ehrminger, p. 33.

297. Oberpfarrer Dr. Wetzel, "Reformation—keine Bilderstürmerei," *Beiträge zur sächsischen Kirchengeschichte* 11 (1896): 181–82.

298. This was pointed out years ago by Georg Dehio, "Die Krisis der deutschen Kunst im sechzehnten Jahrhundert," p. 9. Cf. Otto Häcker, "Evangelische Altarkunst der Renaissance- und Barockzeit in Schwaben," p. 6; F. Fischer, pp. 3–4.

299. David McRoberts, "Material Destruction Caused by the Scottish Reformation," in *Essays on the Scottish Reformation 1513–1625*, ed. David McRoberts (Glasgow, 1962), p. 459.

300. Ibid., p. 455.

Chapter 4

1. Albert Schramm, *Luther und die Bibel*, vol. 1, *Die Illustration der Lutherbibel*; Hildegard Zimmermann, *Beiträge zur Bibelillustration des 16. Jahrhunderts*; James Strachan, *Early Bible Illustrations*; Ph. Schmidt, *Die Illustration der Lutherbibel 1522–1700*; Kenneth A. Strand, *Reformation Bible Pictures*; Kenneth A. Strand, *Woodcuts to the Apocalypse in Dürer's Time*; *Lucas Cranach d. Ä. 1472–1553: Das gesamte graphische Werk*, with an introduction by Johannes Jahn (Munich, 1972).

2. Schmidt, *Lutherbibel*, pp. 17, 137, 179; WA, Bibel, 2:274.

3. Schmidt, *Lutherbibel*, pp. 25–26; WA, Bibel, 6:lxxxvii.

4. Cf. Schmidt, *Lutherbibel*, pp. 11–12.

5. For the large number of Luther Bibles sold during the reformer's lifetime, see E. G. Schwiebert, *Luther and his Times* (St. Louis, 1950), p. 662.

6. Paul Oskar Kristeller lists as the five major arts: painting, sculpture, architecture, music, and poetry. *Renaissance Thought II: Papers on Humanism and the Arts* (New York, 1965), pp. 164–65.

7. Cf. Oskar Thulin, *Cranach-Altäre der Reformation*, p. 126; Eberhard Ruhmer, *Cranach*, trans. Joan Spencer (London, 1963), p. 27. Other titles also have been given to this motif. For example, Allegory of Law and Grace: Donald L. Ehresmann, "The Brazen Serpent," p. 33; Craig Harbison, *The Last Judgment in Sixteenth Century Northern Europe*, p. 94. It is called simply Law and Grace in Richard Foerster, "Die Bildnisse von Johann Hess und Cranachs 'Gesetz und Gnade,' " pp. 117–43; also in Ernst Grohne, "Die bremischen Truhen mit reformatorischen Darstellungen und der Ursprung ihrer Motive," pp. 20, 54. For the title Fall and Redemption, see Max J. Friedländer and Jakob Rosenberg, *Die Gemälde von Lucas Cranach* (Berlin, 1932), p. 63; Ulrich Gertz, *Die Bedeutung der Malerei für die Evangeliumsverkündigung in der evangelischen Kirche des XVI. Jahrhunderts*, p. 31; Thulin, *Cranach-Altäre*, p. 126; Katharine Morrison McClinton, "The Lutheran Reformation Paintings of Lucas Cranach, the Elder," p. 5; Herbert von Hintzenstern, *Lucas Cranach d. Ä.: Altarbilder aus der Reformationszeit*, p. 88.

8. For a recent discussion of the origins of the Law and Gospel theme, see Harbison, *Last Judgment*, pp. 95 ff. In relation to this question the reader also should consult F. Grossmann, "A Religious Allegory by Hans Holbein the Younger."

9. For the view that these panels were intended to hang in churches, see Karl Ernst Meier, "Fortleben der religiös-dogmatischen Kompositionen Cranachs in der Kunst des Protestantismus," p. 426; Foerster, pp. 125, 129; McClinton, p. 5. For the suggestion that the creation of this motif should be seen in connection with the liturgical and ecclesiastical consolidation, see Foerster, p. 125; Grohne, p. 12, n. 6; Thulin, *Cranach-Altäre*, p. 126.

10. McClinton, p. 5.

11. Meier, pp. 415, 431; Thulin, *Cranach-Altäre*, p. 134 and *passim*.

12. Oskar Thulin, ed., *Illustrated History of the Reformation* (St. Louis, 1967), pp. 195, 217; Strachan, pp. 77, 78.

13. Thulin, *Cranach-Altäre*, p. 139.

14. Hans Carl von Haebler, *Das Bild in der evangelischen Kirche*, p. 18; Grohne, pp. 53, 64.

15. Harbison refers to "the tiny Judge on the left side difficult to reach and influence" (*Last Judgment*, p. 95).

16. It was characteristic of Luther to personify the "demonic powers," e.g., death. See Paul Althaus, *The Theology of Martin Luther*, trans. Robert C. Schultz (Philadelphia, 1966), pp. 208–9.

17. Cf. Ehresmann, p. 41. In a description of a later Cranach drawing of this same theme, the figure in question has been called "Adam." Jakob Rosenberg, *Die Zeichnungen Lucas Cranachs d. Ä.* (Berlin, 1960), p. 37. Cf. Gertrud Schiller, *Ikonographie der christlichen Kunst* (Gütersloh, 1966–), 2:174.

18. For the motif of nakedness, see Grohne, pp. 23–24.

19. Ehresmann, p. 35.

20. For the texts of the Gotha inscriptions, see Ehresmann, p. 36, n. 15. The biblical passages quoted are from Rom. 1:18; Rom. 3:23; 1 Cor. 15:56; Rom. 4:15; Rom. 3:20; Matt. 11:13; Rom. 1:17; Rom. 3:28; John 1:29; 1 Pet. 1:2; 1 Cor. 15:54–55, 57.

21. Ewald M. Plass, comp., *What Luther Says: An Anthology*, 3 vols. (St. Louis, 1959), 2:732–33.

22. Ibid., pp. 734–35.

23. Ibid., p. 738.

24. Cf. Ehresmann, pp. 41–43.

25. Harbison, *Last Judgment*, p. 94.

26. John 1:29 (cf. the panel inscription).

27. Ehresmann, p. 42.
28. 1 Cor. 15:54 (cf. the panel inscription).
29. Friedländer and Rosenberg, p. 64; Ehresmann, p. 36; Harbison, *Last Judgment*, p. 97.
30. Foerster (p. 129) noted the parallelism of these two themes. Cf. Harbison, *Last Judgment*, p. 97.
31. Ehresmann, pp. 36–37.
32. For the texts of the Prague inscriptions, see Foerster, p. 128. For the identifying labels on the Prague panel, see Ehresmann, p. 37; Thulin, *Cranach-Altäre*, p. 134.
33. The label is "Mensch an [ohne] Gnad." Grohne provides a lengthy discussion of the "representative" man motif on this panel and its medieval forerunners (pp. 21 ff.).
34. Harbison, *Last Judgment*, p. 97.
35. Schlossmuseum, Weimar; Germanisches Nationalmuseum, Nuernberg; Stadtgeschichtliches Museum Königsberg. For photographic illustrations of all three panels, see Thulin, *Cranach-Altäre*, figs. 170–73. Ehresmann claimed that these paintings form part of a larger group of workshop productions all based on a woodcut rendition by Cranach the Elder (p. 38). For more on this print, see Thulin, *Cranach-Altäre*, p. 132 (fig. 167); von Hintzenstern, pp. 28–29; Craig Harbison, "Reformation Iconography," p. 80 (fig. 1).
36. Ehresmann, p. 43.
37. Luther did not strictly equate Law and Gospel with Old and New Testaments, respectively, for he saw Law also in the New Testament and Gospel in the Old; see Althaus, pp. 92–102, 261–66.
38. Meier, p. 418; Grohne, *passim*; Thulin, *Cranach-Altäre*, pp. 143–48; Ehresmann, p. 43.
39. Plass, 2:732.
40. Ibid., pp. 738–39.
41. Ibid., p. 743.
42. The didactic emphasis given this motif in early Lutheran art is stressed by P. Bloch, "Ehebrecherin," *Lexikon der christlichen Ikonographie*, 8 vols. (1968–76), 1:582.
43. Nor even in Cranach's own oeuvre. See the 1509 drawing in Rosenberg, no. 18.
44. The theme appears only once in my sample of 441 German religious paintings from the late Middle Ages; see appendix. The painting in question, however, is the 1520 Cranach work mentioned here in the text. A 1479 altar painting of the motif by Michael Pacher is mentioned in Franziska Schmid, "Ehebrecherin (Christus und die E.)," *RDK*, 4:797.
45. The quotation is from Ehresmann, p. 47. For a listing of examples in fifteenth-century German graphic art, see Schmid, col. 797. Cf. Schiller, 1:170.
46. Cf. Friedländer and Rosenberg, p. 62; Pierre Descargues, *Cranach*, trans. Helen Ramsbotham (New York, 1961), p. 72.
47. Schmid, col. 799.
48. Friedländer and Rosenberg, p. 100.
49. Ibid., no. 110.
50. Ibid., pp. 62, 83.
51. Von Haebler, p. 40; Thulin, *Cranach-Altäre*, p. 24. For this description of the chapel and a photograph of the pulpit, see Thulin, *Illustrated History*, pp. 60–61.
52. For photographic reproductions, see Friedländer and Rosenberg, nos. 110, 178, 292.
53. Ibid., nos. 178, 292.
54. Schmid, col. 798. Contrast the 1509 drawing. For possible Venetian influence on the later Cranach paintings of the theme, see Dieter Koepplin and Tilman Falk, *Lukas Cranach*, 2:514–16.

55. To my knowledge, this group of paintings has never before been analyzed in relation to Luther's exegesis of the biblical text.
56. *LW*, 23:ix–xi, 310–19.
57. Ibid., p. 310.
58. Ibid., p. 319.
59. Ibid., p. 314.
60. Ibid., p. 315.
61. Ibid., p. 316.
62. Ibid., p. 317.
63. Ibid., p. 316.
64. Ibid., pp. 318–19.
65. Cf. Friedrich Buchholz, *Protestantismus und Kunst im sechzehnten Jahrhundert*, p. 41; Hans Preuss, *Die deutsche Frömmigkeit im Spiegel der bildenden Kunst*, p. 182.
66. *LW*, 23:318.
67. *WA*, 17:430; *WA*, 47:99; *WA*, 48:135; *WA*, 47:277. All these passages are cited in Hans Preuss, *Martin Luther der Künstler*, pp. 35–36.
68. The basic studies are Hans Preuss, "Zum Luthertum in Cranachs Kunst"; and Christine O. Kibish, "Lucas Cranach's 'Christ Blessing the Children.' " See also Schiller, 1:166.
69. Friedländer and Rosenberg, p. 62; Preuss, "Zum Luthertum," pp. 119–20.
70. *Deutsche und Niederländische Malerei zwischen Renaissance und Barock*, Alte Pinakothek München, Katalog (Munich, 1963), p. 55; Ludwig Burchard, " 'Christ Blessing the Children' by Anthony van Dyck," *The Burlington Magazine* 72 (1938): 26–29; Schiller, 1:166.
71. Friedländer and Rosenberg, p. 100.
72. Preuss, "Zum Luthertum," p. 111; Preuss, *Die deutsche Frömmigkeit*, p. 181; Kibish, pp. 196–97, 203; Schiller, 1:166; J. Seibert, "Kindersegnung Jesu," *Lexikon der christlichen Ikonographie*, 8 vols. (1968–76), 2:513. The theme does not appear in my inventory of 441 late medieval German religious paintings (see appendix).
73. Preuss mentions a woodcut of the theme used to illustrate a 1526 Nuernberg edition of Luther's New Testament (*Die deutsche Frömmigkeit*, p. 305, n. 515).
74. Kibish, p. 198.
75. See Kibish, p. 197. But cf. Preuss, "Zum Luthertum," pp. 109–10, and Thulin, *Cranach-Altäre*, p. 163, n. 7.
76. Friedländer and Rosenberg, p. 62.
77. Ibid., pp. 62–63; Kibish, p. 198; Preuss, "Zum Luthertum," p. 109.
78. See Friedländer and Rosenberg, nos. 179, 291; Kibish, p. 197, n. 13.
79. Kibish, p. 197.
80. Another modern author calls attention to the intimacy of the interpretation and the "homely approach to the Bible" which it reflects (McClinton, p. 2).
81. Kibish, pp. 199–200.
82. For the baptismal theology of an early and influential Anabaptist—Balthasar Hubmaier—see Rollin S. Armour, *Anabaptist Baptism: A Representative Study* (Scottdale, Pa., 1966), pp. 19–57.
83. Both quotations are from Luther's important treatise of 1528, "Concerning Rebaptism," *LW*, 40:252, 257. On Luther's doctrine of infant baptism, see also Jaroslav Pelikan, *Spirit versus Structure: Luther and the Institutions of the Church* (New York, 1968), chap. 4.
84. *WA*, 12:45; *WA*, 19:540; *LW*, 53:98–99, 108; Kibish, p. 200; Preuss, "Zum Luthertum," p. 114.
85. See also Preuss, "Zum Luthertum," pp. 115–16; Preuss, *Die deutsche Frömmigkeit*, p. 181; von Haebler, pp. 18–19.
86. Carl C. Christensen, "The Significance of the Epitaph Monument in Early Lu-

theran Ecclesiastical Art (ca. 1540–1600)," pp. 301–2; Gertz, p. 53. Cf., however, Charles L. Kuhn, "The Mairhauser Epitaph."
87. The earliest epitaph monument I know that utilizes this theme dates from 1541 or later.
88. Buchholz, pp. 40–41; Preuss, "Zum Luthertum," p. 118; Preuss, *Die deutsche Frömmigkeit*, p. 182. Cf. Kibish, p. 200, n. 40.
89. *WA*, 31I:415; H. Kressel, "Das Problem des Altars in der lutherischen Kirche," *Monatsschrift für Gottesdienst und kirchliche Kunst* 41 (1936): 205.
90. *WA*, 19:80; Kressel, p. 204.
91. *WA*, 31I:415; Kressel, pp. 204–5.
92. Helmuth Eggert, "Altar (prot.)," cols. 430, 435–36; Helmuth Eggert, "Altarretabel (prot.)," cols. 565, 592; Otto Häcker, "Evangelische Altarkunst der Renaissance- und Barockzeit in Schwaben," p. 6.
93. Eggert, "Altarretabel," col. 568.
94. Ibid., cols. 570, 582, 588.
95. Eggert, "Altar," col. 435.
96. Cf. Eggert, "Altarretabel," col. 565.
97. Ibid., col. 566.
98. For the suggestion that perhaps even more altars were produced in the Protestant north of Germany than in the Catholic south during this time, see Friedländer and Rosenberg, p. 25.
99. For an example of a monumental altar contributed by a lay (merchant) donor, see Ludwig Rohling, *Die Kunstdenkmäler der Stadt Flensburg* ("Die Kunstdenkmäler des Landes Schleswig-Holstein"; Munich, 1955), pp. 90–96.
100. The closest thing extant to such a systematic study apparently is the fine article by Eggert, "Altarretabel." Several additional sixteenth-century altarpieces are discussed in Gertz, *passim*.
101. For useful discussion and a detailed set of black and white photographs, see Thulin, *Cranach-Altäre*, pp. 33–53. See also von Hintzenstern, pp. 94–98.
102. Thulin, *Cranach-Altäre*, p. 36.
103. Ibid., pp. 34–35.
104. Ibid., p. 35; cf. Rosenberg, nos. A 16, A 17.
105. Thulin, *Cranach-Altäre*, p. 36.
106. Ibid., pp. 35, 50.
107. For the Wittenberg altar, see Thulin, *Cranach-Altäre*, pp. 9–32; Otto Stroh, "Der Wittenberger Altar"; von Hintzenstern, pp. 99–105.
108. For the texts of some relevant documents, see Thulin, *Cranach-Altäre*, p. 163, n. 9.
109. Ibid., pp. 5, 9; Eggert, "Altarretabel," cols. 565–66.
110. Thulin, *Cranach-Altäre*, p. 163, n. 9; Sibylle Harksen, "Bildnisse Philipp Melanchthons," in *Philipp Melanchthon: Humanist, Reformator, Praeceptor Germaniae*, ed. Melanchthon-Komitee der Deutschen Demokratischen Republik (Berlin, 1963), p. 276, n. 13.
111. Thulin, *Cranach-Altäre*, p. 9.
112. Gordon Rupp, in his *Patterns of Reformation* (Philadelphia, 1969), remarks that on this Wittenberg altar "Judas is shown as a small, negroid figure much as Karlstadt is said to have been. At any rate that is how he was regarded by his former comrades and colleagues: the lost leader who had made the great refusal" (p. 141).
113. Oskar Thulin, "Luther in the Arts," p. 1438; Thulin, *Cranach-Altäre*, pp. 12, 15.
114. Shirley Neilsen Blum, *Early Netherlandish Triptychs: A Study in Patronage* (Berkeley, 1969), p. 66; Karl Möller, "Abendmahl," *RDK*, 1:39–40.
115. Thulin, *Cranach-Altäre*, p. 100; Oskar Thulin, "Reformatorische und frühprotestantische Abendmahlsdarstellungen," pp. 31, 34; Preuss, *Die deutsche Frömmigkeit*, pp. 164, 185.

116. For the retention of private confession in early Lutheranism, see Theodore G. Tappert, ed., *The Book of Concord*, pp. 34, 61–63; Althaus, pp. 316–18.
117. Harksen, p. 276; von Haebler, p. 19.
118. Thulin, *Cranach-Altäre*, p. 24; von Haebler, p. 19.
119. Stroh, p. 281.
120. Eggert, "Altarretabel," col. 580; Stroh, p. 292; Schiller, 2:51. For absolution as a sacrament, see Tappert, p. 211; Pelikan, *Spirit versus Structure*, pp. 126–30.
121. Tappert, p. 32. Cf. Thulin, *Cranach–Altäre*, pp. 10–11, 24, 27.
122. Thulin, *Cranach-Altäre*, p. 10; Thulin, "Luther in the Arts," p. 1438.
123. Stroh, p. 290.
124. Schwiebert, pp. 627, 632.
125. Cf. Schiller, 2:51.
126. Thulin, *Cranach-Altäre*, p. 11; Thulin, "Reformatorische," p. 34. The back panels of the Wittenberg altar contain (1) central panel—*The Trinitarian Christ Sitting in Judgment over Death and the Devil,* (2) left wing—*Sacrifice of Isaac,* (3) right wing—*The Brazen Serpent,* (4) predella—*Resurrection of the Dead.* See Thulin, *Cranach-Altäre,* pp. 27–32.
127. For the Weimar altar, see Thulin, *Cranach-Altäre,* pp. 54–74; Hanna Jursch, "Der Cranach-Altar," pp. 65–83; von Hintzenstern, pp. 106–14.
128. For the predella inscription, see Eva Schmidt, ed., *Die Stadtkirche zu St. Peter und Paul in Weimar* (Berlin, 1955), p. 143.
129. Von Hintzenstern, however, has speculated that the altarpiece may have been completed by the Cranach pupil Peter Roddelstedt aus Gotland (pp. 18, 106).
130. Thulin, *Cranach-Altäre,* pp. 54–55.
131. Ehresmann refers to it as "a rather free rendition of the Allegory of Law and Grace" (p. 38).
132. For the parallelism of tree and cross, see Grohne, pp. 48 ff.
133. The scriptural texts displayed in the open book held by Luther are from 1 John 1:7; Heb. 4:16; John 3:14–15.
134. With respect to the iconography of this work, Harbison observes that "the panel shows a reversion to an almost pre-Lutheran form" (*The Last Judgment,* p. 256).
135. Thulin, *Cranach-Altäre,* pp. 54–55.
136. Ibid., p. 57.
137. Ibid.
138. The basic work on the Kemberg altar is Thulin, *Cranach-Altäre,* pp. 111–25.
139. Thulin has pointed out this parallelism (*Cranach-Altäre,* p. 112).
140. Ibid., p. 113.
141. Ibid., p. 112.
142. Ibid.; Friedländer and Rosenberg, p. 22.
143. Thulin, *Cranach-Altäre,* p. 113.
144. Ibid.
145. Ibid.
146. For the Dessau altar, see ibid., pp. 96–110.
147. Ibid., p. 96.
148. Ibid.
149. Ibid., p. 98.
150. Ibid., pp. 99–100.
151. Gerhard Pfeiffer, "Judas Iskarioth auf Lucas Cranachs Altar der Schlosskirche zu Dessau."
152. Thulin, *Cranach-Altäre,* pp. 98–99.
153. Ibid., p. 96.
154. Ibid.
155. Ibid.

156. Ibid., p. 98.
157. Thulin, "Luther in the Arts," p. 1438.
158. Harksen, p. 277.
159. Thulin, *Cranach-Altäre*, p. 99.
160. Ibid., p. 98.
161. The fullest discussion of this altar can be found in Arnulf Wynen, "Michael Ostendorfer (um 1492–1559)," pp. 64–81. For photographs, see Eggert, "Altarretabel," cols. 567–70, and Schiller, vol. 4, pt. 1, pp. 338–39.
162. For the texts of a series of documents relevant to the commission, see Wynen, pp. 407–13 (nos. 26–32).
163. Ibid., p. 64.
164. Ibid., p. 68; Eggert, "Altarretabel," cols. 567–68.
165. Wynen, p. 68; Eggert, "Altarretabel," cols. 567–68.
166. Wynen, p. 75.
167. Ibid., pp. 75–76.
168. Cf. ibid., pp. 78–81.
169. Ibid., p. 78.
170. Ibid.
171. Hans Aurenhammer, *Lexikon der christlichen Ikonographie* (Vienna, 1959–), 1:351–56; Christian-Adolf Isermeyer, "Beschneidung Christi," *RDK*, 2:327–31; Schiller, 1:99–100.
172. Schiller, 1:138.
173. Pelikan, *Spirit versus Structure*, p. 95.
174. Hermann Sasse, *This Is My Body: Luther's Contention for the Real Presence in the Sacrament of the Altar* (Minneapolis, 1959), pp. 89–99, 167.
175. Thulin, "Reformatorische," p. 32; Gertz, p. 62.
176. Schiller, 2:48.
177. Ibid., pp. 35–36; Klaus Lankheit, "Eucharistie," *RDK*, 6:238–39.
178. Eggert, "Altarretabel," col. 566.
179. Von Haebler, p. 33.
180. Lankheit, "Eucharistie," col. 243.
181. Where a Crucifixion is used above a Last Supper predella, as at Schneeberg and Kemberg, the former is given a eucharistic significance (ibid., col. 239).
182. Eggert, "Altarretabel," col. 574; von Haebler, p. 35; Schiller, 2:51; Gertz, p. 64; Thulin, "Reformatorische," p. 31.
183. Eggert, "Altarretabel," *passim*. The data are not always complete.
184. The locations and dates of these altars are as follows: Augustusburg, 1571 (col. 580); Bast, 1588 (col. 587); Bismarck, 1574 (cols. 592–93); Brandenburg, 1559 (col. 588); Celle, 1569 (col. 584); Flensburg, 1598 (col. 586); Friedrichswalde, ca. 1570 (col. 590); Garding, 1596 (col. 585); Oldensworth, 1592 (col. 585); Rheinsberg, 1574 (col. 589); Salzwedel, 1582 (cols. 580–81); Schwerin, 1562 (col. 588); Stettin, 1577 (col. 587); Walkenried, 1577 (col. 581). The figures in the parentheses indicate the location of the data in the above-cited Eggert article.
185. Thulin, "Reformatorische," p. 31; Gertz, p. 56.
186. Creighton E. Gilbert, "Last Suppers and their Refectories," in *The Pursuit of Holiness in Late Medieval and Renaissance Religion*, ed. Charles Trinkaus and Heiko A. Oberman (Leiden, 1974), pp. 372, 387, 390–91; Lankheit, "Eucharistie," cols. 187–88; Schiller, 2:48; von Haebler, p. 34; Blum, p. 62.
187. In the sources I used to prepare the appendix, at least 234 of the 441 paintings are designated as forming part of altarpieces; undoubtedly many of the others also were created for such a purpose.
188. The Last Supper theme seems to have been employed more typically as a part of a series depicting the Passion narrative, or, in Italy, as the subject of frescoes

adorning monastery refectory walls (e.g., Leonardo's *Last Supper* in Milan). See von Haebler, p. 34; Schiller, 2:47; Gilbert, *passim*.

189. Gilbert suggests that the paucity of Last Supper altarpieces in Renaissance Florence may be a result of the fact that "the theme had developed a special association with refectories" (pp. 390–91).
190. Lankheit, "Eucharistie," col. 187.
191. Gilbert, pp. 387–88.
192. Cf. Blum, p. 62.
193. Klaus Lankheit, "Dürers 'Vier Apostel,' " pp. 245–46; Gilbert, p. 388; Preuss, *Die deutsche Frömmigkeit*, p. 121.
194. *LW*, 13:375; *WA*, 31¹:415. The importance of Luther for the new popularity of Last Supper altarpieces is emphasized also in Hermann Oertel, "Das protestantische Abendmahlsbild im Niederdeutschen Raum und seine Vorbilder."
195. Von Haebler, pp. 34–35.
196. On one early altar depicting the Lutheran Celebration of Holy Communion, Christ is shown as the one distributing the sacramental elements (Möller, cols. 43–44).
197. All five, and in this order, appear in Matt. 26:20–29 and Mark 14:18–25. St. Luke (22:14–23) presents them in a somewhat different order.
198. Möller, cols. 28, 39–40; Schiller, 2:48.
199. Möller, cols. 28, 37; Lankheit, "Eucharistie," col. 189. Cf. Schiller, 2:38, 43, 48; Blum, p. 61; E. Lucchesi Palli and L. Hoffscholte, "Abendmahl," *Lexikon der christlichen Ikonographie*, 8 vols. (1968–76), 1:11; Johannes Kühn, *Die Darstellung des Abendmahls im Wandel der Zeiten* (Schaffhausen, 1948), p. 13.
200. Aurenhammer, 1:14; Schiller, 2:48.
201. Schiller, 2:43–44; Aurenhammer, 1:12; Lucchesi Palli and Hoffscholte, col. 12; Blum, p. 62.
202. Aurenhammer, 1:12.
203. Cf. Schiller, 2:50; V. Denis, "Last Supper, Iconography of," *New Catholic Encyclopedia*, 15 vols. (1967), 8:399.
204. Schiller, 2:48.
205. Ibid., p. 38.
206. Ibid., p. 44.
207. Aurenhammer, 1:12.
208. Ibid.; Möller, col. 29.
209. Möller, cols. 28–29; Stroh, p. 284. Cf. Lankheit, "Eucharistie," cols. 183–84.
210. Möller, cols. 29, 33, 38; Schiller, 2:45; Pfeiffer, p. 398; Lankheit, "Eucharistie," col. 188.
211. *WA*, 54:155–56; Stroh, pp. 286–87.
212. Von Haebler, p. 19; Sasse, p. 170. Cf. François Amiot, *History of the Mass*, trans. Lancelot C. Sheppard (New York, 1959), pp. 90–91.
213. Schiller, 2:37.
214. Pfeiffer, p. 398.
215. Tappert, p. 181. For the original text, see *Die Bekenntnisschriften der evangelisch-lutherischen Kirche*, p. 250.
216. Tappert, p. 454; *WA*, 30¹:231. Cf. Stroh, p. 286.
217. Pfeiffer, p. 398.
218. Schiller, 2:51.
219. This section is based almost entirely upon an earlier study of mine, which is both more detailed and more heavily documented; see the work cited in n. 86. For an older study of early Lutheran funerary art, see E. Wernicke, "Grabdenkmäler aus dem Jahrhundert der Reformation in evangelischen Kirchen Deutschlands." See also von Haebler, pp. 24–31; Gertz, *passim*.

220. For an excellent general article on the epitaph monument, see Paul Schoenen, "Epitaph," *RDK*, 5:872–921. There are also some useful comments in Erwin Panofsky, *Tomb Sculpture* (New York, n.d.), p. 55 and *passim*.

221. *Der Kirchenbau des Protestantismus von der Reformation bis zur Gegenwart*, pp. 19–40; Edward A. Sovik, "Church Architecture," *The Encyclopedia of the Lutheran Church*, 3 vols. (1965), 1:503; Buchholz, pp. 23 ff.

222. Peter Poscharsky, "Kurze Entwicklungsgeschichte der Kanzel," pp. 51–64; von Haebler, pp. 39–42; Gertz, pp. 23–24.

223. Theodor Goecke, *Die Kunstdenkmäler der Provinz Brandenburg*, vol. 2, pt. 3, *Stadt und Dom Brandenburg* (Berlin, 1912), 19–25. See also Wernicke, pp. 77–78.

224. Von Haebler, p. 23; Wernicke, p. 51.

225. For the iconography of pre-Reformation epitaphs in Germany, see Schoenen, cols. 890–903.

226. Christensen, "Significance of Epitaph Monument," p. 311, n. 18. For additional information on the iconography of Lutheran epitaphs, see Wernicke, pp. 76–78.

227. For Luther's doctrine of the Atonement, see Althaus, chap. 17.

228. Tappert, p. 345; *WA*, 30:249.

229. Althaus, p. 411.

230. Ulrich Asendorf, *Eschatologie bei Luther* (Göttingen, 1967), p. 289.

231. For the popularity of the Christ Blessing the Children theme on epitaphs, see also Wernicke, p. 76.

232. Thulin, *Cranach-Altäre*, pp. 134–35.

233. For epitaphs displaying the Baptism of Christ, see also Günter W. Vorbrodt, "Der Cranach-Schüler Peter Roddelstedt als Maler Jenaer Professoren," *Ruperto-Carola: Mitteilungen der Vereinigung der Freunde der Studentenschaft der Universität Heidelberg e. V.* 11 (1959): 98, 110.

234. André Grabar, *Christian Iconography: A Study of Its Origins* (Princeton, 1968), p. 115.

235. The Counter-Reformation fully appreciated the Trinitarian implications of this theme (Schiller, 1:152).

236. Ibid., p. 138.

237. Tappert, p. 349; *WA*, 30:256.

238. Tappert, p. 349; *WA*, 30: 257–58.

239. *LW*, 36:67–68; *WA*, 6:534.

240. *LW*, 36:69; *WA*, 6:535. Cf. Pelikan, *Spirit versus Structure*, pp. 77, 96.

241. Althaus, p. 407.

242. For discussion and a photograph, see Oskar Thulin, "Das Bugenhagenbildnis im Zeitalter der Reformation," in *Johann Bugenhagen: Beiträge zu seinem 400. Todestag*, ed. Werner Rautenberg (Berlin, 1958), pp. 74, 84–85.

243. Walter M. Ruccius, *John Bugenhagen Pomeranus: A Biographical Sketch* (Philadelphia, n.d.), p. 80.

244. Eggert, "Altarretabel," col. 575.

245. Cf. Gertz, pp. 46–49.

246. Schiller, 1:190.

247. Grabar, p. 10.

248. See Aemilius Ludwig Richter, ed., *Die evangelischen Kirchenordnungen des sechszehnten Jahrhunderts*, 1:366; 2:21, 141, 274.

249. Thulin, *Cranach-Altäre*, pp. 75–95; Christensen, "Significance of Epitaph Monument," pp. 305–6.

250. Erwin Panofsky, "Comments on Art and Reformation," p. 10.

251. This figure of thirty-one includes the back panels of the Wittenberg altar (see n. 126). For numerous other Old Testament paintings in the later work of Cranach the Elder, see the catalog of Friedländer and Rosenberg.

252. The Friedländer and Rosenberg catalog contains illustrations of 96 religious

paintings by Cranach the Elder for the period up through the year 1520; only 5 of these depict Old Testament motifs (see nos. 39, 40, 69, 88, 98). Of the 441 religious paintings from the period 1495–1520 tabulated in the appendix of this book, only 20 (or less than 5 percent) display Old Testament scenes.

253. According to Heinrich Bornkamm, Luther "occupied himself with the Old Testament far more than with the New Testament" *(Luther and the Old Testament,* trans. Eric W. and Ruth C. Gritsch [Philadelphia, 1969], p. vii).

254. Ehresmann goes so far as to suggest that "nearly every traditional Christian subject represented in the post-Reformation works by Cranach and his workshop has a new meaning inspired by the teachings of Martin Luther" (p. 32).

255. Harbison, *The Last Judgment,* p. 92; see also pp. 93–94, 145, 174.

Chapter 5

1. For an example of such an interpretation, see Johannes Janssen, *History of the German People at the Close of the Middle Ages,* trans. A. M. Christie and M. A. Mitchell, 16 vols. (London, 1896–1910), 11:27. The following chapter draws a great deal of its material from my article, "The Reformation and the Decline of German Art."

2. Art historians have become increasingly conscious of the impropriety of attempting to pass judgment on the relative merits of one historical style as over against another. See Arnold Hauser, *The Philosophy of Art History* (Cleveland, 1963), pp. 216–17. But, as Hauser goes on to point out, "In reality, not only do we often see incompetent individual works, but it is possible for all the known examples of a style, *e.g.,* the works of early Christian painting, to fall far short of what their creators are likely to have intended" (p. 219).

3. H. W. Janson, *Key Monuments of the History of Art: A Visual Survey* (New York, 1959).

4. Otto Benesch, *German Painting,* p. 149; Otto Fischer, *Geschichte der deutschen Malerei* (Munich, 1942), pp. 303–8; Charles D. Cuttler, *Northern Painting from Pucelle to Bruegel* (New York, 1968), p. 415; Helen A. Dickinson, *German Masters of Art* (New York, 1914), pp. 283–84.

5. Gert von der Osten and Horst Vey, *Painting and Sculpture in Germany and the Netherlands 1500 to 1600,* pp. 283–87; Adolf Feulner and Theodor Müller, *Geschichte der deutschen Plastik* (Munich, 1953), pp. 441–42; Chandler R. Post, *A History of European and American Sculpture,* 2 vols. (Cambridge, Mass., 1921), 1:253, 256; Wilhelm Pinder, *Die deutsche Plastik: Vom ausgehenden Mittelalter bis zum Ende der Renaissance,* 2 vols. (Potsdam, 1924–29), 2:483.

6. Otto Fischer, *Geschichte der deutschen Zeichnung und Graphik* (Munich, 1951), p. 360; Arthur M. Hind, *A History of Engraving & Etching* (Boston, 1923), pp. 81, 109; Arthur M. Hind, *An Introduction to a History of Woodcut,* 2 vols. (London, 1935), 1:41; Carl Zigrosser, *Six Centuries of Fine Prints* (New York, 1939), pp. 57–58.

7. It goes without saying, of course, that this later period was not totally lacking in competent painters and sculptors and in continued artistic productivity, particularly in the decorative arts.

8. Hugh Trevor-Roper, *The Rise of Christian Europe* (New York, 1965), p. 194.

9. For references to historians who once did, see Alexander Rüstow, "Lutherana Tragoedia Artis," p. 891; Janssen, 11:180, n. 2.

10. Hind, *Engraving & Etching,* p. 81; von der Osten and Vey, pp. 285, 287; Post, 1:248, 253.

11. Fischer, *Geschichte der deutschen Zeichnung und Graphik,* p. 360; Fischer, *Geschichte der deutschen Malerei,* p. 303; Feulner and Müller, p. 442; Cuttler, p. 415.

12. Arthur Burkhard, *Hans Burgkmair d. Ä.* (Leipzig, 1934), p. 172; Gertrud Otto, *Bernhard Strigel* (Munich, 1964), p. 81; Benesch, *German Painting,* p. 149.

13. See Christensen, "The Reformation and the Decline of German Art," p. 230, app. A.
14. This does not overlook the fact that certain segments of the German art community may have suffered economic hardship at various times in the century before the Reformation. See Hans Huth, *Künstler und Werkstatt der Spätgotik* (Augsburg, 1923), pp. 70 ff.; Wolfgang Stechow, ed., *Northern Renaissance Art 1400–1600*, p. 76; cf. Janssen, 11:45, n. 2.
15. This document is reproduced in Rott, 3, pt. 2, pp. 304–5; a portion of a related document (also found in ibid., p. 305) is given in translation in Janssen, 11:46. For other, individual, petitions for municipal employment, see: Rott, 3, pt. 3, p. 62; ibid., 2:64; ibid., 3, pt. 2, p. 227; ibid., pp. 229–30.
16. Stechow, p. 131.
17. For the document, Rott, 3, pt. 3, pp. 131–32; for some explanation, ibid., 3, pt. 1, p. 161.
18. Janssen quotes the following statement by a Nuernberg writer in 1548: "It is pitiful that in these days excellent artists not only get no honour, but they cannot even earn their daily bread" (11:45).
19. This translation is from Janssen, 11:45. For the original German text of the preface, plus some biographical data on Vogtherr, see Georg Stuhlfauth, "Künstlerstimmen und Künstlernot aus der Reformationsbewegung," pp. 509–12.
20. In 1525 Albrecht Dürer had observed that "arts very quickly disappear, but only with difficulty and after a long time can they be re-discovered" (Albrecht Dürer, *The Writings of Albrecht Dürer*, p. 212; cited hereafter as *Writings*). For the original German text, see Albrecht Dürer, *Dürer: Schriftlicher Nachlass*, 1:115 (cited hereafter as *DSN*).
21. Alfred Woltmann, *Holbein und seine Zeit*, 2d ed. rev. (Leipzig, 1874), pp. 315–16.
22. The documents are printed in Georg Habich, "Studien zur deutschen Renaissancemedaille, 3: Friedrich Hagenauer," *Jahrbuch der königlich preussischen Kunstsammlungen* 28 (1904): 181–98, 230–72 (see pp. 269–72).
23. Habich, p. 245; Janssen, 11:46–47. Cf. the unsuccessful attempt of the Nuernberg painters in 1534 to secure an ordinance restricting the inflow of artists from outside the city (Wilhelm Schwemmer, "Freiheit und Organisationszwang der Nürnberger Maler in Reichsstädtischer Zeit," *Mitteilungen des Vereins für Geschichte der Stadt Nürnberg* 60 [1973]: 222).
24. Rott, 3, pt. 2, p. 306.
25. Such jurisdictional disputes, of course, were not new at the time of the Reformation; see Huth, p. 73, and Habich, pp. 182–83.
26. In addition to those cited below, see Rott, 1, pt. 2, p. 135.
27. Ibid., p. 233.
28. Ibid.; ibid., 2:104.
29. Ibid., 1, pt. 1, p. 235 (cf. ibid., p. 191).
30. Christoph Bockstorfer, a painter in Constance, in 1523 paid tax on property valued at 300 lb; in 1524 the valuation sank to 150 lb; in 1525, to 45 lb; in the years between 1530 and 1543, he paid on a valuation of only 30 lb. See ibid., 1, pt. 2, p. 44. Andreas Haider, also a Constance painter, in 1522 paid property tax on 192 Pf.H.; by the year 1525, this had dropped to 144 Pf. H.; and, by 1529, he was being taxed on a valuation of only 40 Pf. H. See ibid., p. 46. For further evidence of the plight of the painters in Constance see ibid., 2:46.
31. In 1534 the Basel authorities had the property of the painter Gabriel Zehender inventoried at the request of his impatient creditors; within the year Zehender had fled the city (ibid., 3, pt. 3, pp. 64–65).
32. Carl C. Christensen, "Dürer's 'Four Apostles' and the Dedication as a Form of Renaissance Art Patronage," esp. pp. 333–34.

33. Heinz Stafski, *Der jüngere Peter Vischer* (Nuernberg, 1962), p. 48. It has been maintained that one of the reasons for the decline of the Vischer foundry was the increasing preference in Germany, in emulation of Italy, for red and white marble rather than bronze for sepulchral monuments (Post, 1:252). However, there is evidence that the Reformation was responsible for disrupting work on at least one large and important Vischer commission, the bronze screen ordered by the Fugger family of Augsburg for their burial chapel in St. Anna Church. See Norbert Lieb, *Die Fugger und die Kunst im Zeitalter der Spätgotik und frühen Renaissance* (Munich, 1952), pp. 125–39.
34. Theodor Hampe, ed., *Nürnberger Ratsverlässe über Kunst und Künstler im Zeitalter der Spätgotik und Renaissance*, 1, nos. 3179, 3182, 3184, 3185, 3186.
35. Rott, 3, pt. 3, p. 63; ibid., p. 58; ibid., 1, pt. 2, p. 233; ibid., 2:29.
36. Ibid., 2:64; ibid., 1, pt. 1, p. 190; ibid., 1, pt. 2, p. 186; Janssen, 11:46. In this connection, see the poem printed in Stechow, p. 133.
37. Rott, 3, pt. 1, p. 144; ibid., 2:30; ibid., p. 64; Janssen, 11:46, n. 2. There are, to be sure, known examples from the pre-Reformation era of artists, and even financially successful ones, supplementing their income from sources outside the field of artistic endeavor. For instance, see Walther Scheidig, "Urkunden zu Cranachs Leben und Schaffen," p. 161, no. 17.
38. See Christensen, "The Reformation and the Decline of German Art," pp. 230–31, app. B.
39. Stechow, p. 131. For other examples of migration, see Rott, 1, pt. 2, p. 44 (cf. ibid., 1, pt. 1, p. 89); Habich, pp. 183–84.
40. For painting, see Christensen, "The Reformation and the Decline of German Art," pp. 231–32, app. C.
41. Eugenio Battisti, "Reformation and Counter Reformation," col. 902; Helmuth Eggert, "Altarretabel (prot.)," *RDK*, 1:565.
42. Charles Garside, Jr., *Zwingli and the Arts*, pp. 120, 137, 163–70; Hans Frhr. v. Campenhausen, "Die Bilderfrage in der Reformation," pp. 100–104, 109.
43. Garside, *Zwingli*, pp. 141–42, 172–73; Campenhausen, "Die Bilderfrage in der Reformation," pp. 106–7.
44. Albert Schramm, *Luther und die Bibel*, nos. 249–365; James Strachan, *Early Bible Illustrations*, pp. 46–47; Ph. Schmidt, *Die Illustration der Lutherbibel 1522–1700*, pp. 17, 179 ff.; *WA*, Bibel, 2:549–52.
45. Schramm, pp. 42–43; E. G. Schwiebert, *Luther and His Times* (St. Louis, 1950), p. 662.
46. See Schmidt, pp. 484–85.
47. *WA*, $10^{.2}$:xix; Schmidt, pp. 21–22, 50, 224, 330–46.
48. *WA*, 10^{I}:341, 359, 459 ff.; *LW*, 43:42–45.
49. Martin Hoberg, *Die Gesangbuchillustration des 16. Jahrhunderts*, pp. v, 13.
50. Max Geisberg, "Cranach's Illustrations to the Lord's Prayer and the Editions of Luther's Catechism"; Ernst Grüneisen, "Gründlegendes für die Bilder in Luthers Katechismen"; *WA*, 30:472–73, 631–35.
51. For information on the early Lutheran carved pulpits, see Peter Poscharsky, "Kurze Entwicklungsgeschichte der Kanzel"; and Hans Carl von Haebler, *Das Bild in der evangelischen Kirche*, pp. 39–42.
52. Cited in Huth, p. 98.
53. Johannes Kessler, *Johannes Kesslers Sabbata mit kleineren Schriften und Briefen*, pp. 311, 305.
54. For Ulm, see Rott, 2:iv; Janssen, 5:337, 339 and 11:32. For Bern, see Richard Feller, *Geschichte Berns*, 4 vols. (Bern, 1946–60), 2:162; Friedrich Fischer, "Der Bildersturm in der Schweiz und in Basel insbesondere," p. 9.
55. Janssen, 11:39–40.

56. Cf. Karl Holl, *The Cultural Significance of the Reformation*, p. 148.
57. Max J. Friedländer and Jakob Rosenberg, *Die Gemälde von Lucas Cranach* (Berlin, 1932), p. 25; Janssen, 11:150; Stuhlfauth, p. 513.
58. Something of this sort is suggested by Stuhlfauth, although along with portraiture and genre art, he mentions landscape painting rather than the representation of mythological, allegorical, and historical themes (pp. 513–14).
59. For the nineteen-year span 1502–20 Friedländer and Rosenberg provide illustrations of 32 paintings with a secular subject matter. For the thirty-three year period 1521–53 they provide photographs of 148 paintings with a nonsacred iconography. Of the 32 secular paintings up through 1520, 26 or about 81 percent, are portraits. Of the 148 nonsacred paintings done after 1520, 85, or about 57 percent, are portraits. All 6 of the nonportrait secular paintings from the years 1502–20 are placed by Friedländer and Rosenberg in the category that they call "Mythology, Allegory, and History" (pp. 108–9). Of the 63 nonportrait secular paintings from the years 1521–53, 51 are listed in the category "Mythology, Allegory, and History" (pp. 108–9), while 12 are designated by Friedländer and Rosenberg as "Genre" (pp. 109–10).
60. Royall Tyler, *The Emperor Charles the Fifth* (London, 1956), p. 26.
61. Earl E. Rosenthal, *The Cathedral of Granada: A Study in the Spanish Renaissance* (Princeton, N.J., 1961); Earl E. Rosenthal, "The Image of Roman Architecture in Renaissance Spain," *Gazette des Beaux-Arts* 12 (1958): 334; Hugh Trevor-Roper, *Princes and Artists: Patronage and Ideology at Four Habsburg Courts 1517–1633* (New York, 1976), chap. 1.
62. Von der Osten and Vey, p. 175. For the art patronage of Maximilian I, see Ludwig Baldass, *Der Künstlerkreis Kaiser Maximilians* (Vienna, 1923); and Gerhard Händler, *Fürstliche Mäzene und Sammler in Deutschland von 1500–1620* (Strasbourg, 1933), pp. 9–25.
63. Von der Osten and Vey, p. 175. For an example of the importance imperial patronage could have in liberating a German artist from provincialism and stimulating him to a more stylistically advanced creativity, see Otto's work on Strigel, p. 9.
64. Anthony Blunt, *Art and Architecture in France 1500 to 1700* (London, 1953), pp. 1–87; Otto Benesch, *The Art of the Renaissance in Northern Europe*, 2d ed. rev. (London, 1965), pp. 122 ff.
65. For the princes, see Händler; Benesch stresses the decisive importance of ducal patronage (*German Painting*, p. 12).
66. For the townsmen, see Norbert Lieb, *Die Fugger und die Kunst im Zeitalter der hohen Renaissance* (Munich, 1958); Wilhelm Schwemmer, "Aus der Geschichte der Kunstsammlungen der Stadt Nürnberg," *Mitteilungen des Vereins für Geschichte der Stadt Nürnberg* 40 (1949): 97 ff.; Carl C. Christensen, "Municipal Patronage and the Crisis of the Arts in Reformation Nuernberg."
67. Julius von Schlosser, *Die Kunst- und Wunderkammern der Spätrenaissance* (Leipzig, 1908), pp. 34–35; Theodor Hampe, "Kunstfreunde im alten Nürnberg und ihre Sammlungen," *Mitteilungen des Vereins für Geschichte der Stadt Nürnberg* 16 (1904): 57 ff.; Otto Fischer, "Geschichte der öffentlichen Kunstsammlung," in *Öffentliche Kunstsammlung Basel: Festschrift zur Eröffnung des Kunstmuseums* (Basel, 1936), pp. 8–25; Janssen, 11:187 ff.
68. Hajo Holborn, *A History of Modern Germany: The Reformation* (New York, 1961), pp. 79, 85; Gerald Strauss, *Nuremberg in the Sixteenth Century* (New York, 1966), pp. 147 ff.
69. Wallace K. Ferguson, "Recent Trends in the Economic Historiography of the Renaissance," *Studies in the Renaissance* 7 (1960): 23–24; Trevor-Roper, *Rise of Christian Europe*, pp. 194–95.

70. Holborn, p. 85.
71. See ibid., p. 67: "The German cities reached the peak of their productive energies in the half century between 1480 and 1530."
72. In Dürer's period communal patronage may already have lost some of the importance it had earlier held for art. See Benesch, *German Painting*, p. 12.
73. G. von Below, *Das ältere deutsche Städtewesen und Bürgertum*, 3d ed. (Bielefeld and Leipzig, 1925), p. 20; Bernd Moeller, *Reichsstadt und Reformation* (Gütersloh, 1962), pp. 67 ff.; Strauss, pp. 147 ff. With respect to the significance of this for art, see von der Osten and Vey, p. 318, and Fischer, *Geschichte der deutschen Malerei*, p. 303.
74. In most of the monumental arts there clearly must have been a quantitative as well as a qualitative decline. This, however, apparently does not hold true with respect to the art of engraving. See Hind, *Engraving & Etching*, pp. 86, 118.
75. Von der Osten and Vey, p. 254.
76. Arnold Hauser, *The Social History of Art*, trans. Stanley Godman, 4 vols. (New York, 1957), 2:42.
77. Von der Osten and Vey, p. 176.
78. Fischer, *Geschichte der deutschen Zeichnung und Graphik*, p. 360; Stuhlfauth, p. 513; Feulner and Müller, p. 442; Pinder, 2:483; Benesch, *German Painting*, p. 149.
79. There might be adduced here the statement of J. H. Plumb that, in the Renaissance, "great artists are as common as peaks in the Himalayas, leading one to believe that the ability to draw or carve is no rarer in human beings than mathematical skill and only requires the appropriate social circumstances to call it forth in abundance" (*The Italian Renaissance* [New York, 1965], pp. 32–33).
80. Cf. von Haebler, p. 9.
81. Cf. Fischer, *Geschichte der deutschen Malerei*, p. 308.
82. One historian refers to the artist as "an oscillating needle of the seismography of life" (I. Schöffer, "Did Holland's Golden Age Co-incide with a Period of Crisis?" *Acta Historiae Neerlandica* 1 [1966]: 89).
83. Alfred Peltzer, *Deutsche Mystik und deutsche Kunst* (Strasbourg, 1899), p. 3; Arthur Burkhard, *Matthias Grünewald* (Cambridge, Mass., 1936), pp. viii–ix; Dickinson, p. 4.
84. Myron P. Gilmore, *The World of Humanism 1453–1517* (New York, 1952), pp. 229–30.
85. I do not find convincing, however, the suggestion of Rüstow that Hans Baldung Grien's apparent preoccupation with demonic forces and his disturbing compositions based on these themes derive from the spiritual unrest produced by the Reformation (pp. 899 ff.). G. F. Hartlaub, in his *Hans Baldung Grien: Hexenbilder* (Stuttgart, 1961), makes clear that Baldung Grien's interest in witchcraft long antedated the Reformation.
86. Eduard His, "Holbeins Verhältniss zur Basler Reformation," p. 159 (referring to the Basel painter, Hans Herbst). Allegedly a "radical decline" in Dürer's artistic production after 1522–23 resulted from the artist's own questioning of the value of religious art (Craig Harbison, "Dürer and the Reformation," pp. 370–71).
87. Cf. David McRoberts, "Material Destruction Caused by the Scottish Reformation," in *Essays on the Scottish Reformation 1513–1625*, ed. David McRoberts (Glasgow, 1962), p. 459. Young artists were accustomed to sketch works of art seen and studied on their *Wanderjahre* and to draw on these ideas and themes later for the production of their own work (Huth, p. 34).
88. Benesch, *German Painting*, p. 169.
89. Dürer, *Writings*, p. 70. For the original German text, see *DSN*, 1:73.
90. Veit Valentin, *The German People* (New York, 1946), p. 174; Willy Andreas,

Deutschland vor der Reformation: Eine Zeitenwende (Stuttgart and Berlin, 1932), p. 623.

91. Janssen, 11:27.

92. F. Saxl, "Dürer and the Reformation," 1:271. Cf. the statement concerning Hans Baldung Grien made by Fritz Baumgarten, "Hans Baldungs Stellung zur Reformation," p. 262.

93. F. Saxl, "Holbein and the Reformation," 1:277; His, pp. 156–59.

94. Ernst Staehelin, *Das theologische Lebenswerk Johannes Oekolampads* (Leipzig, 1939), pp. 534–35; His, pp. 157–59.

95. Theodor Kolde, "Hans Denck und die gottlosen Maler von Nürnberg." For another example of the banishment of an artist, see von der Osten and Vey, p. 209.

96. Günther Franz, *Der deutsche Bauernkrieg*, 7th ed. (Bad Homburg vor der Höhe, 1965), p. 280; Benesch, *German Painting*, p. 148.

97. Franz, pp. 280–81; Battisti, col. 906.

98. Franz, p. 281; cf. Battisti, col. 906.

99. Battisti, col. 906.

100. Von der Osten and Vey, p. 283.

101. Some other suggested connections between the Reformation and the decline of German art: (1) The partitioning of Europe along religious lines allegedly resulted in a weakening of German art in that it led to a breaking off of contacts with Italy. See von Haebler, p. 21; Battisti, col. 902; cf. von der Osten and Vey, p. 309. (2) It has been suggested that the religious and moral preoccupations of the Reformation were injurious to a branch of art such as portraiture. John Pope-Hennessy, *The Portrait in the Renaissance* (New York, 1966), p. 178. (3) Certain Roman Catholic historians have argued that the Reformation introduced a deadly poison into art in the form of the religious dissensions and hatreds characteristic of the period. Artists degraded their noble talents and profession by placing them in the service of sectarian polemics and party strife. See Janssen, 11:51–52, 76; Hartmann Grisar, S.J., *Luther*, trans. E. M. Lamond, 6 vols. (London, 1913–17), 5:224. This is not the place to attempt an evaluation of the various arguments listed here, but concerning the impact of the Reformation upon portraiture, see Donald B. Kuspit, "Dürer and the Lutheran Image."

102. Paul Lehfeldt, *Luthers Verhältniss zu Kunst und Künstlern*, pp. 81 ff.

103. Eberhard Ruhmer, *Cranach*, trans. Joan Spencer (London, 1963), p. 28; Alfred Woltmann, *Die deutsche Kunst und die Reformation*, pp. 35–36; Donald L. Ehresmann, "The Brazen Serpent," p. 47; Lehfeldt, pp. 95–96. For the recent suggestion that "neither Protestant nor Catholic didacticism was . . . responsible for any long-range detriment or damage to the arts," see Craig Harbison, *The Last Judgment in Sixteenth Century Northern Europe*, p. 256; cf. pp. 157, 255.

104. Lewis W. Spitz, *The Religious Renaissance of the German Humanists* (Cambridge, Mass., 1963), p. 262; Erwin Panofsky, "Erasmus and the Visual Arts," p. 204; Hajo Holborn, *Ulrich von Hutten and the German Reformation*, trans. Roland H. Bainton (New Haven, Conn., 1937), p. 89; Donald B. Kuspit, "Melanchthon and Dürer," *passim*.

105. For portraits, see Hans Preuss, *Martin Luther der Künstler*, p. 44. For the decorative use of art, see Campenhausen, "Die Bilderfrage in der Reformation," p. 115.

106. Jakob Burckhardt, *Force and Freedom: Reflections on History*, ed. James Hasting Nichols (Boston, 1964), p. 61.

107. *LW*, 53:316; *WA*, 35:475.

108. Martin Luther, *Martin Luther on "The Bondage of the Will,"* p. 83.

Excursus

1. See, for example, Ludwig Grote, *Dürer: Biographical and Critical Study,* trans. Helga Harrison (Geneva, 1965), p. 118.
2. For helpful suggestions as to the centrality of the Word of God to an understanding of Dürer's later religious development, I am indebted to Wendell G. Mathews, "Albrecht Dürer as a Reformation Figure," pp. v. 134–52.
3. The basic documentary source is the published corpus of Dürer's own writings. For the standard modern edition, see Albrecht Dürer, *Dürer: Schriftlicher Nachlass,* cited hereafter as *DSN.* For an English translation of some of these materials, see Albrecht Dürer, *The Writings of Albrecht Dürer,* cited hereafter as *Writings.* For the secondary literature on the *Four Apostles,* see Matthias Mende, *Dürer-Bibliographie* (Wiesbaden, 1971), nos. 3006–48.
4. At this point some readers will be reminded of an important recent study by Gerhard Pfeiffer, "Albrecht Dürer's 'Four Apostles.' " It will be observed, however, that in the present work the significance of Dürer's painting as a memorial is interpreted somewhat differently than in Pfeiffer's essay.
5. Dürer himself gave the painting no name (Peter Strieder, "Albrecht Dürers 'Vier Apostel' im Nürnberger Rathaus," p. 152).
6. Grote, *Dürer,* p. 120. See also the photographic detail in Kurt Martin, *Albrecht Dürer,* fig. 7. For additional illustrations, see Fedja Anzelewsky, *Albrecht Dürer: Das malerische Werk* (Berlin, 1971), pls. 185–89.
7. Grote, *Dürer,* p. 118.
8. Ibid., pp. 118, 120.
9. Ibid., p. 120; Erwin Panofsky, *The Life and Art of Albrecht Dürer,* 4th ed. (Princeton, N.J., 1955), p. 231.
10. Heinrich Wölfflin, *The Art of Albrecht Dürer,* trans. Alastair and Heide Grieve (London, 1971), p. 274.
11. Ibid., p. 273. Grote observes, "The wings of Giovanni Bellini's *Altarpiece of the Madonna* in the Frari Church in Venice appear to have served as Dürer's models for the Apostles" (*Dürer,* p. 122).
12. Grote, *Dürer,* pp. 118–20; Wölfflin, p. 273.
13. For the original text of the inscriptions, see *DSN,* 1:210–11, no. 83.
14. Pfeiffer makes clear (p. 272) that it was Dürer who wrote these introductory passages and selected the biblical texts to follow, not the calligrapher Johann Neudörfer. Neudörfer merely inscribed the texts on the base of the panels at Dürer's behest. For Neudörfer's own description of his part in this process, see the document in *DSN,* 1:321, no. 33. It was Neudörfer who stated that in the figures of the *Four Apostles* one may recognize the four human temperaments: sanguine, choleric, phlegmatic, and melancholic.
15. *DSN,* 1:213, n. 48.
16. *Writings,* p. 134. As noted by Rupprich, one should compare here Rev. 22:18–19 (*DSN,* 1:212, n. 43).
17. *Writings,* p. 134. The biblical texts are given here in the translation used by Conway.
18. Ibid.
19. Ibid.
20. Ibid.
21. Ibid., p. 135. For the original, see *DSN,* 1:117, no. 59. Cf. ibid., 1:242, no. 21.
22. *DSN,* 1:242–43, nos. 22, 23.
23. Ibid., p. 249, no. 12. For discussion of some problems relating to the dating of this document, see Anzelewsky, pp. 275–76.
24. Carl C. Christensen, "Dürer's 'Four Apostles' and the Dedication as a Form of Renaissance Art Patronage," p. 334.

25. *DSN*, 1:243, no. 23. Pfeiffer (p. 274) unaccountably dismisses the importance of this statement. For the text of a newly published document that contains similar wording and that seems to provide additional support for this interpretation, see Strieder, p. 151.

26. Ludwig Grote, "Vom Handwerker zum Künstler: Das gesellschaftliche Ansehen Albrecht Dürers," *Erlanger Forschungen, Reihe A: Geisteswissenschaften*, 16 (1964): 41; Grote, *Dürer*, p. 122. Strieder gives a somewhat similar interpretation, pp. 151-52.

27. Mathews comments as follows: "Grote's idea that Dürer was here showing a humanistic desire to have his work in a place of honor in the City Hall gives to the artist too much self-assertiveness. After all, Dürer did not know this work would be his epitaph; only history has taught us this" (p. 150, n. 69).

28. Pfeiffer, "Dürer's 'Four Apostles,' " p. 274.

29. Wölfflin, p. 272.

30. Panofsky, *Life and Art of Dürer*, pp. 230 ff.

31. Martin, pp. 21-23; Mathews, pp. 154-57; Herbert von Einem, "Dürers 'Vier Apostel,' " p. 90; *Albrecht Dürer 1471-1971*, Exhibition Catalog of the German National Museum in Nuernberg (Munich, 1971), p. 209.

32. Panofsky, *Life and Art of Dürer*, p. 232.

33. See pp. 329-33 of my article, "Dürer's 'Four Apostles.' "

34. Klaus Lankheit, "Dürers 'Vier Apostel,' " p. 249; Anzelewsky, p. 79.

35. Wölfflin, p. 273.

36. Ibid.; von Einem, p. 89. Cf. Strieder, p. 152.

37. Many years ago an interesting suggestion was made that St. John and St. Paul, respectively, were similar in temperament to the two Wittenberg reformers Melanchthon and Luther (Alfred Woltmann, *Die deutsche Kunst und die Reformation*, p. 28).

38. Grote, *Dürer*, p. 122.

39. Panofsky, p. 234; von Einem, p. 100.

40. Roland H. Bainton, *Here I Stand: A Life of Martin Luther* (New York, 1950), pp. 65, 331.

41. Ewald M. Plass, comp., *What Luther Says*, 2:1026.

42. Ibid., p. 1027.

43. Ibid.

44. Jan D. Kingston Siggins, *Martin Luther's Doctrine of Christ* (New Haven, Conn., 1970), p. 9.

45. Ibid., pp. 191-92, 207. Cf. Ernst Heidrich, *Dürer und die Reformation*, p. 32, n. 1.

46. Quoted in Siggins, p. 9.

47. Ibid.

48. Ibid., p. 10.

49. F. L. Cross and E. A. Livingstone, eds., *The Oxford Dictionary of the Christian Church* (London, 1974), p. 1067.

50. Cf. Grote, *Dürer*, p. 122.

51. Ibid.

52. Von Einem, p. 100.

53. Cf. Martin, p. 27.

54. The indispensability of written documentary evidence for answering this question has been stressed by Heinrich Lutz, "Albrecht Dürer in der Geschichte der Reformation," pp. 23-24. Many of Lutz's findings were published also in an earlier essay, "Albrecht Dürer und die Reformation."

55. Lutz, "Dürer und die Reformation," p. 175; *Writings*, p. 154.

56. *DSN*, 1:260-61, no. 39.

57. The letter was to Nikolaus von Amsdorf (*DSN*, 1:263, no. 51).

58. *Writings*, p. 89. For the original, see *DSN*, 1:85-87, no. 32. The "great distress"

out of which Luther helped Dürer apparently was the burden of an oppressed conscience. See Georg Weise, *Dürer und die Ideale der Humanisten*, Tübinger Forschungen zur Kunstgeschichte, no. 6 (Tübingen, 1953), pp. 5–7; Mathews, pp. 135–36.

59. Wilhelm Waetzoldt, *Dürer and His Times*, trans. R. H. Boothroyd (London, 1950), p. 160.

60. *Writings*, p. 156. For the list, see *DSN*, 1:221, no. 1; *Writings*, pp. 156–57.

61. *DSN*, 1:160, 175; *Writings*, pp. 107, 123.

62. From *Writings*, pp. 158–59. For the original, see *DSN*, 1:170–72.

63. Lutz, "Dürer und die Reformation," p. 175; Lutz, "Dürer in der Geschichte der Reformation," pp. 33–34.

64. Gottfried Seebass, "Dürers Stellung in der reformatorischen Bewegung," pp. 105–6; Wolfgang Braunfels, "Die reformatorische Bewegung im Spiegel von Dürers Spätwerk," pp. 125, 141–42; *Albrecht Dürer 1471–1971*, p. 201. Hans Rupprich, who was writing before the publication of Lutz's articles, also rejected the possibility that the *Lutherklage* might be an interpolation (*DSN*, 1:198). A computer study of Dürer's language usage conducted at Erlangen, Germany may finally resolve the issue. For analysis of the content of the *Lutherklage*, see Rupprich's extensive notes in *DSN*, 1:196–99; Seebass, "Dürers Stellung," pp. 106–8; Mathews, pp. 140–44; and Gerlinde Wiederanders, *Albrecht Dürers theologische Anschauungen*, pp. 80–82.

65. Pointed out by Lutz, "Dürer in der Geschichte der Reformation," p. 34. However, Luther responded as follows upon receiving the news of Dürer's death in 1528 from a Nuernberg friend of the artist: "As to Dürer, it is natural and right to weep for so excellent a man; still you should rather think him blessed, as one whom Christ has taken in the fullness of his wisdom and by a happy death from these most troublous times, and perhaps from times even more troublous which are to come, lest one, who was worthy to look upon nothing but excellence, should be forced to behold things most vile. May he rest in peace. Amen." (From the *Writings*, p. 136; for the original, see *DSN*, 1:281, no. 125).

66. The translation is from Mathews, p. 50. For the original, *DSN*, 1:210, no. 76.

67. *Albrecht Dürer 1471–1971*, p. 204. The Luther passage referred to here is quoted in part in the text of chapter two of this volume, at n. 17.

68. *Writings*, p. 28; *DSN*, 1:111, no. 54.

69. *Writings*, p. 131; *DSN*, 1:113.

70. Gottfried Seebass, "The Reformation in Nürnberg," in *The Social History of the Reformation*, ed. Lawrence P. Buck and Jonathan W. Zophy (Columbus, 1972), pp. 29–30; Gerald Strauss, *Nuremberg in the Sixteenth Century* (New York, 1966), pp. 174–76.

71. Seebass, "Dürers Stellung," pp. 117–18.

72. Cf. Lankheit, p. 248; Martin, p. 27.

73. Heidrich emphasizes this point (p. 3).

74. It would appear that a century after the completion of the painting there were at least some Nuernberg residents who believed that the inscriptions could have an anti-Catholic interpretation. Waetzoldt provides a succinct description: "In 1627, when the Elector Maximilian of Bavaria wished to acquire Dürer's 'Four Apostles' for Munich, the Nuremberg Council in an endeavour to save the painting for Dürer's native city, drew attention to the disapproval which the wording of the inscription might arouse among the Jesuits of Munich" (pp. 172–73).

75. Heidrich, p. 8.

76. Pfeiffer, "Dürer's 'Four Apostles,' " p. 286; Seebass, "Dürers Stellung," pp. 119–20.

77. Pfeiffer, "Dürer's 'Four Apostles,' " p. 286. In Dürer's original German text the introductory passage of the inscription reads as follows:

> Alle weltliche regenten jn disen ferlichen zeitten nemen billich acht, das sie nit für das göttlich wort menschliche verfüerung annemen. Dann gott wil nit zu seinem wort gethon, noch dannen genomen haben. Darauf horent dise trefflich vier menner Petrum, Johannem, Paulum vnd Marcum ire warnung [*DSN*, 1:210, no. 83].

The verb in question is *horent*. It employs an ending (*-ent*) that, according to Pfeiffer, Dürer uses for the third person plural indicative and present participle as well as the second person plural imperative.

78. Pfeiffer considers it unlikely that Dürer would have referred to the apostles as merely "excellent men" (p. 286).
79. Pfeiffer, "Dürer's 'Four Apostles,' " p. 288.
80. Ibid., pp. 278, 280–81.
81. Ibid., p. 286.
82. Most of the commentary to appear in print so far concerning Pfeiffer's thesis is in response to an earlier version of his essay (1960). Skepticism has been expressed by a number of authors, e.g., Martin, p. 25; von Einem, p. 89; Braunfels, p. 135; Anzelewsky, p. 279; Lutz, "Dürer in der Geschichte der Reformation," p. 40, n. 35. Seebass, however, has expressed a more sympathetic opinion in "Dürers Stellung," p. 130; so has Donald B. Kuspit, "Dürer and the Lutheran Image," pp. 60–61.
83. Strieder, p. 154.
84. Mathews proposes that the introductory inscription is directed against both the papists, who add to God's Word in the form of human laws and teachings, and the radicals, who take away from—i.e., do not fully accept—the Word of God (p. 151). Cf. Wiederanders, p. 112.
85. Heidrich rejected the possibility that the painting could have been intended in 1526 as a warning against papal opponents, on the assumption that there was no further threat from this direction (pp. 8–9).
86. Grote, *Dürer*, p. 121.
87. Moriz Thausing, *Albrecht Dürer: His Life and Works*, trans. Fred A. Eaton, 2 vols. (London, 1882), 2:271.
88. Panofsky, *Life and Art of Dürer*, p. 234.
89. Heidrich, p. 9.
90. Ibid., pp. 30 ff.; *Albrecht Dürer 1471–1971*, pp. 209, 212; Seebass, "Dürers Stellung," pp. 121–22.
91. This is especially true of the Petrine passage (Pfeiffer, "Dürer's 'Four Apostles,' " p. 287).
92. Heidrich, pp. 9, 21, 32.
93. Heidrich insists that this accusation cannot have been directed against the Roman Catholics (p. 9).
94. See Theodor Kolde, "Hans Denck und die gottlosen Maler von Nürnberg"; Heidrich, pp. 18 ff.; Strauss, p. 180.
95. Pfeiffer, however, questions the closeness of Dürer's relations with all three of these (p. 275).
96. Kolde, p. 65; Heidrich, pp. 19–20; Strauss, p. 180.
97. Kolde, p. 50; W. F. Neff, "Denk (Denck), Hans," *The Mennonite Encyclopedia*, 4 vols. (1955–59), 2:33.
98. George H. Williams, *The Radical Reformation* (Philadelphia, 1962), p. 149; Neff, pp. 32, 35.
99. Kolde, pp. 52–63; Williams, pp. 152–54.

100. Kolde, pp. 52–55. Cf. Williams, pp. 152–53.
101. Kolde, p. 65; Strauss, p. 180.
102. Heidrich, pp. 18, 21.
103. Ibid., p. 26. This viewpoint has been strongly expressed more recently, in a work drawing upon Heidrich's arguments, by Adolf Max Vogt, "Albrecht Dürer—Die Vier Apostel," p. 122. Mathews, however, asserts that no evidence exists to show that Dürer in fact was being accused of such a sympathy or involvement (p. 97, n. 82).
104. Pfeiffer, "Dürer's 'Four Apostles,' " pp. 285, 288. Pfeiffer also believes that "the passage from the Epistle of John leads to the subject of the Eucharistic dispute itself" (p. 288).
105. Seebass, "Dürers Stellung," p. 121. Seebass also discusses the possibility of viewing the Johannine text as anti-Catholic in its intended application.
106. Pfeiffer, "Dürer's 'Four Apostles,' " p. 287.
107. Dürer's reaction to the Peasants' Revolt is discussed in ibid., pp. 276–78.
108. Pfeiffer, however, has argued against Heidrich that "one may not seek the explanation for Dürer's painting in one episode, such as is presented by the trial against the 'godless painters' " (ibid., p. 276).
109. The translations are from Strauss, p. 180; see also Kolde, p. 65.
110. For the following paragraph, see Heidrich, pp. 45–46, 51, 55.
111. Pfeiffer, however, says, "The position of the pupil in the corner of the eye of the Apostle Paul . . . can easily be explained psychologically by the sideways glance that the person being painted made at the work of art being created" ("Dürer's 'Four Apostles,' " p. 282).
112. Cf. Rom. 13:1. There might be noted here Wiederanders' pertinent observation that Dürer fails to include in the inscriptions to the *Four Apostles* any of the Pauline passages really central to Reformation theology (p. 115).
113. Heidrich, pp. 48–51.
114. Ibid., p. 9.
115. Seebass, "Dürers Stellung," p. 128. On Denck's character, see Neff, who speaks of "the beauty of his sincere Christian spirit" (p. 35).
116. Lutz, "Dürer und die Reformation," p. 182; Lutz, "Dürer in der Geschichte der Reformation," pp. 42–43.
117. Gottfried Seebass, *Das reformatorische Werk des Andreas Osiander* (Nuernberg, 1967), pp. 210–11; Seebass, "Dürers Stellung," p. 129. Lutz, "Dürer und die Reformation," pp. 181–82; Lutz, "Dürer in der Geschichte der Reformation," p. 43.
118. Gottfried Seebass, "Zwei Briefe von Andreas Osiander," *Mitteilungen des Vereins für Geschichte der Stadt Nürnberg* 57 (1970): 201–15, esp. p. 215; Seebass, *Werk des Andreas Osiander*, pp. 209–16.
119. Seebass, *Werk des Andreas Osiander*, pp. 211–12.
120. Lutz mentions as another possible clerical target of Dürer's inscriptions the Nuernberg Lutheran preacher Dominicus Schleupner; Lutz, "Dürer in der Geschichte der Reformation," p. 43.
121. There is one piece of evidence from 1525, a phrase that Dürer inserted in his book of measurements: "Das wort gotes bleibt ewiglich. Dis wort ist Cristus, aller cristglaubigen heil" (*DSN*, 1:210, no. 78). Seebass interprets the artist's use of this formulation as reflecting a continued adherence to the Reformation movement (Seebass, "Dürers Stellung," pp. 118–19).
122. For the probable date of this letter, see *DSN*, 1:283, no. 137; Lutz, "Dürer und die Reformation," p. 180.
123. Quoted from Lewis W. Spitz, *The Religious Renaissance of the German Humanists* (Cambridge, Mass., 1963), p. 194. For the original German text, see *DSN*, 1:285.
124. Cf. Heidrich, pp. 59–60; Mathews, p. 93.

125. Seebass, "Dürers Stellung," p. 128.
126. Seebass, ibid., pp. 107, 109, 114–15. Cf. Weise, pp. 4, 21–22, 47; Wiederanders, pp. 15, 119–20.
127. Seebass, "Dürers Stellung," p. 131.
128. For the suggestion that Dürer may have consulted with Pirckheimer concerning the formulation of the inscriptions, see Hans Rupprich, "Dürer und Pirck-heimer: Geschichte einer Freundschaft," in *Albrecht Dürers Umwelt: Festschrift zum 500. Geburtstag Albrecht Dürers am 21. Mai 1971* (Nuernberg, 1971), p. 94.
129. *DSN*, 1:213.
130. The computerized study of Dürer's language mentioned above in n. 64 involves an analysis of the introductory inscription.
131. For this comprehensive definition of memorial painting, I am most indebted to Seebass, "Dürers Stellung," p. 130.
132. In addition to the works cited above in n. 26, cf. Seebass, "Dürers Stellung," p. 130.
133. Cf. Hans Rupprich, *Dürers Stellung zu den agnoëtischen und kunstfeindlichen Strömungen seiner Zeit*, p. 18.
134. Craig Harbison, "Dürer and the Reformation."
135. This quotation and the following one are reproduced from *Writings*, p. 212; for the original texts of both, see *DSN*, 1:115.
136. Cf. Anzelewsky, p. 277.
137. Grote, *Dürer*, pp. 121–22.
138. Pfeiffer suggests that the biblical texts from Paul and Mark might be read to suggest that "the council did not allow itself to be shaken by its disappointment over the way of life of fellowmen and especially of theologians and adhered to its ecclesiastical policy" ("Dürer's 'Four Apostles,' " p. 288).
139. Seebass, "Dürers Stellung," p. 120; *Albrecht Dürer 1471–1971*, p. 199.
140. Seebass, "Dürers Stellung," p. 130.
141. Ibid., pp. 130–31.
142. Cf. Lutz, "Dürer in der Geschichte der Reformation," p. 24; Seebass, "Dürers Stellung," p. 103.
143. A number of Catholic historians have asserted that Dürer lived and died true to the Roman church, e.g.; Wilhelm Neuss, "Dürer, Albrecht," *Lexikon für Theolo-gie und Kirche*, 2d ed., 10 vols. (1930–38), 3:500. For the older Catholic historiog-raphy on Dürer, see Mathews, pp. 79–80, 82–85, 88–93, 108–11.
144. Lutz, "Dürer in der Geschichte der Reformation," pp. 37–39, 43–44.
145. In order to evaluate properly the evidence from Pirckheimer's letter to Tschertte, we must take account of certain facts not hitherto discussed. First, Pirckheimer had certain personal grievances against the Lutheran preachers Osiander and Schleupner that Dürer did not necessarily share (see Spitz, pp. 192–93; and Seebass, "Dürers Stellung," p. 127). Second, Pirckheimer was by nature quarrelsome, hot-tempered, and quickly offended (Spitz, pp. 159–60).
146. For Venatorius, see Pfeiffer, who points out that the humanist preacher "was connected to Dürer by his interest in art theory" ("Dürer's 'Four Apostles,' " pp. 289–90).
147. In addition to ibid., see Spitz, p. 196.
148. Seebass, "Dürers Stellung," pp. 129–30; Pfeiffer, "Dürer's 'Four Apostles,' " p. 289; Wiederanders, p. 95.
149. Seebass, "Dürers Stellung," p. 130.
150. See n. 58.
151. Cf. Mathews, p. 63.
152. Cf. Thausing, 2:274.
153. Cf. Martin, p. 27.

Selected Bibliography

The following bibliography is quite selective. The first part listing primary sources is restricted to printed documents and does not include the unpublished manuscript materials cited in the section of the book dealing with Nuernberg. The next part consists largely of secondary sources considered to be directly relevant to the topic of art and the Reformation in Germany. Most works of a general historical nature have been omitted; the same is true, with some few exceptions, of broad monographic studies of individual artists and religious reformers.

Primary Sources

Barge, Hermann. "Neue Aktenstücke zur Geschichte der Wittenberger Unruhen von 1521/22." *Zeitschrift für Kirchengeschichte* 22 (1901): 120–29.

Die Bekenntnisschriften der evangelisch-lutherischen Kirche. 6th rev. ed. Göttingen: Vandenhoeck & Ruprecht, 1967.

Bernoulli, August, ed. *Basler Chroniken.* Vol. 6. Leipzig: S. Hirzel, 1902.

———, ed. *Basler Chroniken.* Vol. 7. Leipzig: S. Hirzel, 1915.

Bucer, Martin. *Martin Bucers Deutsche Schriften.* Edited by Robert Stupperich. Martini Buceri Opera Omnia, ser. 1. Gütersloh: Verlagshaus Gerd Mohn, 1960 ff.; Paris: Presses Universitaires de France, 1960 ff. Vols. 1 and 2.

Dacheux, L., ed. *Les Annales de Sébastien Brant.* Fragments des anciennes chroniques d'Alsace, 3. Strasbourg: Imprimerie Strasbourgeoise, 1892.

———, ed. *La Chronique Strasbourgeoise de Sebald Büheler.* Fragments des anciennes chroniques d'Alsace, 1. Strasbourg: R. Schultz et Cie, 1887.

———, ed. *Les Chroniques Strasbourgeoises de Jacques Trausch et de Jean Wencker.* Fragments des anciennes chroniques d'Alsace, 3. Strasbourg: Imprimerie Strasbourgeoise, 1892.

———, ed. *La Petite Chronique de la Cathédrale.* Fragments des anciennes chroniques d'Alsace, 1. Strasbourg: R. Schultz et Cie, 1887.

Denck, Hans. *Schriften.* Part 3. *Exegetische Schriften, Gedichte und Briefe.* Edited by Walter Fellmann. Quellen zur Geschichte der Täufer, vol. 6, part 3. Gütersloh: Verlagshaus Gerd Mohn, 1960.

Dietrich, Veit. *Summaria vber die gantze Bibel.* Nuernberg: I. vom Berg & V. Newber, 1562.

Dürer, Albrecht. *Dürer: Schriftlicher Nachlass.* Edited by Hans Rupprich. 3 vols. Berlin: Deutscher Verein für Kunstwissenschaft, 1956–69. Vol. 1. ———. *The Writings of Albrecht Dürer.* Translated and edited by William Martin Conway. New York: Philosophical Library, 1958.

Dürr, Emil, and Roth, Paul, eds. *Aktensammlung zur Geschichte der Basler Reformation*

in den Jahren 1519 bis Anfang 1534. Vol. 2. *Juli 1525 bis Ende 1527.* Basel: Verlag der Historischen und Antiquarischen Gesellschaft, 1933.

Erasmus, Desiderius. *Desiderii Erasmi Opera Omnia.* Edited by J. Clericus. 10 vols. Leiden: Petrus vander Aa, 1703–06; reprint, London: Gregg Press, 1962. Vol. 10.

———. *Opus Epistolarum Des. Erasmi Roterodami.* Edited by P. S. Allen, H. M. Allen, and H. W. Garrod. 12 vols. Oxford: Clarendon Press, 1906–58. Vol. 8.

———. *The Praise of Folly.* Translated by Hoyt Hopewell Hudson. Princeton: Princeton University Press, 1941.

"Zur Geschichte des Bildersturms von 1529." *Basler Taschenbuch* 5/6 (1855): 193–96.

Hampe, Theodor, ed. *Nürnberger Ratsverlässe über Kunst und Künstler im Zeitalter der Spätgotik und Renaissance.* 3 vols. Vienna: K. Gräser & Co., 1904. Vol. 1.

Harms, Bernhard, ed. *Der Stadthaushalt Basels im ausgehenden Mittelalter.* Erste Abteilung. *Die Jahresrechnungen 1360–1535.* Erster Band. *Die Einnahmen.* Tübingen: H. Laupp, 1909.

Herminjard, A.-L., ed. *Correspondance des Réformateurs dans les pays de langue française.* 9 vols. Geneva: H. Georg, 1866–97; reprint, Nieuwkoop: B. de Graaf, 1965–66. Vol. 1.

Karlstadt, Andreas Bodenstein von. *Von abtuhung der Bylder Vnd das keyn Betdler vnther den Christen seyn soll.* Wittenberg: Nicolaus Schirlentz, 1522.

———. *Von Abtuhung der Bilder und das keyn Bedtler vnther den Christen seyn sollen 1522 und die Wittenberger Beutelordnung.* Edited by Hans Lietzmann. Kleine Texte für theologische und philologische Vorlesungen und Übungen, no. 74. Bonn: A. Marcus & E. Weber, 1911.

Kessler, Johannes. *Johannes Kesslers Sabbata mit kleineren Schriften und Briefen.* Edited by Emil Egli and Rudolf Schoch. St. Gall: Fehr'sche Buchhandlung, 1902.

Kolde, Theodor. "Gleichzeitige Berichte über die Wittenberger Unruhen im Jahre 1521 und 1522." *Zeitschrift für Kirchengeschichte* 5 (1882): 325–33.

———. "Wittenberger Disputationsthesen aus den Jahren 1516–1522." *Zeitschrift für Kirchengeschichte* 11 (1889/1890): 448–71.

Krebs, Manfred, and Rott, Hans Georg, eds. *Quellen zur Geschichte der Täufer.* Vol. 7. *Elsass.* Part 1. *Stadt Strassburg 1522–1532.* Gütersloh: Verlagshaus Gerd Mohn, 1959.

Luther, Martin. *D. Martin Luthers Werke, Kritische Gesamtausgabe.* Weimar: Hermann Böhlau, 1883 ff.; reprint, Graz: Akademische Druck- u. Verlagsanstalt, 1964 ff.

———. *Luther: Lectures on Romans.* Translated and edited by Wilhelm Pauck. The Library of Christian Classics, vol. 15. Philadelphia: Westminster Press, 1961.

———. *Luther's Works, American Edition.* Edited by Jaroslav Pelikan and Helmut T. Lehmann. 55 vols. St. Louis: Concordia Publishing House, 1955 ff.; Philadelphia: Fortress Press, 1957 ff.

———. *Martin Luther on "The Bondage of the Will." A New Translation of "De Servo Arbitrio" (1525).* Translated by J. I. Packer and O. R. Johnston. Westwood, N.J.: Fleming H. Revell Co., 1957.

Melanchthon, Philipp. *Philippi Melanthonis Opera Quae Supersunt Omnia.* Edited by C. G. Bretschneider and H. E. Bindseil. Corpus Reformatorum, vols. 1–28. Halle and Braunschweig: C. A. Schwetschke et Filium, 1834–60; reprint, New York and London: Johnson Reprint Corp., 1963. Vol. 1.

Müller, Nikolaus. "Die Wittenberger Bewegung 1521 und 1522." *Archiv für Reformationsgeschichte* 6 (1908/1909): 161–225, 261–325, 385–469; 7 (1909/1910): 185–224, 233–93, 353–412; 8 (1910/1911): 1–43. Also published in book form in Leipzig, 1911, under the same title.

Pirckheimer, Charitas. *An Heroic Abbess of Reformation Days: The Memoirs of Mother Charitas Pirkheimer, Poor Clare, of Nuremberg.* Introduction by Francis Mannhardt, S.J. St. Louis: Central Bureau, C.C.V. of A., 1930.

Plass, Ewald M., comp. *What Luther Says: An Anthology.* 3 vols. St. Louis: Concordia Publishing House, 1959. Vols. 2 and 3.

Reuss, Rudolf. "Strassburg im sechzehnten Jahrhundert (1500–1591): Auszug aus der Imlin'schen Familienchronik." *Alsatia* 39 (1873–1874 [1875]): 363–476.

Richter, Aemilius Ludwig, ed. *Die evangelischen Kirchenordnungen des sechszehnten Jahrhunderts.* 2 vols. Weimar: Landes-Industriecomtoir, 1846; reprint, Nieuwkoop: B. de Graaf, 1967. Vols. 1 and 2.

Roth, Friedrich, ed. *Die Chronik des Augsburger Malers Georg Preu des Älteren 1512– 1537.* Die Chroniken der deutschen Städte vom 14. bis ins 16. Jahrhundert, vol. 29. Leipzig: S. Hirzel, 1906; reprint, Göttingen: Vandenhoeck & Ruprecht, 1966.

Roth, Paul. "Eine Elegie zum Bildersturm in Basel." *Basler Zeitschrift für Geschichte und Altertumskunde* 42 (1943): 131–38.

———, ed. *Aktensammlung zur Geschichte der Basler Reformation in den Jahren 1519 bis Anfang 1534.* Vol. 3. *1528 bis Juni 1529.* Basel: Verlag der Historischen und Antiquarischen Gesellschaft, 1937.

Rott, Hans. *Quellen und Forschungen zur südwestdeutschen und schweizerischen Kunstgeschichte im XV. und XVI. Jahrhundert.* 3 vols. Stuttgart: Strecker & Schröder, 1933–38.

Scheidig, Walther. "Urkunden zu Cranachs Leben und Schaffen." In *Lucas Cranach der Ältere: Der Künstler und seine Zeit,* edited by Heinz Lüdecke, pp. 156–77. Berlin: Henschelverlag, 1953.

Schiess, Traugott, ed. *Briefwechsel der Brüder Ambrosius und Thomas Blaurer 1509– 1548.* 3 vols. Freiburg: Ernst Fehsenfeld, 1908–12. Vol. 1.

Sehling, Emil, ed. *Die evangelischen Kirchenordnungen des XVI. Jahrhunderts.* Vol. 1. *Sachsen und Thüringen, nebst angrenzenden Gebieten.* Part l. *Die Ordnungen Luthers. Die Ernestinischen und Albertinischen Gebiete.* Leipzig: O. R. Reisland, 1902.

———. *Die evangelischen Kirchenordnungen des XVI. Jahrhunderts.* Vol. 11. *Bayern.* Part 1. *Franken.* Tübingen: J. C. B. Mohr (Paul Siebeck), 1961.

———. *Die evangelischen Kirchenordnungen des XVI. Jahrhunderts.* Vol. 12. *Bayern.* Part 2. *Schwaben.* Tübingen: J. C. B. Mohr (Paul Siebeck), 1963.

Staehelin, Ernst, ed. *Briefe und Akten zum Leben Oekolampads.* 2 vols. Leipzig: M. Heinsius Nachfolger, 1927, 1934. Vol. 2.

Stechow, Wolfgang, ed. *Northern Renaissance Art 1400–1600: Sources and Documents.* Englewood Cliffs, N.J.: Prentice-Hall, 1966.

Tappert, Theodore G., ed. *The Book of Concord: The Confessions of the Evangelical Lutheran Church.* Philadelphia: Fortress Press, 1959.

Thomas Aquinas. *Summa Theologiae.* Latin Text and English Translation. 60 vols. New York: McGraw-Hill Book Co., 1964 ff.; London: Eyre & Spottiswoode, 1964 ff. Vols. 39 and 50.

Vischer, Wilhelm, and Stern, Alfred, eds. *Basler Chroniken.* Vol. 1. Leipzig: S. Hirzel, 1872.

Williams, George H., ed. *Spiritual and Anabaptist Writers: Documents Illustrative of the Radical Reformation.* The Library of Christian Classics, vol. 25. Philadelphia: Westminster Press, 1957.

Zwingli, Huldreich. *Huldreich Zwinglis Sämtliche Werke.* Edited by Emil Egli, Georg Finsler, Walther Köhler, and Oskar Farner. Vol. 4. Corpus Reformatorum, vol. 91. Leipzig: M. Heinsius Nachfolger, 1927.

———. *Huldreich Zwinglis Sämtliche Werke.* Edited by Emil Egli, Georg Finsler, and Walther Köhler. Vol. 8. Corpus Reformatorum, vol. 95. Leipzig: M. Heinsius Nachfolger, 1914.

Secondary Sources

Battisti, Eugenio. "Reformation and Counter Reformation." *Encyclopedia of World Art* 11 (1966): 894–916.

Baumgarten, Fritz. "Hans Baldungs Stellung zur Reformation." *Zeitschrift für die Geschichte des Oberrheins* 19 (1904): 245–64.

Benesch, Otto. *German Painting: From Dürer to Holbein.* Translated by H. S. B. Harrison. Geneva: Albert Skira, 1966.

Bevan, Edwyn. *Holy Images: An Inquiry into Idolatry and Image-Worship in Ancient Paganism and in Christianity.* London: George Allen & Unwin, 1940.

Braunfels, Wolfgang. "Die reformatorische Bewegung im Spiegel von Dürers Spätwerk." In *Albrecht Dürer: Kunst einer Zeitenwende,* edited by Herbert Schade, pp. 123–43. Regensburg: Friedrich Pustet, 1971.

Buchholz, Friedrich. *Protestantismus und Kunst im sechzehnten Jahrhundert.* Leipzig: Dieterich'sche Verlagshaus, 1928.

Campenhausen, Hans Frhr. v. "Die Bilderfrage in der Reformation." *Zeitschrift für Kirchengeschichte* 68 (1957): 96–128.

———. "Zwingli und Luther zur Bilderfrage." In *Das Gottesbild im Abendland,* edited by Günter Howe, pp. 139–72. Witten and Berlin: Eckart-Verlag, 1957.

Christensen, Carl C. "Dürer's 'Four Apostles' and the Dedication as a Form of Renaissance Art Patronage." *Renaissance Quarterly* 20 (1967): 325–34.

———. "Iconoclasm and the Preservation of Ecclesiastical Art in Reformation Nuernberg." *Archiv für Reformationsgeschichte* 61 (1970): 205–21.

———. "Luther's Theology and the Uses of Religious Art." *The Lutheran Quarterly* 22 (1970): 147–65.

———. "Municipal Patronage and the Crisis of the Arts in Reformation Nuernberg." *Church History* 36 (1967): 140–50.

———. "Patterns of Iconoclasm in the Early Reformation: Strasbourg and Basel." In *The Image and the Word: Confrontations in Judaism, Christianity and Islam,* edited by Joseph Gutmann, pp. 107–48. Missoula, Montana: Scholars Press, 1977.

———. "The Reformation and the Decline of German Art." *Central European History* 6 (1973): 207–32.

———. "The Significance of the Epitaph Monument in Early Lutheran Ecclesiastical Art (ca. 1540–1600): Some Social and Iconographical Considerations." In *The Social History of the Reformation,* edited by Lawrence P. Buck and Jonathan W. Zophy, pp. 297–314. Columbus: Ohio State University Press, 1972.

Coulton, G. G. *Art and the Reformation.* Oxford: Basil Blackwell, 1928.

Dehio, Georg. "Die Krisis der deutschen Kunst im sechzehnten Jahrhundert." *Archiv für Kulturgeschichte* 12 (1914): 1–16.

Eggert, Helmuth. "Altar (prot.)." *Reallexikon zur deutschen Kunstgeschichte* 1 (1937): 430–39.

———. "Altarretabel (prot.)." *Reallexikon zur deutschen Kunstgeschichte* 1 (1937): 565–602.

Ehresmann, Donald L. "The Brazen Serpent: A Reformation Motif in the Works of Lucas Cranach the Elder and his Workshop." *Marsyas* 13 (1966–67): 32–47.

Einem, Herbert von. "Dürers 'Vier Apostel.'" *Anzeiger des Germanischen National-Museums* (1969), 89–103.

Fischer, Friedrich. "Der Bildersturm in der Schweiz und in Basel insbesondere." *Basler Taschenbuch* 1 (1850): 3–43.

Foerster, Richard. "Die Bildnisse von Johann Hess und Cranachs 'Gesetz und Gnade.'" *Schlesiens Vorzeit: Jahrbuch des schlesischen Museums für Kunstgewerbe und Altertümer,* N.F., 5 (1909): 117–43.

Freedberg, David. "The Structure of Byzantine and European Iconoclasm." In *Iconoclasm,* edited by Anthony Bryer and Judith Herrin, pp. 165–77. Birmingham: Centre for Byzantine Studies, 1977.

Garside, Charles Jr. "Ludwig Haetzer's Pamphlet against Images: A Critical Study." *The Mennonite Quarterly Review* 34 (1960): 20–36.

———. *Zwingli and the Arts.* New Haven: Yale University Press, 1966.

Geisberg, Max. "Cranach's Illustrations to the Lord's Prayer and the Editions of Luther's Catechism." *The Burlington Magazine* 43 (1923): 85–87.

———. *The German Single-Leaf Woodcut: 1500–1550.* Revised and edited by Walter L. Strauss. New York: Hacker Art Books, 1974.

Gertz, Ulrich. *Die Bedeutung der Malerei für die Evangeliumsverkündigung in der evangelischen Kirche des XVI. Jahrhunderts.* Berlin: Rudolph Pfau, 1936.

Giese, Rachel. "Erasmus and the Fine Arts." *The Journal of Modern History* 7 (1935): 257–79.

Grohne, Ernst. "Die bremischen Truhen mit reformatorischen Darstellungen und der Ursprung ihrer Motive." *Schriften der Bremer Wissenschaftlichen Gesellschaft, Reihe D: Abhandlungen und Vorträge* 10 (1936): 3–88.

Grossmann, F. "A Religious Allegory by Hans Holbein the Younger." *The Burlington Magazine* 103 (1961): 491–94.

Grüneisen, Ernst. "Grundlegendes für die Bilder in Luthers Katechismen." *Luther-Jahrbuch* 20 (1938): 1–44.

Guldan, Ernst and Riedinger, Utto, O.S.B. "Die protestantischen Deckenmalereien der Burgkapelle auf Strechau." *Wiener Jahrbuch für Kunstgeschichte* 18 (1960): 28–86.

Gutmann, Joseph, ed. *No Graven Images: Studies in Art and the Hebrew Bible.* New York: Ktav Publishing House, 1971.

Häcker, Otto. "Evangelische Altarkunst der Renaissance- und Barockzeit in Schwaben." *Das schwäbische Museum* 9 (1933): 5–16.

Haebler, Hans Carl von. *Das Bild in der evangelischen Kirche.* Berlin: Evangelische Verlagsanstalt, 1957.

Harbison, Craig. "Dürer and the Reformation: The Problem of the Re-dating of the St. Philip Engraving." *The Art Bulletin* 58 (1976): 368–73.

———. *The Last Judgment in Sixteenth Century Northern Europe: A Study of the Relation Between Art and the Reformation.* New York: Garland Publishing, 1976.

———. "Reformation Iconography: Problems and Attitudes." *Print Review* 5 (1976): 78–87.

Hasse, Max. "Maria und die Heiligen im protestantischen Lübeck." *Nordelbingen* 34 (1965): 72–81.

Heidrich, Ernst. *Dürer und die Reformation.* Leipzig: Klinkhardt & Biermann, 1909.

Hintzenstern, Herbert von. *Lucas Cranach d. Ä.: Altarbilder aus der Reformationszeit.* Berlin: Evangelische Verlagsanstalt, 1972.

His, Eduard. "Holbeins Verhältniss zur Basler Reformation." *Repertorium für Kunstwissenschaft* 2 (1879): 156–59.

Hoberg, Martin. *Die Gesangbuchillustration des 16. Jahrhunderts: Ein Beitrag zum Problem Reformation und Kunst.* Strasbourg: J. H. Ed. Heitz, 1933.

Holl, Karl. *The Cultural Significance of the Reformation.* Translated by Karl and Barbara Hertz and John H. Lichtblau. New York: Meridian Books, 1959.

Hollstein, F. W. H. *German Engravings, Etchings and Woodcuts: ca. 1400–1700.* Amsterdam: Menno Hertzberger, 1954 ff.

Jursch, Hanna. "Der Cranach-Altar." In *Die Stadtkirche zu St. Peter und Paul in Weimar,* edited by Eva Schmidt, pp. 65–83. Berlin: Union Verlag, 1955.

Kibish, Christine O. "Lucas Cranach's 'Christ Blessing the Children': A Problem of Lutheran Iconography." *The Art Bulletin* 37 (1955): 196–203.

Der Kirchenbau des Protestantismus von der Reformation bis zur Gegenwart. Herausgegeben von der Vereinigung Berliner Architekten. Berlin: Ernst Toeche, 1893.

Koepplin, Dieter and Falk, Tilman. *Lukas Cranach: Gemälde, Zeichnungen, Druckgraphik.* 2 vols. Basel and Stuttgart: Birkhäuser Verlag, 1974, 1976.

Kolde, Theodor. "Hans Denck und die gottlosen Maler von Nürnberg." *Beiträge zur bayerische Kirchengeschichte* 8 (1901–02): 1–31, 49–72.

Kuhn, Charles L. "The Mairhauser Epitaph: An Example of Late Sixteenth-Century Lutheran Iconography." *The Art Bulletin* 58 (1976): 542–46.

Kuspit, Donald B. "Dürer and the Lutheran Image." *Art in America* 63 (1975): 56–61.

————. "Melanchthon and Dürer: The Search for the Simple Style." *The Journal of Medieval and Renaissance Studies* 3 (1973): 177–202.

Lankheit, Klaus. "Dürers 'Vier Apostel.'" *Zeitschrift für Theologie und Kirche* 49 (1952): 238–54.

Lehfeldt, Paul. *Luthers Verhältniss zu Kunst und Künstlern.* Berlin: Wilhelm Hertz, 1892.

Lutz, Heinrich. "Albrecht Dürer in der Geschichte der Reformation." *Historische Zeitschrift* 206 (1968): 22–44.

————. "Albrecht Dürer und die Reformation: Offene Fragen." *Miscellanea Bibliothecae Hertzianae* 16 (1961): 175–83.

McClinton, Katharine Morrison. "The Lutheran Reformation Paintings of Lucas Cranach, the Elder." *Response in Worship, Music, the Arts* 4 (1962): 2–6.

Martin, Kurt. *Albrecht Dürer: Die Vier Apostel.* Stuttgart: Philipp Reclam, 1963.

Mathews, Wendell G. "Albrecht Dürer as a Reformation Figure." Ph.D. dissertation, University of Iowa, 1968.

Meier, Karl Ernst. "Fortleben der religiös-dogmatischen Kompositionen Cranachs in der Kunst des Protestantismus." *Repertorium für Kunstwissenschaft* 32 (1909): 415–35.

Oertel, Hermann. "Das protestantische Abendmahlsbild im Niederdeutschen Raum und seine Vorbilder." *Niederdeutsche Beiträge zur Kunstgeschichte* 13 (1974): 223–70.

Osten, Gert von der, and Vey, Horst. *Painting and Sculpture in Germany and the Netherlands 1500 to 1600.* Translated by Mary Hottinger. Harmondsworth, Middlesex: Penguin Books, 1969.

Panofsky, Erwin. "Comments on Art and Reformation." In *Symbols in Transformation: Iconographic Themes at the Time of the Reformation,* Exhibition Catalog, pp. 9–14. Princeton: Princeton University Art Museum, 1969.

————. "Erasmus and the Visual Arts." *Journal of the Warburg and Courtauld Institutes* 32 (1969): 200–27.

Pfeiffer, Gerhard. "Albrecht Dürer's 'Four Apostles': A Memorial Picture from the Reformation Era." In *The Social History of the Reformation,* edited by Lawrence P. Buck and Jonathan W. Zophy, pp. 271–96. Columbus: Ohio State University Press, 1972.

————. "Judas Iskarioth auf Lucas Cranachs Altar der Schlosskirche zu Dessau." In *Festschrift Karl Oettinger,* edited by Hans Sedlmayr and Wilhelm Messerer, pp. 389–400. Erlangen: Universitätsbund Erlangen-Nürnberg e.V., 1967.

Pope, Myrna B. "Woodcuts by Lucas Cranach the Elder and his Workshop: A Catalogue." Ph.D. dissertation, University of Pennsylvania, 1976.

Poscharsky, Peter. "Kurze Entwicklungsgeschichte der Kanzel." *Kunst und Kirche* 23 (1960): 51–64.

Preus, James S. *Carlstadt's "Ordinaciones" and Luther's Liberty: A Study of the Wittenberg Movement, 1521–22.* Cambridge: Harvard University Press, 1974.

Preuss, Hans. *Die deutsche Frömmigkeit im Spiegel der bildenden Kunst.* Berlin: Furche-Kunstverlag, 1926.

————. *Martin Luther der Künstler.* Gütersloh: C. Bertelsmann, 1931.

————. "Zum Luthertum in Cranachs Kunst." *Neue kirchliche Zeitschrift* 32 (1921): 109–21.

Rogge, Christian. *Luther und die Kirchenbilder seiner Zeit.* Leipzig: Verein für Reformationsgeschichte, 1912.

Rott, Hans. "Kirchen- und Bildersturm bei der Einführung der Reformation in der Pfalz." *Neues Archiv für die Geschichte der Stadt Heidelberg und der rheinischen Pfalz* 6 (1905): 229–54.

Rupprich, Hans. *Dürers Stellung zu den agnoëtischen und kunstfeindlichen Strömungen seiner Zeit.* Munich: Verlag der Bayerischen Akademie der Wissenschaften, 1959.

Rüstow, Alexander. "Lutherana Tragoedia Artis." *Schweizer Monatshefte* 39 (1959): 891–906.

Sauer, J. "Reformation und Kunst im Bereich des heutigen Baden." *Freiburger Diözesan-Archiv* 46 (1919): 323–506.

Saxl, F. "Dürer and the Reformation." *Lectures*. Vol. 1, pp. 267–76. London: Warburg Institute, University of London, 1957.

———. "Holbein and the Reformation." *Lectures*. Vol. 1, pp. 277–85. London: Warburg Institute, University of London, 1957.

Schade, Werner. *Die Malerfamilie Cranach*. Dresden: Verlag der Kunst, 1974.

Schildhauer, Johannes. "Der Stralsunder Kirchensturm des Jahres 1525." *Wissenschaftliche Zeitschrift der Ernst Moritz Arndt-Universität Greifswald* 8 (1958/1959): 113–19.

Schmidt, Ph. *Die Illustration der Lutherbibel 1522–1700*. Basel: Friedrich Reinhardt, 1962.

Schramm, Albert. *Luther und die Bibel*. Vol. 1. *Die Illustration der Lutherbibel*. Leipzig: Karl W. Hiersemann, 1923.

Seebass, Gottfried. "Dürers Stellung in der reformatorischen Bewegung." *Albrecht Dürers Umwelt: Festschrift zum 500. Geburtstag Albrecht Dürers am 21. Mai 1971*, pp. 101–31. Nuernberg: Selbstverlag des Vereins für Geschichte der Stadt Nürnberg, 1971.

Sider, Ronald J. *Andreas Bodenstein von Karlstadt: The Development of his Thought, 1517–1525*. Leiden: E. J. Brill, 1974.

Spelman, Leslie P. "Luther and the Arts." *The Journal of Aesthetics and Art Criticism* 10 (1951): 166–75.

Stirm, Margarete. *Die Bilderfrage in der Reformation*. Gütersloh: Verlagshaus Gerd Mohn, 1977.

Strachan, James. *Early Bible Illustrations: A Short Study Based on Some Fifteenth and Early Sixteenth Century Printed Texts*. Cambridge: Cambridge University Press, 1957.

Strand, Kenneth A. *Reformation Bible Pictures: Woodcuts from Early Lutheran and Emserian New Testaments*. Ann Arbor: Ann Arbor Publishers, 1963.

———. *Woodcuts to the Apocalypse in Dürer's Time*. Ann Arbor: Ann Arbor Publishers, 1968.

Strauss, Walter L. *The German Single-Leaf Woodcut 1550–1600: A Pictorial Catalogue*. New York: Abaris Books, 1975.

Strieder, Peter. "Albrecht Dürers 'Vier Apostel' im Nürnberger Rathaus." In *Festschrift Klaus Lankheit*, edited by Wolfgang Hartmann, pp. 151–57. Cologne: M. DuMont Schauberg, 1973.

Stroh, Otto. "Der Wittenberger Altar." *Concordia Theological Monthly* 17 (1946): 280–96.

Stuhlfauth, Georg. "Künstlerstimmen und Künstlernot aus der Reformationsbewegung." *Zeitschrift für Kirchengeschichte* 56, 3rd ser. 7 (1937): 498–514.

Thulin, Oskar. *Cranach-Altäre der Reformation*. Berlin: Evangelische Verlagsanstalt, 1955.

———. "Luther in the Arts." *The Encyclopedia of the Lutheran Church* (1965), 2:1433–38.

———. "Reformatorische und frühprotestantische Abendmahlsdarstellungen." *Kunst und Kirche* 16 (1939): 30–34.

Vogt, Adolf Mat. "Albrecht Dürer—Die Vier Apostel." In *Festschrift Kurt Badt zum siebzigsten Geburtstage*, edited by Martin Gosebruch, pp. 121–34. Berlin: Walter de Gruyter & Co., 1961.

Warnke, Martin. "Durchbrochene Geschichte? Die Bilderstürme der Wiedertäufer in Münster 1534/1535." In *Bildersturm: Die Zerstörung des Kunstwerks*, edited by Martin Warnke, pp. 65–98, 159–67. Munich: Carl Hanser, 1973.

Wernicke, E. "Grabdenkmäler aus dem Jahrhundert der Reformation in evangelischen Kirchen Deutschlands." *Christliches Kunstblatt* 24 (1882): 49–55, 73–79.

Wiederanders, Gerlinde. *Albrecht Dürers theologische Anschauungen.* Berlin: Evangelische Verlagsanstalt, 1975.

Woltmann, Alfred. *Die deutsche Kunst und die Reformation.* Berlin: C. G. Lüderitz, 1867.

Wynen, Arnulf. "Michael Ostendorfer (um 1492–1559): Ein Regensburger Maler der Reformationszeit." Ph.D. dissertation, University of Freiburg, 1961.

Zimmermann, Hildegard. *Beiträge zur Bibelillustration des 16. Jahrhunderts.* Strasbourg: J. H. Ed. Heitz, 1924.

———. "Vom deutschen Holzschnitt der Reformationszeit." *Archiv für Reformationsgeschichte* 23 (1926): 101–12.

Zschelletzschky, Herbert. *Die "drei gottlosen Maler" von Nürnberg: Sebald Beham, Barthel Beham und Georg Pencz. Historische Grundlagen und ikonologische Probleme ihrer Graphik zu Reformations- und Bauernkriegszeit.* Leipzig: E. A. Seemann, 1975.

Index

Carl C. Christensen is professor of history at the University of Colorado at Boulder. He has been a Woodrow Wilson and Fulbright Fellow and has made extensive scholarly contributions in the area of Reformation history. He holds the Ph.D. degree from Ohio State University.

The book was designed by Gary Gore.
The typeface for the text is Palatino, designed by Herman Zapf about 1950.
The display face is Palatino.
The text is printed on Booktext Natural paper, and the book is bound in Joanna Mills' Arrestox A cloth over binder's boards.

Manufactured in the United States of America.